W9-AHQ-062

The Red Fez

The Red Fez

Art and Spirit Possession in Africa

FRITZ W. KRAMER

Translated by Malcolm Green

VERSO

London · New York

First published as *Der rote Fes: Über Besessenheit und Kunst in Afrika*
by Athenäum Verlag 1987
This translation first published by Verso 1993
© Athenäum Verlag 1987
Translation © Malcolm Green 1993

Verso
UK: 6 Meard Street, London W1V 3HR
USA: 29 West 35th Street, New York, NY 10001-2291

Verso is the imprint of New Left Books

ISBN 0-86091-465-8

British Library Cataloguing in Publication Data
A catalogue record for this book is available from the British Library

Library of Congress Cataloging-in-Publication Data
A catalogue record for this book is available from the Library of Congress

Typeset in Baskerville by York House Typographic Ltd, London W13
Printed in Great Britain by Biddles Ltd

Contents

Foreword

There is a minor tradition in the history of European thought which runs counter to the scientific mainstream; it diverts from the largest and most enduring of obsessions, the desire to observe, in order to draw attention to the *state of being observed*: it sets being known against knowledge, and being discovered against discovery. The most important image for contemplation created during the baroque period was that of the Eye of God; yet although the Enlightenment understood itself as observant intellect, it also invented the figure of the foreign traveller, the Persian, Chinese or Hottentot who visited Europe and viewed it with foreign and unerring eyes, with a secular but otherworldly gaze. This counterpart was only forgotten with the coming of systematized, scientific observation, which made its knowledge irreversible.

One would imagine that anthropology, which observes people in foreign societies, would be the most likely place to find a hint of discomfort at the one-sidedness of this obsession. Observation in anthropology is called *participant* observation; but the anthropologist tends to exclude himself from actual participation, reducing himself to an observing point which itself cannot be perceived. Indeed Malinowski, the founder of "participant observation", spoke explicitly of the "ethnographer's eye", which he liked most to imagine as "a super-film-camera in a helicostatic aeroplane" suspended above the Trobriand Islands. This discomforting state of affairs becomes even clearer if we think of modern video surveillance.

In 1783, Herder, who was familiar with the literary genre of *Lettres persanes*, was still able to write that what interested him most were reports on "how foreign nations view us", for he considered the various cultures to be on equal footing and, in keeping with the Enlightenment, accredited the *view from without* with powers of judgement and perception which, based on natural reason, could surpass those of the *insider's view*. Nowadays this confidence must appear rather peculiar, first because modern civilization alone has systematized the form of scientific observation, and second because we have such great trust in the *insider's view* that the assignment the anthropologist sets himself is precisely that of seeing the society he is investigating just as it sees itself.

So what value should be attached to the way a foreigner perceives modern civilization from *without*?

In fact just one outsider among the German ethnologists dared once, in all seriousness, to sketch out a picture of modern civilization "as seen through the eyes of the savage": Julius Lips, whose research still comes across as slightly audacious – or, if one prefers, avant-garde – even though or because he wrote not for his professional peers, but rather for a broad circle of readers. Lips had photographs taken of items in European, American and African collections of drawings and plastic arts from non-literate cultures, and identified them as depictions of Europeans. Thus he relied not on the scientific but on the artistic eye, whose trace could be found in these works.

The society in which he carried out his examinations assumed that his collection was full of abominations: the Gestapo tried to seize the photographs because, in their eyes, the "primitive" picture of the white man could be nothing but a smear on the "Führer" or the "Aryan race". Lips escaped this hunt by emigrating, but evidently it led him to the opinion that he was holding the material for a ruthless satire on "civilization"; when in 1937 his study was published in American exile, he gave it the title *The Savage Hits Back*, even though in the text he stressed the understanding nature of the "primitive's image of the white man" rather than the aggressive side. What Lips had discovered was that the non-European portrayals of Europeans often have an astonishing *likeness*; and by interpreting this likeness as a means for *committed satire*, he blocked

the insight that he had discovered a *realistic* tradition which did not fit in with the then prevailing picture of abstraction in "primitive art".

According to my thesis, this realism, which in keeping with Erich Auerbach I understand as the "interpretation of the real by mimesis", arises from the confrontation with an alien reality whose underlying premises are not shared by the outside observer. The *view from without* lacks any understanding of the hierarchies and values of the everyday world it observes, a world which regulates itself according to them and thus all too easily overlooks the "problematic and contradictory" in its everyday reality. The alien, uncomprehending eye eliminates the hierarchies; it isolates the hidden and ordinary and raises it to the point at which it is identified as monstrous. This vantage point is interesting because the outside observer maintains an essential distance, doing so precisely by making his replicas – and in some cases even himself – similar to that which he observes, and not, as Lips believed, by passing critical judgement.

A shift in perspective is essential if, fifty years later, one wishes to take up Julius Lips's theme once again. I would have loved to have drawn on the full range of non-literate cultures, as did Lips, but my knowledge of the ethnographic background is too limited. Originally I had intended to tackle at least the African representations of Europeans in their entirety, but soon this too proved unfeasible. In the end I had to be content with very few paradigms, namely with the Asante and the Kalabari, the Shona, the Pende and the Cokwe; yet even here I could select only a handful of works for interpretation. My choice and the occasional comparisons are the product of chance. I claim to have amassed neither the most representative works, nor those of the greatest aesthetic importance. Above all I have not entered into the major topic of court arts, which was of great significance for Lips.

The common thread linking the images I have interpreted resulted from a broadening of the perspective defined by Lips to include phenomena which are not customarily designated as art. This broader perspective touched both the form and the contents of the portrayals. Now that Europe, with the exception of a few

cultural philosophers and countless backwoodsmen, no longer conccives of itself as the centre of the world or the crowning point of history, it seemed inappropriate to me to take the European as the exact, definitive counterpart to the African, as Lips had done, in keeping with the tradition of the *Lettres persanes*. Similarly I was unable to agree with the notion of a uniform "primitive art" which exists in its own terms, such as Lips took for granted.

A glance at African myths and cosmologies shows that the first Europeans in Africa were by no means "discovered" to be the unique, incomparable beings which they liked to regard themselves as. A way of thought to which the category of the new is unknown, recognizing in its place solely the return of that which has always been, could not avoid likening the curious appearance of the European with that which was already familiar, placing it in a relationship to self which had been established at the dawn of time. The familiar, of which the European was seen as one variation, was the opposite to the cultivated person, and European culture was purely and simply the other to the native culture in question. Where the epitome of the "other" was the wilderness void of man, the European seemed to be a part of what we call "nature"; and where the other was epitomized by a neighbouring people, the European seemed to be a representative of some other people, a stranger or barbarian. In other words, Europeans were for Africans as Africans were for Europeans: primarily one further sort of savage among other savages. Thus the images of Europeans could not have been an attack on civilization, as Lips believed, but rather the opposite: images in which another civilization gave plastic form to its "savage" counterpart. For this reason I have decided to investigate the African representations of Europeans only in connection with representations of other savages.

Some of these images of barbarians, although by no means all, played a part in rituals in which Africans identified with the other to their own particular culture, whereby an identification of this sort with strangers expressed and acknowledged the individual's own partial otherness. Sometimes, but no by means always, these sorts of rituals involved carvings which depicted the same figures that were being represented by ritual mimesis. The most widespread and poignant form of this were the cults of spirit possession

– which comparatively seldom involved sculptures – or their equivalent, masquerades, in which the sculptures merely acted as one element in a complex, danced presentation. For this reason I have included both cults of spirit possession and masquerades in my investigation; indeed it turned out that these can provide a special means of access to a particular aspect of African art. The paths which lead from spirit possession to art became increasingly important for me during the course of my studies, and finally also determined the choice of carvings which have been interpreted.

The gaze from without affixes itself to the surface of the phenomena, to the outer skin of things, without bothering about their internal organization; it isolates the detail which, under this gaze, is elevated to a suggestive image or even an autonomous force. What is revealed here is not the order, the structure or the system, but rather the power of the visible, the detail. In a reality viewed from outside, it is mostly the small, insignificant items which come to possess the alien observer: a feather, a shirt, a hat or knife and fork. Under the influence of this process of isolation, I have singled out one artefact for the title from the mass of objects which cause possession, the red fez, which runs like a leitmotif through so many of the spirit possession cults of the early colonial period.

At this juncture I would like to thank all who helped me in my studies or who indeed gave me the initial impetus. I would like to thank Ali Kea for first introducing me to the topic, by acquainting me with the spirit possession cult of the Ilwana in Kenya; this unanticipated encounter with alien spirit possession in Africa has guided my interpretation of the entire material. Jens Jahn showed me his collection of "Colon" figures, which finally led me to relate Lips's ideas to my studies on spirit possession cults. From the many anthropologists whose advice I was able to take while elaborating individual sections, I would like to single out Ute Röschenthaler, who drew my attention to the Pende, as well as Tobias Wendl, whom I thank for the important information he gave me on the spirit possession cults of the Ewe, and who was kind enough to provide me with several photographs taken during his field research. For the other photographs I would also like to thank the

museums and collections listed in the acknowledgements for the illustrations.

My greatest thanks go to Mr Armin Morat, the Heinrich-Heine-Stiftung and the Morat-Institut who supported my work. Without their assistance I would not have been able to tackle a topic which removed me far away from everyday practical thoughts and necessities.

Finally I would like to thank my friends and my wife for their comforting words in moments of discouragement.

Teisenham, November 1986

1

The Asante and the people

from the grasslands

The *Objet trouvé* from Asante

Several years ago a gallery in Munich held an exhibition of African sculptures about which little or nothing was known.[1] These figures are mostly clothed, wearing either a European suit or an Askari uniform, and either a pith helmet or a fez, which gives them a narrative, genre-like character which is sometimes fairly bizarre. In our ethnographic museums, whose African departments generally present themselves in the form of art exhibitions, one rarely gets the chance to see such works. African artworks, which were collected at some point during the late nineteenth and early twentieth centuries, are found objects; and as with every *objet trouvé*, the question as to whether they are to be seen as art is decided by the art with which they are displayed. Yet this art of presentation is under the sway of modern aesthetics, which interprets the foreign figures, freed of their context, in accordance with its own intentions – a process which is merely disturbed by any inherent meaning in the figures themselves.

Although there can be no question that some of the works which we shall come across in the following studies meet our aesthetic criteria, it is anything but my intention to present them explicitly as art. What interests me far more about the found object from Asante, which chanced to trigger my investigation, is primarily something outside of aesthetics (see Figs 1, 2). We see two figures showing barefooted Africans, wearing a red fez on their heads, shorts, uniform jackets and belts;[2] thus what we have here is the

1

portrayal of a "native" serving under the British – albeit a "native" who was a stranger to both the sculptor and his presumed client. The man's face is scarified, with a scar running from the root of the nose diagonally down both cheeks. We know, however, that the Asante disapproved of scarification, and identified it with the "barbarians" from the northern savannahs.[3]

With this, the bed-rock of my theme has been delineated. Just as Europeans since antiquity have created an image of the savage which, even if it has assumed differing forms from one epoch to another, has always acted as a counterpart to their own culture and civilization, African societies have also devised their own respective inversions and counterparts which have helped them articulate their sense of self and determine their political and ritual practices. In contrast to the Europeans, many Africans incorporated their images of barbarians into curious cultic systems. This constitutes the central topic of my investigation. But before turning to it, it is essential first to examine African concepts of barbarians and aliens by means of a few examples.

Like the other Akan peoples, the Asante distinguished three categories of outsider: *ohoho*, the free stranger from another chiefdom of the Akan; *ntafo*, the non-Akan who has settled as a trader; and *odonko*, the slave.[4]

The non-citizen, *ohoho*, was a free-born Akan who spoke an Akan language and shared the largely uniform culture of the Akan. He remained a member of his native chiefdom for the entire duration of his life, and under no circumstances could he attain citizenship of a foreign chiefdom, although he was free to take up residency there and acquire cultivable land and conventional rights. He enjoyed the protection and hospitality of the autochthonous community which accommodated him, but, in contrast to the community's own citizens, he could be stripped of all rights. Even if he had remained in the host community all his life, had seen the light of day and died in it, he remained excluded from its politico-jural system. "A stranger", according to an Akan saying, "does not break customary laws."[5]

The societal status of the outsider could not be formulated with more precision. The saying states that a law can be broken only by someone who possesses citizenship and has attained jural majority.

2

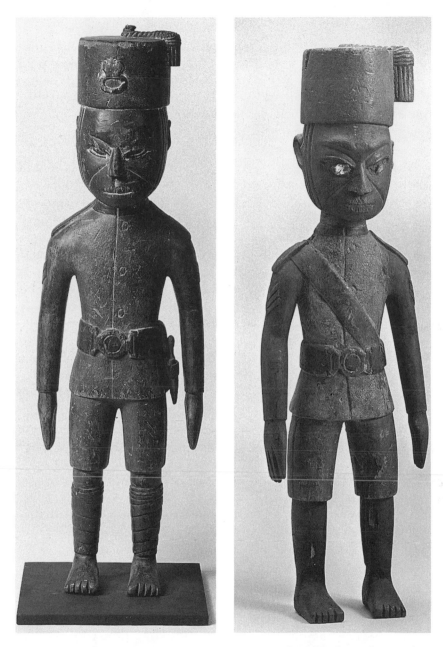

FIG. 1 Man from the north
(Asante, Ghana).

FIG. 2 Man from the north
(Asante, Ghana).

3

Only a citizen who is of age can violate the laws, and only he can be brought to account by the community. The free stranger cannot and must not answer to the law; should he commit a transgression, the host community will either overlook it deliberately or strip him of his rights, which had only been bestowed on him conditionally. But what applies to the quasi-citizen without civil rights applies in double measure to the trader and the slave. They, too, can neither insist on their inviolable rights, nor contravene them.

Whereas the *ohoho* was a stranger with the same culture and language, the Asante associated the second category of outsider, *ntafo*, with the savannah zone to the north. *Ntafo* referred originally to the Gonja, who for a time controlled part of the trade between the forest regions of Asante and the northern savannahs, later coming to designate traders as a whole, who were always members of foreign ethnic groups and had no part in the Akan culture. And while the free strangers of Akan origin were provisionally allowed to work the land, the traders were excluded from using cultivable soil. But precisely for this reason the traders were able to enjoy the benefits of being foreign; they lived in the *zongo*, the foreign quarter which was reminiscent of the European ghetto. Originally the *zongo* was inhabited by Muslim traders and Koran teachers (the word itself comes from the Hausa), later by Yoruba involved in trading and migrant workers from the north. Decisive here was the fact that the foreigners in the *zongo* maintained relations with the communities they came from, therefore allowing them to trade over distances and to maintain their culture, religion and language. They married women from the *zongo* or their own countries of origin, and thus in the town in which they attended to their business they were free from any ties with relatives and in-laws, and with that the obligations of altruism these entailed. So not only did they live outside the politico-jural system, they were free too from those social ties which prevented the indigenous inhabitants from trading purely on the basis of personal economic interest.[6]

Apart from the category *ntafo*, there was a definite tendency among the Asante to mix the categories of "slave" and "non-Akan", because in former times, before the British did away with slavery, one could, under certain circumstances, hand over an Akan to a debtor as a security, but not enslave him.[7] It must be assumed that

somebody who is taken slave does not participate freely in the human order; similarity in language and customs guarantees hospitality, dissimilarity can be compounded to the inequality of slavery. Thus in former times the expression *odonko* meant not only the slaves, but rather, as Rattray writes, the inhabitants of the northern savannahs in general, all of whom the Asante viewed as potential slaves.[8] Hence the specific facial scarifications for each tribe, which were customary only in the north, constituted for the Asante the personification of *odonko*, the personification of the barbarian's deplorable customs which legitimized enslavement. This was all the more so because, after several generations of social absorption via adoption and marriage with free Asante, and cultural assimilation through gradual domestication, the slaves' descendants were not scarified as a matter of principle. At the end of this process, the status of the slave was on a par with that of the lower strata; slaves could own property, including their own slaves, give testimony as witnesses, swear oaths and inherit from their masters. The majority carried out work which was considered unclean, but some of them held positions at court. As a rule they wore special garments which identified them as slaves, and at all events they remained jural minors, like perpetual children.[9]

Although slavery was abolished under colonial rule, the Asante conceptions of the savannah inhabitants remained little more than modified. The figure which was the starting point for our examination shows a man from the north, wearing a modern uniform, which precludes us from thinking of a slave in the strict sense of the word. The category *odonko* will, however, have a lasting effect on the figure's quality, and will determine how it is perceived by the Asante. It seems natural therefore to suppose that our found object is an African counterpart to the pictures of blackamoors in European art, where black Africans are shown as jockeys, stable lads or servants bringing flowers and drawing the curtains. Nevertheless, we still know nothing of the meaning the Asante attributed to our figures, or of the rituals in which they were used. Before turning to these questions, I would like to examine a few variations, taken from other African cultures, on the distinctions the Asante made between free strangers, traders and barbarians, in order to provide a basis for the subsequent comparative studies on the position of

the outsider in the cosmic order. This is because we will have the key to the complete iconography of our figure only once we have understood the relationship between the exclusion from the politico-jural domain of the stranger who breaks no law and the mythical charter of legal inculpability.

The outsiders among the Tallensi

The distinction made by the Akan between the category *ohoho* – the stranger with the same language and customs whom the community grants the right to take up residence and cultivate land, without being able to enslave him, but also without allowing him to take part in their legal system – and the category *odonko* – that other sort of stranger who speaks an incomprehensible language and whose face is disfigured by scars, and who may be enslaved and forced to perform unclean chores – this differentiation is just one of many African versions of the antithesis the Greeks labelled with the concepts *xenos* and *barbaros*, and antique Judaism with *ger* and *nokri*.[10] For all the individual shifts in emphasis – the *xenos* could acquire civic rights, for instance, but not the *ohoho* – the stranger, following Georg Simmel, as someone who does not share any particular attributes of culture, language or of being human, but just highly general ones, contrasts with another sort of foreignness in which "the other is denied precisely those general attributes which are felt to be intrinsically and purely human".[11]

According to E.E. Evans-Pritchard, the Nilotic Nuer, to give at least one further example of this principle, knew three categories of ethnicity, *diel*, *rul* and *jaang*, beside other terms which are so remote that they no longer allow themselves to be subsumed under a common concept.[12] *Diel* and *rul* are Nuer, *jaang* non-Nuer who, however, own cattle like the Nuer and as such take part in their economic culture. The Nuer call non-nomadic peoples, such as the Shilluk or the Europeans, by their own respective names. First and foremost among those designated as *jaang* are the Dinka, followed by sections of the Anuak and a number of smaller tribes. In comparison with other non-Nuer, the *jaang* are close to the Nuer because they too are nomads, although compared with

the Nuer themselves they are seemingly barbarians. *Diel* is the name given to the members of the clan which is considered to be the most dominant, oldest established or most aristocratic within a tribal region. *Rul* are foreign Nuer who immigrated from other Nuer tribes; whenever they joined the *diel* as a result of common clanship, kinship or affinity, it was on the basis of equal social footing, although they were still not incorporated into the autochthonous jural system. The members of the *rul* category could no more be enslaved or adopted than could the *ohoho* by the Akan; but this was not due to some law which effectively prevented this, but rather because the relatives of the person in question would have comprehended either enslavement or adoption as kidnapping, and taken revenge. The head of a household could only enlarge his sphere of influence by means of captured *jaang*, for the *jaang* were not only enemies, but, as nomads, they were much easier to assimilate than other non-Nuer. Just as the Asante went slave-hunting in the northern savannahs, the Nuer regularly descended on their *jaang* during the dry season, burning down their villages, taking their women and cattle, adopting their children and either killing or enslaving their men. For my argument, the most important consequence of this constellation, which only permitted the capture of people who were denied having the most general human qualities, but who otherwise demonstrated no differences in their way of living, was that in contrast to that of the Asanteland, the culture of the Nuer remained homogeneous despite these forays.[13]

At the same time, this scheme of contrasting the culturally identical stranger with the apparently uncultured barbarian, the *ohoho* with the *odonko* in the slave-holding society of the Asante, and the *rul* with the *jaang* of the nomadic Nuer, by no means defines the ethnic categories of all African societies. The alternative pattern, which I shall introduce here in order to delimit a particular conception of the other from the normal picture we have of the barbarian, is based not on the criterion of being human, nor on the similarity or dissimilarity of language and customs, but rather on the rules of exogamy: here a foreigner is anyone whose sisters and daughters one may marry. Whereas the one scheme of excluding the other from the politico-jural system justifies adoption and enslavement, here it legitimates marriage.

For the Shona of Zimbabwe, the word *vatorwa* – which can be translated as stranger or outsider – designates all those who do not belong to the speaker's particular exogamous unit, namely women who have married or could marry into his exogamous descent group, male Shona from other descent groups, and non-Shona of any sort, regardless of race, culture or language. The same range of application can be seen for the word *saan*, which is used by the Tallensi living in the savannahs of the former Gold Coast, whom the Asante would assign to the traditional *odonko* category.

The Tallensi, whose social structure should now be sketched out on the basis of Meyer Fortes's analyses as a representative model for many comparable societies, are acephalous, egalitarian farmers, who are organized in a segmentary system of patrilinear descent groups which have a pronounced corporative aspect.[14] The basic unit of the social system is the extended family, consisting of one man, his wives, his unmarried daughters, and his sons with their respective wives and children. They are all legal wards of the household head; when the latter dies, his status is passed on to the first-born son, whose brothers, however, will shortly leave in order to set up their own households. On a higher level in the segmentary system, a number of such extended families, whose heads are descended as a rule from one common great-grandfather, form a corporative group, the lineage. This lineage works together from time to time on the fields, and their chief, who is empowered with little real authority, is the senior of the oldest, still-living genealogical generation. On a yet higher level come segments, which assist one another in feuds and can be traced back genealogically to a common ancestor some five to seven generations previous. And finally the political system, which is no longer defined by descent, but rather by co-residence and a common territory, consists of a number of segments which are even larger quantitatively, and connected even deeper genealogically. Presiding over these political systems, whose totality constitutes "the Tallensi", is a chieftain who holds ritual prerogatives, while only being able to reach political decisions in the council meetings when all the household heads from his region are in agreement with him.

The highest units in the segmentary systems, the clans, are exogamous; they view each other mutually as *saan*, foreigners, even

though they exhibit no cultural differences. They are, however, divided into two groups, the Talis and Namoos, who are entrusted with two complementary offices: the Talis with that of the Earth Priest, the Namoos with that of the chieftain, and at the dawn of time the two groups confronted one another as representatives of two different cultures; the Talis are considered to be autochthonous, the Namoos as foreign immigrants.

According to the myth which tells of the first encounter between the Talis and Namoos and which sanctions their bond, an ancestor of the Talis, the Earth Priest Genet, once spotted a horseman in the distance and fled in panic and terror to the mountains. The horseman was Mosuor, the ancestor of the Namoos, who had fought for the throne of the neighbouring kingdom of the Mamprussi, and was now escaping after defeat. Using a ruse, Mosuor lured the frightened Genet from the mountains and made a solemn pact with him of blood-brotherhood; he founded the office of the chieftain, which has since been the right of the Namoos, while Genet bequeathed the office of the Earth Priest to the Talis. In the traditional version told by the Namoos, what terrified Genet was Mosuor's fluttering robe and his red fez (see Fig. 3), the insignia of sovereignty which were unknown to the Talis, whereas in the Talis rendition it was the horse and rifle, the combination of an unknown weapon and the unknown phenomenon of the rider. But regardless of whether the original difference was technological or emblematic, the character of cultural foreignness has in any case dissolved to form a single, closed system of ritual distinctions. While the Nuer absorbed their *jaang* without changing their own culture, the symbiosis of the Talis and Namoos brought about a new, extended system which was, however, no less homogeneous.[15]

Although both non-Tallensi and Tallensi from foreign clans are called *saan*, the same difference can be observed in their practical dealings with the two sorts of stranger which was at the root of the Nuer distinction between *rul* and *jaang*. Thus here, as with the Nuer, it was *de facto* impossible for a Tallensi to adopt or enslave a fellow tribesman, for the Tallensi would always have found ways and means of bringing back their relatives. On the other hand, non-Tallensi who were seized as lone wanderers on tribal territory were treated in an inconsistent and contradictory manner; one

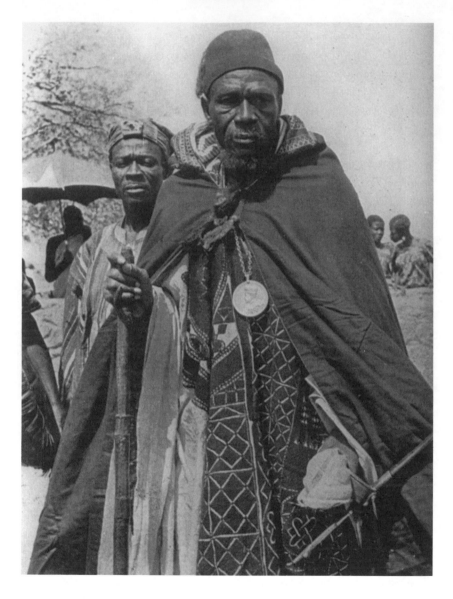

FIG. 3 Tongo chief with cloth robe and red fez (Tallensi, Ghana).

should never close the door on an unknown stranger, but rather
invite him to partake of a meal in one's home or at least hand him a

drink of water. This commandment was surrounded by myths and mystical sanctions. One myth tells of the humiliation suffered by a leper who, wandering through Taleland, was spurned by everyone when he invited them to eat with him, until finally he found a host who consented, and whom he thanked by endowing with the sowing festival, on which the lives of the Tallensi now depend. There is also the fear that one could go mad if one refused a stranger hospitality, for he might be a creature of the wild which has assumed human form, or an evil stone or tree which is able to repay a rebuff with madness.

Even if accompanied by negative portents, this is reminiscent of the worldwide belief that a stranger might be a god in human guise. And indeed, wanderers who had lost their way were first granted hospitality before being handed over to the chieftain, who possessed the ritual power to avert the mystical sanctions and to turn the stranger into a slave. However, he was at once placed under the protection of his master's lineage ancestors, so that he was able to take a fixed place in the web of social relationships as a quasi-adopted son: with that he ceased to be a foreigner.[16]

The myth of Genet and Mosuor and the ritual provisions for dealing with strangers explain why the Tallensi developed a concept of the stranger, but not why they developed a concept of the barbarian. Signs of cultural foreignness, such as horse and rifle, fez and robe, spread terror and panic; the lost wanderer who does not fit into the social order is a source of confusion and awakens deep-rooted anxieties. The wanderer might be a creature of the wild, who has therefore as little to do with proper humanity as the barbarian. But it is dangerous to admit such a suspicion, and the rites and social institutions are there ready to tackle all practical concerns, being set out in such a way as to dilute cultural foreignness and social alienage, and annul them within a broadened unity.

The relationships between man and woman, who are seen mutually as *saan*, also conform with this picture. As Fortes informs us,

a newly married wife is described as a "stranger", *saan*, in her husband's house. So, it is said, she must be treated with special consideration. Guinea fowls will be killed for her meals and she will be urged to be at

ease and will be stopped from helping with the domestic chores that normally fall to a woman's lot. By degrees, as she becomes accustomed to her husband's family, and in particular to her mother-in-law, as she becomes incorporated in its economic and ritual activities, perhaps in some months, perhaps only after she has borne a child and thus become a mother in her conjugal family, she stops being regarded as a *saan* and is accepted as a member of the family. Nevertheless, there is always a trace of feeling that a wife is never wholly free from stranger-hood. This is connected with the fact that a woman does not forfeit her status as sister and daughter in her paternal family and lineage when she marries. There is a reflection of this in the way her kinsfolk – above all either of her parents or her siblings – are received when they visit her. Choice meals should be offered to a husband's visiting affine, be he or she his wife's own parent or sibling or even a more distant lineage kinsman.[17]

The foreignness which exists between man and wife, and which never disappears completely, is not transferred to the children from this match. On the contrary, they are allowed an especially carefree and affectionate relationship precisely with their mother and their relatives on their mother's side. The politically and legally binding relationships are those to their own, patrilinear lineage; they are inviolable, as well as inescapable; they are burdened with pressures from authority figures and societal morals, from which the complementary relationships of maternal filiation are free. The complementary filiation, which is irrelevant in legal and political terms, but which has the greatest emotional and societal impor- tance for the individual, forms mystical bonds between a man and the patrilineage of his mother and his mother's mother. The relationships operate on a plane outside of the politico-jural sys- tem; they do not apply to the corporate groups but rather to individual people who are mutually *saan*, strangers because they belong to differing exogamous units.

The ancestor cult practised by the Tallensi allows tribute to be paid to these complementary relationships: under certain circum- stances a man can erect a shrine to his matrilateral ancestors, and since it is not uncommon for Tallensi to enter into intertribal marriages, one sometimes finds deceased non-Tallensi among these ancestors. It would seem that we have come a long way from

our starting point, but as our investigation develops, we shall see that shrines of this sort constitute a structural equivalent to those cults to which we want to trace back our found objects from Asante.

Digression on cultural heterogeneity

African societies are not windowless monads. Incest taboo and exogamy force a permanent exchange between the corporate groups, which stand as mutual strangers in the legal system, yet merge as soon as it comes to the complementary systems of marriage and the family. Marital alliances of this sort entail a social experience of alienage which is distinguished by a certain coldness on the one side, and exaggerated friendliness and attention on the other. The same condition of alienage appears in the relations to the quasi-citizens who have immigrated to a village, to resident traders or those passing through, and to roving wanderers of all kinds, such as refugees, lost hunters and explorers. Strangers, women or men who marry into a group, immigrants, traders and wanderers, are the bearers of a culture which is similar to, or differs to a greater or lesser extent from, the autochthonous culture. The chance of being given a friendly welcome depends largely on the similarity of the cultures, while as a rule enslavement presupposes cultural heterogeneity. But as representatives of a different culture, strangers can also enjoy the status of dealers, or, like Mosuor, be nominated as judges, chieftains or rulers.

Strangers are middlemen between cultures. One becomes acquainted with another culture as a stranger, or via the strangers one takes in. Consequently the picture one gets of other cultures or of the other's lack of culture depends on the prevailing social relationship to foreignness. Both the coldness and the exaggerated gestures of love, friendliness and affection which are shown to the stranger can be projected on to their culture and their supposed lack of culture. Inasmuch as strangers represent other cultures, the attitude towards them is largely congruent with the attitude to the other to one's own particular culture.

The difference between the status of the *odonko* in Asante and the *saan* of the Tallensi has paradigmatic importance. The Asante

13

accorded the *ntafo* category permanent rights of residency, while the traders enjoyed the protection of the Tallensi only as transient visitors. Both the Asante and the Tallensi took non-Akan or non-Tallensi as slaves; but while the cultural assimilation of the *odonko* first began only with their offspring, and required several generations, the Tallensi made immediate efforts to subordinate their slaves to their ancestors as quasi-adopted sons. The result of these differing treatments was that Asante culture as a whole contained elements of heterogeneity, but that of the Tallensi did not. The heterogeneity of the one culture accords with political centralization and social stratification, the homogeneity of the other with rigorous political and legal egalitarianism.

The nexus of cultural heterogeneity and dominion, on the one hand, and political egalitarianism and homogeneity, on the other, was first formulated by Fortes and Evans-Pritchard.[18] Prevalent in acephalous, egalitarian societies is an equality among the people and segments which allows no dissimilarities in customs and practices. But generally where groups with different cultures amalgamate to form one society, there is a need for a political and economic power, a military and administrative organization which prevents violence without enforcing mutual assimilation on the subjects. Minorities enjoy the protection of the state, and the state is all the more able to resist possible attacks on its authority if, as a result of the lack of a common culture, its subjects are less able to perform unified actions against the ruling class.[19]

In the light of this, one can briefly sketch out the mechanisms for incorporating strangers into the two types of political organization.

Some acephalous systems developed expansive tendencies; their segmentary structure was set out in such a way that relatively large segments could assemble for raids. However, the only persons suitable for incorporation were those of foreign ethnicity but with similar cultures, who moreover enjoyed no effective protection and were thus easy to assimilate. It seemed obvious to use a concept of the barbarian which described this circle of people exactly. In this way the Nuer distinguished the *jaang*, who were to be taken by force, from the *rul*, the strangers speaking the same language, who had to be accorded the rights due to a guest and quasi-citizen with

only residential rights. The *jaang* were similar to the Asante category of *odonko* in terms of their initial lack of any rights, but in contrast to the latter they revealed no more than minimal cultural differences. Other acephalous systems lacked this expansive tendency, such as the Tallensi, who only took slaves by chance, and with careful ritual precautions. Instead of developing a notion of the barbarian, they employed an undifferentiated concept of the stranger, *saan*, being those outside of their own lineage. In both cases the society maintained its cultural homogeneity by forcing foreigners to assimilate.

In centralized systems, the granting of citizen's rights, amounting to the complete negation of foreignness in the politico-jural sense, either depended on legitimate descent, as with the Asante, or had the character of a contract; in this latter case it was independent of descent and legitimate birth, and consisted of the acceptance of feudal obligations, as with the Alur and numerous other societies in East and South Africa. In the first case arose a culturally heterogeneous class of slaves, in the second a similarly heterogeneous stratum of vassals.

This is reminiscent, on the one hand, of the slave-holder society of antiquity, and on the other of feudal society in the Middle Ages. But generally speaking the African feudal system differed from the latter in that it lacked a hierarchy to distribute the tenures from above to below. Hence the vassals of the Alur chose their own masters; and since they were also able to depose these masters, who in turn had no means at their disposal to enforce the collection of duties, the subjects had to be treated with circumspection. This means that it was less likely that the populace of the territories into which such feudal systems expanded would be segregated as "barbarians", even if the feudal lords had not only the arcanum of authority at their disposal, but above all a sense of their cultural mission.

Whereas the segmentary expansion of the Nuer excluded the incorporation of any larger cultural differences, the expansion of the feudal systems depended precisely on the vassals' culture differing considerably from that of the aristocracy. Among the Lendu, for instance, the fact that the Alur had cattle, regardless of how few, while they themselves possessed none, was of decisive

importance for their acknowledgement of the superiority of the Alur, and their appointment of aristocratic Alurs as their chieftains.[20]

Apart from cattle-raising, above all the hunter's craft exerted a fascination of the foreign. Hunters straddle the borders between cultures, as well as between culture and the wilds, and in some respects they are even strangers to their own community, for part of their lives belongs to the wilds. Hunters often formed communities with their own practices, taboos and cults; from time to time they would travel far from their settlements in search of new hunting grounds, so that they alone possessed a broader topographical knowledge and were often the first to establish contact with foreign groups. If the population became too dense in their homeland, it was they who led individual households or lineages to uncultivated regions in order to found new settlements. Thus it is not uncommon for hunters to appear in genealogies and mythico-historical accounts as the founders of dynasties and villages.[21] According to the traditional accounts given by the autochthons, as, for instance, by the Luba, foreign hunters often impressed with their "cultivated" customs and were thus appointed as their leaders. As in the feudal culture of the Middle Ages, the hunt could count as the epitome of courtly-aristocratic customs.

Without doubt the cultural distance between immigrant traders and autochthons was more enduring than that between sedentary farmers and their aristocratic hunters and cattle-raisers. This was because the traders, as and when they were involved in trading over distances, often remained in contact with their home communities and were therefore under less pressure to assimilate than the aristocracies, which sometimes adopted the language and customs of their vassals at great speed. This was especially true for Christian or Muslim traders, who had a written tradition and a holy book which, unlike the myths and beliefs that were handed down orally, conveyed a strong core of identity and set bounds to cultural assimilation. The trade links with the central Islamic powers ensured periodic correctives and revisions from paganization. Much the same applies to the Portuguese, who settled in Angola, on the east coast and in the Zambezi valley, from the end of the fifteenth century.

Looking at these structural constraints on assimilation or non-assimilation, one can now distinguish the zones in which Africans were confronted with cultural heterogeneity in their own society before the onset of colonialism. The difference conveyed by strangers was least in the acephalous societies, while playing an important role in the stratified societies, which assimilated their slaves only over a long period of time, and in those systems which took shape by way of feudal duties. And this difference was of greatest importance in the trading societies of the West African savannah, which mediated between the Guinea Coast and the Mediterranean, in the Nile corridor, and on the East Coast, which linked trade between the Indian Ocean and the hinterland, as far as the region between Lake Victoria and the Central African plateau in East Africa, on the one side, and the gold regions of Zimbabwe on the other. The confrontation with cultural heterogeneity is reflected in the African traditions right across these zones.

Sometimes the Europeans who penetrated the African continent during the nineteenth century were still interpreted along the lines of these traditional categories of strangers. Fifty years after colonization, the Alur and Lendu still compared the arrival of the English and Belgians with that of the Alur themselves, for the Europeans, like the Alur, presented themselves as elected masters and were recognized and acknowledged as such.[22] The difference in the material inventories was already of decisive importance for internal adjustments in Africa: in 1817 the Asantehene Osei Bonsu could still compare the European's relative superiority in industry and the arts over the Asante with the Asantes' similar superiority over the Gonja.[23] Only with industrial technology were the final yardsticks broken and comparisons based on inner-African differences rendered obsolete. If it was initially possible to view Europeans as strangers among other strangers, industrialization introduced a new element and a new quality of foreignness and estrangement which demanded the matter be tackled in new ways.

Wherever colonies of settlers arose, as in South Africa, Rhodesia or the Kenyan highlands, the Europeans presented themselves not as strangers, but rather as what has been termed "estrangers". In South Africa, the Europeans named themselves "Afrikaans", while at the same time warring against the Africans, either exterminating

them or concentrating them in reservations; when they finally employed the once autochthonous population as workers, these workers became strangers. The concept of the native inhabitant became identical with that of the stranger.[24]

In the colonies, dealers, missionaries, civil servants, teachers and artisans could take up residence wherever it seemed appropriate and useful. On losing their autonomy, the acephalous societies also lost control over where foreign Africans settled. These new strangers were no longer placed under any compulsion to assimilate, nor were they any longer dependent on the indigenous institutions of hospitality, for the colonial powers undertook their protection. In this way cultural heterogeneity, such as had existed previously only in centralized societies, also came into existence within the acephalous systems.

Where conditions were favourable, the influx of foreign Africans swelled to such proportions that the autochthons felt alienated. The construction of the Kariba Dam in Zambezi, for instance, opened new opportunities for trading and fishing, but the old-established, acephalous Tonga lacked the experience and initiative to make use of this opportunity; thus they had to put up with an invasion of people who to them were *makalanga* – babblers and barbarians.[25] The end result was those multi-ethnic conurbations in the cities and the mining and industrial regions in which the autochthons lost their privileges or simply disappeared without trace. Although there can be no doubt that these zones were already, decades ago, on their way towards the new homogeneity of an anonymous industrial culture, even in this advanced state of modernization the traditional ways of dealing with the other to one's own culture have by no means come to a standstill.

Digression on the mythologeme of the state of innocence

The most simple and universal form in which the Africans lent expression to their encounters with heterogeneity – whether in a setting of social equality or political super- and subordination – was the myth.

Myths define the relationship between the home culture and its other as an irreversible disaster at the dawn of time. They tell of a primal event which determined this difference, and in some cases the sub- or superordination of the stranger, for all time. I shall attempt to show that the actual subject of these myths is human culpability, such that the other with regard to one's sense of humanity, or the other to one's culture, can only be articulated as a state of innocence.

The myths tell of the beginnings of the world and the dawning of time, in which things came into being and were ordered according to what they are and will be. However, the primal time they talk about is anything but an intact world or just order, such as anthropologists and historians of religion of the romantic persuasion project on to the world of myth with the inner hope of inverting it into a story of redemption. The redemption story expects salvation and the cleansing of sins, whereas the myth expresses the necessity of acknowledging them.

Myths about the origin of cultural differences and asymmetry in the relationships of sub- and superordination can often be arranged in pairs, whose sides act as mirror images of one another. Two versions of a single myth, one handed down in the one culture, the other in its opposite, legitimize superiority in the one and inferiority in the other: one version fits the classical picture of ethnocentricity in traditional cultures, whose others are segregated as inferior and barbarous, while the other version is seemingly anti-ethnocentric, or ethnocentric in another sense, for it distinguishes the other to its own culture as pure and uncontaminated. For the moment I shall illustrate these with three pairs coming from mutually remote areas: a choice-motif from the Nama and Bergdama in the south-west of the continent, a deception-motif from the Nuer and Dinka in Sudan, and Arabian and black-African versions of the myth of Noah's sons.

The myth of the Nama and Bergdama defines the difference between the two peoples as one of skin colour, whereby both tend to stick to the most visible sign of their dissimilarity: the Nama, who belong to the Khoisan, are considered to be "red", and the black-African Bergdama "black". The Nama relate how, in ancient times,

two women slaughtered an animal and chose between the liver and
the lungs; one chose the lungs and her descendants, the Nama,
became red, while the other took the remaining liver, and her
descendants, the Bergdama, became black.[26] The Bergdama tell of
how an ox was slaughtered; the first woman picked up the lungs,
only to replace them in order to eat the liver, and the children of
this woman became the black Bergdama. The other woman ate the
left-over lungs and became the mother of the red Nama.[27] For both
the Nama and the Bergdama, lungs are better than liver, and it is
better to be red than black. The two versions reveal one single
difference, namely that the ancestress of the Nama makes the
choice in the Nama version, while the ancestress of the Bergdama
chooses in the Bergdama version. The significance of this differ-
ence can be left aside for the moment, for it will come to light when
we follow up the broader dispersion of the choice-motif.

In the myth of the Nuer and Dinka, instead of liver and lungs we
find cow and calf, and instead of the opposites red and black,
we find cunning and force. The Nuer relate that Nuer and Dinka
were two sons of God,

> who promised his old cow to Dinka and its young calf to Nuer. Dinka
> came by night to God's byre and, imitating the voice of Nuer, obtained
> the calf. When God found that he had been tricked he was angry and
> charged Nuer to avenge the injury by raiding Dinka's cattle to the end
> of time.

The Dinka version is not given in full in the ethnographic litera-
ture, but Evans-Pritchard assures us that the Dinka tell exactly the
same story, adding, however, that "to this day the Dinka has always
lived by robbery, and the Nuer by war".[28] Both versions acknowl-
edge the existing state of affairs: the Dinka grazing lands and herds
are finer than those of the Nuer, but the Nuer are the superior
warriors. Yet the Dinka accuse themselves of a transgression
against God at the dawn of history, while the Nuer use the same
myth to legitimate their raids on the barbarians, their *jaang*.

The myth of Noah's sons, originating outside of Africa but now
deeply rooted in African mythology, also centres on skin colour in

order to distinguish a more encompassing difference. Already in the early days of Islam, the Arabs had used the story of Noah's sons as a charter for their relations with the black Africans. In the biblical version, Noah's curse is directed solely at Canaan, whose father, Ham, Noah's youngest son, had looked at Noah's genitals as the latter was drunk and asleep, whereas his brothers, Shem and Japheth, averted their gaze.[29] The first to extend Noah's curse – whereby Canaan was to be a servant of servants to Shem and Japheth – to all four of Ham's sons would seem to be Ibn Isḥāq, who died in 767: he applied it, ethnographically speaking, to Cush and the Abyssinians, Mizraim and the Berbers and Copts, Phut and the Indians and Sindis, along with Canaan and the Nubians, Zang and Zaghawa. In the ninth century al-Yaᶜqūbī reduced the range of the curse back to Canaan, who was now seen as the first ancestor of all the black peoples. And finally Ṭabarī put it tersely:

> Ham begat all those with black skin and curly-hair, Japheth all those with broad faces and small eyes, and Shem all those with beautiful faces and beautiful hair; Noah cursed Ham, such that the hair of his descendants would not grow over their ears, and, wherever his descendants met those of Shem, they would be enslaved.[30]

A black-African version of the myth of Noah's sons was recorded by A.J.N. Tremearne among the Islamic Hausa in North Africa before the First World War. Adam curses his son with a black skin because he has laughed at the uncovered genitals of his sleeping father; the son tries to wash himself in a lake, but this dries up as a result of his father's curse; Adam's son marries his sister who has remained white, and their children are part black, part white.[31] This version merely replaces Noah with Adam, and Shem and Japheth with his daughter. The motivation for the curse remains the same: in both the Arab reading and the Hausa version the black skin is seen as just punishment for the one-time humiliation of the father. The Hausa identify themselves with the indiscreet son, just as the Dinka identify themselves with their ancestor who stole his brother's calf from God, and as the Bergdama identify with the ancestor who ate the liver.

In our eyes, the curious inversion of ethnocentrism we find in these myths – in which the myths portray the Bergdama, Dinka and Hausa as burdened with irredeemable guilt, while exonerating their respective counterparts, the emphatic other to their own cultures – seems to reach the point of incredibility when Africans formulated their relationship to the colonial powers along the same lines. The earliest written documentation of such a myth from the Guinea Coast, which "explains" why the whites rule over the blacks, can already be found in Bosman;[32] but the heyday of myth really came during the early phase of colonization, when European travellers, missionaries and ethnographers collected hundreds of such myths from all parts of the continent.

There are many interpretations of these myths about the origins of the blacks and whites, such as those by Hofmayr, Baumann, Beidelman, Görög-Karady and Duchâteau.[33] These myths seem embarrassing now that they no longer correspond to a modern imperialist consciousness and run contrary to the new African nationalism; they appear to reveal a fatalistic self-contempt, combined with an admiration for foreign power and foreign wealth. Thus it was tempting to doubt both their authenticity and the philological veracity of their transcriptions.[34] Many versions are correctly documented philologically, however, such as those from Hofmayr and Westermann, although one must certainly allow for a mirror effect between the narrator and transcriber: the African narrator will prefer to choose those tales which relate to the cultural identity of the listener, who in turn prefers to pass on such stories. This explains why versions of these myths have been recorded in such abundance, while leaving their underlying pattern, which the Bergdama, Dinka and Hausa also used outside of colonial asymmetries, unexplained. For this reason I shall include the myths about the origins of the whites and blacks in my investigation, while largely ignoring the fact that here the Europeans play the role of the other; we shall see that these myths determine the identity of the other in a fairly casual and arbitrary way, for at root they attempt to define the locus of their own culture.

The myths about the origins of the blacks and whites, together with those which tell of the origins of differences within Africa, can be

assigned to three ancient groups of myths; these concern the discrepancy between father and son, "death in a bundle", and the overslept chance of immortality.

The myths about Noah's sons and about Nuer and Dinka dealt with the origins of inequality in the sibling group after a son had disobeyed God or his father; Ham was cursed for casting a forbidden glance at his father's genitals, Dinka for deceiving God. The myths Hofmayr and Westermann collected from the Nilotic Shilluk follow a comparable pattern. At the time these myths were collected, the Shilluk had for some time already entertained relations with the Kingdoms of Darfur and Abyssinia, as well as with Egyptians, Turks and Englishmen; these ethnic categories formed a hierarchy which was reflected in numerous ways in the sibling groups found in the origin myths. Apart from the incidental aetiologies, one can distinguish two motifs regarding the origins of inequality in the sibling group: defiance of the creator and attachment to the mother of mankind.

The defiance-motif governs the myth of the primeval council called by Jwok, God, in order to listen to the humans' complaints. The whites prove to be contented, but the blacks complain that, although they possess earth, grass and water, they do not have milk and beer in abundance. The whites conceal their cows near the huts of the Egyptians, and at night the Egyptians open the door and the blacks steal the whites' cows. Called by Jwok to explain themselves, the blacks deny any part in it, remaining silently seated on the ground and offering no word of apology. With that, Jwok sends them back to their barren land, bestows minor gifts on their accomplices, the Egyptians, while giving the whites everything.[35]

The secondary character of the aetiological connection to the whites becomes apparent as soon as we recall the myth from the neighbouring Nuer and Dinka. In place of Dinka come the ancestors of the Shilluk and Egyptians, and the whites in place of Nuer. The motif of nocturnal cattle-stealing, which certainly had nothing to do with the Shilluks' actual relation to the colonial powers, also plays the central role; and if God leaves Nuer's calf to Dinka and charges Nuer with revenging the primeval deception, and also takes back the cows stolen by the Shilluk and returns them forthwith to the whites, this accords with the fact that the Dinka are rich

in cattle, but not the Shilluk. Thus in essence the myth is nothing but a charter for being rich or poor in cattle, directed to some respective other – the Nuer in the Dinka version, the whites in that of the Shilluk.

Another Shilluk myth justifies the differentiation within the primeval sibling group in terms of the similarly archaic motif of the mother of humanity's visible and concealed children. In a version recorded by Westermann, the cow is the grandmother of humanity; she gives birth to a pumpkin with which Jwok begets two children, one black and one white. Later Jwok visits the mother of humanity who shows him the white child, whom she hates, while concealing the black child, whom she loves; with that God condemns the blacks to be ruled over by the whites.[36] In the version given by Hofmayr, the mother of humanity shows her first three sons, the Turk, the Abyssinian and the Darfurian, while hiding the youngest, the Shilluk. She allows the Turk to starve while feeding the Shilluk, the Darfurian and the Abyssinian; the father kisses the Turk on the mouth and curses the remaining sons.[37]

This myth articulates the relationship between food and hunger, in direct proportion to that between the visibility of the self-identical and the concealment of the other, as the result of a primeval inversion; the Shilluk are hungry and visible, the Turks sated and hidden because, in the logic of the myth, the mother of humanity had wished the opposite.

We shall come across this constellation once again in connection with the *zar* and *bori* cults, where the subject of the myth is the concealed state of the spirits and the visibility of the humans. Suffice it to say for the moment that the other in this mythological structure can sometimes be the invisible world of the spirits, and on other occasions Darfur, Turkey and Abyssinia.

At first the myth about the mother of humanity's visible and concealed children seems to lack the element of defiance towards the father which stamped the myth of nocturnal cattle-raiding. Yet one does not need to be a psychoanalyst to link being-concealed-by-one's-mother with the rejection of paternal authority. Here one is also reminded of J.G. Frazer's classic description of the "Divine King" of the Shilluk, who, himself a patricide, keeps watch night after night in the darkest shadows, constantly on his guard for the

son who will kill him as soon as he shows any sign of weakness; also of the custom of banishing the sons from the king's court until one of them is strong enough to succeed his father; and finally of the belief that the dying king will be immured, his head in the lap of a virgin.[38] There is a necessary relationship between concealment and rebellion, and so it comes as no surprise when the father in the myth punishes not the mother of humanity for her disobedience, but rather the concealed son.

The fact that the forefather of the whites or the Turks had no part in the rebellion against the father, and was not concealed by his mother, means that he is outside the realm of culpability in which, according to the myth, the home culture has become entangled as a result of the doings of its ancestors. This idea also governs the second group of myths, in which the origin of death is reworked to provide a charter for cultural differences.

In an Asante myth, we are told of how God creates three whites and three blacks, and allows them to choose between two calabashes; the blacks choose first, taking the calabash containing iron, gold and other metals; with that the second calabash, in which there is a piece of paper, becomes the whites' lot.[39] The neighbouring Ewe tell of how God models a black and a white couple and lets them choose between two baskets which he lowers on a rope from heaven; the blacks snatch greedily at the larger of the two, which contains a hoe to work the fields, cotton for spinning, a bow and arrow for the hunt and gold dust with which to trade; with that the smaller basket, containing this time a book, goes to the whites.[40]

At first this myth seems to be reminiscent of the belief in a prenatal destiny, such as the Asante and Ewe share with many West African peoples; according to this, the unborn soul steps before God in heaven and chooses the fate which is to determine its life; the word spoken in heaven incarnates and enforces its realization, quite independent of the conscious will of the soul which spoke it but forgot it on birth. Modest souls demand simply that which makes up a human life, while others place inordinate demands. Thus the destiny chosen before birth legitimates the portion of fortune or misfortune which the individual can neither deliberately summon nor ward off during his life.[41] Just as the soul in heaven

chooses its future fate, the ancestors of the blacks and whites in our myth choose the fate of their descendants. This parallel even extends to the contents of the choice, for often he who is immoderate in his demands leaves empty-handed; immodest and greedy, black chooses the larger basket and thus his descendants must till the soil, hunt with bow and arrow and trade, while white, with the book, wins both knowledge and dominion. Yet subsequent to this primal choice the relationships are reversed, for it is precisely agriculture, hunting and trading which constitute human life for the blacks.

Perhaps the belief in destiny really does explain why, in the West African versions, the greedy choice results in a meagre lot. But this can scarcely be the reason behind this whole motif-group, for myths of the same structure are also to be found outside of West Africa, where no equivalent belief in prenatal destiny can be demonstrated, although in these versions the choice is made not out of greed, but rather out of foolishness.

We have already looked at the Bergdama myth of the foolish choice between liver and lungs, so I shall content myself with just one further example. The Lotuho, neighbours to the south of the Nuer and Dinka, relate how Ajok, God, created a woman who gave birth to a red and a black pair of children; her red children were the ancestors of the Galla, Arabs and Europeans, the other pair those of the Lotuho and all other blacks. Ajok holds a race, with a choice of two objects displayed on the winning line: black wins and chooses the shield, whereupon red receives the remaining weapon, a rifle, and is instructed by Ajok to take black as his slave.[42]

If we compare the choice-motif of the Nama, Bergdama, Asante, Ewe and Lotuho, we are at once struck by a common feature in all versions, namely that basically just one party ever chooses, which, in every case, is also that of the narrator's own ancestors. In the Lotuho myth, black wins the race and black chooses; in the Nama myth red chooses, and in those of the Bergdama, Asante and Ewe black chooses. But in every case the second lot falls automatically to the other party. From this we can gather that their own respective ancestors are the actual agents in the myth; moreover we can ascertain a structure in the myth which would also remain intact if only one party were mentioned.

As we know since Herrmann Baumann's great study of African mythology, the choice-myths are variations of an older myth about "death in a bundle", in which the choice-motif is sometimes missing. The Kumbi by Lake Victoria tell of a time in which there was neither death nor suffering; but one day a man sliced open a pumpkin and out popped death, misfortune and poverty. The Pygmies from the Ituri Forest say that God gave the toad a pot which it was not to break, for imprisoned inside was death; however, the toad gave the pot to a frog who broke it. In the myth told by the Lamba, a messenger was sent to God to collect corn; he received two bundles, one of which he was not to open, and from this forbidden bundle came death. For the Wemba, on the other hand, the first human couple had to choose between two bundles, and chose death. Finally the Bemba tell of two parties; that of the humans and animals chose the bundle containing death, the other party, the snake, received the bundle containing immortality.[43]

Our last motif-group touches on a similar transformation: the relationship between the human and the snake is reworked to give a relationship between one's own culture and its respective other. A myth in Rwanda tells how God commanded man to keep watch by night; but man fell asleep at the first cockcrow, so that only the snake heard the word of the renewal of life and man remained condemned to continued mortality.[44] In Loanga the myth was told of how God created two pairs of humans and instructed them to sleep beside a well; at the first cockcrow the one pair woke, leapt into the well and washed themselves until they were white, while the other pair slept until the well contained nothing more than dirty water, and have remained black ever since.[45]

I have attempted to show that the aetiologies which Baumann and Görög-Karady used for their interpretations of African myths about the origins of this difference are of secondary importance to the deep structure of these myths, which define the actual nature of being human. The impression that these myths dealt with the superiority of the whites is merely a result of their concluding lines, which in fact say nothing more than that it is advantageous not to be caught up in the lot chosen by the ancestors. Only Hofmayr, who

worked as a missionary among the Shilluk, and was consequently familiar with the strangeness and incomprehensibility of mythical thought, recognized that this is a mythical formulation, in the true sense of the word, which is alien to both the Christian story of salvation and modern ideas of progress.

"The Shilluk", as Hofmayr summed up his thoughts, "recognize their inferiority to the white man, and give the reason in [...] fables in which they always admit to their own sense of guilt." But despite this feeling of guilt, "in the end they lay all the blame at the door of their Cuok [...], for he had created them as step-children and is also not allowed to improve this situation, for: 'Things must remain as they have been created'".[46]

When more recent authors interpret the African myths of difference as an expression of a "pessimistic view of history", or, seen differently, as the expression of "a curious self-contempt and resigned awareness of the white-man's superiority", they overlook the remoteness these myths have to any historical dimension, such as Hofmayr correctly recognized in this otherwise seemingly patriarchal Shilluk adage.[47] The mythical account avoids any recognition of the new; against our expectations, the first encounter with the unknown, the alien culture of the Nama, Arabs or Europeans, is interpreted not as a historic event, but rather as the return of something which was created irreversibly at the dawn of time, and thus cannot be changed in the future.[48] Only in the later colonial period did stories come into circulation in which the colonial asymmetries appeared to be the result no longer of the blacks' guilt, but rather of deceptions perpetrated by the whites.[49] In addition the adherents of the South African Ethiopianist Movement inverted the Sons of Noah myth to a charter of black-African self-awareness in that although they continued to define themselves as Ama-Kushi, the children of Kush, as a result of the fact that their ancestors, in contrast to those of the whites, are mentioned in the first pages of the Bible, they concluded that their own church was of greater antiquity and dignity.[50]

These later versions come close to both the Christian hope of redemption and the modern belief in the need to change a world whose injustice and imperfection had been accepted as inevitable by the myths. Perhaps we can better understand the older versions

of the myth of difference by bringing to mind the fact that underprivileged social strata everywhere, inasmuch as they have not developed a resentment against the rich and powerful, like to blame themselves for their unfortunate situation in order to avoid despairing at the injustice of a world which is outside their effective grasp. This would be in no way incompatible with the thesis that the myths of difference are derived solely from the subject matter of the myths about the origins of death. Just as man has to come to terms with his mortality, he must also accept that he tills the soil, hunts and trades, has a particular skin colour or lives in a country in which one cannot support large herds of cattle.

The myths of difference indicate the stranger's perceived otherness with symbolic brevity; just as scarification was for the Asante not just one cultural feature among many, but rather the personification of the northern barbarians, the myths take skin colour or the possession of a particular cultural asset (cattle, paper, book or rifle) in order to talk about the other to one's own culture in mythological language. Although the home culture is reduced by turn to similarly simplistic features, at the same time its ancestors gain in form and colour over those of the strangers, for they alone take the initiative and act. The white man in the Shilluk myth remains silent, passive and obedient, while the Shilluk themselves are like real people, grumbling about their poverty, making loud demands for beer and milk, stealing cows by night and being stubborn and unrepentant in their denials of the theft. The Asante and Ewe choose the implements which they require for lowly, albeit perfectly human work, whereas the white man remains passive in the background and receives a mysterious piece of paper. The myths begin with the image of an original state of innocence common to all mankind, then relate how part of humanity forfeited this state, while the rest remained in it without any action or will of their own.

If we reduce the myths of difference to this one concept, they give a picture of the innocent other which is reminiscent of our own topos of the noble savage who, for the Enlightenment, was distinguished by standing outside of civilization, being neither oversophisticated nor morally corrupt. Just as the savage in the Asante myth drew his mysterious, superior wisdom from a piece of paper,

the eighteenth century viewed the Chinese as invested with enligh-
tened wisdom; the Romantics sought deep, scarcely comprehen-
sible mysteries in the Orient. The savage had not entered the social
contract and so had been spared the evils of civilization. As we
know, European civilization sometimes considered the savage to be
good, sometimes evil, but as a rule beyond both, as being close to
nature or completely at one with it. "In Africa", wrote Hegel,

> what we basically find is that which has been termed the *state of
> innocence*, man's oneness with nature. [...] *Paradeisos* is the zoological
> garden where man once lived in the animal state and was innocent,
> which is wrong for him. Man first becomes man when he understands
> good, knows its opposite, and has divided.[51]

The basic stratum of the African myths about the origins of
cultural differences – derived from the myth of the origins of
mortality – prove to be reworked anthropogonies; they tell of how
man became what he is, namely mortal and condemned to work
and lack. The shortages which bring primal man to rebel against his
father and creator, his laziness which makes him sleep through the
proclamation of immortality, and the foolish curiosity which drives
him to open the bundle containing death, all these are distinguish-
ing features of man who, in modern terms, crosses the threshold
between the natural state and the cultural order, and divides
himself from nature. It so happens that the myths concerning the
other to one's own culture designate him as the other to culture as a
whole, regardless of whether this other is a toad or frog as opposed
to a person, red or white as opposed to black, or paper as opposed
to hoe, bow and arrow. This negative mode of segregation will now
also be observed in the cosmologies, which assign one's ancestors to
the cultivated soil, and the strangers to the wild.

The female ancestors of the Tallensi

Although Meyer Fortes's study on *Oedipus and Job in West African
Religion* was not the first publication of its sort, it was the first to
tackle the topic with such explicitness and analytical lucidity; it

showed us that the pre-monotheistic thought of African peoples conceives the self not as a self-identical and self-aware whole, but rather as a complex of brighter and darker spheres which, partly accessible to the subject's conscious will, partly at the mercy of alien powers, from time to time demand ritual acknowledgement.[52] According to my thesis, these sorts of rituals, which, on the one hand, serve to enlighten a dark sphere within the self, on the other entail in certain cases the acknowledgement of a category of outsiders. This is true of the Tallensi when a man erects a *bakologo* shrine in compliance with his calling to be a diviner.

The meaning of the *bakologo* configuration is revealed within the frame of the ancestor cult and the belief in fate, which Fortes analysed in *Oedipus and Job*. The core of self is formed by the *yin*, the person's soul, which, in its prenatal existence, steps before God in heaven in order to utter the word which will assume form and determine the earthly life of its author. The *yin* does not have the option of whether to be born or not, and cannot choose a destiny which raises its earthly embodiment at the cost of its fellow humans; but the word decides whether the future person will be allotted all that makes up a normal, authentic human life, whether he will fit into the community of the living, whether he or she will beget or bear children, and whether he is capable of meeting the needs of a family. After its birth the *yin*, or the person whose soul it is, cannot remember the word it had uttered in heaven, but the word itself is in him, is the person's lucky or unlucky genius.

The word is not able to fulfil itself by its own means, and requires the assistance of spiritual powers which it elects, and which announce themselves to the person and demand that he acknowledge and honour them as the guardians over his destiny. These powers can be divided into three classes according to their moral character; the first consists of ancestors who are subordinate to the overall ancestral group in a person's patrilineage, and thus cannot offend the values of the corporate group; the second consists of powers of the wilds which stand completely outside of human society, and are feared by the Tallensi as evil; and the third class consists of ancestors from the maternal side, belonging to neither the wilds nor the person's own patrilineage; as such corporate morals are a matter of indifference to them.

A word which embodies a good destiny will at first seek the guardians for its soul solely among the powers in the first class. A configuration of ancestors crystallizes during adolescence, when the person's character gradually forms, and it is to this that the Tallensi attribute the individual's particular characteristics. The steps along the path towards individuation, which decides whether one will be successfully admitted into the community, always begin with suffering; an unusual incident in day-to-day life, or a sickness or a mishap, is interpreted as a sign that a new destiny ancestor is demanding to be admitted by a ritual to the *yin* configuration of destiny ancestors. Not only does the manner in which the destiny ancestors announce themselves entail suffering, but so do the rules they impose when their ward acknowledges them. Only by observing them can the initial suffering be averted, and sometimes they force one to make painful renunciations. But no one can evade the call of his destiny ancestors; they enforce the destiny which each has chosen before God in heaven, and since they are subordinate to the community of ancestors, they cannot be unjust, neither elevating their ward at the cost of his kinsfolk nor damaging him in the long term. Hence there is no choice but to submit oneself unquestioningly to the destiny ancestors and accept one's sufferings as a necessary test – like Job in the Bible, whose God Fortes compared with the Tallensi destiny ancestors.

The wilds surround and threaten the order of the cultivated earth, and like Leviathan in the Book of Job, their powers are those of chaos. The Tallensi treat these powers with caution, although in the long run always aloofly. A stranger at the door of my home might be an evil tree or stone in human guise; I shall receive and regale him politely because he has the power to punish me with madness, but then hand him to the chief whose ritual power is able to cope with mystic sanctions. Sometimes a being, born of a woman and having grown up in the midst of the community, turns out to be so unruly and evil during its life that the Tallensi conclude that it is a power of the wild masquerading as a person. And finally a power of the wild will sometimes creep into a person's *yin* configuration, placing him under its power and trying to cause his ruin. In addition a word with an unpropitious destiny might also choose such a power of its own accord. But the Tallensi do not believe that

they are at the complete mercy of these powers; they will try at least to dissuade the person from acknowledging the dark force which reveals itself in him, and to purge himself of it.

Even in such a strictly patrilinear society as that of the Tallensi, an individual's character does not merely reflect the characteristics of his patrilineal forebears; he will always be simultaneously shaped by attributes which he and his relatives ascribe to his maternal side, so it is not surprising that ancestors from the mother's patrilineage, or from the mother's mother's, are also generally present in the *yin* configuration. Here traits, as well as social and emotional ties to kinsmen on the maternal side, find their ritual expression, although all in all the *yin* configuration remains under the control of the ancestors from their ward's patrilineage, whose moral order they may as little infringe as the ward himself. On the other hand, outside of this order – though not in contradiction to it, like the wilds – is the *bakologo* configuration, which is composed entirely of ancestors from the mother's side. When a man acknowledges his *bakologo* ancestors, dedicating to them a shrine of his own, he becomes a diviner.

Divination, which we shall often encounter in the course of this study, is viewed by African societies as a whole not as *work* in the modern sense, i.e. a trade which all can learn and pursue if they wish, but rather as a form of *téchne* in the Greek sense, the epitome of the sort of abilities which nowadays we link with the work of the artist. The diviner is an initiate who recognizes hidden things, but he requires a genius with whom he can communicate, and who communicates in turn with those powers which trouble the diviner's clients. As a result of its nature and origins, this spirit has no relationship either to the word of destiny given in heaven or to the destiny ancestors which this has chosen, communicating rather with the client's ancestors via the ancestors of outsiders, *saan*.

In *Oedipus and Job*, Fortes does not even mention the *bakologo* ancestors, although it is they, not the paternal ancestors, which occasionally afflict a man with the worst, most dogged misfortune. Thus a man who is pursued by an unrelenting *bakologo* configuration could well be compared with Job, while the power, the character and moral constitution of the *bakologo* forbid any parallels being made between it and Job's God. Just like the paternal

ancestors in the *yin* configuration, this God reveals himself in the form of suffering; one can neither doubt nor vindicate the justice of both; and the afflicted person has no alternative but unquestioning submission. While in some respects the central attributes of the *bakologo* ancestors, vindictiveness and jealousy, are also attributes of the biblical God, the difference from the Book of Job can be seen again in the fact that the afflicted person transforms the hate of his *bakologo* ancestors into love by erecting them a shrine, honouring and praising them, and entering the profession of the diviner. Whereas one ultimately expects justice from one's paternal ancestors, the maternal ancestors accord love.

The character of a male Tallensi – especially during adolescence – is moulded by the ancestors in the *yin* configuration; on reaching the middle of his life and becoming the father and head of his own family, the *yin* configuration gradually sinks into the background. At this point he interprets his deeper feelings of guilt and uncertainty, illness, misfortune and suffering as the work of the *bakologo* ancestors. He tries to withstand their demands for as long as possible, but nine times out of ten he finds himself forced finally to acknowledge them, although only rarely will he keep his pledge and actually work as a diviner. Psychologically speaking, he is compelled by feelings of guilt and uncertainty, and not by some desire to become a diviner.[53]

The Tallensi define a *bakologo* configuration in its entirety as feminine, and in almost all cases the dominant figure is a woman, one of the mother's ancestresses, around whom further ancestors – mostly, although not exclusively, female – from matrilaterally associated lineages congregate. For this reason Fortes interprets the *bakologo* configuration – on to which the men start to project their feelings of guilt and uncertainty in the middle of their lives – as a mother image; at first they attempt to suppress this, but they expect to gain love and wisdom from it if they finally acknowledge and respect it. It should be noted that a man also dedicates a shrine to his own mother on her death, and this sometimes takes on enormous importance for him and holds its own alongside the *bakologo* shrine. The woman at the centre of the *bakologo* configuration is thus an ideal, a personification of female attributes, and an adherent of analytical psychology might well interpret her as an

anima. But before entering into any such psychological interpretations, we should note here that the *bakologo* configuration contains a concentrated sphere of pure emotionality, one which is generally associated in a patrilinear society with relationships with matrilateral relatives. It is a sphere which, complementary to the corporate lineage, is not regulated by prescriptions, commandments and ineluctable morals. This sphere of innocence, to which belong both conduct and feelings, and which is characterized by love and hate, jealousy and forbearance, but in which the difference between good and evil plays no role, cuts across the boundaries of the politico-jural systems; it links people and ancestors who, seen politically and jurally, are mutually *saan*, strangers, and even extends beyond the cultural unity of the Tallensi; for occasionally a *bakologo* configuration contains the images of non-Tallensi women, such as Mamprusi or women from other neighbouring peoples.[54] If, then, the acknowledgement of a *bakologo* configuration means the enlightenment of a dark, suppressed and uncanny sphere in one's self, at the same time it also means the recognition of an alien, an other which reveals itself incontrovertibly in the self-same suffering. This thesis about the ritual recognition of outsiders will now hopefully gain in plausibility when I turn to intersocietal comparisons.

Moral topography in Asante

Rattray quotes the reply of a priest when asked why he honoured a number of other powers beside the One God:

> We in Ashante dare not worship the Sky God alone, or the Earth Goddess alone, or any one spirit. We have to protect ourselves against, and use when we can, the spirits of all things in the Sky and upon Earth. You go to the forest, see some wild animal, fire at it, kill it, and find you have killed a man. You dismiss your servant, but later find you miss him. You take your cutlass to hack at what you think is a branch, and find you have cut your own arm. There are people who can transform themselves into leopards; "the grassland people" are especially good at turning into hyenas. There are witches who can make you wither and

die. There are trees which fall upon and kill you. There are rivers which drown you. If I see four or five Europeans, I do not make much of one alone, and ignore the rest, lest they too may have power and hate me.[55]

The world picture expressed in this passage places the unpredictability and impenetrability of phenomena to the fore. Just as one must respect a European because one does not know what power is embodied in him, one must also approach a number of things with caution: heaven and earth, whose power is visible and evident to all; animals which could be disguised humans; the people from the northern savannahs who transform themselves into hyenas, witches, trees and rivers. Perhaps the way in which the last two things are understood demonstrates the greatest distance from enlightened thought; although everyone would admit that one could drown in a river or be killed by a falling tree, the priest talks of a river which drowns people, or a tree which kills, and he gives no reason why one must beware of rivers and trees, but says rather that one must honour and respect them and make use of them whenever possible. Moreover, the fact that the Asante are afraid of witches or people from the north is not directly comprehensible to our enlightened way of thinking. The priest's discourse contains one aspect whose reality cannot, however, be denied by a psychological reading, namely that some of our deeds involve a force whose authorship we cannot recognize as our own. Our task now is to show how this acknowledgement of the contradiction within the subject can be linked with the acknowledgement of alien powers in the outside world.

The cosmologies of the Tallensi and Asante concur in their central belief in destiny, while being virtually mirror images of one another when it comes to the moral classification of the ancestors. Whereas for the Tallensi the patrilineal ancestors guarantee the morality of their descendants, while the maternal inheritance bestows love and wisdom outside of the jural system, the Asante consider the ancestors of the matrilineage to be the guarantors of the corporate order, which is complemented by patrilineally inherited powers. Admittedly a deeper, qualitative difference can be sensed behind this formal mirroring.

In Asante thought, the human microcosm is a compound of soul, blood and semen.[56] The soul speaks the word in heaven, which takes on form and supervises the fulfilment of the chosen destiny on earth. Yet here the word does not choose the powers which shape the person's destiny and character. Rather the author of the central tie is the maternal blood, which firmly binds the person to the body, and the corporate group to the matrilineage. The father's semen, on the other hand, imparts a quality which is held in common by all patrilineally linked individuals. Blood and semen are not only physical substances, but also spiritual forces which play a part in the individual's moral make-up, character and inner processes; although they constitute the basic substance of large groups of humans, in connection with a soul they crystallize within the person to produce individually distinct forces, which on the one hand represent the general substances, but on the other stand somewhat at variance to them. Hence several antagonisms emerge within the microcosm: between the soul, which has forgotten its destiny, and its prenatal word, which supervises its fulfilment; between the blood, which personifies the lineage, or more specifically the spiritual power of the blood, which is responsible for the solidarity and unity of the corporate group, and the semen, which unites one with father and paternal kin via patrilinear ties, and the hypostasis of the semen, which divides one from those with whom one is tied by the blood, although it may also turn against the father. The microcosm therefore turns out to be the mirror of the social world, whose contradictions have been internalized by the individual.

The elements of the microcosm have more extensive and meaningful correspondences with the macrocosm than is the case with the Tallensi. The blood and its spiritual hypostasis in the subject correlate with the lineage ancestors, the semen and its hypostasis with the deities, *abosom*, which manifest themselves in rivers and occasionally in trees. Each patrilinear unit pledges itself to its deities and dedicates a cult in their honour. Hence the moral aspects of the social forces that the subject internalizes are transposed to the topography. The cultivated earth correlates with the harmonious life of the community, the ancestors with the well-being of the lineage, the ancestors in the chiefly lineage with the

political life of the chiefdom; the patrilinear units correlate with the rivers and parts of the wilds, as well as the well-being of the individual – in so far as this is not dependent on the regions regulated by matrilinear authorities, or stands in contradiction to them. The respect which, according to the priests, one should pay to heaven and earth, rivers and trees, becomes considerably easier to grasp in the light of these correlations.

The structural analogy between the *bakologo* shrines of the Tallensi and the *abosom* cults in Asante, both of which come from complementary filiation – giving expression on the one hand to matrilateral ties, and on the other to patrilateral ones – is an example of the way the fusion of the ritual acknowledgement of the morally neutral other within the subject with the acknowledgement of a category of outsiders in the cosmos can take in both the social as well as the natural world. The place of the foreign ancestors is taken by rivers and trees. However, one also finds a fusion of the other within the subject with the other to one's own culture in the two remaining things which the priest instructs one to guard against: the witches and the people from the grasslands.

A key to the mystical significance of the people from the grasslands is the belief in witches, which the Asante share with many African societies as well as a large portion of humanity the world over. According to almost all moral topologies, the witches' nighttime society takes place outside the settlement, in the forest or the wilds, but, like other matrilinear societies, the Asante simultaneously believe that the lineage, being the heart of the social system, is the place where witchcraft arises and where the witches seek their victims.

It is the belief of the Asante that the uncanny, destructive power – which at times resides inside a person without his being in any way aware that at night he attacks his relatives, makes them sick or kills them – is passed on by a mother to her children. Sometimes this occurs as soon as she gives birth, sometimes in a later moment of physical contact, and sometimes only on her deathbed, when the witching power wafts out of the mother and enters the child. Hence the power of witchcraft belongs to the lineage, like the very blood which circulates through all links of a corporate social group, bringing them together to form the inviolable unity of one single

corpus; just as sons and daughters are equally part of the corpus to which their mother belongs, so the power of witchcraft resides in men and women of the lineage, although mostly in the latter, and only mothers, never fathers, pass it on to their children. Moreover, the victims of the witches and sorcerers are invariably members of their own lineage, preferably closely related uterine relatives, and never outsiders, patrilateral relatives or male or female spouses.[57]

Nevertheless, the witches feel the indwelling power to be something utterly foreign which does not belong to them. This is expressed in the feeling that the power has slipped into the witch's body or vagina in the form of a snake. In addition, the secret, nocturnal life of the witch is carried out not in the fenced-off, orderly area of the settlement, the scene of everyday life among people who are close, and who are obliged to reciprocal altruism by matrilateral bonds, but rather in the forests beyond the cultivated land. Occasionally the witch entertains sexual relations with *sasabonsam*, an eerie forest spirit; witches and sorcerers congregate by night in the forest, and anyone who wishes to be admitted to the society must hand over the flesh and blood of a uterine relative for a cannibalistic feast.

All things are turned into their opposites in the world of the witch. At the centre of all these inversions is the inversion of love into hate; the witch's victims are those she loves most in the human world – although admittedly those she *must* love as a result of an ineluctable moral system. Governing the world of witchcraft is the equally inexorable law of hating and destroying those whom, in the human world, one may not even turn against when they hurt one, neglect one or leave one in the lurch. The witches in their counterworld walk about naked, their heads downwards, fly and turn into animals, owls, crows, vultures, flies, hyenas, snakes and more. *Sasabonsam*, their lord and beloved, who has intercourse with them, appears as the epitome of inversion (See Fig. 4); he inhabits parts of the dense virgin jungle, is covered with long hair, has large bloodshot eyes, long legs and feet pointing both ways. There, in his solitude, he is at enmity with man – especially priests, but hunters also fall victim to him.[58]

In olden days the witches in Asante were subjected to trial by ordeal, then strangled after being convicted, for it was forbidden to

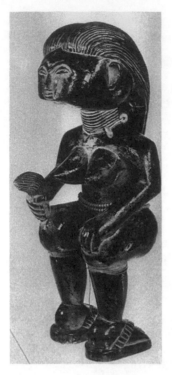

FIG. 4 Forest spirit with long hair and feet
pointing backwards and forwards (Akan,
Ghana).

shed their blood. Those who confessed their guilt had a firebrand
placed in their hands before being expelled from the village,
thereupon informing the neighbouring villages so that they too
would drive them away; thus, in all probability, the witches died in
the forest. The colonial powers forbade such customs, so that the
Asante considered that they were placing the witches under their
protection. The question as to whether the fear of witches grew
as a consequence of the prohibition of their persecution, as a
consequence of the general insecurity which colonization and
modernization brought with it, or whether merely the customs of
the witch-finders changed and the fear of witches remained the
same, has no bearing on our examination of the relationships
between the lineage morals and the remote wilds. Even if one was no
longer allowed to kill the witches, one could still ostracize them or
drive them to suicide. But beside this was a second, cultic behaviour
pattern which, even though it was not first created as an answer to

the prohibition of witch-hunting, simply coming to the notice of European observers during the colonial period, gradually established itself as the sole pattern, finally assimilating the new forms which were imported from the northern savannahs.[59]

Essentially this pattern consists in the fact that the same antagonism to the identity of the matrilineage, which the witch lives through unconsciously, and the same attachment to a power outside of society, which the witch experiences in her forbidden intercourse with *sasabonsam*, are brought to consciousness and recoined in the form of an accepted peculiarity by a priest who has already undergone an analogous, albeit legitimate experience. In place of intercourse with *sasabonsam* comes the ritual attachment to the deity of a shrine, and instead of aggression towards one's own flesh and blood the complementary identification with a cult community, by which the former witch distinguishes herself at least from the people she had previously hated. The deity of this cult community is either an *obosom*, analogous to the *abosom* of the patrilinear units to which a person belongs by virtue of his paternal semen, or a foreign deity from the savannahs of the north.

The once injurious power now heals. Rattray, who made his observations at a time when the so-called new shrines, although already existing here and there, had not yet come into fashion, tells of an old priest, a witch-finder, who was possessed by *sasabonsam*, the same creature with whom the witches associated. However, this spirit, who came upon the priest like a wind, had taught him how to recognize witches by their aura of red smoke, capture them and then either kill them or purge them of their witchcraft.[60]

The *abosom* of the patrilinear units, the deities of the rivers and trees, did not concern themselves with witches; but beside them there were, even in the old days, the *abosom-brafo*, deities who served the witches as hangmen or executioners. During the colonial period, the cults of these deities, or of the newer ones which followed along the same lines, assumed the task of making the witches confess, purging them and restoring them, more or less adjusted, to society. In all cases the head of the cult was a priest who was possessed by a particular *obosom*, or who required the help of a medium through whom the *obosom* revealed its will (see Fig. 5). The typical story of the priest's or medium's calling – such as is repeated

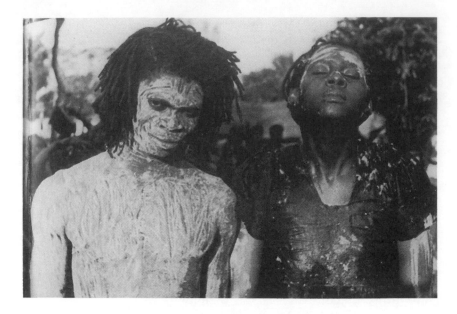

FIG. 5 Priest and medium (Akan, Ghana).

in all African possession cults – started with affliction, as well as fits
and seizures, which recurred until the called person left the village,
as if out of his mind. Sometimes it was possible to catch him, but
sometimes he would spend weeks or months far from the village.
After living in the wild he placed himself under the guardianship
of a priest in order to learn the rites of his deity and finally, after
receiving the consent of the regional chieftain, to inaugurate a
shrine of his own. The extraordinary clear-sightedness and can-
dour with which he unravelled his clients' confused circumstances
brought him and the deity which spoke from him both respect and
esteem.[61]

The affliction which comes at the beginning of a priest's calling
corresponds with the mood in which his clients visit the shrine,
being more than willing to accuse themselves of the most heinous
crimes against their maternal kinsmen; the immersion in the soli-
tude of the forest occasions the vision of the witch's flight, and
receiving the deity into one's own body, internalizing it, resembles
the forbidden assimilation of *sasabonsam*.

The second category of shrines, at which the Asante and their neighbours convicted and purged witches during the colonial period, had no further relationship to either the morals of the lineage, on the one hand, or to their inversion in the witches' counterworld, on the other. Here the place of the *obosom-brafo* in the mystic-moral topography of Asante is taken by a foreign deity from the savannahs to the north; in place of the individual's story of his calling and his initiation period in the forests comes the journey to the people of the grasslands, the barbarians, who once constituted the category *odonko*. And in place of the instruction by an Asante priest comes the initiation into an alien cult. But in the north, these cults rarely served the purpose of purging witches, only first being given this task, along with their structure and their social embedment, in the south; they became Asante shrines, retaining nothing of their origins but their characteristic stamp and the ambience of the north.

Beside the structural equivalence between the forests as a counterworld to the settlement, and the grasslands as a counterworld to the forest regions of Asante, two further elements can be advanced which help explain the custom of importing purification shrines. First, one would have been vaguely aware in Asante that the societies to the north were patrilineally organized, or at any rate that they had no knowledge of matrilineage, which the Asante viewed as the epitome of civilization; thus since they believed that witchcraft is handed down only within the matrilineage, and the witch selects her victim only therein, one could conclude that there would be no witches in the grasslands. But if no witches were present there, there must have been mighty counter-forces which prevented their activities. This line of thought which was occasionally advanced is certainly more of a supplementary rationalization, for these imported shrines retained exactly the same function when they moved on from the matrilinear Akan to the patrilinear Ewe.[62]

In all likelihood the other difference between the southern Gold Coast and its hinterland, which was also stamped by colonization, was much more clear and distinct, namely the fact that the economic development in the south, triggered by the cocoa

43

monoculture, accelerated the decline of the traditional culture, while the process of modernization only skirted the north. Hence the people of the grasslands appeared no longer primarily as uncivilized savages, whose enslavement the Asante saw as their unquestionable right, but rather as the vigorous tribes who successfully withstood the break-up of culture, along with the social conflicts and psychic burdens of modern existence.[63] During the period of colonial infiltration the Asante had the impression that witchcraft was spreading in a threatening manner; streams of people made pilgrimages to the purification shrines in order to accuse themselves of witchcraft, as if under a compulsion to confess. Witchcraft was, as we saw, a personification of guilt, and there can be no doubt that these self-accusations were the expression of the same deep feelings. One had become guilty oneself while, returning to the mythologeme analysed above, the people of the grasslands remained in a state of innocence.

Here we seem to be dealing with a widespread pattern which is also familiar in European history: the Asante, as members of a highly differentiated and increasingly conflict-ridden and complex civilization, adopted the miraculous shrines of the unsophisticated, vigorous tribes of the north and even flocked as pilgrims to the ritual festivals in the hinterland, there to implore offspring, profit and protection from rivals. Thus, for example, the earth-shrines of the Tallensi in Tongo enjoyed especial popularity; the Tallensi allowed the pilgrims from the south special rights of way, which outsiders speaking foreign tongues did not normally enjoy. However, the shrine which the Asante imported from there was named purely and simply Tongo, and in the south it had lost the character of an earth-shrine. Moreover, shrines of other sorts, adopted from the Lobi, the Gonja and even more distant peoples, were given similar new interpretations.[64]

The majority of the imported shrines only first became shrines for deities in Asante. For this reason alone it would be inappropriate to describe the admission to one of their cults as conversion. The incorporation of foreign deities does not signify any change in the Asante religious conception of the world. The centre of cultic life is still composed of the ancestor cult and the cult of the *abosom*, to which everyone belongs by virtue of paternal filiation. The

foreign deities do not provide any new cultic identity, but merely extend the existing spheres of identity by bringing a dark, unconscious sphere in the subject to consciousness and legitimizing it. This ritual acknowledgement of a dark sphere, in all cases constrained by feelings of guilt and insecurity, and often found among older adults whose place in society is already clearly delineated, is reminiscent of the erection of the *bakologo* shrines by the Tallensi, with the proviso that here it is not solely men who free themselves of their guilt, but primarily women. The purged witch returns to the bosom of her lineage, but never again will she be completely one with her society; she differs from the rest of her lineage in that she is simultaneously a member of a cult community, and observes the special rules laid down by a deity which is foreign and indifferent to her lineage. While the Tallensi man who erects a *bakologo* shrine is honoured as a diviner, the novice of a foreign deity is stigmatized. She is treated amicably but at the same time avoided;[65] like a stranger, and like the foreign deity who gives her protection, she is simultaneously close and distant.

Thus the more exact parallel to the Tallensi diviner would be the priests of the foreign deities, who have similar extra-human gifts and a similar wisdom. Although these priests are Asante, they portray strangers. When they use the characteristic paraphernalia of northern cults in their rites, in particular cola nuts and a dramatic hen-oracle, we may assume that these are simply the necessary elements of the adopted cult. At the same time they wear the characteristic dress of the north, not priest's gowns, which could be assumed to be part of the original cult, but national dress which points to the general ethnic background of the grasslands.[66] These costumes, which seem quite exotic to the Asante, lend a decidedly dramatic and histrionic note to the performances of the priests, who initiate and attend the witches' confessions at the shrines. If we restrict ourselves to what the pilgrim actually saw at his destination, the one thing which was really new about the shrines of the foreign deities were the costumes, which were hitherto unknown from the traditional mediums in trance.

The priests of the foreign deities set themselves apart from the common mass of the Asante with their exotic ritual costumes, being

FIG. 6 Spirit hosts of the Kunde cult. Medium with copies of the red
fez and the costumes of the northern grasslands (Ewe, Togo).

the visible expression of their foreignness and otherness. In addi-
tion, it is certain that the dramatic representations given by the
costumed priests also gained their own impetus, finally allowing
them to leave behind the cultic context of convicting and purging
witches. The neighbouring Ewe, who adopted these cults from the
Asante, have in part maintained these dramatic presentations to
this day, even though the witch trials, which were originally part
and parcel of them, are no longer practised. The ritual catharsis

46

FIG. 7 Spirit hosts of the Kunde cult. Medium with mossi hat and the typical dress of the northern grasslands (Ewe, Togo).

can start to sublimate itself into something more aesthetic. In the *vodu* societies of the Ewe, cola nuts are still offered to the god Kunde, who was imported no later than 1918 by the Asante from the north, and at some point handed on to the Ewe, and the cult still has mediums who perform their ecstatic dances in costumes from the northern savannahs (see Figs. 6 and 7).[67] The mediums are possessed by deities who were imported decades ago; they embody these deities while at the same time portraying people from the grasslands. In trance, when they don their exotic garb, they are

47

strangers. I shall demonstrate that in large sections of the conti-
nent, these patterns of behaviour – which always manifest them-
selves identically, even if they receive different interpretations –
represent an elementary answer to cultural heterogenization,
which in the end can also be categorized along with the *objets trouvés*
from Asante.

2

Concerning trans-Saharan

convergences

The soul and the landscape

The partial identification with the other, whether in the form of an attachment to an object in one's natural environment, or the acceptance of a foreign deity equipped with attributes from another culture, or the erection of a shrine to the ancestors of outsiders, constituted in the minds and experience of the Asante and Tallensi an acknowledgement of an alien power, whose demands the individual must in the end obey against his own conscious will. The modern observer likes to think of these powers, whose independent existence he disbelieves, as unconscious projections, or as the repressed rearing its head.

According to the thesis Meyer Fortes developed in *Oedipus and Job*, the educated European can grasp the Tallensi belief in destiny thanks to its kinship with the Oedipus myth, and their ancestor cult, which grants the chance to ward off a calamitous fate, through its kinship with the theology of the Book of Job. In this synthesis of ethnography and classical education, Freud's psychoanalysis played the role of the hidden go-between. Robin Horton has pointed to this in his commentary on *Oedipus and Job*.[1] His elucidation of the analogies between psychoanalysis and world picture can help us understand the subject during the process of ritual acknowledgement of outsiders.

According to Horton's essay on *Oedipus and Job*, the *yin* of the Tallensi, the soul which pronounces its earthly fate in heaven, and this word, embodied as an independent being, is the counterpart to

that part of the unconscious which Freud termed the id. Like the id, the *yin* is seen as the source of urges of which the ego is unaware, and which often frustrate the latter's own intentions. The *yin* of the father and that of the son are in enmity to one another; a good fate will ameliorate this animosity and, with the help of the destiny ancestors selected by the *yin*, induces the son to accept his father's authority, and with that the society he represents – as opposed to a bad fate which incites the son to rebel against his father and brings him, in opposition to the societal values, misfortune and eventual failure. Thus it is important to honour the ancestors of the *yin* configuration, which announce themselves one by one during adolescence, with a shrine, or, in other words, become aware of them. At the same time one must unmask and cast out any powers of the wild which insinuate themselves into the configuration or are chosen by a bad *yin*.

The counterpart to the super-ego in Horton's system is the ancestors, whom the individual internalizes bit by bit as the elements of his *yin* configuration, and who help him to fit into society. In other cases they remain distant and condemn their ward to failure. It is important that here the super-ego is not equated with the lineage ancestors, as many authors have done, even though the *yin* configuration is subordinate to them.

The corresponding conceptions of the Asante can also be correlated with psychoanalysis along the same lines, even though this is necessarily less exact because in matrilinear societies the father shares his role with the mother's brother. Although, in the Asante version, the destiny word also seems to correspond with the id, being subconscious and in certain circumstances hostile, it does not choose the extra-human powers which mould and guide the individual. Rather it is the hypostasis and individual crystallization of the paternal semen which binds one to the deities, and, unlike the ancestors of the *yin* configurations, these deities are not subordinate to the lineage ancestors; they link father with son, who revere them jointly. The super-ego corresponds with the ancestors of the matrilineage to which one belongs via the maternal blood. The radical antithesis to the super-ego, which we must add to Horton's exposition, is for the Tallensi the powers of the wild in either a *yin* configuration or human guise, and for the Asante the power of

witchcraft which, although inherited within the lineage, is a negation of the values for which the super-ego is responsible.[2]

Thus the ways in which a person finds his place in life, submits with either stubbornness or resignation to his destiny, and sometimes finally recognizes and acknowledges alien or unfamiliar powers within himself, are predetermined by family circumstances, and moulded by matrilinear or patrilinear structures which consequently contribute to determine the structure of the world pictures. Included here is the degree of differentiation, the degree to which the individual differs from his near ones or acquires characteristics which he does not share with the other members of his corporate group. Put differently: the world pictures and ritual practices reflect not merely the linearity and the differing roles of the father, mother and mother's brother, but also the degree of corporateness in the society. This corporateness is the product of the relation between the pressure towards a corporate group identity, as expressed in the power of the moral authorities, and the prospects for differentiation and individuation that are present, and which are controlled by other, morally indifferent forces.

What we can see in our two paradigms, the world pictures held by the Tallensi and Asante, is not a difference in the relationship between corporateness and differentiation, but rather a difference in the way they get involved in the process of differentiation. In both paradigms the word pronounced in heaven embodies the individual destiny, but only the Tallensi believe that the word chooses the destiny ancestors who bring about its realization. By and large these ancestors originate from their ward's lineage, and thus, even though they effect differentiation, they can be internalized as a moral authority, which Horton compares with the super-ego. Apart from the choice of *bakologo* ancestors, which occurs in the middle of life, differentiation takes place within the framework of the lineage. The Asante, on the other hand, name the deities of the rivers and trees which are handed down by the patrilineage as the differentiating moment. As such this amounts to the acknowledgement of a contradiction between individuation and corporate group identity, but this is not the same as the radical contradiction which is expressed in witchcraft or ties to alien, non-inherited deities.

Thus the Asante paradigm should not be read solely as a
matrilinear reversal of the Tallensi paradigm, but also as its aug-
mentation, in terms both of the pressure to adopt the corporate
group identity, and of the prospects for personal differentiation.
Indicative of the increased pressure to adopt the corporate group
identity is the spread of the obsession with witchcraft, which
exceeds the analogous anxiety about masked powers of the wild in
quantitative terms. And indicative of the greater prospects for
differentiation are the early, inherited ties to the paternal deities –
the stronger version when compared with the choice of the mater-
nal *bakologo* ancestors, which is made later in life. The ritual
acknowledgement in Asante of one's father not only comes earlier,
and involves less crisis, than that of one's mother among the
Tallensi, but also reveals an asymmetry in the actual powers which
are acknowledged. For whereas the *bakologo* configurations consist
of maternal *ancestors*, the Asante honour paternal *deities* associated
with rivers and forests.

This latter asymmetry is more sharply delineated if one formu-
lates it in terms of the objects involved: the Asante accept a bond
with the deities of the rivers and forests, by which the subject
differentiates himself from his lineage, whereas the Tallensi con-
demn any association with the powers of the wild, viewing this as a
defection of the subject from the lineage. Following Horton's
commentary on *Oedipus and Job*, this asymmetry in the evaluation of
the uncultivated land, bush, forest or waters proves to be the most
evocative expression of the degree of differentiation the Asante, or
the Tallensi, allow the individual. By taking a third paradigm into
our study, we shall see that this thesis gains in plausibility.

We must thank Horton for our knowledge of the Kalabari, a people
living on the Niger Delta, an area suited to both trade and fishing,
and whose world picture he used for the most convincing demonst-
ration of his thesis. For the Kalabari the corporateness of the
lineage is secondary to that of the settlement; neither maternal
filiation alone, as with the Asante, nor paternal filiation alone, as
with the Tallensi, decides lineage membership. The children of a
mother for whom a high bride price has been paid belong to their
father's lineage, while the reverse is true for the children of a

mother whose husband has paid a small bride price. Thus the family situation is not moulded clearly and uniformly by the principles of linearity, parental authority cannot be simply equated with a political corporate group, and the pressures exercised by a lineage to assume a particular identity are comparatively weak.

While the rural Tallensi and Asante view the wild, as uncultivated land, as standing in sharp contrast to cultivated land, the delta creeks seem to the Kalabari to contrast with the settlement, although they are also the arena which every adult Kalabari must know for his day-to-day work as trader or fisher.

The Kalabari also believe that the soul decides its destiny in heaven, and that its word takes on bodily form in order to realize itself on earth. Sometimes the word manages this task on its own, sometimes it elects water spirits, *owuamapu*, which shape and guide their elector. The *owuamapu*, which play a similar role for the Kalabari as the destiny ancestors in the *yin* configurations of the Tallensi, live among the delta creeks; their area of activity covers the fish and aquatic animals and the water itself; they churn up the waters and thwart the catch, or smooth them and allow good catches. Humans and water spirits marry; the word of a man can chose a female water spirit, and that of a woman a male water spirit. These people meet their aquatic partners in the solitude of the creeks and dedicate shrines to them. A good destiny word chooses water spirits which grant their ward and partner luck, power, success and special abilities; on the other hand a bad word might choose deceitful spirits which pile misfortune on its unlucky ward.

These water spirits, which decide on a person's fortune or misfortune according to their whims and favours, but not according to any moral principles, contrast in turn with the ancestors, who are the legitimate guardians of their descendants, and the heroes, who are honoured as the founders of the settlement, and who maintain and advance the unity and strength of the political system.[3]

According to Horton's thesis, in the world pictures held by the Tallensi, the Asante, the Kalabari and the Yoruba – whom I shall not examine here – the moral authorities, the "forces of society", stand in a complementary relationship to the morally neutral

authorities, the "forces of nature".[4] If we transpose the cosmological code into psychoanalytic terms, the "forces of society" correspond with the super-ego, and the "forces of nature" with the id. For the Kalabari, the "forces of society" are made up of the ancestors of the patrilineage and the village heroes, for the Tallensi the ancestors of the patrilineage and the earth, i.e. the cultivated land as opposed to the uncultivated bush, and for the Asante the ancestors of the matrilineage and, once again, the earth. The "forces of nature" can be described just as well as "powers of the wild" for all of them, whether of savannah, river, sea or tropical forest, stand in opposition to the cultivated land which man has wrested from the wild and has domesticated.

The two sides of this scheme – a variation of the structuralist myth theory based on African world pictures – are judged differently in the paradigms chosen here, and in each case these evaluations can be related to the respective degree of social differentiation, or, as Horton says, the development of individual, competitive aspirations and abilities. In a relatively open, individualistic and agonistic society like that of the Kalabari, self-assertion can function only when the individual can "divide" himself to a large extent from his society. Although, within the political life of the community, there is no evading the heroes' moral demands which uphold the unity, solidarity and strength of the village community, nor the commands of the ancestors within the family organization, outside of this sphere of enforced harmonious co-existence the individual can and should develop independence, skill and initiative as fisher and trader. Since success and failure have repercussions on social status, the same antagonism arises between individualism and collective solidarity which we know in modern society; and just as we might relate personal attributes, fortune and misfortune to an ego and id configuration, so the Kalabari speak of marriages and kinship relationships between human and water spirit; they consider these relationships to be as precarious as they are unavoidable.

The Asante encourage both the collectivism of the matrilineage and individual achievement, which significantly they do not see as being solely dependent on the complementary ties to the father, but also link with the cult of the deities, with the rivers and forests

outside of the cultivated land. Only with the Tallensi is the individual's societal success dependent not on his personal achievement or his attributes, but rather, apart from serious physical and mental handicaps, solely on his genealogical status and above all his father, for only with his father's death does he acquire jural majority. The morally neutral "forces of nature" which, as the Tallensi believe, compel the individual to turn against his father and the society the latter represents are thus seen as not just morally indifferent, but rather as evil; they must be unmasked and ritually exorcized.

Horton's commentary on *Oedipus and Job* can be summarized henceforth under these two aspects, which will prove their worth in the following stages of my investigation into East and Central African cults and world pictures. African societies vary in the amount of opportunity they grant the individual to differentiate, to develop personal attributes and abilities with which he can demarcate himself from his fellow men and above all his corporate group. Moreover, the societies articulate this differentiation as an individual tie to certain "forces of nature" which they associate with places and regions which lie outside of, and contrast with, their own familiar cultivated land.

A number of elaborations on this thesis are already emerging. I have introduced the term differentiation, following Simmel, in order to combine the acquisition of specific characteristics with cultural heterogeneity. For if one thinks of individualization in terms of a strengthening of the ego, as might be suggested by Horton's reference to the analogies between the cosmological and psychoanalytic codes, one could gain the probably misleading impression that the development of the ego is weaker among the Tallensi than among the Asante and Kalabari. But the "cosmological code" of the Tallensi by no means spells "equality" for all members of a patrilineage, for every individual's *yin* configuration distinguishes him as something unique and special, without his having to resort to the "forces of nature". On the other hand there can be no denying the fact that the acephalous society of the Tallensi, lacking stratification and any real central authority, is far more dependent on social equality and cultural homogeneity than are those of the Asante or Kalabari. The Asante and Kalabari were

55

traders, or granted traders the right to reside on their territory; the Asante were culturally heterogeneous, the Kalabari were in touch with the Europeans, on the one side, and the societies of the hinterland on the other.

Strangers, as representatives of cultural heterogeneity, could assume the position of those entities which Horton groups as "forces of nature". This was only true to a very small extent for the Tallensi; sometimes the *bakologo* configurations, whose acknowledgement led a man to acquire the specific, differentiating attributes and abilities of the diviner, were joined by maternal ancestors. These belonged not only to the lineages of outsiders, *saan*, but also to foreign, "ethnic" categories, such as the Mamprussi. Beside the cults of patrilineally inherited deities – which as "forces of nature" they assigned to the rivers and forests outside of the cultivated land, but within Asante – the Asante practised cults of foreign gods which they vested with the attributes of foreign, "ethnic" categories and whose homeland was the grasslands of the north. In the masquerades which will be discussed later, the Kalabari gave a number of their water spirits European characteristics. And in many societies on the East Coast, in Zimbabwe and Angola, the powers which correspond with the "forces of nature" in Horton's scheme were not represented at all as deities or spirits of the wild, the waters, the forests or the savannahs, but solely as the spirits of dead people who had formerly belonged to foreign "ethnic" categories.

The possible objection that, all said and done, it is a matter of indifference which elements are chosen from the visible world to act as "forces of nature" in a structured world picture must contend with two ethnographic facts. First, the priests and adepts of the cults place the greatest importance not only on the distinctions between the spirits, but also on the exact identification and identity of their visible manifestations. Second, they respect the deities and spirits as entities which can act and are endowed with their own will, and which are not merely at the cult's disposal like the elements of some code, but actually take possession of people. This fact in turn takes on additional significance when the prenatal soul in heaven has chosen its destiny, and the word-become-form elects the powers which are to carry it out. This belief in destiny is missing

outside of West Africa, so that the object-quality of the individual who is at the mercy of the powers is even further enhanced.

If we conceive of the identification of parts of the soul with parts of the landscape, as Horton has ascertained, not simply as an "intellectual operation", which undoubtedly it is, we arrive at the far-reaching question as to the emotional quality of the ties to deities and spirits, which the cults give a permanent, ritually circumscribed form. The ageing Tallensi who sees himself pursued by maternal ancestors knows the spots which are peculiar to these ancestors; he knows the Mamprussiland beyond the White Volta, which he had visited when hunger, say, had forced him to search for food outside of his homeland. The priest-to-be and the medium responding to his calling stray through the Asante forests before dedicating themselves to the cult of a deity. The Kalabari go on long, solitary journeys, scouring the delta creeks before encountering their aquatic lovers and spouses and erecting shrines to them. Although we cannot grasp the impressions the landscape makes on the individual's mind, we can examine the mode of experience which is expressed in the view that the landscape imprints itself on the psyche.

The power of the manifest

The anthropologist who poses himself the problem of alien beliefs about spirits and deities soon ceases to be content with the facile observation that this or that people simply "believes" in them. In keeping with E.E. Evans-Pritchard, spirits and divinities are viewed as "refractions" of social reality.[5] Whereas the older anthropology spoke of "manism" and "animism", as if they were dealing with ideologies or belief systems, following Fortes and Horton we have discovered projections of psychic complexes: ancestor spirits as parent images, nature spirits as personified drives. One of the tacit assumptions of this method is the conviction that the anthropologist and his reader have a theory at their command which enables them to decipher these other beliefs.

It is fashionable to accuse the rational explanation of belief in spirits and deities of being ethnocentric. Even Robin Horton, a

champion of critical rationalism who calls his approach expressly "intellectualistic", does not bother to find any explanation for the West African cosmologies, but simply searches for evidence that cosmological and psychological codes are mutually translatable. With that our psychology is put in a different perspective to reveal a system of beliefs, and the cosmology becomes one psychology among others.[6]

Outside of the realm of psychoanalytic interpretations, Godfrey Lienhardt, in his book *Divinity and Experience*, attempted to "translate" the cosmology of the Dinka into modern language, and to make the divinities they believe in comprehensible as a characteristic expression of their experience of the world.[7] However, instead of being content, like Horton, with the concepts from our present-day psychologies, he reverted to a Latin word in order to denote a mode of experience and of conceiving of experience for which there is no longer a word in modern languages.

What we term *passions* in English no longer accords with the meaning of the word *passiones*, which means the opposite of actions in relation to human self. But only with the aid of this counter-notion can we convey properly the concept of the powers, the spirits and deities peculiar to the Dinka. The powers are "the images of human *passiones* seen as the active sources of those *passiones*". By putting it this way, the anthropologist is saying that we are guilty of simplification and overlooking a decisive meaning in the original if we translate what for the Dinka are "images of *passiones*" as "passions" or "drives", and equate them with the id.[8]

The difference between our psychology and the cosmology of the Dinka can be sensed in several figures of speech and areas of experience. While we say that someone has caught an illness, the Dinka say that someone has been seized by an illness. And when we say that we remember something, even though we know that our memories are often unwilled, the Dinka who recalls a debt sees this as the work of a power acting under the instructions of the creditor. The Dinka also deal with the images which crop up in their memories differently; the Dinka honours and respects the image of an object or event which had once affected *him* – or, as we would say, which *he* was concerned about.[9]

Only a pure empiricist, who concedes the validity of nothing but experience, could do justice to the needs of a polytheistic cosmology.[10] The images and subjects of the *passiones* are located on the one hand in visible objects, in trifling things which have little meaning to the majority, as well as in great, impressive phenomena, in the sky and sun, rain, earth and the wild, and on the other hand inside the individual who perceives and honours them. This means that we should not conceive of the powers as entities, as bodies or substances with extension and location in space, nor of the human self as an independent whole; the powers act as self-determining subjects in the world and in the person. When these subjects dissociate in a person's self, when one power ousts another inside, the person embodies this power whose effects then fuse with the *passiones*.[11]

Not every event or phenomenon occasions a *passio*; some people share *passiones*, others do not; alike *passiones* unite people, unalike divide. The Dinka distinguish between "forces of society", the clan divinities, and "forces of nature", the free divinities and lesser powers. All members of a clan are linked together and as one when it comes to their clan divinity, but they are unalike when it comes to other realms of experience; each individual differs and this differentiation is connected with the multiplicity of ties to the powers. The categories of powers, or in other words the contents of experience, correspond with moral and morally indifferent values and differentiated ways of behaving towards the visible phenomena: deference and fraternity towards the clan divinities, ecstatic excitement towards the other powers and the divinity of the priestly clans.

When Lienhardt reverts to the concept *passiones* in order to "translate" an African mode of belief into a European language, this tacitly reflects a far-reaching change within Europe, and not, as Horton presumes in his own analogous scheme, some difference between African and European codes. The decisive boundary is not one which divides African and European conceptions of the social and individual constitution of the subject, but rather one which divides cosmology from psychology in their entireties. The

cross-over point between cosmology and psychology is to be found in the microcosmic refractions of the powers within the individual. These would normally be called not *passiones*, but rather possession, being moved or being filled with emotion.

"Being moved* and being possessed", writes Ernst Benz,

> are basic forms of religious experience which can be traced back to the earliest days of religious history. The distinction between being moved and possession is, however, fairly recent and can be dated in linguistic history to the seventeenth century. Since that time "being moved" has denoted an encounter with the divine in its beatific, healing, regenerative form, while "possession" has meant being overwhelmed in the sense of being taken over by a demonic, infernal or evil spirit which makes itself evident in a person's personality in a harmful or destructive way. In the older strata of the terminology for religious experience, the two terms were still fairly close and in part interchangeable, denoting two variable aspects of enthusiasm, of the state of being possessed, of being moved, of being filled by a god, demon or spirit.[12]

According to this, the difference between being moved and being possessed depends on which power is recognized as the agent. It is not difficult to find African equivalents of the "divine" and "demonic" powers named here. As we have seen, dualism was also at home in the African world pictures, even if it resists reduction to the dualism of good and evil, God and Devil. Christians and Tallensi reject the demonic powers of nature, but in the majority of African cosmologies these were simply considered to be indifferent to morals.

* Translator's note: sadly the original German word *Ergriffenheit* lacks a direct English equivalent which adequately reflects the historical dimension discussed on this and the following pages, in particular when it comes to the language of Pietism. Nowadays one would normally translate this noun with "profound emotion", its verbal form with "transported", or "seized" (as in "seized by panic"), but the sense of divine possession is missing: seventeenth-century translators faced a similar dilemma when searching for an equivalent to the Greek *katalambàno*, the King James Bible settling for "apprehended"; more radical Protestants described the same experience as "the indwelling Christ", "active renewal", etc., etc., but I have plumped for "being moved", as in the Quaker "moved by the spirit", occasionally resorting to the more Wesleyan "seized" (e.g. in Jürg Zutt's text) where sense dictates.

It is wrong in this context to think of the devil as an abstract power of evil. The powers of the cosmos, both animals and land-scapes, recur in the person possessed, so that we can truly speak of *passiones* of an experienced reality. Notwithstanding the great contrasts between the Christian and African ways of approaching possession, which are marked by the degree of tolerance towards morally neutral behaviour, the symptoms of possession are always much the same: a sudden transformation to bestial behaviour, deep sleep, raging, uncustomary, barbarian sounds and bestial cries, appalling grimaces and great agitation, such that the person con-cerned is unable to remain in one place and goes in search of solitude, etc.[13]

Modes of experience which we name, with Lienhardt, *passiones*, outlive the historical loss of the belief in deities and spirits as self-determining powers in whose clutches the person experiences himself as an object. The *passiones* become psychic states, transient moods or a lasting mark and imprint which form under the "impression" left by particular encounters. The terms being moved or possessed, as they are used today, retain this meaning without our having to think of active forces. The historical transformation of the cosmological into the psychological code took place in the eighteenth century. "The modern psychological meaning of being moved", so Benz leaves his history of the concepts,

> whereby one customarily talks of being moved by an emotion or a play, a piece of music, a poem, a painting or even a landscape, goes back initially to the psychologization of older mystical terms used by the Pietists in the seventeenth century, who also had a very strong influence on the language of the German classical period.[14]

It is part of the anthropologist's normal métier to search for covert world pictures in everyday figures of speech. We owe our understanding of African world pictures to precisely the analysis of trivial words and everyday expressions, and not to the interpreta-tion of some texts in which Africans have more or less systemati-cally expounded their conceptions. If we apply this procedure to our present-day language, we come across a vocabulary which is

still sufficiently precise to denote psychological counterparts to *passiones*.

According to the *Wörterbuch der deutschen Gegenwartssprache (Dictionary of Modern German Usage)*, we use the words "possessed",* "filled" and "moved" in different, clearly differentiated contexts. Although we do not believe that people are possessed by spirits, we do say that a person works, paints, talks, gambles, etc. like one possessed. The "like one" disappears the moment we talk about thoughts, ideas or passions. A person is obsessed with sport, his work or with the task at hand, as well as by fears, truth, sex, cleanliness, fame, a desire or a crazy notion. In some cases one could say "filled with", but never "moved by".

We are "filled", but not "obsessed", with new impressions and stimulating experiences, especially with such feelings as cheeriness, joy, distrust, bitterness, rage, hate, impatience, anxiety, woes, fear, horror, revulsion, despair, desire, reservations, misgivings, cares, complacency, sadness, etc.

In the final analysis we are only "moved" by the sublime, by fate and necessity, by funeral orations or music. We know – and this expression points like no other to the language of mysticism – a moving occasion. Moved, we either remain silent or weep, and moved we bid farewell.

The terms possessed, filled and moved refer to mental states which we view as neither normal nor morbid. In all three cases we are talking about *passiones* rather than actions. Sometimes the individual appears to be a sort of mount, ridden or obsessed by notions or passions, at others as a vessel filled with feelings, and in the end as one moved by the sublime, whereby the latter is said mostly either with a touch of irony or in literary speech. Despite the passive formulation, each of the three states manifests itself in its own characteristic patterns of behaviour which, however, we cannot simply construe as conscious and deliberate actions.

The behavioural patterns demonstrate the same modifications as the *passiones*. This can be seen most clearly in the behaviour of people who are obsessed or moved; for while we can say that a

* Translator's note: *Besessen* in the original. The word has two English counterparts, both of which are used in the following: *possessed* (in all senses) and *obsessed*.

person is obsessed with his work, task or idea, it would sound odd if one said that he was "moved" by *his* oration, *his* music or *his* fate. This means, then, that we relate the notions or passions with which a person is obsessed immediately to that person, whereas we can only be moved by something which, being sublime, has no specific relationship to the single individual, and must necessarily affect others. After all, in historical terms movement was always by the divine, possession by the demonic.

Thus our language retains the remnants, the ruins of a cosmology in which every reality which was once experienced as out of the ordinary was interpreted as an "image of a *passio*". This mode of interpretation has been ousted from scientific discourse in favour of an "emphasis on action".[15] At the point where notions which one would normally describe as "obsessing" a person harden into delusions, they are viewed by psychiatry as the subject's own products. Jürg Zutt, a prominent outsider in this field, has, however, spoken out emphatically against the one-sidedness of this emphasis. Instead he has attempted to develop a trans-cultural psychiatry on the basis of clinical experience, one which perhaps offers us a more far-reaching definition of the "images of *passiones*".

Zutt's deliberations, which have the advantage of resorting not to exotic beliefs, but simply to experiences which are accessible to all, seem best suited to "translating" the cosmological code into a psychological one. The decisive step consists in no longer viewing the contents of exceptional mental states merely as their "more or less chance accidentals, having little significance".[16] Zutt's most convincing illustrations of the necessity of not overlooking these contents are phobic anxieties, vertigo, fear of empty rooms and claustrophobia.

It is not true that,

> as might appear to a descriptive psychological approach which dismembers the phenomena, the abyss is a more or less unspecific stimulus which evokes an irrational, unfounded anxiety in the individual, an anxiety which in turn seizes him and has such a crippling effect that he is prevented from carrying on. Rather, the abyss reveals a power of the manifest. The abyss does something: it opens up, it yawns, it seizes the person, seizes him with a specific fear, namely the fear of falling and

plunging into the depths. It is the abyss, not the fear, that forces him to
his knees and into retreat. The fear is itself the state of being com-
pelled. Not everyone experiences the abyssal in this way. Not everyone
suffers from vertigo. Not everyone is forced to the ground by this
power. Not everyone is confronted with the yawning danger. Some
remain indifferent. But some fall into a state of intoxication, the abyssal
seizes them too, but in a different way. It lures them to overcome the
abyss and climb the peaks [...]. Just as the individual can be seized by
the abyss and the peaks, he can also be seized by the darkness or the
vastness into which he strays. Even the milling crowd can transport
one, as in the marching formation or the arena. But many phobia
sufferers avoid crowds and cannot even sit in the middle of a concert
hall, but only on the side near the door. In all such situations the
manifest reveals its power.[17]

Spirit in its various embodiments

The extreme empiricism which Lienhardt describes when he con-
ceives of the spirits and divinities of the Dinka as "images of
passiones" captures the very essence of the non-monotheistic world
pictures in Africa. Our rather woolly talk about "spirits" can easily
awaken the impression that the African cults revolve around
invented, hallucinated shades and entities, in which one either
simply believes or not,[18] but which are in any case secondary to
either the classification system in which they are categorized, or the
relationships and processes surrounding their veneration. But in
fact the basic words in African languages which we translate as
"spirit" denote first and foremost the spirit of something. I would
like to discuss this, using one West African and two Central African
paradigms, in order to prepare the ground for the examination of
the "spirit of the other" or the "spirit of the stranger".

The Akan word which denotes the character, "personality" or
individuality of a person, and which therefore we have already
come across as the personification of the characteristics transmitted
by the paternal semen and crystallized in the subject, is *sunsum*. But
the word does not mean just the "essential nature" of some person,

but quite generally the "essential nature" of an object, that which gives the object its characteristic properties and allows it to exercise powers and behave in its own particular way. Thus it can be rendered with our word "spirit", if we understand this to be the whole and the peculiar characteristics of a person or phenomenon, as opposed, that is, to a "spirit" which merely "dwells within" its physical manifestation and controls it as something removed from itself.[19]

Linked with this is the notion of the class. Everything that exists is endowed with spirit, every single sentient being distinguishes itself from all others by its spirit, and the types or categories of spirit give rise to the classes. But beside the *sunsum* which is visible in things, in the classes and the entire world, there is a *sunsum* which is nothing else but *sunsum* and which is only perceived as something visible by exceptional people in exceptional situations, namely deities, ancestor spirits and personified talismans ("fetishes"). Yet even the invisible spirits assume visible form when they seize a person and oust, as it were, his own *sunsum*, his own "personality"; the invisible *sunsum* then becomes visible as a person's "spirit". In other words, a possessed person is himself the deity, the ancestor spirit or the personified talisman.[20]

In the thinking of many other peoples, not all of the world appears to be endowed with spirit, but rather just that which we in our tradition group together as "capable of independent motion". Thus the word *muuya* in the language of the Tonga in Zambia, generally translated as "spirit", means above all air or breath. People, animals and various unembodied powers of the wild possess *muuya*; the *muuya* can release itself from its visible counterpart, make itself independent and move of its own volition; it appears to others in dreams and visions, even after death of the creature whose *muuya* it is. It is unembodied, not a substance but rather a motion which one perceives in something. For this reason the Tonga compare it with the wind; they call the spirits "wind" "because we do not see them. We know what they are by what they do, just as we do not see the wind but know that it is present by what it does."[21]

Every single *muuya* is the essence of a class, and, reproducing itself in every specimen of a class, it makes every living being a

specimen of its class. In some circumstances it can also "flow out" of the specimen, enter a person and affect them in a characteristic fashion. Once again the person's own *muuya* is ousted, and he is then filled with or possessed by the alien *muuya*, i.e. he assumes the characteristics of another class. Not only do the *muuya* of people and animals have this ability, but so also do those of objects which we view as capable of independent motion, but not alive: cars, tractors, trains, motor-boats and aeroplanes.

It is clear that the Tonga spirit concept is closer to the concept of the human psyche than is that of the Akan. By limiting the spirit concept to that which is capable of independent motion, it can be assigned, if only very vaguely, to a cosmological code which the older, cultural-historical ethnologists termed "manistic". In contrast to the dominant belief in West Africa and the Sudan in the "animation" of nature as a whole, or its "endowment with spirit" – i.e. to "animism" – at the centre of the "manistic" world picture are the spirits of the dead. The relationship between the spirits of the ancestors and heroes, the "forces of society", and the spirits and deities of the wild and waters, the "forces of nature", which we have seen in West African cosmologies, cannot be demonstrated so poignantly in the "manistic" Bantu cosmologies. This is either because only that which is capable of independent motion is considered to be endowed with spirit, as with the Tonga, or because although certain natural phenomena are viewed as "animated", their "spirit" is equated with the spirit of someone who has died, as is the case for instance with the Bemba.

"In the Bantu territory", writes Herrmann Baumann, "this category of non-manistic spirits is generally less developed, and quite often their link with the omnipotent ancestor spirits can still be made out clearly."[22] Although spirit also reveals itself here in natural phenomena, such as whirlwinds, rain, a rich harvest, in grottoes, springs and solitary forests, this spirit is considered to be not the "essence" of the phenomenon itself, but rather the spirit of a dead person who causes it. Such spirits of the departed are similar, however, to that particular sort of Akan *sunsum* which is not itself the "essence" of a phenomenon, but rather that which "discloses" itself in the phenomenon and is only visible to exceptional people.

In many Bantu languages the words which we translate as "spirit" also mean wind, breath or a waft of air. The animation of spirit seems logical where that which can move independently is considered to be endowed with spirit, but it also reflects the fact that the spirit of a phenomenon is seen to be that which touches or moves a person. Thus the Tonga speak of *muuya* above all in those phenomena which possess or move people emotionally. Although the comparison of the spirit with wind, breath or a waft of air falls under the aspect of motion and includes the vicissitudes of being physically moved, it does not include the waxing and waning of spirit itself. Rather, *muuya* is the immutable part of a creature which remains when it dies, that which is specific to a class, recurring in the living creature and even being able to shape a human's body in its own distinctive fashion.[23]

Sometimes one word which means basically shadow or likeness has the task of denoting that immutable part which reproduces itself in a variety of phenomena and also fills people. For the Cokwe in Angola, the pneumatic principle *moyo*, life or breath, has become a transient one which dies with the living being. The Cokwe call the immutable in the phenomena *cizulie*, the image, the form within changing appearances which remains ever the same as an intangible yet visible, unembodied yet acting subject. *Cizulie* can be translated as "shadow" (or "soul"), but the Cokwe use other words to denote actual shadows.

More exactly then, *cizulie* means the form one perceives in both the objects and their shadows, as well as the images seen in a mirror, or formed in clay or wood sculptures. What moves people emotionally about things, living beings or the dead is their *cizulie*, which appears in dreams and fills them with anguish or happiness. It is the *cizulie* which seizes people and forces itself – the form – on them.[24]

The spirit concepts in African languages form a family whose genealogy is unknown to us. A word which is the name of a certain spirit or a group of spirits in one language may denote spirit in general in a neighbouring one, although we do not know whether this is the result of generalization or a sinking into the "demonic". The meanings change with the words; our own concept of spirit

can only partially follow these changes in meaning, and when we consider concepts regarding essence, form or image, we are forced to think via translations. Nevertheless, a characteristic relationship between spirit and reality is emerging in our paradigms, which can be best described in the constellation of observed object, moving spirit and performing possession.

In all three paradigms the spirit appears, on the one hand, as a counterpart to the individual, confined to one location, and, on the other, as a freely roving, moving thing which sometimes moves and fills individual people. *Sunsum*, which is not the spirit of a phenomenon, but which manifests itself in phenomena (just like the spirit of a dead person which reveals itself in nature), *muuya*, that which is specific to the class of self-mobile things, and *cizulie*, the immutable image in the phenomena, all embody themselves, inasmuch as they actually become visible, in either the cosmos or the person; they go from one spot to the next, and from one person to another.

The interplay between the spirit's confinement and its movement in the outside world is repeated in the ritual practices. The person who is moved makes himself resemble the figure which moves him; and as a rule he erects a shrine to it, in which he worships the spirit which sometimes fills him as a stationary, confined counterpart. The ritual practice makes the spirit present. And because it can be handed down, it inserts itself between the observed object, which had once been considered to be a manifestation of the spirit, and its human embodiment. It is of no importance here when interpreting the concepts *cizulie*, *muuya* and *sunsum* whether the figure, which ritual practice brings to life either in its shrine or in the moving representation, changes with the course of time over the generations: it is viewed as immutable.

The figure of the deceased is known from personal memory, and later, even when modified and generalized, from the ritual practices at their shrines and from their embodiment in people, links in a chain stretching from one generation to the next as the form is handed down alongside its "real" genealogy.

Although one has the chance to see the natural powers, such as rain and storms, animals and trees, mountains, forests, rivers and lakes, and the sight of strangers with their exotic dress, their trappings, their figures and skin colour, from time to time, they

remain unavailable for daily and practical purposes. Thus in all these cases spirit is the image of a *passio* whose subject, whether bygone or distant, is absent and inaccessible in practical terms and embodies itself in people and shrines.

Admittedly the thesis regarding the empiricism of these conceptions of spirit should not be taken to mean that what the "images of *passiones*" refer back to is necessarily something which is vivid and realistic, or is always identical with a reality which stands up to "empirical testing" in the scientific sense. On the contrary, the "images of *passiones*" often appear to those who do not share them as mere phantasms which, in comparison with reality, are distorted, reduced, enlarged, dismembered, inverted or pieced clumsily together. The images of amorphous phenomena, such as wind spouts, gales, thunder storms and water lacking colour or form, are reminiscent of phantasms. But hunters, for example, also encounter entities on their travels which we could call "spirits" in a plain and ordinary sense.

Let me illustrate this aspect of spirit. The Cokwe hold that Muhangi, an old man who was once a great hunter, wanders through the forests emitting hideous cries; Kanyali, who has the form of a girl, wears a termite hill on his head and pursues wanderers; Kapwakala, a child who lives in holes in trees, rustles an apron made of hide; Ciyeye, a great fire, roams the forests; Kalulu, a small, red child whizzes buzzing through the air; Nguza, a large eye, squats in trees and gapes; and Samutambieka, an animal with one eye, one foot, one ear and one tooth, carries a club red with the blood of slain humans.[25]

In other places people believe in *sasabonsam*, whose feet point in both directions, in half-people, in creatures with water flowing from their wounds, in others made half out of wax, or in beings, half-man, half-fish, which live in water and have long smooth hair. Sometimes these dismembered and pieced together creatures are also spirits to whom one erects shrines and which embody themselves in humans.[26]

Just as these spirits appear to us as phantasms, our own phantasms, our experiments with theriomorphic and anthropomorphic forms, often appeared to the Africans during the first phase of

their encounter with modern technology to be manifestations of a spirit which, like other spirits, also embodied themselves in humans. The aeroplane, which flew like a bird, the tank which thundered through the country like a rhinoceros – all these new, iron manifestations of spirit could be confined and revered in shrines and represented in dances.

3

In the grip of another culture

The Shona and the people from the coast

The ritual process by which a person erects shrines to spirits and deities in order to worship them, and on other occasions represents them with his body because he is "possessed" by them, can, assuming that the possible translations we have examined are all legitimate, be viewed in terms of two complementary aspects: a subjective one, where psychic complexes are expressed and made plastic by ritual, and an objective one, where exceptional, "moving" events are repeated, making them plastic as cultural attainments and hence aiding their controlled internalization. The person, who in part feels the "images of his *passiones*" embodied within him, and in part sits opposite them in a shrine, submits himself, his *passiones*, to a ritual in which at the same time he acknowledges that part of his self, with which he demarcates himself from his close ones, as the other to his own culture.

We have already come across this "other to one's own culture" among the Tallensi, where it was defined more precisely as the "other to one's own lineage", being the specific characteristics – and in this sense the "culture" – of *saan*, strangers or an "other" which are expressed by the rites of the *bakologo* configurations. This other had first and foremost feminine and maternal traits, which only then fused with the images of another culture, in our sense, when a man introduced the "images" of Mamprussi women with whom he was related via his mother to his *bakologo* shrine.

The ritual cosmos of Asante expressed the "other to one's own lineage" as the *sunsum*, the characteristics of the father and his kinsmen passed on in the semen, and the other in the sense of an absolute negation of one's own lineage, one's own blood, as an attachment to *sasabonsam*, a power from the impenetrable rainforests. The epitome of the "other to one's own culture" was, on the other hand, that most alien of landscapes, the savannahs to the north, along with its inhabitants who in older times were placed in the category of *odonko*, the slave, then coming to be admired in the colonial period as unspoilt people in the state of nature whose "spirit" was adopted for rituals by scores of Asante.

Sometimes, but by no means chiefly, the Asante and Tallensi "other to one's own culture", which is honoured in rituals by those who are moved by it and are therefore differentiated from their near ones, coincides with that which we in turn would call "another culture". This ranking of the various specific "others" is turned on its head when we come to certain regions of the Bantu territory, namely those whose landscapes are more uniform than those of Asante, and whose social systems allow more cultural heterogeneity than that of the Tallensi. Simultaneously we come across those cosmologies which Herrmann Baumann categorized under "manism", i.e. cosmologies in which spirit is always or mostly the spirit of the deceased, even if it also embodies itself in natural phenomena or animals. However, these spirits are by no means always ancestors, for beside the ancestors there are above all the spirits of deceased strangers which, drawing on an anthropological convention, I shall call "alien spirits".[1] These "alien spirits" now prove to be the personification of an "other to one's own culture".

The Shona, a conglomerate of tribes with mutually comprehensible dialects and mutually related social structures, live in present-day Zimbabwe and the bordering parts of Mozambique. For centuries they have had contact with strangers who came to their land as traders, hunters and settlers. Gold was already excavated between the Zambezi and Limpopo a thousand years ago. Between the eleventh and fifteenth centuries Greater Zimbabwe controlled the trade routes between the gold mines and the Indian Ocean, and although land-locked, it was attached to the trade routes from the

Indian Ocean. Excavations at the ruins in Zimbabwe have turned up Persian fayences and Chinese plates from the thirteenth and fourteenth centuries.

After the collapse of Greater Zimbabwe came two empires which shared control over the gold trade. In the valley of the Mazoe River, which is rich in gold, arose the empire of the Mwene Mutapa, and to the south, close to present-day Bulawayo, that of Changamire. Both empires consisted of a stratum of farmers, gold-diggers and warriors whose culture was already very close to that of the Shona today, and an aristocracy which has still survived at least in the memory of the priests. A system of trading posts controlled by the Islamic coastal dwellers sprung up along the Zambezi, but this, along with the Mwene Mutapa empire, had already fallen under Portuguese influence in the sixteenth century. Dominicans and Jesuits came to the empire during the seventeenth century, and deserters from the Portuguese army and navy settled by the Zambezi, along with orphaned girls and prostitutes from Portugal and Indians from Portuguese Goa. The Changamire empire, on the other hand, was only destroyed in the 1830s by the Ndebele under Gundwane, who then settled there where, together with the Shona, they were finally colonized by the English. Both the dynasties and the encounters with strangers left their traces on the Shona cults.

The Shona word which we translate as "spirit" is *mwea*, and like the Tonga word *muuya* it means waft of air or breath, and is compared by the Shona with wind. The Shona recognize spirit only in living human beings, in released form as the spirit of the departed, and in baboons, who are more akin to humans than other animals; the spirit of the departed embodies itself in lions, in stretches of water, in heavenly bodies, rain, thunder storms and wind, as well as in living human beings – their mediums. As in many Bantu cosmologies, there are four categories of spirits, namely the heroes (*mhondoro*), the ancestors (*vadzimu*), the restless dead (*ngozi*) and the alien spirits (*mashave*).

In their funerary rites, the Shona transform the spirit of the departed into an ancestor spirit, who then aids and supervises his patrilinear descendants. But the spirit of anyone who bore a grudge at his time of dying – whether because he had been murdered, or because he had lent someone something or had

performed someone a service during his life, and the pledge or service had not been returned, or perhaps because of a disappointed marriage or unacknowledged parenthood – will attack the guilty person or his close relatives, possess them and use them as his mouthpiece to demand atonement or recompense. These restless spirits withdraw as soon as the injustice has been recompensed.[2]

The spirits of the heroes see to the well-being of the land, each in his own province, and govern the political fortunes of the inhabitants. They are just, as are the ancestors and even the restless spirits, who simply wish to see atonement for the injustices they have suffered. Yet the humans do not show the heroes of their province the same deep trust they have for their ancestors. Each tribe draws a boundary between itself and the heroes in its own way, believing that the heroes embody themselves in uncultivated countryside or that they do not come from the land itself, but rather have immigrated at the dawn of time from a region north of the Zambezi, or alternatively that they never embody themselves in the autochthons of their own provinces, but rather in people of alien provinces.[3]

In the images of the heroes, natural phenomena fuse together with the great dynasties of the past and the charismatic priests, who embody these images from one generation to the next. Chaminuka is equated with the rain and Mwene Mutapa, Nehanda with the morning star and the Mwene Mutapa empire, Dzivaguru sometimes with rain, thunder, lightning and wind. Often the heroes live as lions in the wilds, just as distant ancestors sometimes reside in trees, at the bottom of pools and rivers, in the woods, on mountains or in the sky.[4]

The hero cult, which already played an important political role in the Mwene Mutapa empire before the arrival of the Portuguese, has survived especially among the Korekore by the Zambezi, an amalgam of Shona-speaking Karanga who founded the Mwene Mutapa empire in the fifteenth century and autochthonous Tonga and Tavara. Like an autochthonous earth spirit, each hero is revered only in his own province, but the heroes form a hierarchy among themselves which reflects the political system of the conquerors. Groups of provinces combine to form a district, the heroes of these provinces are subordinate to a hero of higher rank. At the

pinnacle of the hierarchy is a hero who is sometimes identified with Mwene Mutapa.

The hierarchy of spirits and provinces is repeated in the hierarchy of their priests. In generation after generation, one priest will personify an image which he makes resemble that of Mwene Mutapa, and others the images of his "brother", "father-in-law", "mother's brother" and other "relatives". Fictitious relationships such as these define the mutual relations between the spirits and the provinces, as well as the hierarchy of offices, while the office-holders are (almost) always appointed from outside. Unlike the autochthonous worldly authorities, which are often biased and act out of vested interests, as foreigners they are able to pass cool and distanced judgements on legal and political questions.

The distance between humans and heroes is expressed not only in the appointment of foreigners to the office of priest, but even more dramatically in the story of his calling. A person who has a calling to become a priest is possessed by a spirit which has lived for a while as a lion in the wilds; the person roars like a lion, rages, eats raw meat, and strays about the wilds in order to learn hidden knowledge and recognize the nature of his spirit. Only then does he present himself to the senior priest to be examined and invested with his office.[5]

The heroes, whether autochthonous or from outside, create justice in the land they rule, and this inviolable tie to the land and its inhabitants by no means contradicts the twofold distance which its priests, being strangers and people who have temporarily turned wild, have to the just order of the land, for such distance is a prerequisite for a just, unbiased, impartial judgement. Against this the *shave*, who are not confined to any specific location, do not, as our Akan saying puts it, break laws; as the ghosts of strangers they are, like strangers themselves, outside of the jural system. The ways in which the priests of the hero cult and the people who are possessed by *shave* receive their calling follow the same pattern, the general pattern of rites of passage, although the *shave* hosts show only mild indications of turning wild during the initiation period, and never leave the everyday circle of their homes. They also gain

no, or only little, distance, which would enable them to cast objective judgements, although they do acquire specific endowments, characteristics and abilities which qualify them to carry out an occupation and by which they differentiate themselves from close relatives and neighbours. And while the priests of the hero cult form a hierarchical corporate body, those who are possessed by a category of alien spirits form a loose community of equals who meet from time to time for cultic purposes, and that I shall thus term a "conventicle".

A *shave* conventicle brings together everyone from an otherwise not more closely defined region who is possessed by the ghosts of a particular "tribe", whether of Shona from foreign clans, foreign tribes, Ndebele, Europeans or of people from the coast who came to the Shona as traders or hunters and died there. Since the spirit hosts assume the characteristics of a tribe, in some respects a *shave* conventicle also gives a picture of a tribe. If, as I assume, spirit possession cannot be understood solely as projection and differentiation, but also always produces "images of *passiones*" at the same time, we must pay just as much attention to the images of ethnicity in the individual conventicles as to their structure and recruiting, i.e. we must go into the details of the costumes and customs which are portrayed. This is possible thanks to the meticulous accounts on the *shave* cult of the Zezuru in central Shonaland which Michael Gelfand has published.[6]

I shall begin my overview of the strangers-become-spirit with a *shave* called Zvipenzi, whose ethnicity I am unfortunately unable to name. Only girls and women are possessed by Zvipenzi. When an eleven- or twelve-year-old girl is sent on an errand by her mother, such as fetching water, and carries out the task conscientiously but without receiving any thanks from her mother, her neck might suddenly relax and her head flop downwards, as if having no support. Here instead of saying that the girl is downcast, it is presumed that she is possessed by Zvipenzi, a spirit who urges her to work hard and then makes her unwilling when her industry is not rewarded with a word of thanks. Now it does not occur to the Shona to exorcize this wilful spirit from young girls. Rather the father will invite a woman from the Zvipenzi conventicle, who examines his daughter in order to see whether she really has the

Zvipenzi. If so, preparations are made for a ceremony immediately; the relatives gather together and the women brew beer, singing Zvipenzi songs: "I'm a fool, let me be a fool."

Besides the neighbours and relatives, the feast is attended by droves of Zvipenzi women who come to dance, sing prize-songs and drink beer; they carry a small axe and a stick in their hands, and put on particular dresses and adorn themselves with small trinkets, just as the spirit likes to be portrayed: a cream-coloured skirt with pockets, a string of beads with a white shell round their necks and another round their waists. The rhythm which summons the Zvipenzi is beat on two small drums. The women shake rattles and dance Zvipenzi. After a while the newcomer also puts on the spirit's costume and, still heavy-footed, joins the dance, thus completing her initiation. From then on she belongs to the conventicle with the similarly possessed women, and dances at the initiation of other girls. Now filled with Zvipenzi, she will grow up as both an industrious and a sensitive woman. If, on marrying, her husband forgets to thank her for her household chores, she will no longer cast down her head like an uninitiated girl, but rather will continue repeating the task she was not thanked for with neither sense nor purpose, both possessed and as one possessed. Her neck contorts but still she will not stop fetching water until, for instance, her husband expressly acknowledges and praises the specialness of her spirit.[7]

If we are still in the dark here as to the actual tribe from which the Shona borrowed this spirit of the industrious housewife, the origins of another spirit, Varungu, who incites the people to meticulous cleanliness, are sadly all too clear. It is the spirit of the Europeans. Varungu, a spirit whose name, like that of the majority of alien spirits, has a plural prefix because it is the spirit of a class, is the ghost of Europeans who came in earlier times to the Shona in search of gold and game.[8] Long before the Shona adopted the customs, costumes or food of the Europeans in their everyday life, the spirit hosts in the Varungu conventicle slept in beds on white sheets, wore white shirts and white hats, ate with knifes, forks and spoons from white plates and drank out of white cups. Their cult food consisted of rice, fish, chicken, pepper, onions, tomatoes and boiled eggs, which were all quite unknown in the normal kitchen. On falling into trance, they had a tendency to make complaints;

they would point to a shirt and say that it was old, or to a sheet, saying it was too dirty for them. Also outside of the conventicle they paid great attention to cleanliness, washing their hands constantly, their whole bodies twice a day, and when they sat down they would always spread a mat or skin on the ground to keep their clothes clean.[9]

Not all Europeans known to the Shona were as clean and harmless as Varungu. Madona, a *shave* who embodies himself only in women, wears a clean hat, a white shirt, a white shoulder cloth, white beads and a small axe; he eats with a knife and fork, puts pepper in his beer and slurps it from a plate. If a woman in his conventicle gets pregnant and is neglected by her husband, or in other words if he does not praise her spirit properly, she will lose her child. Then it is said that Madona has eaten the foetus.[10]

Many *shave* had numerous forms, just as not all people in an ethnic category resemble one another. Mazungu, the spirit of the people from the coast, who once passed through Shonaland as slave- and elephant-hunters, puts on a white shirt like the Europeans whom he serves, while also donning a straw hat or red cap and dressing in cloths with black and white spots; he loves rice flavoured with pepper, but also accepts mealie meal mixed with raw eggs and pepper. Sometimes he speaks Portuguese, sometimes English or Afrikaans. In one of his forms he is Katswamuni, a traveller who never stops at one spot, in another Boroma, who loves places with a lot of flowing water. Accordingly the Mazunga conventicle is divided into chapters in which everyone has one of the special abilities which had been observed among the people from the coast; some were hunters, others diviners, and yet others healers and witches.[11]

The members of another conventicle revere Bveni, the spirit of the baboons. They initiate boys and girls aged between eight and eleven, who become possessed and suddenly, when a spirit host points at them during a conventicle, scamper up the nearest tree with enormous dexterity. The children come down from the trees only once pumpkins, maize or peanuts have been thrown to them, snatching the food and eating it at a safe distance. A person possessed by the spirit of the baboon girds his waist with a black cloth, which has a horse or zebra tail hanging down at the back; he

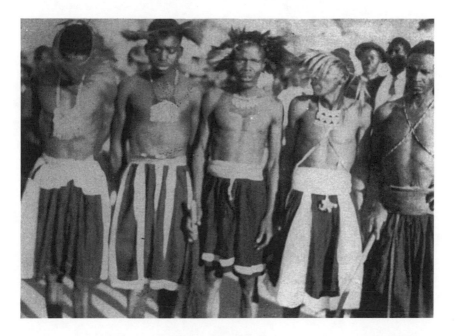

FIG. 8 Spirit hosts possessed by the spirit of the baboon, in their
costumes (Shona, Zimbabwe).

also dons a baboon-like wig and sometimes hangs a plate made of
black, white and gold beads on his chest (see Fig. 8). The spirit
hosts, masterful acrobats, amuse the spectators with their dances,
while also healing and possessing the gift of prophecy, and often
they discover hidden treasures in caves.[12]

The spirits of departed Ndebele embody themselves in the form
of hunters, healers and witches. The hunters' chapter is further
divided into subsections; one group hunts game with nets, another
sets traps, and yet another goes hunting with a rifle or dogs. They
place rows of black beads round their foreheads, carry spears with
iron barbs and mark themselves with the skin of a serval cat, a
spotted genet, a wildcat or red cat (See Fig. 9). The members of the
healers' chapter carry a curved axe and wear a feather headdress
and six plaited strings – two worn on each shoulder, the fifth and
sixth tied to the two double-cords – and a silent rattle just above
their calves. At their conventicles the spirit hosts slurp the beer

79

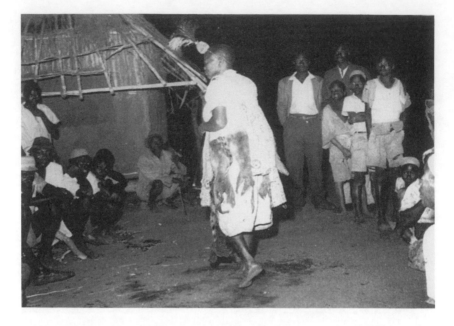

Fig. 9 Spirit hosts from the hunters' chapter of the Ndebele *shave*, in
their costumes (Shona, Zimbabwe).

from their axes, search restlessly for sour milk and eat fresh
manure or roast mice. The witch chapter is surrounded by myster-
ies; it is said that a pregnant woman possessed by such a Ndebele
will eat her own child if her husband partakes of his bagged game
en route, instead of bringing it home untouched. As soon as Ndebele
leaves the woman and she returns to herself, she will discover a leg
of her child which the *shave* has left hanging from the roof of the
hut. Her other children tell her that she has eaten the foetus
herself. She weeps bitterly, suddenly sees a blood-stained knife and
realizes that her hands are drenched with blood. Although the
atrocity is attributed not to "her", but rather to "her spirit", the
hunter will send her back to her parents; the Ndebele conventicle
tries to keep their distance from women who are possessed by this
version of his spirit, even though they wear the same costume as the
members of the healers' chapter, sing similar songs and perform
similar dances.[13]

The Shona word which we translate as "foreign" is *vatorwa* and, like the Tallensi word *saan*, it denotes everyone who does not belong to the patrilinear lineage, in this case the clan of the speaker in question: the category of outsiders. *Shave* are the ghosts of *vatorwa*, the spirits of the Europeans, the people from the coast, the baboons, the Ndebele, the Shona from other tribes — here the Zezuru have the *shave* Makorekore, and alternately the Korekore the *shave* Mazezuru — and finally also those spirits from other clans within one's own tribe. Each clan portrays its own specific totem; every person belongs to a totem; one can never be "possessed" by this, as one certainly can by *shave*, the ghosts of humans who had once belonged to another totem in the tribe. Thus among the Zezuru of the district Mtoko there is a *shave* named Mazezuru which, like the Zezuru themselves, is divided into clans and totems. A Zezuru can be possessed by every variation of this *shave* which differs from his own totem.

The spirit hosts in the Mazezuru conventicle have a medicine horn, an axe and a spear; they dress themselves with two skins worn apron-fashion front and back, they wrap a black cloth round their shoulders on which a large knife is fastened, and tie a black cloth round their foreheads. They work as healers and diviners, employing precisely the same means as the "actual" Zezuru healers and diviners, while the spirit hosts from other *shave* conventicles employ foreign practices if and when they carry out the profession. However, the "actual" diviners of the Zezuru are not possessed, they "read" the hidden meanings in cast bones. Although the diviners of the Mazezuru conventicle identify themselves with the "actual" diviners of the Zezuru, at the same time they are thrice removed from the latter: when they work they are in a state of trance; it is not "they themselves" who "read" the hidden meaning in the bone oracle, but rather the spirit of another totem residing within them; and generally they do not cast real bones like the "actual" diviners, but imitations made of wood or plant seeds.[14]

If we recall the immense importance which the *shave* conventicles give to the foreign dress, artefacts, food, language and customary ways of moving, this substitute for the bones seems surprising. Evidently the cultural attributes — profane as they are in their "actual" contexts — become the paraphernalia for the spirit hosts'

cult. But the ritual demands meticulous exactitude, and the spirit hosts check every single attribute. Yet here they avoid adopting "genuine" paraphernalia, and that in a situation where it would pose the fewest technical problems. It is possible that a taboo hangs over the paraphernalia of the "actual" diviners, preventing its use by outsiders. But even then this substitution reveals a decisive element in the structure of mimesis, which is what we are dealing with here, namely the fact that the spirit host is never completely identical with that which he portrays in his conventicle; he is possessed by the spirit, the form of a thing, and not the thing itself.

The Shona and the community of ancestors

A person who is possessed by a *shave* differs, not as a whole but in a part of his self, from the corporate group which includes him, and from his kinsmen, with whom he should, in an ideal sense, be equal. The Shona do not know any other category of spirits to whom they could attribute this differentiation within the corporate group, and they do not recognize a deliberate wish to differentiate. Hence from their vantage point the alien spirits have the same effect as the paternal deities have for the Asante, and the paternal ancestors of the *yin* configuration for the Tallensi; and those *shave* which bestow the gift of divination are also reminiscent of the maternal ancestors of the *bakologo* configuration, whose recognition leads to a man receiving his calling as a diviner.

The Shona accept the typically human wilfulness which expresses itself in the spirit host in two ways: in a strong version during the conventicle, where he represents his otherness in the form of a fusion with the spirit of a stranger, and in a weak everyday version, where in part his special talent as a hunter, healer or diviner is esteemed, and in part his idiosyncrasies, such as his obsessional washing or sensitivity, are tolerated. Their belief that the otherness of the spirit host is not in accordance with his own wishes, but rather the expression of an alien subject, presupposes, however, an ideal of self-constraint which the spirit host is evidently not quite able to meet. While the Tallensi subject determines its *yin* configuration before birth, and the Asante subject is already tied to

the paternal deities at the moment of conception, with the Shona we have come across an open contradiction between ideal autonomy and contingent possession.

The Shona word for their cultural ideal is *unhu*, which Gelfand translates as "personality" or "character".[15] To me the construct "being a person" seems closer to its actual meaning, for it denotes neither some quintessential qualities of humanity which are attributed to all human beings, nor the "personality" in our rather antiquated sense of an ideal, in which general humanity is combined with a unique, unmistakable character. The meaning of *unhu* is less some abstract quality of being human, and more a specific quality of the Shona, and less individual character than the same characteristics as one's fellow clansmen.

As an abstraction, *unhu* denotes a moral ideal, the way of life to which the elders adhere.

> A person with *unhu* behaves in a good way, respects his parents and sets a good example. He shows respect to a stranger, particularly one older than himself. A man possessed of *unhu* can adapt himself to any environment; he will also be particularly careful not to damage the reputation of another person, and careful to admit any wrong.[16]

Anyone who follows such rules is a person, *munhu*.

> The *munhu* thinks rationally and in a responsible way. He can control his passions, instincts and desires. If his desires overcome him it is said that he has no *unhu*. The man with *unhu* is above the animal, but a greedy person lacks *unhu* because he is enslaved to animal instinct.[17]

Unhu is therefore a personification of virtue, common sense and self-constraint; animals, children and people lacking sense or restraint do not have *unhu*. Children come to acquire *unhu* to the same degree they grow up to be adults and receive recognition as social persons.

Just as parents are responsible for their children's behaviour, so are the ancestors responsible for the behaviour of their descendants who have come of age. They are guarantors of the *unhu* of the living, and themselves are the sole pure representatives of *unhu*.

The transformation of a human being, who has more or less approximated *unhu* during his life, into an ancestor spirit who accords with it completely takes place during the funerary rites which, thanks to Peter Fry's analyses, we can describe for the Zezuru.

When a Zezuru dies, his relatives perform three rites so as to appropriate his possessions, property and status. In the first rite the body is buried and his personal effects, clothes, cushions and pipes are shared out. A year later his property – which the departed had held in trust by virtue of his genealogical status – is handed over to his legal successor to this position, namely his brother or son; this property consists of his cattle, his wives for whom he had paid a bride price from the property of the lineage, and the bride price he had also received for his daughters. While the rites mark for the living the legal distribution of property and possessions, for the deceased they effect his transformation into an ancestor spirit; the first rite purifies the dead man's spirit of all personality traits, the second initiates him into the community of the ancestors, and the third is probably intended to prevent him from bothering the community of the living in the form of a *ngozi*, a restless spirit. Accordingly, the community of the ancestors consists solely of figures who have been cleansed of all personal characteristics, possessions, desires, passions and resentments.[18]

What the spirit of a human being is cleansed of during the first funerary rite, when his personal effects are distributed among his surviving dependants, is that admixture, as it were, which distinguishes a human spirit from the pure ideal of the ancestors, namely the *shave*. Every Shona is possessed by a *shave*, even though not everyone becomes aware of it, identifies the spirit and enters its conventicle;[19] and for this reason no one can enter the community of the ancestors without first undergoing the purifying funerary rites. Just as the property of the deceased is separated from him during the first rite, being shared among his relatives, and not just the agnates, so is the *shave* separated from him as well. This can then also seize one of the relatives in order to be embodied once more.

Many *shave* are handed down from one generation to the next, partly from mother to daughter via complementary maternal

filiation, partly within the lineage. In the latter case the *shave* is adopted, as it were, by the lineage, serving it as an ancestor spirit, but without being answerable for the moral values of the corporate group. And the lineage reveres it, almost as one of its own ancestors, but without sacrificing animals to it, as they do for heroes and true ancestors.[20] While the *shave* of hunters, and to a lesser extent of healers and diviners, are often passed on to a son, a brother's son or son's son, the dangerous witching *shave* are often passed from mother to daughter.[21] This means purely and simply that the Shona believe that each person probably inherits his character, his specific susceptibilities and talents from his father, his mother, his grandfathers or his grandmothers. In this respect the *shave* are reminiscent of the destiny ancestors of the Tallensi, except that in the maternal line the *shave* are bequeathed to women, whereas *bakologo* ancestors are bequeathed to men, and above all the Tallensi see the lines of inheritance as predestined, while the Shona view them as contingent, or as expressions of the will of the *shave*.

Since the *shave* are passed on from generation to generation, they form what is probably a relatively closed stock of figures which remains unmodified over long periods of time, or at most changes only imperceptibly. The *shave* conventicles virtually constitute a system of frozen history. Just as in each generation the priests of the hero cult embody spirits which the Korekore associate with the glorious rulers of the past, the *shave* hosts personify the figures handed down from that part of Shona history relating to their encounters with the Portuguese, the Ndebele and the people from the coast. Just as the ancestor and hero cult transmits an idealized past, the *shave* cult transmits past characters, worked into the form of transmittable types and figures, which contrast with their idealized past and are also suited to expressing the necessary counterpart to the ideal Shona community in the present.

The contradiction between the ideal community of the Shona, the community of the ancestors and the incalculable ups and downs of real life, which is the *shave*'s field of action, becomes most evident in those realms of life where the agnatic lineage opens to women marrying in from outside, and on all occasions when the individual is not set the task of submitting to the agnatic morals and fulfilling

the duties of his genealogical status, but rather must act independently and autonomously as a hunter, healer or diviner.

The contradictions and tensions between husband and wife, who regard each other mutually as *vatorwa*, strangers, demand thoughtful tolerance on both sides; and this principle of tolerance, which is more important in some marriages than in others, is formulated expressly in the ritual precepts which a husband must observe towards the *shave* of his wife, and the wife towards the *shave* of her husband. The husband must praise his wife for the housework she had done if she is possessed by Zvipenzi, must extol Madona when his wife is pregnant and possessed by Madona, and may eat none of the game he has caught before reaching home if his wife is pregnant and possessed by the witching version of the *shave* Ndebele.

On the other hand, possessed husbands often involve their wives in certain rites. Thus, for example, before a man from the hunters' chapter of the Mazungu conventicle sets out on the hunt, his wife must set before him a cloth, a calabash, a spear and a big, flat copper button which is fastened to the *shave* cloth or the hunting knife, then sit in front of him and adopt the role of the hunter, while the hunter himself embodies his *shave*. His wife must then clap her hands and speak the words: "*Senhoro* [being a spirit from the coast, he is entitled to the Portuguese form of address], I am going out into the forest to hunt, show me the animals." In a similar way the wife of a diviner from the same conventicle must place the advance payment from a client in front of her husband before he dons the Mazungu garments and proceeds with his divination.[22]

Many *shave* bestow useful faculties, and are virtually the genii of healers, dancers, acrobats, diviners and hunters, whose specific abilities are well above average. In these cases the "conventicles", as I have named what are in fact sporadic gatherings to honour a common spirit rather than proper organizations, could also be called occupational groups, the prototypes of guilds or fellowships, because in every case they bring together the people who follow one common profession. Significantly neither farmers nor priests as such are possessed by *shave*: farmers because their job requires precisely the same knowledge and abilities which all Shona share; and priests because, unlike diviners, they are primarily concerned

not with the personal problems of individual clients, but rather with general questions concerning the political system which affect all. Hunters and diviners track down the hidden: the one roams the wilds, the other recognizes illnesses and the will of the spirits. Both form conventicles, but they practise their professions alone, possessed, or *like* ones possessed.

Nevertheless, the priests of the hero cult are also spirit hosts. Together with the ancestors, their spirits form the ideal community of the Shona, in which there should be just as little differentiation based on specific attributes and abilities as irritations and petty jealousies between husbands and wives. Consequently the spirits of the heroes, or priests which embody them, do not effect any differentiation like the *shave*. On the contrary, their task is to reduce differentiation, to annul the differences which divide the members of a political community and which hinder joint solidary action. When the priests pronounce the will of the heroes, in that moment at least they are anticipating the ideal community of the ancestors and heroes; they are the charismatic leaders who enlist their followers in a common interest. But then their form of possession must also be different to that of the *shave* conventicles.

Digression on possession as celebration and charisma

It is one thing to be the one sole individual who is possessed by a semi-divine power from a glorious past, and to give advice and instruction to the faithful in his name, as do the priestly hero cult mediums of the Korekore; but it is another thing to be possessed by hordes of spirits of dead strangers, to dress up in an exotic costume and to dance and drink beer in a conventicle of those likewise possessed, as do the mediums of the *shave*. This antithesis is universal and has been often described by anthropologists and historians of religion, although no uniform terminology has arisen in the process. The particular form of individualization we believe we can discern in collective possession by alien spirits, but not in the individual possession of the medium who faces the collective alone, must be developed in the light of the diverging concepts and evaluations.

We have seen that the present-day meaning of the terms "posses-
sion", "being filled" and "being moved" can be traced back to the
psychologization of mystical terms from the language of Pietism.
Possession as a psychic state – which expresses itself in the human
physis in trance and hyperkinesia, and is interpreted within the
framework of a belief system as an expression of alien powers
inside of a person – has degenerated in European civilization to
superstition and spiritism. This can be seen as a consequence of the
witch trials and later Mesmerism, along with the process of secular-
ization which changed spirit to its subjective and objective forms of
thought and culture. But outside of present-day fringe areas we
still use "possessed" to describe a type of behaviour which differs
from the norm in its intensity, exaltation and extreme individua-
lism. We tend to expect possession most among gamblers, lovers
and people in the professions, whose self-forgetful devotion stands
in sharp contrast to the social and even conventional framework of
their actions.

If this seemingly self-forgetful devotion does not contradict the
agonistic motives which drive the obsessed person on, however
much they must be excluded from the actual moment of obsessive
action, then that which we refer to as "sublime" or "moving" causes
the individual agon to be extinguished in the moment the person
is moved, because that which moves appeals to that which is held in
common by those who are moved. Thus the older notions of being
possessed by the demonic and being moved by the divine are still
clearly reflected in this terminology.

When using this terminology to describe other cultures, we shall
have to study the three levels of meaning – the cosmological,
psychological and the sociological – individually, and scrutinize the
attendant evaluations they contain. With this we shall see that the
definitions given by anthropology and the history of religion are
closer to the expressions in present-day language than their often
artificial, sometimes value-free and sometimes overtly or covertly
evaluative wording might allow one to think.

The first Europeans who reported on the African cults of spirit
possession still had the one true religion. The heathens were seen
as being possessed one and all by the Devil, and the missionaries

had to exorcize this Devil by baptism. Later they sometimes distinguished between the ancestor cult, which did show some form of piety, and the possession cults, which even such versed ethnographic observers as Junod and Lindblom interpreted as an "exorcism". They assumed that the people they missionized, namely the Kamba (Lindblom) and the Tsonga (Junod), considered the spirit hosts to be possessed by evil demons, and consequently that the spirit hosts' rituals were intended to exorcize them. In both cases the "demons" were in fact the ghosts of strangers, which, like the strangers themselves, were seen not as "evil", but rather as beyond good and evil, morally neutral powers which the rituals were intended not to cast out, but rather to transform into the hosts' genii or helping spirits. The diagnosis about the psychic state of "possession" was correct, but the Christian dualism of good and evil was projected on to the moral cosmos of the Kamba and Tsonga, and Christian exorcism on to their rituals.[23]

The first anthropologist who translated the Christian concept of being moved into a pagan counterpart, applying it to African cults and cultures, was Leo Frobenius. He contrasted the superficial "facts" with a deeper layer of "reality" which could not be grasped with the intellect, but only "looked at". For him this sort of looking or "beholding" was not something that is accomplished by an autonomous human subject, but rather the grace bestowed by a reality raised to the level of subject which "seizes" the person. At the centre of the "pure" African cultures uninfluenced by the Orient was, in Frobenius's eyes, the Divine King, the epitome of the sublime; the order of his kingdom was supposed not to be based on naked power, but purely on his subjects being "moved", devoted and ready to make sacrifices. These subjects were moved by nature, by reality, and the king's state of "being moved" was for them a rousing model.[24] In contrast to "being moved" as kingly devotion to ruling, spirit possession – termed "Shamanism" by Frobenius, a word intended to signalize the foreign, "Asiatic" origin of the phenomenon – is distinguished by an element of rebellion:

> Essentially it revolves around developing the "ego-potency" to the point where personified powers of imagination are formed, and then exercising power over them. Thus it is the contrasting feeling for life to that of

manism. The latter is based on being one with reality and the according devotion, that of shamanism on a revolt against the natural order of reality. The individual rebels against reality. He makes a divide between himself and his surroundings, poses himself as an "ego" and becomes an usurper.[25]

In other words, he has the Devil in the flesh.

To the same degree that Frobenius is monarchic, Erica Bourguignon is democratic. In her world-wide comparative studies, possession in the sense of a covenant between spirit and person assumes the positive role, while possession in our sense of an expression of the encroached spirit in the form of trances and hyperkinesia takes the opposing one as an apostasy from a state of autonomy. In a sample of 488 societies from all six major ethnographic regions of the world, 74 per cent believe in spirit possession, regardless of with or without trance, 88 per cent on the Pacific islands, 77 per cent in Mediterranean cultures, 64 per cent among South American Indians, and 52 per cent among North American Indians.[26] Possession without trance occurs mainly in societies which depend largely on hunting, gathering and fishing, have neither class differentiation nor slaves, lack any centralized adjudication, have total populations under 100,000, and only rarely circumcise boys but initiate their youths outside of the community. On the other hand, possession with trance is characteristic of societies which are "more complex", i.e. have social relationships based on sub- and superordination, whereby the social subordination is mirrored in the trance as a relinquishing of one's own will and identity to alien powers.[27]

Being moved as allegiance, which is judged positively by Frobenius, and possession ("shamanism") as rebellious self-assertion, which he judges negatively, versus attachment without trance to a spirit as self-assertion and primal religiosity, judged positively by Bourguignon, and trance as being at the mercy of outside control, judged negatively – these, and many other similar schemata which I shall pass over here,[28] each classify whole societies according to their presumed attitude to individual autonomy and collective allegiance, without making any allowance for the fact that every

society contains both elements and must form them into a constellation.

Not the judgements of anthropologists, but rather those of the respective societies are central to Raymond Firth's definition of shamans, as people who it is believed can control spirits, regardless of whether these are located in the external world or the inner world of the shaman; of spirit hosts, as people who develop an "abnormal individual behaviour" which is interpreted by the society as a sign that they are under the control of an indwelling spirit; and of spirit mediums, as people from whom it is believed that beings of the spirit world speak, and whose pronouncements are binding for the entire community.[29]

If we leave the shamanism problem aside, these definitions are still very close to our Pietistic concepts, for by "spirit mediumship" Firth means "being moved" by powers which are viewed variously as divine or semi-divine from one society to another. However, the choice of expressions "spirit mediumship" and "spirit possession" obscures the fact that in Polynesia, which Firth refers to, and in Africa, to which Beattie, Heintze and Lewis have applied Firth's concepts, spirit mediums and spirit hosts are viewed equally as vessels for spirit.[30] Especially in Africa, both forms of possession begin almost always with illness and affliction, which is transformed by the ritual into a controlled attachment of person to spirit. So "mediums" and "spirit hosts" differ only in the rank of their spirits.

For this reason I.M. Lewis, who in his book *Ecstatic Religion* extended Firth's definitions of the concepts "central" possession, which serves public morality, and "peripheral" possession, in which deprived individuals live out their resentments, later criticized all these dichotomies as being based on "the same underlying error", namely a "simplistic concretization of cultural categories and religious and emotional phenomena".[31] Invariably the ritual is said to transform the suffering and trauma into a state where the spirit host can master his ecstasies, trances or hyperkinesias until finally, either recuperating or healed, he is able to help, heal and mediate in his community. The differences between world pictures, types of trance and hyperkinesia prove secondary when compared with the sudden change from sickness to health, from misery to joy and

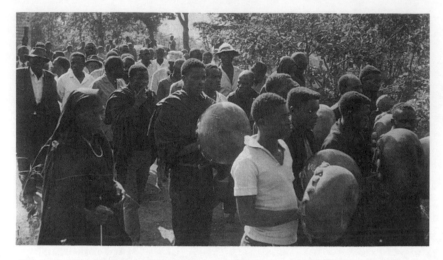

FIG. 10 Procession making its way to a shrine of the hero cult (Shona, Zimbabwe).

fulfilment, or from impotence to the power of the medium, helper and healer one has experienced in one's own suffering.[32]

We have seen that the initiation of the priestly mediums into the hero cult of the Korekore is similar to the initiation into a *shave* conventicle; an alien power enters both the mediums of heroes or alien spirits in order to work from inside them. But if we look at the social form of the hero cult (see Fig. 10), we see that it constitutes an opposite to the *shave* cult. Heroes make single persons possessed, who in turn influence the collective, while *shave* make collective groups possessed, from which individuals with special characteristics emerge. By likening the two forms on the basis of their common initiation patterns, one is ironing out a religio-sociological difference which – just like the initiation – has even greater general significance and can also be described outside of spirit possession cults.

Durkheim's sociology of the "elementary forms of the religious life" pinpoints this difference by examining the genesis of the collective consciousness in two different paradigms, namely the political assembly and the Australian totem ceremony.

In the first case an individual speaks to a crowd.

His language has a grandiloquence that would be ridiculous in ordinary circumstances; his gestures show a certain domination; his very thought is impatient of all rules, and easily falls into all sorts of excesses. It is because he feels within him an abnormal over-supply of force which overflows and tries to burst out from him; sometimes he even has the feeling that he is dominated by a moral force which is greater than he and of which he is only the interpreter. It is by this trait that we are able to recognize what has often been called the demon of oratorical inspiration. Now this exceptional increase of force is something very real; it comes to him from the very group which he addresses. The sentiments provoked by his words come back to him, but enlarged and amplified, and to this degree they strengthen his own sentiment. The passionate energies he arouses re-echo within him and quicken his vital tone. It is no longer a simple individual who speaks; it is a group incarnate and personified.[33]

In the second case the celebrants enter a mutual state of exaltation, all dancing, crying, leaping and writhing to the light of blazing torches. With Durkheim,

one can readily conceive how, when arrived at this state of exaltation, a man does not recognize himself any longer. Feeling himself dominated and carried away by some sort of an external power which makes him think and act differently than in normal times, he naturally has the impression of being himself no longer. It seems to him that he has become a new being: the decorations he puts on and the masks that cover his face figure materially in this interior transformation, and to a still greater extent, they aid in determining its nature. And as at the same time all his companions feel themselves transformed in the same way and express this sentiment by their cries, their gestures and their general attitude, everything is just as though he really were transported into a special world, entirely different from the one where he ordinarily lives, and into an environment filled with exceptionally intense forces that take hold of him and metamorphose him.[34]

Durkheim has a particular term for the power which the individual experiences within yet as separate from himself when he has merged with the collective, namely the "person". Someone is

"person" in so far as he is absorbed in the collective, the society, or in so far as the collective is embodied by him. The individual experiences his person-hood in periodically recurring celebrations and gatherings, but this experience determines a part of his overall life, namely social action.[35] There is no difference in this respect between the political gathering, where a speaker concentrates the emotions and values of the crowd in himself, and where the crowd sees the speaker as the embodiment of their unity and power, and the celebration where everyone feels himself to be transported into a "totally different world".

Durkheim's first paradigm seems able to explain the social and psychological process which gives the hero cult of the Shona its political power. Here the hero who possesses the priest is actually considered to be the "moral power" which moves the entire collective. It would be impossible for the priest to speak in the same way as an individual person as he does as the embodiment of a hero, as a personified spirit of the corporate group. He appeals to the unity, to the power and the morals of the collective, which pays allegiance to him in his political actions.

The second paradigm can be compared with the *shave* conventicles of the Shona, but the collectives, which, with their costumes and ecstatic dances, transport themselves into an alien world – namely that of a foreign people – do not play a powerful role in the political life of the Shona. Outside of the celebration everyone goes about his work on his own, possessed by the spirit of the celebration. In political life even the *shave* hosts obey their clan totem and belong to the following of their heroes. Nobody would become what Durkheim calls a "person" as a result of a *shave* festival.

The initiation into the cult of the heroes is comparable with the initiation into a *shave* conventicle; in both cases the initiates undergo a sudden change from sickness and affliction to joy and fulfilment, even if one suffers more than the other. And both are considered to be possessed by alien spirits. Nevertheless, one does not need to go into any cosmo-theological "discerning of spirits", which will vary from culture to culture and probably from one epoch to the next, in order to describe the differences between the

94

two sorts of medium. Returning to our Pietist concepts, it is questionable to speak of "being moved" by the divine in the one case, and of "possession" by the demonic in the other. But, sociologically speaking, the mediums of the heroes have charisma, i.e. their followers allow themselves to be "moved" by their pronouncements, whereas all the spirit hosts at a *shave* festival are transformed together, without gathering any followers or establishing any social person-hood.

If we look at the structure and the social import of the situations in which possession occurs, one can characterize two situations. First, one which Frobenius names "being moved" and Firth "spirit-mediumship", which is a *charismatic* milieu where the leader and followers are face to face and experience themselves as a powerful whole. And second, a situation which Frobenius categorizes as "shamanism" and Firth and others categorize as "possession", which is an *acephalous* festival.

The marked egalitarianism of the second type, which I call "acephalous", is underlined by T.O. Ranger when he talks in this context about "cults of 'democratic' spirit possession".[36] The political connotations of the adjective "democratic" are, however, poorly suited to the apolitical character of the cults, whose acephalous nature stands in marked contrast to the centralized societies in which they appear.

Charismatic mediums appear in both acephalous and centralized societies. In the latter they sometimes form an important counter-balance to the traditionally legitimated ruling authorities in the narrower sense, pitting both the transmitted values as well as the outsider's freer and more objective ways of seeing things against the authorities' tendency to become autonomous. On the other hand, "acephalous" cults of possession occur less frequently in acephalous societies than in centralized and stratified ones. Their acephalous and apolitical character presents itself as an inversion of, and counterpart to, the society's political and economic constitution, and the festival of the spirit hosts presents itself as a sociable, non-societal event which suspends status, personhood and hierarchy.

Women and the tribes on the East Coast

The towns on the East Coast linked the shipping on the Indian Ocean with the trade routes from the hinterland. On one side they were in contact with Arabs, Persians, Indians and Portuguese, on the other with African tribes which they called Nyika, bush people. The Swahili towns were the point of departure for European explorers and missionaries, later becoming centres of colonial rule and finally centres for mass tourism.

The spirit of the strangers, who came from the sea or the hinterland to the Swahili and their "bush people", has survived in the possession cults. Sickness, grief, restlessness and affliction are often interpreted as signs that *pepo*, the spirit of a stranger, wishes to embody itself in a person and is demanding sacrifices and worship. Here the spirit hosts are also dressed in special costumes when intiated at a *ngoma*, a dance, and here too they are presented with the food of strangers. Also scores of similar spirit hosts, *wateja*, congregate here at the initiation to celebrate. However, the scene at a *pepo* festival shows a major difference from the majority of *shave* conventicles held by the Shona, for almost only women dance at *pepo* festivals. Men are rarely possessed, and even then the majority attempt to suppress the spirit they sense inside and somehow rid themselves of it, for the spectacle of a man possessed is difficult to reconcile with his beliefs and bearing. And because Islamic women are virtually unable to carry out a proper profession, possession remains here a ceremonial event without any possibility of crystallizing into a profession involving possession.[37] But since this possession does not prove to have any useful side-effects, our attention is turned all the more directly to the dramatic role-changes and the ecstatic play in the festival.

One of the first Europeans to report on the *pepo* cult was Johann Ludwig Krapf, who was a missionary on the East Coast during the mid nineteenth century. "As I approached the assembly of dancers and tried to address them," he writes, describing his first encounter with the spirit hosts,

people shouted at me, saying that I should leave at once, for the Pepo (evil spirit) who was inside the sick people could not abide my presence, for they were just in the process of exorcizing the Devil by dancing, drumming and shouting. At that I raised my voice and said: it is more likely that your sinful carryings-on will summon the Devil than exorcize him, for wherever one commits sin, the Devil is quickly at hand, because he enjoys misguiding and deceiving people. [...] It is impossible to say what power of darkness descends on the dazzled people on such occasions. They are scarcely able to control themselves for dancing and screaming, which is intended to ward off the evil spirits. [...] On such occasions the missionary requires a special power from Above in order to remain steadfast in this – as it were – infernal atmosphere against the dark forces to which the people open themselves, and testify with joy to the Word of Truth which must instil fear even in Hell. Indeed it is the power from Above, not mere theological skill and dexterity, which the missionary needs among the heathen. Without this power his word dies on his tongue, so that he no longer knows what to say, as I have often seen. The missionary is faced much more directly with the world of the evil spirits among the heathens than in the Christian world, where so many powers of light work against it.[38]

It is not surprising that Krapf interpreted the *pepo* festival as an exorcism, particularly because the Swahili also use the Arabic word *sheitani*, Satan, to name the *pepo*. Nevertheless, the admission that one cannot oppose the "sinful carryings-on" with one's own strength, but needs the "power from Above" in order to avoid – evidently – getting caught up in the festive frenzy oneself is astonishing. The strength which he had to summon in order to convert rather than be converted points to the pull the other culture exerted on him. Perhaps a wish, which is experienced as irresistible, to dissolve as well in the "infernal atmosphere" presupposes a will to assert oneself which present-day tourists and anthropologists are lacking. Thus we, who wish to "understand" the foreigner, have less sympathy with Krapf and his forceful opposition than for those he describes, even though, like him, they resisted the "spirit" of the stranger, only being "possessed" by it when their resistance collapsed.

I admit that I had no need of a "power from Above" when, several years ago, I lived with the Ilwana by Tana River and was

introduced to the drums for "exorcizing" the *pepo*. The initiate was suffering from what the Ilwana call *mzuka*, which is to say she sat around listlessly for days on end, staring vacantly into space and rotating her head while making a curious buzzing noise. On numerous occasions she had attempted to jump and run away because she could no longer stand being at home – a fact which was considered to be the most certain and serious sign of possession. She was brought to a hut, wrapped in cloths and given a herb extract to inhale. At night people from all around gathered before the hut, some with looks of concern, others with unveiled amusement. The drums were beaten and everyone waited until the novice left the hut and began to dance.

It is virtually impossible to describe such a sudden change from grief and apathy to animation and fufilment. It is easier to give the individual details which the people named and paid attention to. The Ilwana do not have a differentiated inventory of *pepo* spirits, simply maintaining that they all came up the river from the coast and consequently hail from the Swahili. If one succeeds in pacifying them by means of a dance festival, the mental absences and trances will disappear so long as one observes certain food taboos, for example eats no fish. If a spirit host who has been "healed" embarks on a journey, he will quickly find opportunities to point to his special taboo, doing so with a certain pride and earning rather astonished looks, in which, as I believe, one can discern a small but perceptible reserve, rather similar to when someone here looks at another who reveals that he has an allergy.

Enormous emphasis is given to such details, such as the origin of the spirits, the nature of the drums and their rhythms, the cloths, the herb decoctions and the food regulations, all of which is highly reminiscent of what we usually term "fetishism", and which we come close to in the way we handle the sacrosanct accessories of a hobby or the fanatical way we observe the rules of some diet.

Even if they do little more than name the tribes whose spirits were portrayed at the festivals held by the spirit hosts from other tribes, the bland ethnographica which Krapf, Oskar Baumann, Werth, Skene, Koritschoner and others have bequeathed us might take on a little more colour if viewed against the background of our own

over-attention to details in the ways I have mentioned above.[39] Be that as it may, I shall content myself with just a few extracts from the spirit inventories, which will, I hope, elucidate the principle of inter-ethnic "borrowings".

In the eyes of the Swahili, the spirit hosts embody, among others, Kilima, the spirit of the people from Kilimanjaro, Kizungu, the spirit of the Europeans, the spirit of the Galla and the Sanye, a small group of hunters by the Tana River, the spirit of the Somali, the "Nubians", the "bush people" and the Arabs. It is important here that these are not only powerful peoples who are admired, but also unimportant ones who are despised; this alone prevents us from talking about some "identification with the aggressor", for instance. The sole common denominator we can find in all these peoples is their otherness.[40]

The *pepo* spirits of the Islamized and Swahilicized Segeju on the north coast of Tanzania, which are called *shatani* and are organized into *makabila* or tribes, do, however, reflect a system of inter-ethnic relationships: Kipemba, spirit of the inhabitants of Pemba Island, Kimasai, spirit of the Masai, who in former times raided the coastal villages, and the spirit of the Galla who invaded from the north.[41]

The "bush people" of the Swahili, such as the Kamba, Taita and Giryama, who resisted Islamic influence, share a number of spirits with the coastal towns. They arrange them, however, according to a system of their own which reflects their historical experiences with the attempts at Islamization and the economic dominance which came from the coast. Thus among the Kamba we again find the *pepo* spirits (*mbevo*) of the Swahili, Galla, Somali, Europeans and Arabs,[42] and among the Giryama those of the Arabs, Swahili, Masai, Luo and Europeans. But while the Swahili admire the Arabs, the Giryama are much more afraid of the spirits of the Arabs and Swahili than of those of the Europeans, because for them the Devil is a Muslim.[43]

The origin of the *pepo* spirits lies in the mists of a history which, although it gives the historical Swahili account of the rise and fall of the city states, does not mention the women's dance festivals. These festivals are handed down without any historical awareness from one generation to the next, and are conceived as representing the

transmission of a woman's spirit to her daughters and grand-daughters. All that we can now discern is the genesis of a few recent spirits whose appearance and disappearance has been observed by missionaries and anthropologists. At the beginning of the century, sections of the Kamba were possessed by Kijesu, the spirit of Jesus, a consequence of the Christian Mission. No sooner did these people catch a glimpse of a red fez, a pith helmet or indeed a European, than they fell to the ground, groaning and moaning and writhing convulsively, or they felt an irresistible desire to shake everyone by the hand. They sang of *vwana jesu*, the Lord Jesus, and God who comes to earth to save humanity, slashed themselves with knifes without bleeding, and burned themselves with torches without suffering any harm. Occasionally they tried to protect themselves from such attacks by huddling under blankets and avoiding the sight of anything which triggered them.

Possession by Jesus was the alternative to conversion, for in Kijesu we can recognize what one can call, in a precise sense, the spirit of the mission or the missionaries, a personification not of Christianity, but rather of the alien world, such as the missionaries represented to the Kamba, and which was manifest in the pith helmet and red fez. What is especially revealing here is that these manifestations had no effect on the real converts. The mission pupils' resistance to the *pepo* Kijesu pleased the missionaries, who saw it as a sign that their Christianity was invulnerable to such heresies – to the "infernal atmosphere".[44] At the same time our overall investigation shows that the people in these cults are never possessed by a thing to which they themselves belong; being possessed by something means that one has no practical dealings with it.

The fact that the practical and possessed forms of coming to terms with strangers are mutually exclusive can also be seen clearly in the *pepo* complex of the Giryama, which seems to be an exception to this rule. Without openly displaying their possession, young men who had succeeded in establishing careers as coconut producers and dealers, and therefore entered into practical, economic rela-tionships with the Muslims on the coast, maintained that they were possessed by an Islamic *pepo*, more or less the spirit of Islam, which imposed the food taboos of the Muslims. In their case the taboo did

not, however, serve to protect them from fits of possession, but rather they used the *pepo* taboo to justify their inability to eat with their pagan tribal kinsmen; and they were afraid indeed that the latter might add some magical substance to their food out of jealousy towards their economic success.[45]

Functional relations with outsiders within the Islamic trading community and with Islamic and non-Islamic strangers were permitted only to men, for Islam subjects women to far-reaching sequestration. This relationship to women has its effects on neighbouring, non-Islamic peoples, who also view public, outwardly-directed economic activity to be a male privilege, most especially and jealously when the trading entails contact with Muslims. Here the women have mental pictures of the outside world, but no practical experience in dealing with it; the outside world appears as a phantasmagoria which they bring to life by spirit possession. The sight of things outside of their physical grasp causes a confusion which can be appeased only by ritual manipulations.

In the 1950s Taita women were confused by the sight of a car or a bright piece of cloth, the whistle of a train, the smell or sight of cigarettes or bananas, or the sound made on striking a match. Grace Harris tells of a woman who was seized by uncontrollable convulsions at the sight of a parked car: she danced in its direction in a deep trance until, now dancing towards the car and now away from it, it became obvious that she was unable to approach closely and go around this object which was simultaneously attracting and repelling her.[46]

The ritual fixates the objects of vague longings and fears, it provides signs which, although they do not permit one to deal with the object in practical terms, do allow one to deal with the "images of their *passiones*"; it replaces the phantasmagoria with its own reality – the songs, rhythms, dances, costumes and taboos.

The *bori* cult and public life

In contrast to the *shave* and *pepo*, the spirits of the *bori* cult of the Hausa and the North African *zar* spirits – both spirits which possess women in trading societies – were considered to be not dead

strangers in a transformed state, but the invisible brothers and sisters of mankind created at the dawn of time. Long ago, as a Hausa myth tells it, Allah ordered the first pair of humans, Adama and Adamu, to bring him their children. The woman, however, advised her husband to show only some of their children to God and place the rest in hiding, for maybe God wished to keep them himself. Allah saw through this and spake: "The others are hidden over there; they are hidden people; they shall remain hidden people for all time." These hidden people, our relatives to whom we are tied to this day by mutual obligations, are the spirits.[47]

According to a myth from the Abyssinian *zar* cult, Eve gave birth to thirty children in the Garden of Eden; as one day the Creator entered the garden in order to count the children, Eve had hidden the fifteen most intelligent and beautiful. By way of punishment, these are to remain forever hidden as "creatures of the night", the *zar* spirits. These envy their human brothers and sisters, the "children of the light", for their visibility, even though the latter are weaker and uglier.[48]

We recall that, in one of their myths about the origin of the inequality between cultures and races, the Shilluk related how the primal mother hid one of her sons, the black one who was to become the first parent of the Shilluk, from God, his father, presenting only her unbeloved son, who became the first parent of the strangers.[49] At first sight the "myth's logic" seems to leave us in the lurch, for in their version the Shilluk, the "real humans", identify themselves with the hidden figure and the strangers with the revealed one, while the people in the *zar* and *bori* versions define themselves as the revealed sons, and the alien spirits as the hidden ones. Here, however, we should bear in mind that the *zar* and *bori* spirits are not considered to be wholly invisible, but rather embody themselves in women, and that the female spirit hosts represent the spirits or indeed *are* the spirits made visible. Thus, without overtaxing the "myth's logic", we can say that the *zar* and *bori* versions identify the female spirit hosts with the figure of the hidden child, while equating the society which excludes the women with the figure of the revealed son. The relationship between the spirits and the women is based on representation, and that between

the spirits and the society on similarity, as is shown in the representation.

In the course of its history in the Hausa states of Niger and Nigeria and the North African diaspora, the *bori* cult entered into a great diversity of relations with the stratified society and the specific culture of its women. Islamization, which was partially abrupt and radical, and partially a gradual process, was decisively advanced by the Holy War of 1804–10, when the ruling Habe Kings were ousted from the majority of the Hausa states by Fulani, even though some rural areas remained true to the pre-Islamic Hausa religions till recent times. With this, the *bori* cult, which was once closely tied to the state religion, was forced to the periphery of Islam. It was forbidden during the colonial era and rehabilitated by the decolonization movement. Although in its heart-land a women's cult, in the North African diaspora it was joined by more and more men – poor day labourers and liberated slaves who, despite being Muslims in an Islamic society, were marginal strangers who preserved a portion of their Hausa identity in the *bori* cult.

The situation in Anka, the capital of the former kingdom of Zamfara, and which, despite the fact the king converted to Islam at the start of the seventeenth century, still had vestiges of paganism until recent times, has been reconstructed by Kurt Krieger and provides a suitable illustration of the structure of the pagan *bori* and its relations to the political powers.

The pagan cosmology divides the spirits, *iskoki*, or "winds", into black and white. Without over-simplifying the matter, we can assign the white spirits to the society at large, and the black ones to the other within and on the fringes of society. The white spirits correspond therefore to the heroes of the Shona, the blacks to the *shave* and *pepo*. The criterion for dividing the two categories, which are seen as related by kinship and marriage, is the location where they customarily live. The blacks live in the wild, in trees and stretches of water, the whites in the town, in compounds, in trees and stretches of water, grass sweepings and in the palace. The white spirits confer riches if one performs sacrifices to them, while avenging themselves with sickness if they are neglected. The black spirits, on the other hand, always make people ill, each with a

specific illness which can be healed by ritual acknowledgement and in some cases transformed into a vocational possession.[50]

Damisa, for instance, is a black spirit which lives in a tree in the bush, carries a hoe and causes fever; it is a spirit of the hunters who sacrifice a red he-goat in its honour.[51] Doguwar Daji, a black spirit which speaks Ful, a foreign language, lives in the wild and wears a black cloth. She causes a stooping of the body or a twisting of the hand, demands the sacrifice of a black hen or a black he-goat, and protects hunters, butchers and wood-cutters.[52] Dorina, a black spirit, lives in the water and wears a white cloth; she causes sore throats and demands a white hen; she is a guardian spirit of the fishermen.[53] Also living in the water is Gezuwa, a tutelary spirit for ferry-men, as well as Karen Ruwa, a spirit of the fishermen who is considered, however, to be white.[54]

Since the white spirits protect the social order, they become homeless when political institutions collapse. Gidan Daka, for instance, lived in the palace until 1946, when the last king died; since that date she has returned to the palace by night when particular festivals are being celebrated, emitting shrieks of joy and drumming on a calabash. The other spirits who once lived in the palace to protect the king and the state fled in 1928; since then some have still been viewed as "white", while others have been viewed as "black", perhaps in order to describe their homelessness.[55]

The pre-Islamic state had integrated the *bori* cult, as can be seen at its clearest by the way it was linked with the system of administrative offices.

The *bori* cult of the white spirits was under the control of the Magajiya, who, as the daughter or sister of the king, was the leader of all the women in the country and the head of this branch of the *bori* women. The Magajiya's followers had to perform duties at court, such as furnishing the royal stables with sand and the royal apartments with gravel. The Magajiya's compound served as over-night accommodation for travellers visiting the king.[56]

The other branch of the cult was under the control of the 'Yar'dauna. One can see that this branch had less to do with public life and more to do with private matters from the list of functions

attended to by the 'Yar'dauna. One turned to her with very personal hopes and fears, such as the wish for

> food, cures for sicknesses, the death of a disliked person, protection against theft, prosperity, rich harvests, fortune in wars and good spoils, protection for the fields, a particular office or rank, protection against sorcery, the casting of spells on others, protection against fire and other damage, the removal of a rival lover, successful journeys, the transferral of the grain in another's field to one's own, a successful marriage, protection against punishment for perjury.[57]

Nevertheless, this branch also had public duties, and to this end the 'Yar'dauna was also under the charge of a civil servant.

Both branches of the *bori* cult had a complementary relationship to the sacrifices which the men made to the spirits. Here the occupational groups were not, as with the Shona, spirit host conventicles, but rather groups of men who all gave sacrifice to a certain spirit: farmers, hunters, fishermen, ferry-men, woodcutters, canoe-builders, potters, building workers, dyers, butchers, blacksmiths and tinsmiths, drummers and showmen. And just as they sacrificed to the spirit of their trade, the state performed sacrifices when the rains failed, again when they came, at harvest time or the beginning of the fishing season, as well as at the end of the year and to protect against conflagrations. While the men made sacrifices, the *bori* women portrayed the men's society; parallel to the sacrifices, the women from both branches of the cult paraded through the town, singing and drumming and wearing their husbands' costumes and occupational emblems:

> some came with leather aprons, axes and skin bags, some with a staff and accompanied by a captured dog, some with bows, quivers and knives, others with sword and spear, yet others with *tobe*, turban and Malafa hat, etc., and others with *ganga* or *kalunga* drums.[58]

The figure of the hidden in the *bori* myth can now be designated precisely in the light of these processions: the women were possessed by the spirits to whom the men gave sacrifice; the visible form which the invisible spirits adopted in the women resembled

the images of the professions which the men carried out partly in town and partly in the wild.

Let us now look at the way the *bori* cult changed under Islamization, colonization and decolonization.

From the Islamic point of view, the white spirits appear to be Muslims, the black ones heathens – an opinion which is understandably contested in the fringe areas of Islamization.[59] But a topographic schema proves to be a constant, whereby the black spirits are sometimes assigned to the wilds, as the other to the culture, and at other times to the country, as the other to the town. With the fall of the kingdom, the spirits which had tended to the country's well-being fled from the king's palace, possibly changing category from white to black. At the same time new figures emerged, who also needed a counterpart in the spirit world: Fulani, Muslims and Englishmen. The images of the Muslims "occupied" the town, the locus of Islamic culture, while the images of the heathens, along with those of the animals, were banished to the wilds as black spirits.

Among the images of the Muslims, the white spirits of the town, were Mallam Alhaji, the King of the Muslims; the leper; the learned judge; the mother of children; the prince; the chief of rivers, lakes, etc.; the chief of the drummers; the barber who shaved the prince; the chief of the Fulani who chastised himself and tended an imaginary herd; the slave hunter who caused nosebleeds; one who whipped school children; and the chief of blindness who groped his way along with a stick.[60]

The images of the rural dwellers are arranged into a class of farmers, a class of hunters, one of warriors, the classes of high-spirited youths, the "children with smallpox" and the animals from the wild. Among the "farmers" come the snake with the evil eye; Doguwa, who stretches from heaven to earth; a spirit who endangers the fishermen; the nodder who brings sleeping sickness (see Fig. 11); the heathen Hausa, a drunkard who makes people drunk (see Fig. 12); the chief of the farmers; the spirit of rains and storms, a spirit who calls for water; an old man who shakes his head, sits down and nods; and another who coughs and grunts, sits down and bends over to one side. Among the "hunters" come the chief of

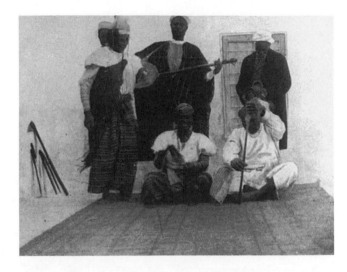

FIG. 11
Hausa
possessed by
fire, leprosy
and sleeping
sickness
(North
Africa, 1914).

the bow; the dwarf of the forest; a fallen mallam who fears death
and drives people mad; Ja-ba-Fari, half-Negro, half-Arab; another
fallen mallam who disseminates venereal disease; one who never
burns himself; the blacksmith; the weaver; the chief of the
butchers. The "children with smallpox" consist of schoolboys
who ape other spirits, either reading the Koran or acting like
warriors, and of young girls such as the one who washes her clothes
and goes dancing, the daughter of an Arab, an impertinent
daughter, the daughter of the scorpion, and a girl who scratches
herself.[61]

If in pre-Islamic times men and women revered the same spirits,
the men as sacrificers, the women as spirit hosts, in Islamic society
the spirit cult was restricted to the women's *bori* cult. In Hausaland
itself, men, who were completely taken up by the Islamic cult, were
considered to be either impotent or homosexual if they entered the
bori cult.[62] Women, who have only a restricted part in the Islamic
cult, were sufficiently unimportant as to be able to continue the
pagan cult. Their attitude to Islam is expressed poignantly by the
fact that they could be possessed by the spiritual counterparts to
Islam, just as the non-converted Kamba were possessed by Kijesu,
the spirit of Christianity.

FIG. 12
Hausa
possessed by
the spirits of
drunkenness
(North
Africa, 1914).

If, for example, [a woman] is possessed by the spirit called Mallam Alhaji [the King of the Muslims], she walks round bent and coughing weakly like an old learned mallam and reads an imaginary Koran. If she is possessed by Dan Galadima, the prince, she acts like a noble man wearing kingly robes. She sits on a mat hearing cases, and people around make obeisance to her – or him.[63]

There is no formal distinction between this possession by a white spirit, the outward manifestation of a figure from the Islamic society, and possession by a black spirit, the outward manifestation of the pagan or "fallen" society. In both cases a woman represents an other to the women's culture, which we alone can describe as their "own" culture. Against this it seems to me of secondary importance that, on some occasions, the women portray the ideal figures of society as a whole, thus in some way participating in its prestige when possessed, while on other occasions they are wild and rebellious.

If she is possessed by Mai-gangaddi, "the nodding one", who causes sleeping sickness, she dances and suddenly dozes off in the middle of some act and wakes up and sleeps again and wakes, etc. If possessed by Ja-ba-Fari, "neither red nor white", a spirit that causes people to go mad, she eats filth and simulates copulation.[64]

In the Islamic Hausa society, with its regulations on dress and sequestration in harems, married women had no possibility of presenting themselves in public. To them the men's public domain from which they were excluded must have become even more phantasmic because, if they had not grown up in especially noble or devout families, before puberty they had been free to move outside their homes. It is understandable that the images of this lost world "visited" the women in the seclusion of their compounds, and that these images were brought to life in the form of possession.

However, the *bori* cult had even more importance for the divorced women who occasionally spent the time before remarriage in the Magajiya's compound. The house of the Magajiya – once a place of lodging for the king's guests, the title having outlived the collapse of the administrative system – became the most important refuge for divorced women. But simultaneously it became, in Western eyes, a hybrid structure, being partly a temple in which the old spirits were worshipped, partly the theatre in which the men watched the possessed *bori* women's representations, partly the sole haven for women seeking protection, and partly the bordello which the men visited as a countermove to the new, repressive sexual morality.

Authors such as A.J.N. Tremearne were not completely mistaken in talking of "temple prostitution", although it was anything but a "survival" of antique or old Oriental cults,[65] but rather a consequence of the way women were segregated under Islam. Indeed, this became all the more stringent as the colonial administration strengthened the Islamic powers, gave the men but not the women access to the cash economy and consequently greater economic power, and forbade the *bori* women's public performances.

As a consequence of this intervention, an alternative female public domain came into being in the House of the Magajiya, where the public presence of women endured from the pre-Islamic society, and moreover in the double sense that the women portrayed the male society and the men, relieved of the pressures of public life, watched these spectacles. It became evident that this did not amount to a one-sided debasement of the women, but contained rather a genuinely political element, when the political parties took up the *bori* institution towards the end of the colonial

era. Under the leadership of the Magajiya, the prostitutes and divorcees of the *bori* formed the women's wing of the newly founded political parties. The *bori* returned to public life when the spirit hosts canvassed for their parties with festive parades, just as previously they had solicited for their bordello and in even older times had once glorified the king and the occupations of their husbands.[66]

Women's culture and differentiation in Sudan

The dispersal area of the *zar* joins the North African diaspora of the *bori* to the east, crossing the Nile Valley and stretching across Ethiopia and Somalia to the north coast of Kenya, where it meets the *pepo* region by the Tana River. The *zar* shares the myth about the origin of the spirits with the *bori*, and the division of the spirits into tribes with the *pepo*. The spirits in all three cults were often equated syncretically with the *jinn* spirits of pre-Islamic times, although historically the *bori* spirits originate from a pre-Islamic polytheism – or were later created on the same model – while the spirits of the *pepo* arose on a "manistic" basis, in part as the complement to the ancestor cult and in part as the complement to Islam.

The historical origin of the *zar* spirits is unknown. The fact that everyone believes that they came from foreign parts does not permit any historical inferences, for what is really being defined here is, as in the *pepo* cult, not the origin of the belief in spirits, but rather the "ethnic" models used to portray the spirits and their character as strangers who are as dangerous as they are fascinating. Thus in Sudan and Somalia it is maintained that some of the *zar* spirits come from Ethiopia, while in Ethiopia itself the *zar* spirits are described with great certitude as "foreign intruders".[67]

Consequently the regional variations in the *zar* cult cannot be explained solely in terms of the size and cultural, linguistic and religious heterogeneity of its dispersion area. Rather, a role is played in all the regional variations of a spirit by inter-ethnic relationships, namely the relationships between the "tribe" of the women who portray a spirit and the "tribe" whose spirit is

portrayed. In Somalia the *saar habashi*, the "Ethiopian spirits" which the Somali women portray as "Ethiopians", are considered to be hostile, like the Ethiopians themselves.[68] In Sudan, on the other hand, where the image of the Ethiopians is determined not least by the immigrant prostitutes from Ethiopia, the *habash* spirits are associated with alcoholism and erotic debauchery.[69] Finally in Ethiopia itself there is no category of "Ethiopian spirits" whatsoever, although there are plenty of spirits from the country's social classes, religious communities and tribes, transformed into the "hidden children of Eve", whose foreign beauty transfigures the faces of the possessed women in trance.[70]

The differentiation which can be expressed in an "idiom of the tribes" of this sort can be read, for example, in the inventory of figures in the *zar* cult in Northern Sudan. At a Sudanese *zar* society gathering the women who depict the spirits appear in the order they are summoned by the woman leader of the cult, the *sheikha*; first the *habash*, the Ethiopian spirits which prefer the colour red. The *sheikha* invokes these spirits by name and lauds them; the drummers beat the spirits' specific rhythms, accompanied by the dances of the spirit hosts from this group. These women wear a red tarboosh on their heads, some of them wrap themselves in a red cloak and others in a red djellaba. They drink coffee; some of them behave in an unseemly fashion and drink arrack; others, the "daughters of the Ethiopians" called Marie, Zu Marie, Luliya and Tibri, dress themselves in silk; some put on wedding dresses, others short fashionable skirts, both donning strings of beads and perfuming themselves. Thus the male spirits of this group represent oafs and drinkers, the "girls" prostitutes.

Following the depraved "Ethiopians" come the pious "Dervishes". The women portraying these devout men dress themselves mostly in modest white djellabas; sometimes they put on a green or white shawl like those worn in the Sudanese Sufi orders. Other spirits from this group hail from West Africa and resemble the pilgrims who cross the Nile at Omdurman when travelling to Mecca; the hosts for these spirits dress in brown, like the men from Bornu, and brandish imitation spears; others wear the costume of

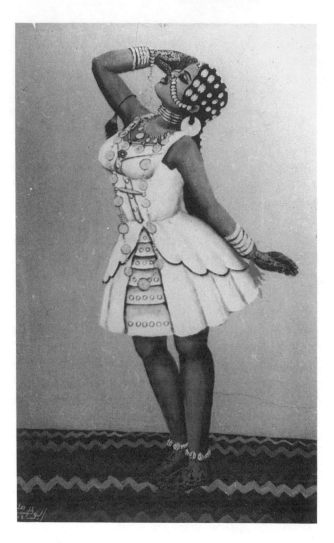

FIG. 13
Dove dance
performed by
a woman in
bridal
costume. A
motif which
draws on the
zar cult
(North
Sudan).

the Nigerian Muslims. The "Dervish girls" enter in green djellabas, modestly veiled.

Then come the *zuruk*, the coarsely dressed blacks, slaves from the various tribes of the south and the Nuba mountains. They are considered to be hostile and malicious; they cause illnesses and spread sleepiness. Their "girls", the black slaves, perform wild Negro dances in scanty costumes.

The conclusion of this display comes in the form of the "Arabs", partly Muslims or Christians, partly Beja or Handandawa. They dress in *tobe* and wield whips. Their leaders are the "Butcher of Mecca" and the "Desert Tiger", and they are accompanied by the "Arab girls" dressed in bridal costumes (see Fig. 13).

Sometimes other figures appear, which the *sheikha* evidently introduces at arbitrary points in the proceedings: the "European" in modern dress, smoking cigarettes or a pipe and drinking beer or whisky; the "barbers" who call for beer; the "crocodile", a symbol of masculinity, who strips the possessed women of their wedding gowns before rolling them on the floor in a very erotic way.[71]

The festive differentiation expressed by the diversity of costumes, dances and prize-songs in no way contradicts the fact that the spirit hosts at a *zar* gathering experience themselves, with their ecstatic exaggeration, as a mighty collective which melts to a whole, just as Durkheim pictured this on the basis of the reports on totem ceremonies. Anne Cloudsley, who, as a woman, was able to gain access to the exclusively female *zar* societies in Omdurman, describes her feelings as follows:

> The throbbing of the drums continued unrelieved. Many women around me began to move their bodies in time with the drumming, raising the right shoulder while drawing the left downwards, backwards and up to repeat the pattern of the right. Each shoulder point described a circle so that the whole effect with the two shoulders was like a figure of eight. Their breathing became very heavy and loud as though the physical work they were undertaking was an immense labour which was exhausting them. They breathed in rapidly and exhaled slowly, then more deeply and dramatically; at first through their noses then through open mouths. The room became hotter than ever, it was packed with women and the sweat poured from their faces. Here and there a *tobe* slipped back from a woman's head onto her shoulders, or more often it was thrown forward over her face as the pattern of breathing brought her head towards her chest. In front of me and to my right, three women were completely submerged beneath a single *tobe*, their heads bobbing up and down. I was aware of a tremendous emotional tension building up in the gloom. The incense

was thick in the air and my head was beginning to reel; the drumming filled the space around me until I was literally "tripping", almost intoxicated.[72]

Thus we find here an interplay between the people seated on the floor and the costumed performers, the chorus and the dancers, the collective ecstasy and the differentiating animation of the spirit hosts. At one moment the possessed woman becomes one with an alien spirit, the exact opposite to the women's normal culture, at another she is completely absorbed by the collective animation of the women. In both cases the women experience the power of their community, whereas outside of the festive excitement of their society, inside the strict bounds of the *hos harim*, the "harem", they live apart and, performing their daily household chores, come to feel their isolation and impotence in a world dominated by men.

Anthropologists who were always fixated on analysing the male roles, getting their information from men and accepting their values, liked to interpret the female possession in such cults as symbolic wish-fulfilment, as if the women in trance identified with the roles and power of the men. According to I.M. Lewis, possession is supposed to demonstrate "not merely that God is *with* us, but that He is *in* us",[73] as if the *zar*, *bori* or *pepo* women were presenting not strangers but "gods". Although it is accurate to claim, as Michael Onwuejeogwu does, that the *bori* cult provides a means "through which women escape the seclusion of the inner compound and enjoy, at least in fantasy, the public life outside the compound", in only a few cases does this mean that the *bori* women "experience in fantasy the trappings of officialdom [...], the world of political power, and the world of supposed splendour that society has denied them".[74]

The inventory of Sudanese *zar* spirits tells us something quite different. The women present themselves as both masters and slaves, as noble Arabs, rich Europeans and as the small, despised tribes of the Nuba, as pious dervishes and as drunk, debauched unbelievers, as men, but also as the attractively dressed prostitutes and the skimpily clad black slaves. So what possessed women portray is not the power of the powerful or the men's dominion, but rather the whole spectacle of life with all its contradictions and

problems. Without idealizing and still without any concrete means of action, it stands on the threshold of tragedy, and the power which the spirit hosts feel inside themselves is the power of the women themselves, transformed collectively into the spectacle.

"A whole horde", as Nietzsche described the birthplace of tragedy, "feels itself enchanted in this way. [...] The dithyrambic chorus is a chorus of the *transformed*, who have completely forgotten their bourgeois backgrounds and their social positions."[75]

The contrast between the women's uniform culture in day-to-day life, where every social distinction is laid down by kinship status, and the differentiation in the men's world outside the harem, with its multitude of differences in professions, rank, character, religious confession and ethnicity, becomes very sharp when we compare the women's possession cult, in which the complementary sphere is repeated as a play, with another ecstatic cult in Sudanese society. Here we shall see precisely the opposite: men in a mystic community who suspend the everyday social differentiation and societal divisions, thus anticipating the universality and equality of a transcendental congregation of believers.

In Sudan the *zar* exists alongside the *zikr* of the Sufi orders, and European observers such as Klunzinger, Littmann or Simon have already pointed to certain similarities between the two cults.[76] Both are ecstatic cults with in part analogous techniques of music and dance, not to mention the fact that, like so many phenomena in the male world, the mystical rapture of the Sufis is naturally also portrayed in the *zar*.[77]

In Sudan the teachings of Islamic mysticism have given way to the ritual practices of the *zikr*. In the *zikr* the Sufis enter collectively and simultaneously a state of mystical ecstasy, in which they experience the ideal equality and fraternity which supposedly characterize the Islamic community in paradise, while being themselves anything but perfect in this world. Thus the *zikr* lends expression to the hope that injustice and inequality will be eliminated in the beyond; the uniform clothing worn by the order and the monotonous, accelerating dances and invocations anticipate the equality in the beyond in a state of mystic rapture.

The *zar*, which in a sense also represents a state of society which is inaccessible to the women in reality, aims in the opposite direction.

Although the diversity of costumes, dances and songs also transports them from everyday life, instead of representing the paradise of equality, the *zar* reflects precisely that contradictory reality from which the Sufis turn away in order to find oblivion in the mystical ecstasy of the *zikr*. This is the reality of drinkers and prostitutes, of pious pilgrims and their lascivious daughters, of treacherous servants and half-naked slave-girls, of noble Arabs and their brides adorned for marriage, of Europeans puffing on their cigarettes and pipes and of the irresistibly masculine "crocodiles".

The Tonga and the world of the migrant worker

In the collective ecstasies of the "acephalous" possession cults, societal divisions and hierarchies are dissolved in a play of theatrical costumes and dramatic gestures. The spirit which embodies itself in the host is the spirit of the social order outside of the women's harem culture, but when it is reflected by the *zar* members it no longer stands for this order, but rather, as with the *shave* of the Shona or the "forces of nature" of the Asante and Kalabari, it serves as a sort of code for differentiation which the women can use to allay the monotony of their everyday world. When the women *represent* figures from society, they are not bowing to the *power* of the society; on the contrary, they are acting in contradiction to this power when they present *themselves* as changed or as others, or, putting it another way, when they represent the social world as it appears to them and not as it pretends or wishes to be.

As such, one can call the viewpoint of the spirit hosts "de-hierarchizing". It does not give any preference to the important, the significant – the "sublime" – over that which society views as trivial or as an ugly deviation, and thus disparages as "foreign" or as "having infiltrated from outside". To be "possessed" by something does not mean that one insists that others should be similarly possessed, even though the spirit hosts elevate their state to central importance so long as they are possessed.

The gap between the spirit hosts' de-hierarchizing view of the other to their own culture and the hierarchy which structures this other as its own culture becomes clearest to us where "acephalous" possession

cults took up colonial phenomena. In our eyes they seem to have selected these phenomena – conceived as "images of *passiones*" – in a highly arbitrary way, one which neither satisfies our colonial nostalgia nor is of service for criticizing civilization.

Generally the possession cults, which existed long before colonization, only enlarged their inventories by a few, fairly incidental refractions of European foreign rule. Thus in their *shave* conventicles, the Shona depicted the European spirits simply as sprucely dressed people who ate with knives and forks; although some of the spirits of European origin could induce abortions, in this matter they resembled a category of African Ndebele spirits. A beer-drinking European doctor appeared with a stethoscope at the Sudanese *zar*, but only as a marginal figure. In the *pepo* cult of the Giryama, the spirit hosts portrayed Muzungu, the spirit of the Europeans, as the most restless of all the spirits; dressed from head to foot in spotless white, he gave commands on a whistle, and when he went on journeys he would be followed by an orderly and a servant carrying his table and chair; a passionate swimmer, he would plunge into the sea, whereupon his orderly had to jump in and rescue him.[78]

Besides such figures and scenes, which seem to have a genre-like quality about them and which were not performed with ecstatic intensity, there is also a form of possession by phenomena which we would most probably consider "impressive". In Bunyoro, for instance, there was a cult in which the spirit hosts portrayed British tanks, even if they called the tanks *kifaru*, rhinoceros, and their image was added to an inventory of spirits which in pre-colonial times had included not only plagues, but above all wild animals.[79] Hence we can also understand this form of possession both as an addition to the code of differentiation and as a way of tackling the new and unknown.

So, generally speaking, these old cults of possession, whose ways of behaving towards strangers were already institutionalized in pre-colonial times and have survived in part to this day, did not react to colonization and modernization at all as if they suddenly had to reconcile themselves with some profound historical change or severe trauma. It is my belief that the new cults of possession,

which either split from these old cults in the early colonial period or grew up as borrowings in societies which had previously had largely homogeneous cultures, and thus not known any alien spirit possession, no longer found the time to form clearly structured inventories. During the whole of the colonial era – and in part even until the present – they presented a picture of continual change, and, being at least a *picture* of this change, could reflect the way the colonizing civilization understood itself.

The acephalous, matrilinear society of the Tonga in Zambia was culturally homogeneous before colonization; having no social stratification or central political authority, it had no means of accommodating strangers from other cultures without at once assimilating them both socially and culturally. The economic system had no room for a colony of traders, and there was no administrative system to which the strangers could have attached themselves as vassals.

The matrilinear descent groups of the Tonga had their settlements scattered all over the territory, so that the communities which co-operated on a day-to-day basis were based not on descent, but rather on the various specific relationships of clanhood, kinship and affinity, and of friends and clientele. These relations could be broadened if necessary; if immigrant strangers arrived, they were asked as to their totem, and if there were members of the same totem in the neighbourhood, they would be categorized as their fellow clansmen. Where no common clanhood could be established, the strangers could either marry in the locality or simply establish friendships. In any case they had to conform, quickly and completely; they dropped their linguistic and cultural peculiarities and their foreign origins were forgotten. The Tonga were as little aware that there were indeed other languages and cultures as they were aware that they themselves differed from others: only with the colonial epoch did they borrow the name "Tonga" from neighbouring peoples and start to call themselves this.

Inside Tongaland strangers settled under the protection of the colonial administration, from then on resisting the Tonga attempts at assimilation; and outside of their country the Tonga migrant workers met up with strangers who placed them within a system of

ethnic categories. Just as they now called themselves "Tonga", the others referred to them as *makalanga*, "babblers".[80]

If we now look at the cosmology and ritual practices of the pre-colonial Tonga, in so far as they can be reconstructed from Elizabeth Colson's ethnography, we discover two aspects wherein the Tonga differ from the neighbouring Shona: they have a category of evil spirits which are exorcized; and the individual's specific characteristics and abilities are expressed by the ritual acknowledgement of an ancestor configuration, and not by possession by an alien spirit. In these two aspects the ritual cosmos of the Tonga is less like that of the Shona, and more reminiscent of that of the Tallensi, who, even if patrilinear and geographically very distant, are likewise acephalous and culturally homogeneous.

By means of their funerary rites, the Tonga transform the spirit of a dead person into an ancestor spirit which then enters the community of lineage ancestors. If someone receives the name of one who has recently died, he will revere the eponymous ancestor as his tutelary spirit. Each household honours the ancestors which it had appointed as it was set up; and each individual honours the configurations of ancestors from his own and his father's matrilineages, to both of which he owes his gifts and talents.[81]

The spirits of the restless dead, which among the Shona only demanded an injustice be settled and departed as soon as satisfaction had been given by the living, are viewed by the Tonga as evil; they attack the living – either because of their own lust for revenge or because a sorcerer has placed them under his power – and cause sudden, serious illnesses. An exorcist isolates the patient, fumigates him and beats together iron implements in order to cast out the spirit. If the exorcism fails, the spirit will promptly kill its victim.[82] Sometimes the Tonga say that restless spirits of this sort are released on every person's death, while the purified ancestor spirit enters the community of the ancestors. This means, however, that the "restless dead" stand on the same footing to the ancestors as the *shave*, with the exception here that the Tonga sense of equality does not allow this "personal" offshoot to re-embody, while the "individualistic" Shona take it for granted and even consider it useful.

The sole form of spirit host which existed among the Tonga before the colonial era were the priests of the hero cult. The Tonga erected shrines on the graves of these priests, where they worshipped the heroes (*basangu*) of their native countryside and asked for rain, protection and good harvests. When a priest died, a matrilinear kinsman inherited his personal ancestor spirit, while the spirit of the hero would even change lineage to reappear re-embodied in a stranger who often lived very far away. The spirit mediums were thus foreign to the community in which they displayed their charisma.[83]

The "other" to Tonga culture were the wilds; on setting out for and returning from the hunt, hunters danced the figures of dangerous and fearful animals: leopards, lions, hyenas, jackals and elephants. These dances were later introduced into the repertoire of the spirit hosts, who portrayed the world of the migrant worker and the white man's heavy machinery during the colonial age.[84] Just as the hunters avowed their otherness, their relationship to the animals which, like them, roamed the wilds, the female spirit hosts demonstrated that something inside of them no longer wished to be equated with the customary ideal of femininity; like the hunters who transformed themselves into lions and jackals, they trans-formed themselves from country women into the ladies from town.

The Tonga borrowed their "acephalous" possession cult from the Shona during the First World War; their word for alien spirits, *masabe*, which is normally only used in the plural, is in all probability a Tongacized version of the Shona word *mashave*. And like the *shave*, the first *masabe* were the spirits of the tribes the Tonga came in contact with during the early colonial era: sometimes the Shona themselves, sometimes the Korekore and Zezuru, then figures also portrayed by the Shona, such as the Ndebele and the white man, and finally the typical representatives of colonial power, the bearers and the police.

In place of the "manistic" ideology of the Shona, according to which the *shave* were supposedly the ghosts of strangers, came the Tonga belief that spirit is the "breath" of things which are capable of independent motion; if the spirits breathe on a person, they force the latter to assume their form. Thus in contrast to the Shona,

the spirit hosts in the *masabe* conventicle danced not only the figures of foreign tribes, but also the figures of wild animals, of railway trains, bicycles and pumps, with a particular penchant after 1940 for machines, aeroplanes, tractors and motor-boats.

The shock, the act of "being breathed on", is the natal hour of every new possession. One day an aeroplane landed, and while the majority took in this event with calm interest, it *struck* a woman who ran into the bush in terrified panic. Her neighbours searched for her and brought her back home. Over the following days and nights she had visions of aeroplanes, and aeroplanes appeared in her dreams until, finally, she dreamt of a dance, a costume, of songs and drum rhythms. She dressed herself in a black cloth, tied rattles to her legs and put on a man's hat; she whirled about like a propeller, alighted from a plane, was brought soap and water, distributed tobacco and held a speech.[85]

A dance born from terror is one thing, but the infectious animation which carries people away when the dance is performed is another. More and more women who watched the dance believed they were infected by the new spirit; if they became sick or were downcast, it was said that they were possessed by the spirit of the aeroplane and could only be healed by being initiated into the new ritual. Each new member could initiate others, such that the aeroplane dance spread through Tongaland like an epidemic. Three years later only country hicks found any pleasure in spinning around or getting out of imaginary aeroplanes; the pace-setters had themselves rubbed down with diesel oil and dragged across the dance floor on ox-chains: they resembled the enormous iron balls which the British towed behind tractors to clear the bush; a year later people danced motor-boats, and another two years later the army of Zambia.[86]

Whereas the *shave*, *pepo* and the spirits of the *zar* and *bori* cults were handed down from one generation to the next, the various possessions of the Tonga women reflected current events at the periphery of their environment. A female spirit host could embody lots of spirits during her life; if she was initiated into a new dance, the previous one was dropped, but at large festivals where lots of hosts danced their figures, past possessions came back to life.

We have seen that in the *pepo*, *zar* and *bori* cults it was precisely those who had no practical dealings with a thing who were possessed by it. Perhaps the reason why there was no "acephalous" possession in the pre-colonial matrilinear society of the Tonga is that the men's culture was not alien to the women. In one part of Tongaland, in which only few of the men went to the towns as migrant workers, both men and women took equal part in the *masabe* cult; but where it became the rule in the 1950s and 1960s for men to spend several years in town, it was believed that the men were immune to *masabe* possession: they knew the town and the machines which confused and terrified their women.[87]

In all of the Tonga women's possession dances one can find the leitmotif of "cosmetic" oils and soaps; in the aeroplane dances they were handed soap and water; the women possessed by tractors anointed themselves with diesel oil; in the motor-boat dance the spirit hosts were doused with buckets of water until the ground turned to mud which they rolled on, then washing themselves with scented soap. In another dance the possessed girls drank soapy water in order to make the inside of their bodies clean and sweet-smelling.[88]

The women and girls followed the old traditional rules for cosmetics in their day-to-day lives; they bathed each day in the Zambezi and anointed themselves with the oil the Tonga women had always used; the girls let their upper incisors be removed, as was customary for Tonga women. On returning from the town, the men discovered that their anointed women smelled bad and that the oil left a mark on everything they touched; their women seemed old-fashioned in comparison with the fashion-conscious women they had come to know in town. Consequently scented soaps and "exotic" oils were seen as the epitome of urban femininity; but instead of competing with this ideal in their own everyday culture, the Tonga women became possessed by it.

The same configuration appeared in the 1960s and 1970s, if now within a different field, as the women also began to visit the town and both men and women came in contact with Western, post-colonial civilization and its goods and wares. Now the dreamland of America took over the place held previously by Lusaka: men and

women became possessed in the city itself, this time by "angels" which they portrayed as Afro-Americans and Japanese.[89]

By the onset of the world economic crisis at the start of the 1970s, the old culture had virtually dissolved into the new African national culture. Nevertheless, during this crisis the Tonga returned to precisely their old egalitarianism and pre-colonial exorcistic rites.

"The disintegration of the national economy", writes Elizabeth Colson,

> frustrated many plans, led to shortages that emptied shops of goods now regarded as essential, and deprived schools and dispensaries of needed supplies and equipment. Rural areas were especially hard hit. Village children found it harder to get into secondary school and almost impossible, on finishing, to find the kind of job once taken for granted. The towns were again seen as privileged places, but places upon which country people increasingly depended. In the common possession dances of the early 1980s, both men and women were being treated to drive out demons now said to be inherent in everyone.[90]

The Zulus, or from possession to exorcism

There were similar developments during the colonial period in the few culturally homogeneous societies which had centralized political authorities. And they too did not have just to contend with an increase in foreign influences in their social and religious practices. Just as with the acephalous societies, they were confronted *en masse* with the images of alien societies which "moved" those who were receptive to them, and who thus had a further code for differentiating portrayals of their own otherness.

The politically centralized but culturally homogeneous Zulus had originally come in contact with the "acephalous" forms of possession as their conquests took them to the large area of the *shave* and *pepo* cults in the north. Probably they adopted the cult of the *ndiki* spirits from the Tsonga in Mozambique, but only around the turn of the century, when more and more migrant workers

came from the north to South Africa, does the cult seem to have become endemic among the Zulus and other south-eastern Bantus.

I do not wish to ignore the presumed connection between the *ndiki* cult of the Zulus and the *shave* cult of the Shona, for it seems an appropriate way of bringing home the broad diffusion and mutability of alien possession in early colonial times. According to Junod, a spirit possession cult which previously had rarely been practised was *en vogue* among the Tsonga during the last two decades of the nineteenth century.[91] The possessed in this cult portrayed the spirits of foreign tribes, which were subsumed under the umbrella term *kwembu*. *Kwembu* denotes the same as *shave* in structural terms; as the Shona adopted these spirits from the Tsonga, they ironed out the ethnic differences they had had under the Tsonga and, without changing their names, placed them in the *shave* inventory as a homogeneous class of spirits.[92] As such, they turned the alien spirits of strangers as a whole into a section of their own alien spirits. In precisely the opposite way, the Zulus elevated a section of the Tsonga alien spirits, namely the *ndiki*, to the status of the totality of the spirits in their new possession cult. And just as the Shona annulled the ethnic differences of the *kwembu* category, the Zulus did the reverse by detaching the *ndiki* from the ethnic prototypes they had had under the Tsonga in order to differentiate them according to new ethnic types which were important for them. Thus under the Zulus the *ndiki*, which for the Tsonga had just been the ghosts of the Ndau by which the Tsonga and Ngoni, as occupiers of Ndauland, had been "infected", became the spirits of all sorts of strangers, but above all of the migrant workers from the north.

The way these ethnic categories became arbitrary, i.e. the transformation of the Ndau ghosts into the ghosts of all imaginable types of strangers, points both to the Zulus' tendency to iron out foreign ethnicity as well as to the frantic pace and the dimensions labour migration assumed. Differentiated and enduring systems of alien spirits with pronounced characters were able to mature in the culturally heterogeneous societies which had already developed alien possession before the colonial era. This was because they had only to deal with a few, clearly distinguishable strangers, and because over the generations the mediums were able to articulate

the characteristics of the spirits clearly. By *bequeathing* the "foreign" characters, they turned them into an integral part of their own culture. We have seen that the Tonga never reached an integration of this sort; and it did not make much difference to the Zulus whether a person possessed by a *ndiki* spirit portrayed an "Indian" or a "Tsonga", for mere hints of foreignness were enough to indicate "people from the north".[93]

In the late 1920s, the mining areas of South Africa attracted one wave of migrant workers after another, creating an amorphous, fluctuating mixture of tribes, peoples and races in which it became increasingly difficult to maintain any cultural identity whatsoever in the face of the industrial society. At this time the Zulus began to practise an exorcistic cult alongside the at least rudimentarily differentiating *ndiki* cult. As in Tonga decades later, this new cult marked the borderline which, although not the point where the productive adoption of other cultures ceased, did at the same time necessitate an express recourse to their own culture.

The new spirits were under the control of sorcerers, who buried a mixture of earth from graves and ants from the graveyard at a spot which the intended victim would one day pass by. Anyone treading on this spell would be instantly possessed by hordes of alien spirits, by hundreds of Sothos and Zulus, thousands of Indians and whites; the spirit host would rage like a mad man, break into uncontrollable sobbing, fling himself on the ground, run back and forth in a daze, tear the clothes from his body and attempt to kill himself.

There was no appeasing these raving hordes of spirits, let alone domesticating them as helpful spirits; this possession was really the impotent expression of their cultural estrangement and of the fact that they were at the mercy of foreign powers, against which the moral "forces of society" had to be mobilized. So the Zulus entrusted the exorcistic functions to their traditional healers and, more significantly, to their *izangoma*, the possessed mediums of their paternal ancestor spirits.

The *izangoma* were the only spirit mediums among the Zulus in pre-colonial times. In this strictly patrilinear society, the ancestor spirits would only embody themselves in their daughters, i.e. "the special and very close contact with the spirits is reserved in this

society for women only – women who are thought of as marginal, and can thus fill the important social role of forming a bridge between the two worlds", the worlds being those of the ancestors and of the living.[94] The few male spirit hosts were viewed as transvestites. Since women were considered to be strangers to their husbands' lineages, they lived with the same distance and ensuing objectivity to their community as the priests of the Shona and Tonga hero cults; and like them, they proclaimed the moral values of the social order, which was given validity by the ancestors which spoke from them.[95]

Nevertheless, on exorcizing the hopeless cases of possession, the *izangoma* by no means insisted on a total return to the handed-down customs of the ideal ancestors whose message they embodied. On the contrary, they permitted the people to keep a considerable distance to the traditions, which the rituals of exorcism merely "fixated". In this point their exorcism resembled the ritual purification of witches in Asante during the colonial era, which not only liberated the witches from the indwelling powers of evil, but simultaneously initiated them into the cult community of a deity from the northern savannahs, i.e. lent them the stigma of a partial otherness, so that from then on they were greeted by the members of their own corporate group with the same friendly distance customarily reserved for strangers.

When the *izangoma* exorcized the hordes of amorphous spirits we have mentioned, they "inoculated" their patients with other spirits which they themselves controlled, and which were supposed to prevent other attacks from within. These spirits, which now possessed the patient after his "inoculation", were called *amabutho*, the "soldiers", because of their ability to defend the patient: no sorcerer could now infect the patient with his raving hordes of spirits.[96]

As soon as the exorcized person was possessed by the "soldiers", he started to behave, as Sundkler reports, in a similar way to the *ndiki* spirit hosts – indeed to the mediums of acephalous possession cults as a whole. When the "soldiers" spoke from him, they talked in foreign tongues, English or the language of the railway trains; and the sign with which the spirit host declared his new otherness was a magic sign of foreign origin, such as machine oil or the hair of a white man.[97]

The politically conscious viewpoint

From the viewpoint of the politically conscious, the possession cults of the colonial epoch must assuredly appear to be hideous deformations. When, to the accompaniment of booming drums, sometimes with foam on their lips, the spirit hosts acted like locomotives or aeroplanes, burbled a fictive English or put on a pith helmet, the educated African or European could hardly avoid such words as "imitation" or "aping" coming to mind. It was like a distorted picture of that other form of imitation which Europe forced on the entire continent, a grotesque surpassal of that other, genuine alienation which political consciousness rallies against.

"From Paris, from London, from Amsterdam we would utter the words 'Parthenon! Brotherhood!' and somewhere in Africa or Asia lips would open ' . . . thenon! . . . therhood!' It was the golden age," wrote Jean-Paul Sartre in his foreword to Frantz Fanon's *The Wretched of the Earth*.[98]

> First, the only violence is the settler's; but soon they will make it their own; that is to say, the same violence is thrown back upon us as when our reflection comes forward to meet us when we go towards a mirror. [...] Of their own accord they will speed up the dehumanization that they reject. [...] In certain districts they make use of that last resort – possession by spirits. Formerly this was a religious experience in all its simplicity, a certain communion of the faithful with sacred things; now they make of it a weapon against humiliation and despair: the Zar, the Loas, the tribal saints come down among them, rule over their violence and waste it in trances until it is exhausted. At the same time these high-placed personages protect them; in other words the colonized people protect themselves against colonial estrangement by going one better in religious estrangement, with the unique result that finally they add the two estrangements together and each reinforces the other. [...] Let us add, for certain other carefully selected unfortunates, that other possession [...]: Western culture. [...] Two worlds: that makes two possessions; they dance all night and at dawn they crowd into the churches to hear mass.[99]

What Sartre recognizes of possession is the festival. But for the politically conscious, no festival can have a meaning in itself; it

either serves politicization, or retards it. In the colonial situation the festival of the spirit hosts becomes a "weapon against humiliation and despair". Unable to act politically, one enters a state of intoxication in order to "waste" the internalized violence. If this internalized violence did not exist – or if one succeeded in liberating it in order to change the world – there would also be no festivals, or at least none held by spirit hosts.

The political consciousness is a historical one: before colonial repression, possession was just a "religious experience in all its simplicity", namely "communion of the faithful with sacred things". This means that pre-colonial Africa did not know the festival as a "weapon against humiliation and despair"; and it also means that, outside of the colonial situation, religious and political manifestations existed side by side without any links. But the political moment in old Africa is not even the issue here, and religious emotion is just the contrast to present-day alienation.

Naturally African historians have long since recognized that, in areas lacking any central political authority, the splintering of the tribes could often be surmounted only by the pronouncements of a possessed prophet. Some of the greatest insurrections in the early colonial period started as "charismatic" possession cults, in which several traditional cults united to form a new community in order to create a counterweight to the universality of colonial repression.[100] Although these forms of possession do not constitute examples of political movements in the eyes of the modern national historiographer, they can certainly be seen as their historical basis.

C.G.K. Gwassa has furnished proofs of the liminal function of such possession cults in the *Majimaji* rebellion. Between 1905 and 1907, more than twenty tribes in the south of what was then German East Africa united for the uprising against the colonial authorities, and this occurred under the influence of a man who was possessed by a giant snake. It was precisely a confluence of a great number of "forces of society" in Kinjikitile's prophecy which suspended the traditions. He held the insignia of the diviners and healers who travelled about the land with large fly whisks; but instead of journeying himself, he dispatched others with these insignia to spread his message. He erected one of the customary

shrines to which the family fathers of numerous tribes in the region made pilgrimage, but not in order to sacrifice to their own ancestors, as custom dictated, but rather to sacrifice to a new totality of ancestors. He was possessed by a power which enabled him to break taboos, walk about naked and discover witches; but instead of convicting the witches individually, as had been done previously, all the pilgrims had to renounce witchcraft at his shrine. He was possessed by a large snake which was as bright as a rainbow, had the head of a black monkey and large eyes which glowed red. But the message he proclaimed in the name of the snake was essentially a political one: the Germans' rifle bullets would be transformed into water, all Africans were free. His cult created the symbols and the "spiritual" unity which then needed a completely different, secular leadership in order to take up armed struggle.[101]

We have seen that, for the Shona, the task of creating inspirational union fell to the possessed priests of the hero cult. But even in this society, with its stronger political and charismatic constitution, the colonial situation called for new means of action, which were developed anywhere but on the pinnacle of the tradition-minded priestly hierarchy. Although the Shona who participated in the 1896 rebellion against the British colonial masters came together under the leadership of the Nehanda medium who at that time was at the top of the Chaminuka–Nehanda hierarchy, the conservative appeal to traditional values no longer sufficed. Rather a man who was possessed by a subordinate spirit called Kagubi came to lead the uprising; Kagubi demanded that the whites be killed, promising in return redemption from all evil.[102]

What was new about these possession cults was their claim to unlimited authority, an "alien" spirit inasmuch as the cults made the colonial foreign rulership's claims to unlimited authority – and in some cases the Christian promise of salvation – their own via an inner reversal. At the same time the new proclamation from the "charismatic" possession cults was also the result of a broadening of their inherent tendency to generalize, to abstract the divergent interests of the individuals and their corporate groups. In revolutionary movements, which above all demand selfless devotion, there was clearly no room for the "acephalous" possession cults, with their emphasis on differentiation.

According to a contemporary source, before the Kagubi medium rose to become the charismatic leader, Kagubi was a *"mondoro"* which bestowed the talent of "tracking and killing wild animals".[103] Although later assigned to the hero cult, it is nevertheless possible that Kagubi was originally the name of a hunter *shave*. But decisive here is not that the alien spirit of an "acephalous" possession cult became the ritual focus for an armed uprising, but rather that it was classified as *mhondoro* as soon as its medium gathered charismatic followers. The sources only first mention the *shave* cult after the Shona uprising was smashed, and this suggests not only that it had no role in the preparations for the uprising, but indeed that it was actively revived as a result of the dashed hopes.

The political irrelevance of the majority of "acephalous" possession cults in the context of anti-colonialist struggle derived already from the fact that they were restricted to women's cultures. But during the colonial period numerous dances also came into existence which were organized by the men and which were rather similar to the spirit possession fashions of the Tonga women. Even though the men did not enter into trance, and the dancers did not consider themselves to be possessed by spirits, they did attach the greatest value to costumes, with which they portrayed the figures of the colonial powers. These dances posed the political historians the question which they had been able to ignore in female spirit possession.

Of all the African dance fashions which depicted the attire, music and physical motions of the colonial rulers, the *beni ngoma* was the most widespread and had the longest and most eventful history. Its name alone, made up from the English word band and the Swahili word *ngoma*, dance, shows its hybrid character. The *beni* came into being during the final decade of the nineteenth century in such Swahili towns as Lamu and Mombasa, then spreading along the coast and across the hinterland to the mining regions of central Africa, and – with the exception of a few isolated remnants and late versions – only disappearing with the onset of decolonization. At first the costume worn by the *beni* dancers was kept as close as possible to German and British uniforms. In the Mombasa of the 1920s one could find all manner of quotes, from khaki trousers and

orange belts to felt hats with peacock feathers, and where all else failed, a tennis dress or bathing suit. Later, in the Copperbelt, civilian dress was preferred, such as neatly pressed grey slacks, elegant sportshirts and immaculately polished shoes; the dancers held white handkerchiefs in their hands and wore their hair neatly groomed and parted.[104]

A similar picture presented itself in the modern dances of the Fang in Gabun, although their ephemeral nature is more reminiscent of the *masabe* dances of the Tonga women. Sometimes they simply quoted European or Afro-American dances, *"bal"* or *"jazz"*; egalitarian though they were, the Fang most liked portraying rigid hierarchies and strict chains of command.[105] Famous Europeans, popular administrators and politicians such as Franco and De Gaulle constituted the centre of many of their dances. The Fang danced the "De Gaulle" in large summerhouses; the women wore Western skirts and blouses, the men shirts and trousers, often ties, and above all shoes. Loges with tables and chairs were set up along the walls of the summerhouse, in which the dignitaries presiding over the dance, such as the president, the customs officials or the police magistrate, took their places; the entrance was draped with a tricolour. De Gaulle was allowed to appear wearing a uniform with heavy epaulettes and a képi; together with Eboue, the governor general, and General Pétain, he inspected the dancers' clothes, imposed fines and watched the women's dances as if on the parade ground. Despite this military ambience, the dance was concerned with love and seduction; for instance, the dancers sang by way of welcome: "De Gaulle, o! come, take the village; De Gaulle, you're the man I cry for . . ."[106]

If we think about the function of exoticism in our own dances, popular songs and operettas, the political/apolitical ambiguity of these dance fads from the colonial period is not difficult to see. Given that Franco and De Gaulle were not seen as political or military figures by the Fang, nor the military marches and tattoos by the people on the East Coast, we need not hesitate in equating them with our own cowboys and gypsies, Carmens and hula-hula girls, sailors and hussars. As a means of imaginary participation, these crazes all gave expression to an unquenchable longing which

was, in fact, quite content with its own self and turned its back all the more resolutely on the reality it conjured up.[107]

The fashions of the Fang have already been interpreted as a sort of "cargo cult" using the fiction of the intrinsic otherness of African dance, while G. Balandier, for example, recognized that they were nothing but amusements.[108] Obviously amusements are not *completely* apolitical; even if our cowboy romanticism is not the expression of some political leaning, it does show a sort of yearning for a world without frontiers; and even though the flag rituals and English and German national anthems in the *beni ngoma* did not pronounce any loyalty to the colonial powers, and the fanfares did not give the call for battle – or revolution – the exciting thing about these dances was the way they conveyed the pomp and glory which Europe also once perceived in the army.

One misses the playful character of these fashionable dances, their peculiar notion of reality, if one views them as an "index" of acculturation or social change in colonial Africa. In this respect African sociologists, such as Bernard Magubane, have rightly objected to the misinterpretation by Mitchell and others that the enormous importance placed on European clothes in these dances is an expression of the adoption of European values.[109] Although the dancer portrays a European, this does not mean that he "really" wants to be one. Rather, on the one hand he is showing a partial otherness to his African surroundings, using a code he has at his disposal, and on the other he is highlighting a specific quality he associates with his model. If one is going to pay any political thought at all to what is merely a means for fashionable differentiations, one must distinguish between the meaning the quoted emblems have in their original context and the meaning they have as fashions in another. A person who *dances* a figure is denoting his distance to it, for he cannot *live it out* at the same time.

When African national historiography rightfully denies either the *beni ngoma* or, above all, the festival of the spirit hosts any true political significance for the anti-colonial struggle, this does not mean that another political consciousness, namely that of the colonial masters and the national states which succeeded them, would always accept such events as harmless amusements.

Although the possession cults basically serve to bring dark, intangible "images of *passiones*" to light and under control, the ecstasies of the spirit hosts contain something wild and anarchic which can unsettle a political power much more readily than any form of political protest.[110]

In some acephalous societies, such as those of the Tallensi and pre-colonial Tonga, the spirits of the wild, or the restless spirits of the dead, were exorcized. The ancestor mediums of the Zulus "inoculated" those who were possessed by hordes of alien spirits with their "soldiers". Some pre-colonial states allowed the spirit hosts' societies, but reserved the right to control them; in Dahomey the societies observed the strict discipline meted out by their mediums;[111] among the Hausa, the *bori* women were under the charge of the king's daughter or sister or some other officiary. In East Africa the Koran teachers were often hostile to the *pepo* cult and hindered at least the men from joining the societies; radical Islamic revivalist movements took action against the possession cults, and certainly managed from time to time to stop them completely: the *zar* cult, for instance, appears not to have been practised during the Mahdi uprising in Sudan.

Every once in a while the subversive character of alien possession would pass into criminal organizations which, although they did not conceive of themselves as at all politically oriented, undermined the colonial order *de facto*. A curious case of this sort was the *ntambwe bwanga* cult which arose in Kabinda and spread through the Belgian Congo colony during the early 1920s, emerging in Kasai in 1922 and a year later among the Luba. Like many spirit possession cults in this region, the *ntambwe bwanga* organized itself along the lines of the secret societies. The adepts of the society were people who served under the Europeans, and the society's "medicine" was supposed to originate from the "Land of the Whites". Anyone who entered the society stopped speaking his tribal tongue and – in Katanga – spoke only Swahili, which had been introduced as a language for communication by the Belgians; he adopted the name of a Belgian resident in the colony, whom he then personified in trance. The society was able to boast that its adepts could portray a complete duplicate of all the Belgians in the colony, from *Le Roi Albert* and *Son Excellence le Gouverneur Général*, down through the

echelons of the military, police and civic administration to the workmen. The adepts' wives represented parallels to the Belgian women, whereby the mediums' marriages were supposed to correspond with those of their prototypes; the women called for hens, eggs, bananas and all that the Europeans otherwise demanded with shrill voices, and, as in similar possession cults, commanded and healed as mediums for the Belgian spirits. The lower, less esoteric ranks of the society were content with portraying their equals, healing and taking magical measures to protect against hostile magic. Professional possession, on the other hand, was the reserve of the higher and strictly secret ranks who specialized in theft and had the gift for placing those they robbed by night in a deep sleep; they also had the gift for releasing fellow society members from the white man's jails.[112]

But of all the possession cults, none has caused so many difficulties for the politically conscious as the *hauka* cult, which was just as keenly persecuted by the colonial powers as by the African national states. War was waged on it by the pious Muslims, by the French and British colonial administrations in Niger and Nigeria, and the cult's adepts were driven out of Ghana as soon as the country attained independence. Indeed, even conservative anthropologists and progressive African students wanted to prevent its ethnographic documentation.

The *hauka* cult arose in the 1920s among the Songhai on the northern Niger Bend, being a break-away group of that complex which included the *bori* cult. Equipped with the expressive means of a long tradition of spirit possession, the men and women of this cult developed a completely new inventory which included first of all figures taken from the Islamic society and the French military and civil hierarchies, and later, as the migratory workers brought the cult to the Gold Coast, figures from the British colonial system as well. Among the more than fifty figures we find the commander Croccichia, who imprisoned the first *hauka* adepts, a Muslim from Istanbul, the General of the Red Sea, his wife, a British judge, the governor and the young lad who had the knack of plucking money from the ground.[113]

FIG. 14 The "trooping of the colours" ceremony: "Among the spectators are the *hauka*, who have come to look for their models." From Jean Rouch, *Les maîtres fous*.

The colonial ambience was indicated at a *hauka* gathering by bright tatters of cloth which were called "Union Jack"; a sculpture was set up depicting the governor with moustache, sabre and rifle. The festival began with a public confession; a whistle gave the sign for everyone to stand in lines. Sentries with wooden rifles and whips made of lorry inner tubes ensured "order"; when they aimed their rifles at a person they made them possessed. One portrayed a locomotive, driving back and forth with mechanical movements; another did drill practice, walking with the gait of the British soldier, while others saluted or inspected something; the governor extended an invitation to a round-table conference; finally the spirit hosts strangled, cooked and ate a dog (see Figs. 14 and 15).[114]

Attempts have been made to interpret the eating of the dog as a sacrificial feast, above all in order to reduce its offensiveness. In the old possession cults, however, the Songhai sacrificed only clean animals, such as chickens, rams, goats, calfs and bulls,[115] as was also customary in the *zar* and *bori* cults. And the *hauka* hosts sacrificed

FIG. 15 "The man dressed in blue is possessed by the general. The governor is grumbling about the general. The captain is saying: 'I, governor, I shall fetch the general.'" From Jean Rouch, *Les maîtres fous*.

nothing other than a hen at the conclusion of the public confession. Hence the devouring of the dog is more reminiscent of the tests of possession which we know from other "acephalous" cults of alien possession, and which, beside the costumes and manner of movement, were the most important means for characterizing a particular ethnic type. Thus the Shona proved that they were possessed by the *shave* of the Portuguese, had been transformed into Portuguese during their trance, when they drank peppered beer and ate peppered eggs and chicken. In Songhailand the spirit hosts of the *hauka* cult ate pigs, a serious infringement of taboos given the Islamic setting, by which they proved that they had been transformed during the trance;[116] and by eating dogs in the Christian Gold Coast, they were showing that they had risen above the bounds of the "normal" human state by breaking a serious European taboo. Although they presented themselves partly as foreign Muslims and partly as Europeans, they managed to outdo even the otherness of their models.

The breaking of a taboo, which the adepts of the *hauka* cult performed with pride, appalled the enlightened European even more than the loaded, ecstatic portrayal of figures he took to be persons of authority. In 1954 Jean Rouch showed ethnographic films at the British Council in Accra; sitting in the audience were adepts of the *hauka* cult, who asked him to film their next festival. They wanted the film for their own use, as a model to be shown at future festivals. The result was the film *Les maîtres fous*, which shocked African students and such anthropologists as Marcel Griaule at its premiere in the Musée de l'Homme; they condemned the film as "racist" and demanded it be destroyed. The film was banned in the British colonies.[117]

On the other hand another spectator, Jean Genet, who was sympathetic to the film, recognized that the *hauka* overrode not only the political consciousness of anti-colonialism, but also social morals as a whole. In *Les nègres*, a play written by Genet under the influence of *Les maîtres fous*, we find more than a large number of figures from the *hauka* cult; above all Genet adopted the motif of the masquerade, the transformation of the poor, despised migrant workers into their white masters, as well as the way the characters are heightened to the level of *types*, to highly evocative dummies, a method which is found in the *hauka* cult as in all "acephalous" possession cults, and which in some respect is interpreted by Genet when he intimates that precisely this heightening brings about a liberation and a cathartic purification from the power such images contain.

4

In the masks of strangers

and the dead

The Pende, or festival and initiation

The Pende live in south-western Zaïre, between the rivers Lut-shima to the west and Kasai to the east; to the south their country borders on that of the Cokwe and Lunda, to the north that of the Mbundu, Pindji and Mbala, to the east that of the Lele and Bena Lulua, to the west that of the Kwese, Suku and Yaka. The Pende knew these neighbours, but they varied very little from them in their matrilineal organization, their economic system and their small, more or less autonomous chieftaincies. Before the colonial period there was neither a central political authority in Pendeland which could guarantee protection for strangers, nor the sort of economic resources which attract foreign traders; the Pende had scarcely any brushes with representatives of cultural heterogeneity in the form of strangers, and so a ritual acknowledgement of other cultures would only first be expected in the colonial period.

As European travellers "discovered" the Pende towards the end of the nineteenth century, they saw that they had a number of cult objects which proved that the Pende had been in contact with Dutch and Portuguese seafarers several centuries earlier. Some of this paraphernalia could be found among their neighbours, who had established relations with the coast at an earlier time, but this was not the case with other items, which showed traces of wear and tear that excluded the possibility of recent adoption. There were ivory whistles with carved heads at one end and key wards at the other, which could only have been based on old-fashioned Dutch or

Portuguese keys (see Fig. 16). There were also copies of European chairs, such as we know primarily from the Cokwe; certainly more recent examples have been influenced by them stylistically, but it is precisely the oldest chairs which reveal the pure Pende style, so they may well have been the originators of this tradition.[1]

Before the Pende migrated to their present homeland, they had lived in Ambaka on the Atlantic Coast, where Portuguese seamen

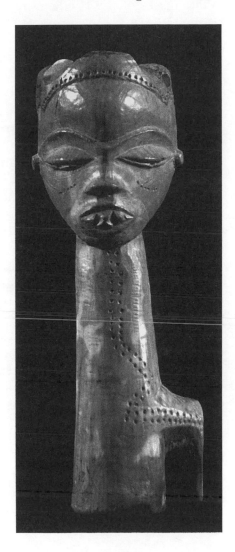

FIG. 16 Ivory sculpture in the form of a European key (Pende, Zaïre).

139

and traders showed up in the sixteenth century. The Pende, who during their entire history had avoided armed conflicts, and to this day are generally esteemed by their neighbours as skilled potters, blacksmiths and carvers,[2] escaped foreign rule by emigrating, just like the majority of ethnic groups who took over the region between Kwango and Kasai, thus evading the Portuguese and the Pombeiros, African slave hunters in the service of the Portuguese.

The masks of the Pende, especially the ivory miniatures, have reminded many Europeans of Florentine craftsmanship. The Afro-Portuguese ivory-work, produced by African carvers commissioned by the Portuguese, reveals the ease and independence with which the Africans adopted European art forms.[3] Probably the Pende had seen portraits of saints and, just as they were able to adopt the forms of European keys and chairs, they were certainly able to embrace Renaissance picture forms in their art as well. But here they were not working for the Portuguese, and so perhaps they drew on their memories of saints' portraits for their masks in the same way they transformed the shape of a key, which had no use for them, into a whistle ornamentation. What, however, interests me about these masks is not their possible kinship with Renaissance art, but rather their similarity with the strangers with whom the Pende came in contact during the course of their history, and whom they portray in their masquerades. For here, in these masquerades, the relationship between the masker and the type depicted in his mask is similar to that between the spirit host and the spirit he embodies in the *shave* cult.

The Pende have two contrasting types of mask, an abstract one, *minganji*, which represents the generalized ancestors who lack any characteristics, and a richly differentiated, realistic one, *mbuya*, in which the Pende mirror the characters from their historical and social background in an idiosyncratic form: in the faces of the dying. The differentiation of the *mbuya* masks will become more evident if we first make a general contrast with the abstractness of the *minganji*.

The *mbuya* masks in the style from Katundu, the region of the Pendeland which is richest in masks and to which I shall largely restrict myself now, are influenced by the calm, uniform and stylized basic form of all the masks, on the one hand, and of the

specific, lively expression given to each, on the other. All of them, with the exception of *tundu*, the merry-maker, have faces with features receding gently to the back; the eyelids are always closed, sometimes almost forming a triangle with its apex pointing downwards; the sweeping eyebrows stand out in relief, descending in the middle over the root of the nose; the forehead arches forwards; the mouth is either shut or slightly open, and mostly drawn slightly downwards at the corners, which, with the heavy, closed eyes, gives the face a singular expression of sadness and melancholy.

Torday, the first to report on the Pende, noted the "gloomy" impression given by these masks;[4] the hollow cheeks, the protruding cheek bones, and the lips, partially slack, partially taut as if cramped, reminded Frans Olbrechts of death masks, for he suspected a "fading" eye beneath the closed lids.[5] But it is not just their gloomy aspect which reminds one of death masks. At least during the last heyday of Katundu art each mask received its own, personal face, so that Carl Kjersmeier could talk justifiably about "portrait masks", even though we do not know the names of the people who might have been portrayed.[6]

The *mbuya*, with the exception of *tundu*, were wooden masks, whereas the *minganji* were made entirely from raffia bast; the masker's entire body was covered in a bast costume, the mask's face often had the shape of a circular disc with just two protruding tubes through which the wearer could see, indicating the spirit eyes of the mask entity. To the left of the River Kwilu the *minganji* were sometimes made of resin or wood, but then the mask's face retained a cool, distant, non-human expression.[7]

This contrast in the forms and materials used in Katundu corresponded with the masks' complementary ritual usage. The *minganji* had the task of instructing the young boys in the traditions, i.e. demonstrating to them the power of the ancestors, whereas the *mbuya* accompanied them back into the society of the living.

At intervals of about fifteen years the Pende initiated a new age-set; they separated the boys from the women and children, taking them to an encampment outside of the village where they were circumcised and initiated into the dances, hunting skills and secret

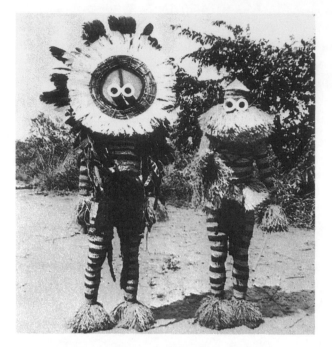

FIG. 17 Two *minganji* with tubular eyes (Pende, Zaïre).

language of the adult men. The climax of these disclosures consisted of the unmasking of the maskers, who were regarded by the women and children not as some sort of masked humans, but as the spirits themselves. As soon as the boys knew the secret of the masks, they were allowed to wear masks as well and return to the women and children in the village.

The terrifying, non-human appearance of the *minganji* was an aid to help the boys don the rigid order of adult manhood, with all its privations, which they had submitted themselves to for the first time at the circumcision site. The faceless, abstract, impersonal *minganji* seem virtually to anticipate the anonymous uniform of modern states (see Fig. 17), and one can only agree with Sousberghe when he calls them the "policemen" of the circumcision site.[8] Anyone who does not know the secret of the masks believes that the *minganji* are the ancestors confronting him in person, whom he is obliged to obey and whose order is imprinted on his body by circumcision. With this spectacular unmasking, the initiate

142

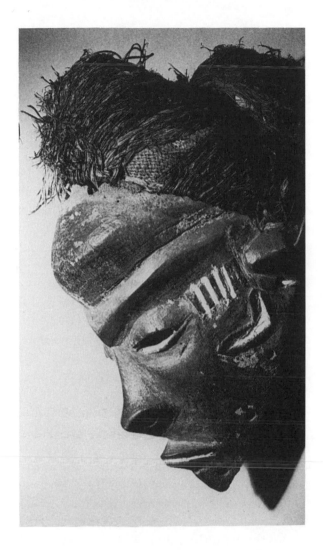

FIG. 18 *Mbuya*
mask (Pende,
Zaïre).

realizes that the power of the ancestors is the power of the men
concealed in the mask, and identifies with it.

The face of the *mbuya* mask marks a boundary between life and
death; the fullness of life is still reflected in the countenance of the
dying person, but it already has something of the transfiguration of
death about it (see Fig. 18). These masks appear when the circum-
cised boys return from the world of the ancestors to the fellowship

of the living. They mark a liminal status where one is no longer completely under the sway of the dead, but still not completely tied to the role one will be assigned in everyday life. In the swirl of this festive return to life, it is deemed fitting to play all the roles behind one's mask which one can enact neither in the ideal world of the circumcision site, with its abstract equality and anonymity, nor in everyday society, with its rigid divisions between men and women; these roles include jesters and wild animals, women and strangers.

Naturally we know this general distinction between *minganji* and *mbuya*, abstract equality and playful differentiation, from many other cultures. It is customary to put on a black suit to invoke societal values, and to don a false nose for a change. In the no-time of the initiation, to refer to Arnold Van Gennep's theory of the *rites de passage*, in which the person has died as an individual in order to merge with the ideal *communitas* of the beyond, the visible signs of his individuality are eradicated either by cladding him in a masked uniform, or by stripping him naked. On the threshold of this state, on the boundary between time and no-time, the here and the beyond, the everyday and ideal world, one acknowledges one's liminality by costumes which, as clothes, belong to time, while removing their wearer from time or keeping him distant from it.[9]

The other rituals in which the *minganji* appear celebrate political or religious authority; at the burial of chieftains or high-ranking persons the *minganji* drove away curious onlookers with whips;[10] after the communal hunt which was held at the investiture of a chieftain, two *minganji* would kill a stranger, and the following day they danced as a hut was erected for the new chieftain; finally they also danced when a woman had lifted the secret of the masks, and at a secret place the initiated men devoured the goats with which they atoned for her forbidden knowledge.[11]

The *mbuya* still dance on all manner of festive occasions, but originally they did so only to suspend ritual restrictions: they appeared at the circumcision site for the unmasking; they finished the period of seclusion; and they danced to bring about reaggregation after a special ritual performed to gain fortune for the solitary huntsman, at the conclusion of large hunting expeditions, at the

gathering of the first fruits which marked the end of the harvesting prohibitions, and at certain healing rituals.[12]

The Pende formulate the distinction between *minganji* and *mbuya* by saying that the one is a "question of magic" and the other is a "question of play".[13] Nevertheless, it would be wrong to consider the *mbuya* simply as playthings, for they are only so in the "esoteric" view of the initiates who enact the *mbuya* play before the women and children. Seen in this way, the masked *mbuya* figures which cross the arena of the village square, mostly alone but sometimes in twos or threes, form a human comedy, and in all versions the men playfully adopt the other to their masked society in the form of animals, clowns, strangers and women.

But the sad, melancholy face of the *mbuya* masks is not in keeping with this playful, comical intention. Yet we do not have to resort to some hypothetical older meaning of the *mbuya* related to hunting and healing in order to solve this contradiction; for in the exoteric view of the uninitiated women and children the masked figures dancing before them are the spirits of the dead which have returned, not in the form of ancestors who have been purified of all their humanity, but as figures which have been elevated to the status of types which reflect the reality of their own world with dazzling clarity – as in the inferno of some Divine Comedy.

The figures of the *mbuya* play

Now and then, half concealed in the bushes on the edge of the dancing ground, appeared *mafuzu*, terrifying theriomorphic figures which framed the comedy proper like the dragons and goblins on the margins of a medieval manuscript. The wearers of these masks had smeared themselves with *mafuzu*, a white powder which was supposed to bestow agility and protect them against accidents; sorcerers used the same powder when they changed into animals at night.

The *mafuzu* strode along majestically, all except the cock, who, with his wooden beak and cockscomb, ran back and forth at an

astonishing pace, suddenly disappearing and reappearing unexpectedly elsewhere. They included the elephant, which the women were afraid of because it ravaged their fields; the buffalo, accompanied by two hunters who slew it with a rifle or bow and arrow before skinning it; a pair of snakes; the man-eating crocodile; giants on stilts; the "sorcerer", a ten-metre-tall puppet with masks; a cannibal with four heads which stepped from the river; finally mask-bearing marionettes whose arms and head were set in motion by concealed threads.

There were also harmless, if eccentric, pets, such as the chick with its closed, childlike eyes, the hen which constantly scratched the ground, the sick pig; also birds, like the lark with its monotonous song.[14]

Mbuya masks were not worn by either the animals or the merrymakers, *tundu*, who created confusion in the gloomy masquerade with their coarse practical jokes. The black resin or wood *tundu* masks came across as dissipated; sometimes they had deep furrows on their foreheads, and they could give nasty malicious looks; occasionally they had tubular eyes like some of the *minganji*, as if their craziness were the seamy reverse side of "police order" or ideal wisdom (see Fig. 19). Often they aped the chieftains; they hung giant artificial leopards' teeth round their necks, in imitation of the genuine leopards' teeth which were a sign of the chieftain's rank; their pot bellies were an allusion to the chieftains' paunches which were distended from too much palm wine, their wooden penis and giant testicles an allusion to the proverbial scrotal hernia of the high and mighty.[15]

The clowns also aped the spectators and the serious masks; they behaved with incredible obscenity, which demanded more than a little courage from the maskers, for their mothers and sisters would be sitting among the audience. In one version the *tundu* portrayed a notorious gigolo who seduces married women, in another a man who lures his sister to him by night by placing bugs in her bed.[16]

There were also female counterparts to these jesters; a filthy, misshapen spinster who smoked and spat, uttered terrible curses, dragged old junk around with her, openly gave obscene advice or caught enormous numbers of locusts; an old woman in rags who displayed her genitals; an unclean woman who crushed fish poison;

a madwoman who undressed on the street. There were also comely maids with smiling mouths and plump cheeks, a village beauty who swayed her hips, the chieftain's wife, the woman who was the centre of all the men's attention, the hunter's girlfriend, the garishly made-up and dolled-up *thambi* who slept with all the men in an age-set.[17]

All of the proper, gloomy *mbuya* masks with their sad mouths represented strangers, or at any rate people with very special professions and characteristics. They included the members of the neighbouring Dinga tribe, sometimes a bird-catcher, sometimes even a pursued bird; an itinerant diviner, also from the Dinga; another itinerant diviner with a vertical white line in the middle of his forehead and a braided or mane-like headpiece, who employed a rubbing-board oracle such as the Pende never used (see Fig. 20); the slave who looked like a white; a Pygmy with a hangover, sad and tired, supported by two *tundu* who wipe his nose and console him. Then there was the epitome of the stranger, *mwenyi*, tired and grimy from his travels (see Fig. 21); either an itinerant Luba trader who danced in the Luba manner, or a white dressed in European fashion; an epicure with thin black hair, hat and glasses who moved about in an ungainly manner, counted the spectators and searched

FIG. 19 *Tundu* mask, clown with tube eyes (Pende, Zaïre).

to the left and right for lodgings. There was a filthy white who carried a pencil and paper in his hand and was called the "locust" because his ceaseless counting got on everybody's nerves; the bearded missionary with his meticulous cleanliness; the industrious Dinga with his knife and axe; the dissipated, uncouth Yaka from the western border of Pendeland; in addition hunters, bird-catchers, wood-cutters and palm-wine tappers, a person who grated cam-wood, an epileptic who had burnt one side of his face, and a hunchback with an arrow in his hump.[18]

We have seen that during the colonial age, the Tonga women turned every new, confusing phenomenon which penetrated their world from outside without being properly comprehensible to them into a new dance possession which then spread as a fashion; to the old, frightening animals came the figures of alien African tribes, the Europeans and finally their machines. Despite being considerably older, the *mbuya* play also began to run riot, as it were, during the colonial era, and thanks to Munamuhega's accounts we can draw on this wealth of new figures and study the genesis of the masks and the initial relationships between a mask and its bearer,

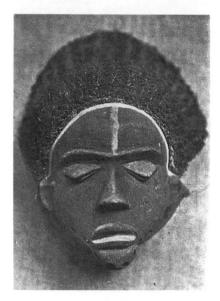

FIG. 20 *Mbuya* mask, an itinerant diviner of the Dinga (after Carl Einstein). (Pende, Zaïre.)

before then turning to the pre-colonial *mbuya*, whose origins are lost in the mists of history.

The *mbuya* masks reflect in part curious events, in part successes and failures in professional life, which the maskers had observed or which had happened to either themselves or their close ones.

One mask represents a Dinga who dances with a knife and axe in order to demonstrate his tireless industry, and this mask had

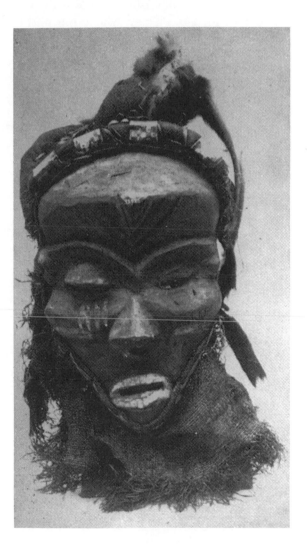

FIG. 21 *Mbuya* mask, the stranger (Pende, Zaïre).

149

appeared to an industrious and thrifty man in a dream; it repre-
sents him, but as a stranger. The figure of the wood-cutter is
danced by men who have either made their mark as wood-cutters
or met their match with a particularly sturdy tree. One man hunts
the buffalo which killed his father; if he manages to slay it he may
wear the buffalo mask, and if he fails he plays the old woman in
rags. One man dances the figure of the old spinster because he had
once given an old spinster a stick with which she caught a large
number of locusts. A man whose pig had been bewitched dances
the figure of the sick pig. A notorious trouble-maker dances the
figure of the cannibal. A person who had saved a woman with large,
bloody wounds in the forest dances the figure of the dirty Yaka,
who is scared of rotting. A man whose mother had died because an
itinerant Dinga diviner had given her the wrong treatment appears
in the Dinga mask as someone living under the delusion his
ancestors had called him to become a diviner.[19]

The classic *mbuya*, and its analogy to the *shave*

Five of the masked comedy figures did not give expression to any
personal experiences; they depicted their own reality, which until
recent times had been entangled in ritual, and which existed only in
the masks themselves. Léon de Sousberghe, the ethnographer and
art historian of the Pende, has compared these masks with the *shave*
of the Shona and shown, on the basis of their iconography, that
they contain surviving images of strangers whom the Pende
encountered long ago.[20] I call these five figures the "classic" *mbuya*
because the Pende saw them as having a model form, which they
simply modified in the other *mbuya* masks.

The Pende state that they have had the five classic *mbuya* masks in
the Katundu style since the time they lived on the Upper Kwango
in Angola under the rulership of the Imbangala and Shinji. They
tell that they adopted there the circumcision rites of the Shinji, and
with them the masks. Given that they probably already left the Upper
Kwango in the seventeenth century, to settle between the Lutshima
and Kasai and evade the Pombeiros' slave-hunts, the oldest faith-
fully handed-down masks retain the image of a past which has long

since faded to mythical shades in Pende memory. Over the course of the generations, the masks, which the Pende accorded great ritual importance, congealed into permanent forms which could be copied, even though – or perhaps precisely because – their original meaning was forgotten.[21]

Two classic *mbuya* figures, *kiwoyo* and *muyombo*, decorated with feathers and furs, hold fly whisks in their hands; they distinguish themselves by massive beards which are carved into the wood of the mask (see Fig. 22). The name Kiwoyo can be traced back to a Kikongo word which denotes the spirits of the dead, more specifically the ghosts of unknown or very remote strangers. The name Muyombo also points to a Kikongo word for the deceased, and can be linked with expressions for sadness and names for the house of the dead. The gloomy, sad faces and fading eyes of the *mbuya* masks have their origins in these masks. They are the masks of alien spirits which, with their enormous beards and at least some echoes in their physiognomies, are reminiscent of the Europeans with their solemn air.

Phota, in some examples a mask showing restrained sadness and inwardly directed psychic tension, has a titanic appearance thanks to his mantle of manioc leaves; his name means "manioc", which might point to its Portuguese origins, because the plant was introduced by the Portuguese (see Fig. 23, bottom). Fumu, the chieftain, still bearded in very old examples, wears a three- or sometimes multi-pointed headdress, clearly in the Lunda fashion, which is vaguely reminiscent of a tricorn, and is accompanied by an umbrella-bearer when he enters the comedy. Since nowadays neither the headdress nor the umbrella can otherwise be found among the Pende – and have nothing more to do with their chieftains' insignia – this can only allude to a foreign commander. The same headdress also characterizes the last of the five classic *mbuya* figures, Phumbu, the man-slayer; his name refers to Mpumbu, written as *pombo* in old travelogues, the terminus of the first great trade route from the coast to the interior, south-west of Stanley Pool, from which the slave-hunters received their name "Pombeiros". In the comedy, Phumbu swings a double-bladed

knife in both hands while two acolytes hold him on a leash, for in his bloodthirstiness he threatens to leap at the audience (see Fig. 24 and Fig. 23, top).[22]

Of all the *mbuya* masks, only the five classic ones were also danced outside of the public masked comedies, above all, at least until fifty years ago, at healing rituals. Just as some *shave* lent their hosts healing powers, these masks also bestowed attributes and faculties which the Pende celebrated in the prize-songs they dedicated to them.

Kiwoyo and Muyombo danced over patients lying on the ground, and often a strip of the raffia trim on the mask's wooden beard was wrapped round the wrist of a small child to protect it

FIG. 22 *Mbuya* mask, *kiwoyo* with long beard (Pende, Zaïre).

FIG. 23 Mask pendants made of ivory. Top: *fumu* or *phumbu*; below: *phota*. The headdress is reminiscent of the tricorn worn by European officers (Pende, Zaïre).

from illness. The titanic Phota, the manioc mask, had in addition a relationship to pregnancy and fertility, and Sousberghe was still able to observe this mask dancing over a mother and her sick child. Probably Fumu and Phumbu also had the gift of healing children; and as late as 1941 a missionary reported seeing, on the occasion of

the healing of a chieftain, a masked figure which, like Phumbu, let its knife whistle fearfully close above the spectators' heads.[23]

Kiwoyo and Muyombo were associated additionally with the hunt; they wore animal skins; Kiwoyo was greeted with a song which extolled him as the hunter of the genet and elephant: as the hunter who "exterminates" the game. And when the catch was brought into the villages of the Kasai-Pende, the people sang Kiwoyo's song.[24]

Like the *shave* of the Shona, the *mbuya* masks were passed down from generation to generation. Since the Pende frequently marry cross-cousins or slaves from their own clan, it makes little difference whether the masks are inherited like personal property and

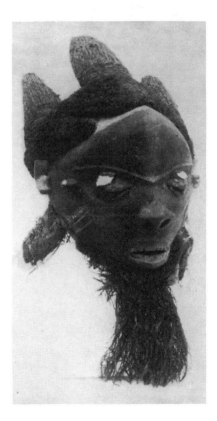

FIG. 24 *Mbuya* mask, *phumbu*, the Pombeiro (Pende, Zaïre).

crafts from father to son, or from mother's brother to sister's son: in both cases they always remain in the matrilineage. As Goertz reports on the Kasai-Pende – although probably it also applies to the Pende of Katundu – masks were said to have the power to make someone possessed, sterile and sick; it was thought that ancestors who felt neglected by their living descendants brought themselves back to memory by having the mask they had danced as they were alive "move" a living person, who can then only be cured of his possession by dancing the mask anew.[25]

Thus whereas a new mask fixes a personal memory, an old mask resuscitates the memory of a predecessor, and in the end also a personal memory, conveyed via the genealogy, of an "impressive" experience. The mask of an other becomes the personification of the individuality of a deceased person from one's own lineage which lives on as *mbuya*, while one honours one's true ancestry in the form of the *minganji*; and finally the mask becomes the personification of the person himself.

The extent to which the owner's identity is expressed by his mask, the degree he himself is equated by other people with his mask's identity, can be seen very clearly in the two ways of handling *mbuya* masks; both give expression to a tie between person and mask which has developed with time, and which has come to have a separate existence from the rituals and comedies. First, the Pende sometimes take their masks with them when they go on journeys which take them across regions containing foreign chieftaincies; with this they enjoy the same esteem enjoyed by the mask they wear, and can therefore count on being welcomed and receiving warm hospitality.[26]

A mask, which in fact cloaks the bearer's identity, becomes the personification of social identity as and when this can be defined as the right to wear a certain mask. The other way the Pende use their masks outside of the rituals and comedies is determined by the necessity of making both face and mask visible simultaneously.

The Pende had miniaturized forms of *mbuya* masks which many wore as amulets round their necks (see Fig. 23). With these amulets they showed that they were under the protection of the respective mask, either because they held the right to dance that mask, or

because they were close to the mask's rightful owner, or because they had been healed at some time by its dance.

The mask amulets of the classic *mbuya* – and these alone – were made of ivory. Only the men of the lineage which owned a particular mask could wear its ivory amulet form, their uninitiated wives and children could wear just copies made of metal, wood, bone or large seeds. The other *mbuya* were never depicted in ivory amulets, but just in these less noble materials; and while the ivory amulets depicting the classic *mbuya* bestowed the wearer with the magical protection of the masks, the other amulets seem merely to have marked their wearer's mask-identity.[27]

The relationship between Pende mask and person fits into the general schema drawn up by Marcel Mauss in his great essay on the concept of the person.[28] The Latin word *persona*, which at first denoted a costume, and then the role which one plays before the court and in the end before justice, can be traced back etymologically to the Etruscan word *phersu*, a disguised figure which separated the soul of the departed from the living being.[29]

As Mauss showed with the mask in the north-west coast of North America, the history of the concept of person started with figures, masks in an inventory which was handed down from the ancestors; the individual received an identity through the right to wear a mask for the duration of a ceremony. Also in America the masks did not actually represent the ancestors themselves, but rather animals or memorable events they had experienced and which had endured as memory traces. Following Franz Boas's descriptions, we see that during the period of development under the Europeans, the masks also included the figures of "policemen" and "judges" who consulted books and imposed punishments.[30]

It is possible that here we have a schema which one must employ for all societies with corporative identities if one wishes to establish the identity of the individual in them: the other respective to each corporate group became the sign for the individual within it. Identification with an ancestor was able to provide this sign only in a restricted and secondary way; it was more important to be possessed by this other oneself – or to wear its mask.

Digression on the asymmetries of change

Anthropologists and cultural historians have sometimes equated masquerades with possession. All in all both forms seem to bring about an intoxicated inner rapture, an ecstatic ego enhancement and a transformation into higher powers. The sober, cool observer thought always that he was faced with the same phenomenon: fancy-dress, screaming and shouting, dancing and drumming.

"The primitive societies", wrote Roger Caillois,

> which I would prefer to term societies of chaos and hubbub, [...] are societies ruled equally by masks and possession. [... Here] there are simulation and vertigo or pantomime and ecstasy which assure the intensity and, as a consequence, the cohesion of social life [...].[31]

From the viewpoint of the rationalist observer – and likewise from that of the irrationalist – maskers and spirit hosts are both equally inundated by dark powers.

> One keeps returning to the general problem of mask-wearing. It is also mixed up with the experiences of possession and of communion with ancestors, spirits and gods. The mask induces a transitory exaltation in its wearer, which makes him believe he is undergoing some decisive transformation. In any case it encourages the unleashing of the instincts, the invasion of frightening and invincible powers.[32]

In polytheistic African religions, such as the *vodu* cult of the Ewe, the worshippers may approach the great deities only with their upper bodies bared; the mediums' clothes are removed when a deity embodies itself in them. But in the "acephalous" cults of alien spirit possession, the hosts actually dress up in the traditional garb of a foreign tribe; they put on a fez or a pith helmet, wrap themselves in black, white or coloured cloths and adorn themselves with exotic jewellery. They enshroud themselves – like a masker, but without concealing their faces.

African mask-bearers cover themselves up completely, so that the spectators are often unable to make out the masker's everyday identity. In many masquerades the face-mask and mask costume

remind one of the uniforms of judges, priests and policemen who, according to Caillois's theory, should exist only in advanced civilizations and modern society. Such masked figures often – or perhaps always – represent the "forces of society", as, for instance, do the *minganji*, the ancestor masks in the Pende circumcision rite. Instead of producing chaos and confusion, these sorts of mask demonstrate the society's ideal, abstract order.

But there were also masquerades, which, in analogy to spirit possession, I shall term "acephalous", where the dominating principle was that of the *differentiating* costumes. In the case of the *mbuya*, the alien masks of the Pende, the differentiation was concentrated primarily on the mask's face; but it also affected the dress, as with Phota, the titanic embodiment of manioc, who distinguished himself by his gown of manioc leaves; and in south-eastern Nigeria there were certain masquerades in which it was more the dresses than the mask's face that made the depicted figures identifiable.

The everyday identity is eliminated, on the one hand, by bright costumes, and on the other by nakedness or uniformity. In the first case masquerades and spirit possession are similar in that they are transformations which differentiate, while in the latter case they constitute opposites; nudity and uniform suspend the differences in everyday identities in the name of an ideal equality, but in the one case the visibility of the face is increased, in the other it is concealed. This first asymmetry – the basic opposition between revealing and masking, in the strict sense, the face – which can already be seen by a superficial look at masquerades and possession, is the basis for a *sociological* asymmetry: women dominate in the cults of spirit possession, men in the masquerades.

The task of the "great" masks of the Dan from Liberia and the Ivory Coast was to track down the "powers of evil", to settle disputes, to nominate a meat-distributor for festivals and to bring about peace between feuding villages. These masks were owned by particular families; they could only be worn by men, but when they danced some of the women and girls from the owner's family became possessed. The masked figure struck them, as the Dan say, "like an electric current".

"The girl", write Hans and Ulrike Himmelheber,

> trembles all over, turns her head back and forth in agony while her arms and legs extend and twist together under an invisible compulsion. Then suddenly she gets up and, gesticulating wildly, runs after the mask which has just left the dance floor. [...] A woman arrives with a calabash full of water and sprinkles it on the girl. The mask comes up to the girl and slaps her on the arms and back. Now she lies flat on her back in the heat of the sun. After a while she gets up and, swaying, follows the mask back into the hut.[33]

When a mask-bearer dies, the mask reveals itself to one of his male relatives, who then has the right to dance this mask. One can easily imagine that a daughter of the dead man might just as likely be visited by her father's mask in dreams or visions; but mask-wearing is a purely male privilege. Excluded from any practical association with the mask, the girl becomes possessed. She feels the mask – as an "image of a *passio*" – and the society around her cannot do otherwise than accept this possession; water is sprinkled on her and she is touched by the mask so that she will return from her trance.

Just as our vulgar psychology once imputed to women – and only women – a hysterical disposition, so some anthropologists and historians of religion assert that women are witches, shamans or spirit hosts "by nature", requiring no more than a special ritual preparation, an initiation to transform them into an effective medium for the spirits.[34]

The mask possession among the Dan girls seems to confirm this opinion all the more because here we are not dealing with a cult in the strict sense; neither do the possessed women form a society, nor do they have any claims to the mask which has "struck" them; their possession follows no cultural pattern and they require no initiation; it is spontaneous – but only as the reverse side of a societal order in which mask-wearing is an exclusive male privilege.

We have seen that the "acephalous" spirit possession cult societies were mainly attended by women, and especially where they were kept apart from public cults or indeed from public life. Public cults can include such things as the mosque, the boys' initiation

camp or the men's masquerades. The most radical restrictions are imposed under Islam, in extreme cases entailing seclusion for the women, and prohibiting masquerades and spirit possession for men. Here a unique women's culture developed in the isolation of the home, one in which the spirit possession cults survived so that the women could summon up the world "outside".

Men sometimes participated in spirit possession cults when these were simultaneously celebrations of specifically male spirit hosts, i.e. those whose professions involved possession, such as among the Shona; and on the other hand everywhere where men, as slaves or migrant workers, were excluded in a way similar to the women from any practical and egalitarian dealings with a part of their everyday world, as was the case, for instance, among the Hausa in North Africa or the Songhai on the Gold Coast.

However, although the masks were often danced *for* and *in front* of women, with a few exceptions they were danced only *by* men. On top of which the women were not only disallowed from wearing the masks, but generally society's conventions even demanded that they pretend not to suspect the "secret" behind the mask. Serious taboos surrounded the circumcision site, the sacred grove or the huts where the men carved, stored and donned their masks; women were not allowed to approach these sacrosanct preserves of manhood under threat of mystical retribution – noticeably often sterility – or substantial demands from the men for atonement.

Probably the women were often quite happy to grant their men this privilege. The occasional mask possessions among the Dan girls illustrate, however, that a power of the manifest could also reveal itself in the masks; and sometimes the women inaugurated their own masquerades. This case is the exception which proves the rule, i.e. the female masquerades were always seen as exceptions, while it was comparatively rare for male spirit possession to be interpreted as travesty.

In 1975 in the north-eastern regions of Igboland, a large number of children died of an illness which could only be cured with the aid of an oracle. The oracle demanded in turn that the women honour it with a masquerade. Like the wishes of the oracle and its actual

healing power, the woman who thence wore an elephant mask was clearly viewed as a mystery.[35]

Only in relatively few African societies did the men's masquerades exist alongside the women's spirit possession cults. Leo Frobenius emphasized the largely complementary nature of their dispersion across large, interconnecting regions of the continent, rather than within single cultures, although at the same time he viewed the masks as merely a part of the plastic arts in general.[36]

The "acephalous" possession cults stretched from south-eastern Bantu across Zimbabwe and Zambia, where a few branches went to the west to Angola, while the rest carried on to the East Coast and the region between the central African lakes, then further to the Nilotic cultures. They also existed as *zar* and *bori* cults in Ethiopia and broad sections of the northern savannahs, later branching into the forest regions, as among the Akan and Ewe, and in North Africa. For Frobenius, this "convex" arc of what he termed "shamanism" appeared to embrace the "concave" zone of sculpture, the "main area of retreat for the equatorial Neolithic culture" (see Figs. 25 and 26).[37]

Frobenius interpreted this geographical distribution as the result of the expansion of "shamanism", which had infiltrated from the Orient and "extinguished" the plastic arts. But there is no contradiction between spirit possession and sculpted figures; rather, as will be shown, figures were an integral part of spirit possession cults. It is merely that masks were not employed in spirit possession, and, with some significant exceptions, spirit possession did not occur in masquerades.

There seems to be no indication whatsoever that masquerades were ousted by spirit possession to any noticeable extent. One can no longer ascertain the historical origins of these two forms of representation, and both the structural contrast between mask and trance, and the complementary distribution between men and women and their co-existence in a number of societies, suggest that the masquerade should be understood as an alternative to spirit possession: in some societies only women developed a cult of metamorphosis, in others just the men, and in a number of societies

FIG. 25 "Major regions for carved African figures and masks. Dots
show where these are very abundant; the arrows show the direction
from which the eroding influence has crossed the ensuing 'extinguished'
or 'razed' places." (Leo Frobenius).

both forms existed side by side without ever touching one another
within the framework of a ritual.

There is a puzzling similarity between the faces of the possessed
and the faces of some masks. The art historian Robert F. Thomp-
son recognized, for instance, the closed eyes and the seemingly

FIG. 26 "Dispersion of shamanism in Africa, namely of the spirit
groups: I. Djegu, II. Bori, III. Zar, IV. Mandva, V. Pepo, VI. Shawe."
(Leo Frobenius).

frozen features of the Akan spirit hosts in several Baule masks, and
the reclining position of their heads in the terracotta heads of the
departed of high rank. Furthermore, a characteristic facial expres-
sion in Yoruba possession, in which the lids are opened wide over
bulging eyes and the lips seem to be frozen, is reminiscent of the
ivory masks and terracotta heads from Benin and the night masks
of the Yoruba *gelede* society.[38]

163

Conversely, the frozen faces of the possessed also generally remind one of masks. In trance and behind the mask, the individuality of the transformed person is extinguished; the natural animation of his face gives way to an unnatural rigidity, distraction to an expression of concentration, the everyday expression to one of ecstasy and transfiguration. When one says a person is possessed, one relieves him of any responsibility for his actions; if someone wears a mask, his anonymity relieves him of the restrictions imposed by the conventions of his everyday existence. Those masks whose expressions recall the faces of the possessed represent a supernatural ideal; but a mask may also reveal a physiognomic fantasy which was certainly not modelled on the rigid, "mask-like" face of the possessed.

The masked comedies of the Anang and Afikpo

We have seen that the five classic *mbuya* masks of the Pende were used in a very similar way to the *shave* of the Shona; those who wore them had healing powers, and probably in some cases the hunter's special talents as well; the mask gave an additional, differentiating identity, and, as with the *shave*, this power of differentiation corresponded with the fact that the types depicted in the masks, being strangers, conveyed an other to the Pende culture. At the same time these classic masks became entwined with the *mbuya* play and its numerous characters, also in part representatives of other cultures, but never invested with such ritual rank as to be able to mould their owners' characters.

The arbitrariness of the figures in the *mbuya* play makes them more reminiscent of the Tonga women's ephemeral possession dances, or even the *beni ngoma* of the colonial East Coast and the dance fads of the Fang. One could introduce some distinctive figure to the repertoire of masked figures at any time one liked, such as a heavily made-up girl, an obscene old woman, a conceited itinerant diviner or a ludicrous census-taker; and the appearance of the clowns, mimicking such characters as the pot-bellied chieftain with his scrotal hernia, takes the proceedings even further

away from the serious, ecstatic representations of the possessed women – to the humorous stage of comic travesties.

If one wishes to parade the weakness of one's fellow citizens before all in a village community which is plain to see, and in which everyone knows each other and has obligations to almost everybody by either kinship or affinity, the best choice of medium is one which distances itself; one such medium was, for instance, the animal fable, in which everyone could recognize the narrator's wicked intentions without being able to pin him down, and another was the mask, under whose protection one could enjoy liberties which would otherwise get one into hot water.

The fact that on occasion some of the male masquerades acquired a satirical aspect, but never the women's spirit possessions – even though one certainly finds bizarre types reflected in their ecstasies – results from the fact that the men staged these masquerades before the public. The numerous correspondences between the masked comedies and the "acephalous" spirit possession cults, especially the superficial resemblance between many of the figures in both forms, should not obscure the fact that the spirit hosts' festival serves expressly no other purpose than to honour and appease their "spirit", while the masquerade appeals to and is directed emphatically at spectators. Instead of acknowledging the other to one's culture as an "image of a *passio*" and as one's own otherness, the masked comedy parades this "other" as a foolish deviation; as with Aristophanes, or the Anang and Afikpo in southeastern Nigeria, in its heart the masked comedy is conservative and traditionally minded: from this standpoint the "other" seems to be nothing but bunkum (see Fig. 27).

The conservatism of the masked comedies performed by the Anang and Afikpo can already be recognized in the origin myths of the mask-societies, as well as in the sorts of spirits which the masks are claimed to be. The Anang tell of a young man with a calling as a diviner who once strayed though the forest and met the ghosts of dead diviners; the latter performed the *ekong* play, instructed him in the masks and dances and ordered him to set up an organization back home to prepare the *ekong* masquerade.[39] This means, however, that although the *ekong* play was conceived in the wild outside

of the cultivated regions – i.e. is based on a position outside of society – its authors nevertheless represent "forces of society". The figures may be alien, as in the *mbuya* play, but the spirit of the masked comedy is the "spirit" of the moral order. In a similar way the masks of the *okumkpa* plays of the Afikpo by Cross River are supposed to transform their bearers into the spirits of the dead, which included heroes, ancestors and the recently departed, or at any rate moral authorities.[40]

In the *okumkpa* plays of Afikpo, it was common for numerous masks to perform short scenes which, in the course of a play lasting several hours and interspersed with songs and dances, united to form the human comedy of this section of the Igbo. Even the style used by the masked ensemble reflected the historical trading links of the Afikpo; they had masks which had been bought from

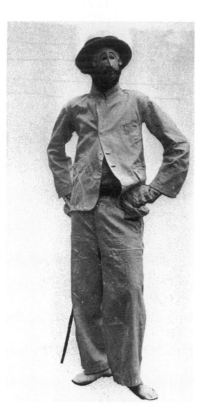

FIG. 27 Masked figure of *oyibo*, the white man (Igbo, Nigeria).

neighbouring Igbo village groups, others originated from the Ibibio and yet others from the Cross River region; one sub-group portrayed non-human nature – goats, monkeys and birds – another the natural side of man, either graceful, or boisterously phallic, or hideous and deformed.

Players, whose roles were recognized less by their masks than by their costumes, acted before a chorus of masked singers and dancers. The plays were about fellow citizens who had lost favour through greed or foolishness; their names were called out loud, and, if they were sitting among the spectators, a watchful eye was kept on them to ensure that they showed no signs of being hurt or of wanting revenge. There appeared hen-pecked men who asked their wives' permission for things which are man's business; men who drank themselves into a stupor at solemn ceremonies; misers who shrank from the costs incurred by a professional palm-wine tapper, even to the extent that they would climb a tree – and fall down again; a man who was so fascinated by the Catholic mission that he forgot his mother tongue and would only burble English; women who had sung the secret songs of the society and been punished with barrenness; others who no longer heeded the customs, so that their pots cracked over the fire; cantankerous and bribable elders; elders who embezzled money, were too timid or talked too much.

Often strangers and the estranged were shown – Igbo from other village groups, modern Africans and Europeans – but always to show how certain villagers had allowed themselves to get involved in foolish deals with these strangers, such as elders who converted to Islam in the hope of advantages when dealing with the Hausa traders; others who forgot that the government's agents could also be members of hostile tribes, whom one should treat with mistrust; finally young men who experimented with modern medications without understanding their proper use.[41]

The *ekong* plays of the Anang were so complicated that the rehearsals for each took six years; beside dancers and masked actors came acrobats, conjurers, tight-rope walkers and stilt-dancers, marionettes and a life-sized female puppet which moved in a mysterious manner. The butt of the ridicule were the citizens from the community in which the last play had been performed,

and who had been carefully spied on by the players. There were Igbos, Hausa traders, native judges, colonial officials, convertees, town-dwellers, over-bearing wives, male and female adulterers, people who accepted bribes, thieves, people who were stupid or incapable, those who mistreated their relatives, others who broke the food taboos, yet others who imitated the Europeans, drunkards, barren women, jealous people, suicides, unreliable friends, the ugly, the mad and the poor.

The *ekong* play castigated ineloquence at court; a judge who permitted women to divorce if they promised to marry him afterwards without any bride price; the loose morals of the town-women and everything which brought the proverbial lasciviousness of the Igbo to the minds of the Anang; the prostitutes in town; the bigotry of the convertees and their custom of swearing oaths on the Bible, and in the name of an indulgent God; the indigenous catechists and teachers – with their over-large hats, undersized shorts, their sunglasses carved out of wood and their shrill, affected English.[42]

Sometimes the masks' faces also showed the features of the persons being played. The Afikpo, for instance, used a mask called *Ibibio* which they had taken from the Ibibio; this mask allowed them to play not only all manner of adult women, but also those foreign to their tribe. Indeed a mask with the name *beke*, white, was reserved solely for the portrayal of strangers (see Fig. 28), whether Igbos from other village groups, non-Igbos or acculturated Afikpos.[43] The Anang presented figures showing, for instance, a British district officer seated at his desk, surrounded by "natives" – or even the King of England on his throne.[44]

It would seem most likely that such comic portrayals of Europeans spring from that intention which "these primitive peoples show in their artworks", and which the ethnologist Julius Lips, who collected non-European carvings of Europeans in the late 1920s, assumed to be at the root of all these "curious representations of the stranger from Europe and America", namely the wish to "hold the mirror up to us, as though to say: 'Look! That is what you white men are!'"[45]

There was no problem in calling strangers by name, just as the village members were held up for open ridicule in the comedy; and

FIG. 28 Mask (Igbo, Nigeria).

169

naturally these caricatures of Europeans were also performed when they were sitting in the audience. But one is missing the actual comedy if one assumes they wanted to hold up a mirror to the outsider, for they had to appeal to collective traditions and values if they wanted to show the funny side of human life. Thus the majority of the European roles in the comedy served solely to show the attitudes of the village members to Europeans.

In 1930 Jeffreys observed, for example, a figure in the *ekong* play which was identifiable as one Graham Paul, a lawyer from Calabar. The play was about a court trial, where the party of "natives" acting as assessors made loud remarks to draw attention to the bribes they had been paid. So the ridicule was directed not at the "white man", but rather at their own people who had acted so stupidly before him.[46]

Nevertheless, the masked comedies did sometimes take on a leading role in the polemics against the foreign culture – by warning their real audience about it. The comedies of the Anang and Afikpo have shown this clearly; and an even more drastic example can be found in the masquerade of the Mang'anja of Malawi, who, since the sixteenth century, when they came in contact with Arabs and Portuguese, had developed a technique of reacting to external pressure by apparent assimilation. In the 1920s they were still making masks which parodied the key figures of the Catholic cult, above all Mary and Joseph, the former as a white woman with an ample bosom, and both with red faces. A song was sung on the entry of these two masks: originally referring to the test of the fiancés potency performed at a girl's initiation – "she has slept with an impotent man" – it now related to the dogma of the immaculate conception.[47]

Mask possession among the Kalabari

A myth of the Kalabari tells of how once a beautiful woman called Ekineba was abducted by the dancing water spirits and taken to their world at the bottom of the creeks of the Niger Delta. The mother of the water spirits ordered her children to take Ekineba back to the land of the humans. Before returning, however, each of

the water spirits showed her his special play, and on returning home she taught her people all the plays she had seen. Whenever the people put on one of the plays, Ekineba had always to be the first to beat the drum. But as one day the young men had started the play for a third time without Ekineba, the water spirits lost their patience and took the beautiful Ekineba away for good. Since then, only the men have performed the water spirit plays; they set up the *ekine* society and elected Ekineba to their patron goddess.

According to another version of this myth, Ekineba found a headdress which one of the dancing water spirits had left on the bank of a creek. She took it with her and gave it to Portuguese traders with the instructions that they should have it copied in their home land. All of the masks of the *ekine* society are supposed to originate from the Portuguese copies of the water spirit's headdress.[48]

The myth has three interlaced motifs which emphasize the fact that the origins of the Kalabari plays and masks are alien to the men of the *ekine* society: it was a woman who introduced the plays to the men; the first masks were made by Portuguese; both plays and masks originate from the other-worldly realm of the water spirits. The motif of the female origins of the mask, which can be found the world over, "explains" in the language of the myth the reason why men now lay claim to the privilege of wearing them. On the other hand the other two, more specific motifs point to the fact that the masks are foreign to the whole of society. By combining the two motifs, the myth brings a first version of the Kalabari "other", the world of the water spirits, close to a second, namely the culture of the Portuguese traders.

We have seen that the water spirits, as "forces of nature", served above all the function of differentiation for the Kalabari, both in their thoughts and in their rituals. The heroes protected their communities and guarded their political order; the ancestors saw to the unity and strength of their descendants, rewarding harmonious co-existence with prosperity and punishing infringements against the solidarity of the lineage with sickness and misfortune. But since the economic system of the Kalabari depended on individual initiative, there had to be cultural institutions alongside

these collectivist systems which encouraged individualism, permitted differentiation and legitimized the ambitions of the one at the cost of others. The legitimation for those who succeeded in their careers lay, on the one hand, in the word of destiny which the soul had uttered in heaven, and on the other in the water spirits which the embodied word chose as the guides for its soul on earth. Men and women "married" water spirits which lived in the creeks far from the villages, and which, depending on their whims and characters, either increased or reduced a person's fortune and abilities.[49]

The Kalabari images of their heroes, ancestors and water spirits took on visible form in spirit possessions, masquerades and sculptures. Ancestors, especially those who had numbered among the high-ranking and successful during their earthly lives, were honoured by sculptures, which naturally did not have the individual features of the departed, but rather displayed the pure ideal of the ancestral group; the figures of the ancestors did not appear in the masquerades, nor did they possess people. "Idealizing" sculptures were also dedicated to the heroes and heroines, whereby their identities were shown solely by attributes. The priests of the hero cult called out to their spirits in public rituals; they localized them in the sculptures and then became possessed while looking at this cult image: the hero left his image and came upon them.[50] Among the priesthood were "dancing" spirit hosts, whose sole task was to demonstrate the figures of the heroes and heroines to the community, and "speaking", charismatic prophets who likewise proclaimed the will of their patrons.[51]

The Kalabari dedicated sculptures, male masquerades and female spirit possession cults to the water spirits.

As in so many "acephalous" possession cults, the women possessed by the water spirits had the gift of divination; in contrast to the priests, they advised personal clients on "private" matters. In trance, and here we see the practical, ritual side of the association between water spirits and strangers as set down in the myth, they spoke fictitious foreign languages: either a modified Kalabari, which was held to be the water spirit language, or the language of some neighbouring people, or stammered normal Kalabari. Sometimes, possessed each night for weeks on end, they would continue

telling fantastic tales of people and encounters from their lover's strange, mysterious town at the bottom of the river.[52]

It is probable at least that such fantasies were also influenced by the experiences the Kalabari had amassed from several hundred years of dealings as slave-traders with the Portuguese and English. Be that as it may, the water spirits, as they appeared in the sculptures which the possessed kept hidden in their shrines, and in the duplicates which they sometimes set before their shrines in order to advertise themselves as diviners, often have attributes which stem from Europe.[53]

The *ekine* society, which held the exclusive right to put on the water spirit masquerades, paid strict attention to equality among its members. This egalitarianism contrasted noticeably with the crass differences of rank between the lineages, which were accustomed to extol their more or less noble genealogies, and with the individual aspirations which, in their social life outside of the societies, were linked precisely with the water spirits. "In the *ekine* society", as the Kalabari say, "everyone is equal to everyone else. Whatever people say on the path outside, it is not our business who owns whom, or whose father is greater than whose."[54]

For this reason every member was also excluded explicitly from the society on death; for the inclusion of the dead would have meant the introduction of ancestor worship into the society, and with that social inequality, along with mutual self-praise and "who-is-bigger-than-whom thinking".[55] In this respect the society, which, apart from occasionally settling minor disputes, did little apart from awarding the right to wear the masks, resembled the "acephalous" spirit possession cults of the women; here as there, the society served first and foremost the festival, a performance free of any practical function which disencumbered them of the centralizing, hierarchical structures of Kalabari society as a whole.

It was simple enough when the water spirits gave their wards and lovers success and fortune in social life; but more complicated when the male and female spirit hosts of the *ekine* cult differentiated themselves through their portrayals of the water spirits in dances, stories and masked plays. For the figures they portrayed were not the water spirits, but rather the characters from the social

world itself. Although, in their long, nightly stories related in trance, the women emphasized the exotic splendour of the cities under the surface of the water, the *dramatis personae* were recognizably members of the community; the gossip which did the rounds in the village community was the fabric with which the possessed women wove their eerie visions.[56]

The figures and themes which were performed in the masquerades, with their songs and dances, were also supposed to come from the world of the water spirits, but what actually was shown in this alienating costume was the everyday life of the Kalabari towns and villages. The masquerades, according to Horton, were

> inspired by things as they are, and not by things as they ought to be. The whole of social experience is grist to their mill – both public happenings and things kept secret and concealed. Indeed, by adding together the contents of all the plays, one could build up a patch-work that covered most areas of Kalabari social life.[57]

In the masquerades one found the ferocious warrior accompanied by his buxom, comely, easy-going wife; the rich, dignified head of the household; a massive, stolid character, half-human half-hippopotamus; the cunning, amoral hypocrite in the form of a tortoise; the lecherous, good-for-nothing Igbo, son of a chieftain; the grim, grunting native medicine man who sniffed out bad medicine and evil spirits; the garrulous, self-pitying old woman; the husband looking for a quarrel with his wife's brother or with his wife and her lover; the "testicle-man"; duelling sorcerers; and a king, embroiled with a group of recalcitrant chiefs.[58]

The figures from the *ekine* masquerade can be easily recognized in the figures from our own comedies: the warlike man, the buxom woman, the rich or fat man, the hypocrite, the wooer, the doctor, the garrulous old woman, the sorcerer, the married couple, the king and the scheming courtiers.

In the *ekine* masquerade there was a peculiar conflict between the comic realism of the play and the masks which, corresponding with the theriomorphic forms of the water spirits, were more reminiscent of aquatic animals (see Fig. 29), and on occasion the "white

FIG. 29 *Owu*-mask *utobo*, the hippopotamus (Ijo, Nigeria).

man's ship".[59] These masks, which were worn on top of the head and not over the face, generally remained out of the spectators' sight; they were directed not towards them, but rather towards the water spirits, who were attracted by the masks' likeness to them. The masks served to fixate the spirits, make them present, and in this respect they were less like the ancestor masks of the neighbouring Anang and Afikpo, which were comically distorted, and more like the cult figures of the Kalabari spirit hosts.

According to Horton, for the Kalabari, all of the various sorts of figures and masks, regardless of whether they took part in the cults of the ancestors, the heroes or the water spirits, served to make spirit controllable. As objects or "names" which bind the spirit, they represented it just sufficiently for the spirit to recognize itself. This confinement in the image divested the spirits of their dangerous independence. "If they did not make the sculpture", as the Kalabari explained their ancestral carvings, "the dead man would come out and finish off his housepeople."[60]

175

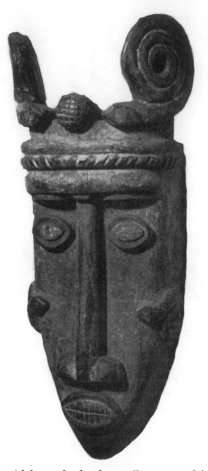

FIG. 30 *Owu*-mask *abiogbo* with python motif (Ijo, Nigeria).

Although the hero figures, which were normally hidden in their shrines from the gaze of the uninitiated, were displayed during public rituals, they were viewed not by the general public but only by the priests, who were literally inspired to their dramatic representations and dances by the sight of the image. As a rule such rituals began with the drum-name of the spirit being beaten repeatedly, interrupted solely by invocations; the priest stripped the sculpture of any old paint, then painted it anew and made it a worthy vessel for the spirit. After the offering he dressed himself in the costume of his spirit and became possessed; the spectators paid little heed to the cult image, devoting their whole attention to the dramatic presentation.[61]

176

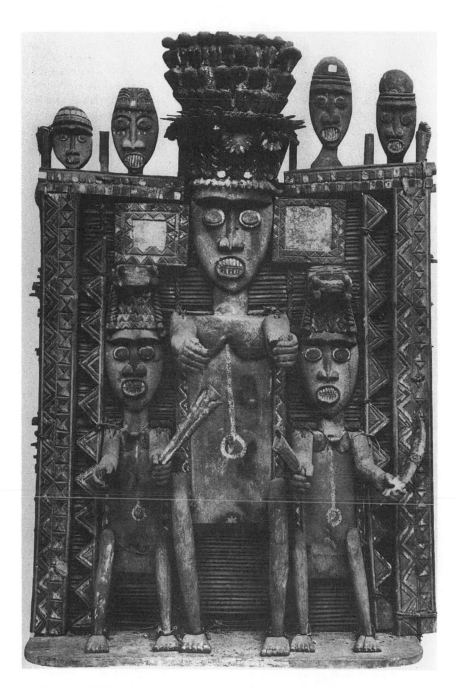

Fig. 31 Wall screen in honour of a dead person who had worn the masks during his life (Ijo, Nigeria).

In much the same way the mask was supposed to summon the spirit from its distant waters and possess the masker. This merging of masking and possession seems to contradict our thesis on the complementary distribution of trance and masks. However, it also appears in connection with another custom which fits as little to a masquerade, in the limited sense, as spirit possession: the players could be unmasked in public, and consequently in the presence of the women, if they did not pass the tests at the beginning of the play.[62]

The *ekine* masks were viewed as cult figures for fixating the spirit; although the masker was usually not recognizable, he could be unmasked because, in the final analysis, his legitimation came not from the mask but from spirit possession. There was no "secret of the masks" which had to be kept from the women. If masked figures were otherwise seen by the uninitiated as the actual spirit in visible form, the *ekine* play was seen as a festival of the possessed and the mask as part of their costume.[63]

Despite the curious contrast between the comic character of the play and the theriomorphic masks, between the merely playful presentation of the role and the aura of destiny surrounding the water spirits as lovers from the beyond, with the Kalabari we see once again that identification between human being and spirit which we know from the *shave* cult of the Shona and the classic *mbuya* masks of the Pende. The Kalabari honoured the departed of high standing with a sort of screen bearing the ideal image of the ancestors, who were devoid of any characteristics; sometimes they also made the identity of the portrayed figures recognizable by placing depictions of the masks which the deceased member of the society had worn during his life beside his ideal image (see Figs. 30 and 31); the ideal image denoted the elevated status of the ancestry, while the mask, not the portrait, captured the personal memories.[64]

5

The art of the possessed as

fixation and allegory

The Cokwe and the sculpture of the possessed

In north-eastern Angola the Cokwe – a people who, like their northern neighbours, the Pende, had had a relatively homogeneous culture before the colonial era, but had then come in contact with the Portuguese and trading Mbundus – practised an "acephalous" cult of spirit possession in which we again find the association between professions and possession by the ghosts of strangers which we encountered in the *shave* cult. It is unnecessary to say any more about the structure of this cult, which goes under the name of *hamba*, but it is worth taking a deeper look at the custom of dedicating sculptures to the *hamba* spirits, which the spirit hosts also portrayed in their dances and costumes. Like the spirit hosts themselves, these sculptures were supposed to resemble the spirits in form, and since they have survived in part in museum collections they still convey, in contrast to the ephemeral spirit possessions, something of the images the spirit hosts made of their spirits.

If a diviner interpreted a sickness or affliction as a sign of possession by a spirit which a forefather, desiring to be honoured by sacrifices, had brought on the person, the client got himself initiated into the *hamba* cult at once; the spirit hosts organized a festival at which the *cimbanda*, a woman healer, imposed taboos on the initiate while the adepts, mainly women, clapped in time with the wooden idiophone and their rattles and struck up an antiphonal song with the *cimbanda*. At the climax of the festival the *cimbanda* fashioned a puppet out of a length of reed and leaves; the spirit

that possessed the novitiate was transmitted into this by means of a magical substance while the women sang their choral songs.[1]

After the festival the novice would commission a professional artist to make a sculpture of her spirit, whose image had appeared to the diviner in a dream, under the careful observation of the ritual provisions.[2] Once finished, this effigy took the place of the unsophisticated doll the *cimbanda* had used during the initiation. The female spirit host placed it in the shrine she had erected in honour of her spirit, and at which she offered him beer, flour and meat at each new moon. She would also return to this sculpture whenever she felt new indications of acute possession. The sculpture was the place where the spirit resided; the possessed woman communicated with the spirit by looking at the sculpture, and, when circumstances dictated, she could also receive it from the same.[3]

This interplay of ritual transpositions can be explained by *cizulie*, the term used for the image; for the Cokwe the *cizulie* was that which remained unchanged when the spirit enters the human medium and then later leaves to reside in the sculpture. We have seen that, according to Cokwe belief, the "likeness" or "shadow" of any thing could detach itself and become independent from its actual bearer; it could appear to people in a dream and sometimes even embody itself in them. Image and spirit were regarded as unembodied, but it seems that the Cokwe only conceived of the spirit, *hamba*, as having an independent will. The difference between the two concepts can be most easily grasped in the belief that not only the normally visible objects had a *cizulie*, but also the spirits which were in fact invisible, and which had the will and ability to make their images enter the body of a living person, i.e. could force him to make himself resemble these images.[4]

The finished image, made of grass, clay or wood and also called *cizulie*, exerted – as one must interpolate from the scant sources and material – a sort of pull on its immaterial likeness or model; whatever, the Cokwe attempted to draw the images of the spirits from out of the bodies of the spirit hosts by means of three-dimensional images. Likewise they sometimes placed carvings of a bird on the roofs of their huts which were intended to "summon and give, as it were," a child-bestowing bird somewhat akin to our

story-book stork "the opportunity to appear"; and the images of the ancestors were also intended to make the ancestors manifest, i.e. summon their protection and blessing.[5]

It seems plausible that a people so imbued with this power of images, which can be called magical, honoured the sculptures themselves as "spirit", *hamba*; after all, "images of *passiones*" do not only have to be impressions of people who are dead or absent, they can equally be the impressions left by images, and since the latter could sometimes reach the point of actually possessing the Cokwe, they said that the carvings were themselves *mahamba* which in turn detached their unembodied images, their *yizulie*, from themselves in order to dispatch them into a person's body.[6]

Even in the cults dedicated to their ancestors, it was not the personal memory, say, of their physical appearance or their purely human characteristics which was honoured, but rather the memory of the images which the ancestors had revered during their own lives. We have seen that the Pende showed their purified ancestors in the form of abstract, depersonalized or non-human masks, whereas their personal memories were presented in the form of the *mbuya* masks which a particular forebear had once worn. Likewise the Kalabari portrayed the purified ancestors in stylized figures without any characteristics, but portrayed their personal memories in the form of the masks associated with the deceased as he had been a member of the *ekine* society. In the same way the Cokwe could also be possessed by a mask with which a forebear had appeared at the circumcision site, the spirit host then had a *hamba* carved for himself, depicting a person wearing the appropriate mask. Or he could be possessed by the same *hamba* which had possessed a forebear, in which case he inherited the ancestor's gifts as a healer, diviner or hunter and placed a *hamba* figure resembling his forebear's in his shrine.

In contrast to these personal memory traces, handed down via a differentiated system of figures, the ideal community of ancestors was honoured by the *hamba* figure *muyombo*, also named *ajimu* or "ancestor pole", which stood in each village and at which offerings were made to the village chief's ancestors. We have already come across the word *muyombo* as the name of one of the five classic Pende *mbuya* masks: it comes from the Lunda, where it denotes the ruler's

ancestors and the pole erected in their honour. The Pende, who never came under Lunda rule, took the name from its cult and gave it to the mask of an imposing stranger. The Cokwe, however, who had assumed the ways of the Lunda, also adopted the cult for themselves, raising it to their central political cult until, as a result of the colonial remodelling of society, it became obsolete, and other matrilineages which did not even have the office of chieftaincy started to erect their own ancestor poles as part of a general "move towards bourgeois respectability".

The *muyombo* figure stood at the centre of a "charismatic" cult of spirit possession, and thus distinguishes itself from the other *hamba* figures and their cults. Two or three times a year, such as when a new *muyombo* figure was erected or one wished to ward off epidemics, the images of the ancestors were allowed to leave the figure and enter one of the spirit mediums. "Then", writes Baumann, quoting a native informant,

> they choose a man whose name is "muhika", and a man who can speak very clearly [...]. Then they all congregate, the "muhika" at their centre [...]. The village "*mwata*" (the chieftain) starts to speak and calls the name of someone who has died. Then the "muhika" starts to move. The mahamba comes from within him and speaks with the words of another (who has died). Everyone starts to clap. Then they partake of meat from platters and beer. Then they ask him his name. And he gives the name of some person or other who had died. The "*mwata*" speaks again and calls the names of the dead. The "muhika" starts to move and speaks with other words. They ask him his name. Once he has called them all out, everyone claps their hands and is glad.[7]

It was the purified ancestor group whom the *muhika* embodied one after the other, and whom the *muyombo* represented in their totality. This corresponded to a complete abstraction and lack of character in the *muyombo* figure which even exceeded the abstraction of the Pende *minganji*, being generally nothing more than a pointed wooden stake. It merely marked the location of the images, which became form and language only in the spirit host. As is to be expected, this contrasted with all the other *hamba* figures, whose cult was never the sole privilege of an aristocratic lineage, and

which were never attributed any political significance. These other figures served the purpose of differentiation, and were themselves differentiated; they needed no interpreter for their privileged observer was the spirit host himself.

The Cokwe and the images of the Portuguese

The Cokwe were hunters; but anyone who set out on the hunt alone, as but few dared, needed a *hamba* who stood by him as his genius; women, possessed by the same spirits, hoped for children; other *mahamba* gave the power of divination and yet others protected travellers. Since the range of influence of each individual genius broadened over the years, it is often difficult to name any specific relation between a spirit's original reality and the gift it bestows. Nor can the outsider identify the sculptures without assistance. But there are sufficient iconographic and etymological clues to allow one to trace the images and gifts back over the generations to an observed reality.

The Cokwe arranged the *mahamba* historically, i.e. in the order in which they first manifested themselves in a spirit host, being largely, if not completely, in agreement on the matter; they distinguished the "old" *mahamba*, which had revealed themselves only to their ancestors, from their "children", the "new" *mahamba*, whose first appearance could still be remembered, and finally the "alien" *mahamba*, whom they had taken *as* spirits from neighbouring peoples.[8]

There were images of hunting dogs and lions, the genii of the hunters which gave men fortune in the hunt and women fertility; also images of diviners' baskets which instructed their hosts in divination; of birds for whom nests were built; of the snakes which shape the foetus in the womb; there was the tooth of a dead hunter which was of great assistance when hunting; images of tall guards carrying clubs, who were posted on the edge of the village; of masks with giant eyes which could see by night, so that their owners whom they possessed had the stuff to be witch-finders.[9]

There were images of *kwanza*, a sacrificial trough in the form of a boat, and when women who honoured this image dreamt they were

floating along a flooded valley or flying over the mountains, they knew that they were pregnant; if a knife or arrow lay inside, the same images bestowed fortune when hunting. In reduced form, such images belonged to the figures in the diviner baskets; if the diviner shook his basket and the *kwanza* image appeared on top, it then had a third meaning: it showed that the client was under a spell from someone who had accompanied a European on his way to the Cokwe. An association with the Portuguese is also indicated by the name, being derived from the River Kwanza which forms the western border of Cokweland, where the Cokwe first came in contact with the Portuguese and their agents. It was also by the River Kwanza that they received their first rifles, which changed the hunters' techniques as radically as earlier had the bows of the Lunda.[10]

Another image, *nzambi* or God, also originated from the Portuguese; *nzambi*, one of the widely spread designations for the otiose high god, was used by the missionaries to name the Christian God, and thus took on the meaning "Spirit of the white man" for non-converted Africans. As a genius, *nzambi* protected its hosts from sickness and misfortune; it made women fertile and lent men hunting skills. Its image was an anthropomorphic figure in a richly worked, oblong frame, a three-dimensional adaptation of the European panel painting; the outstretched arms of the figure mounted within the frame are reminiscent of a crucifix (see Fig. 32).[11]

The representations of the Portuguese or their helpers, who were made to resemble them, were called *cimbali*; these images were sometimes numbered among the "new" *mahamba*,[12] as were all images of strangers, but sometimes they were also considered to be especially old;[13] in some cases they were called *santu*, which shows that they, like *nzambi*, were associated with Christian portraits of saints. The word *cimbali*, which denoted the white man or the Mbundu from the Bihé region, contains the root of the word for two, which accords with the fact that the majority of *yimbali* figures form pairs, a man standing beside a woman, and occasionally the two are united in the form of an amulet.[14]

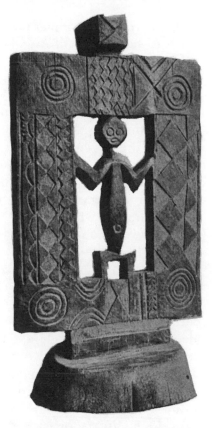

FIG. 32 *Hamba wa nzambi*. The oblong frame is a quotation from the frame of a European saint's portrait (Cokwe, Angola).

Beside *cimbali* there was *cindele*, the European who was not depicted in pair form and who counted as one of the "new" *mahamba*. At a time when very few whites came to Cokweland, just the sight of one made some people possessed, as we have already seen among the Kamba; later the spirit hosts infected themselves from the graves of dead Europeans; they danced with knives and forks, and offerings of European objects, bread, wine and liquor were made to the cult images of their spirits.[15]

Other "new" *mahamba* were the ghosts of neighbouring peoples, such as the Lunda and Lucazi, or the people from the heavens, namely the Christian angels, whose cult once spread like wild-fire. Finally of lesser importance were the "alien" *mahamba* who were taken as finished cult figures from the Pende and Shinji, as well as

185

perhaps from the Pygmies or other indigenous inhabitants of the north-eastern region of Angola.[16]

The art of the *hamba* figures attained the greatest level of verisimilitude in the *yimbali* carvings. We can arrange them on a scale ranging from the crudely carved block, which is, however, astonishingly rhythmic, to the rounded, artistic figures in which every last detail of the attributes is shown. Larger examples stood in the shrines of the spirit hosts, where they were given offerings of fragments from the modern consumer world, such as bottles, glass, plates, paper, cigarettes and so on, while smaller versions were worn as amulets which had a similar function to the Pende mask-amulets, even though the Cokwe miniatures were not as carefully made as these.

An outsider would not recognize that all of the *yimbali* figures represent European couples; occasionally the sculptor was content simply to indicate a pith helmet or a posture he found particularly odd (see Fig. 33); at times, however, he would also make the identity clear by a strongly aquiline nose (see Fig. 34), such as is only otherwise found in Cokwe art in the *katoyo* masks, which also depicted Europeans.[17] Sometimes the figures were shown naked, sometimes fully dressed, in the robes of a priest or the frock coat of a nun – both with their hands folded in front of them (see Fig. 35).[18] One figure shows a Portuguese wearing trousers, coat and hat and with a characteristic European posture – legs astride and hands clasped behind his back; this, together with the thin, pursed lips, suggests a very specific character, so that the figure is approaching a portrait (see Fig. 36).[19]

The rhythmicized, expressive realism we find in these representations does not convey simply an impression of the way the Portuguese traders, priests and nuns were seen by the Cokwe; it also lets us sense something of the ecstasies experienced by the spirit hosts who embodied the same images, the *yizulie*, of these spirits and expressed them in their dances. In this the art of the *hamba* figures differed fundamentally from the court art of the Cokwe, which developed out of the former towards the end of the nineteenth century and distinguished itself by its rounded, empathic forms and a genre-like, anecdotal realism. Only rarely did the two

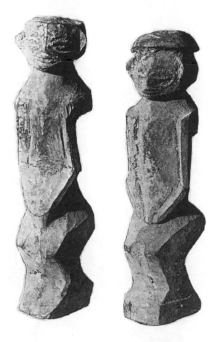

FIG. 33 *Mahamba a yimbali*,
portrait of a Portuguese couple
(Cokwe, Angola).

styles overlap, as in one of the figures in the Kjersmeier collection
which shows a European riding an ox, surrounded by the attri-
butes of the spirit possession cult in the form of figural embellish-
ments, which here have been incorporated into the sculpture (see
Fig. 37).[20]

The expressive realism we encounter in the sculptures from the
Cokwe spirit hosts must be seen as an exception; their West African
counterparts from the Akan and Ewe seem to have a genre-like
style; and even among the closest neighbours of the Cokwe, such as
the Lovale in north-west Zambia – consisting of Lwena, Lucazi and
Cokwe who had migrated there, who practised the same *hamba* cult
and who constitute in our present perspective a sort of bridge to the
Tonga and Shona – the sole material representations of the
mahamba were nothing but simple staves which the spirit hosts stuck
in the earth before their houses. Instead of any expressive con-
centration in their sculpture, we do find, however, that the Lovale
had the elements of an architecture which, analogous to the Cokwe

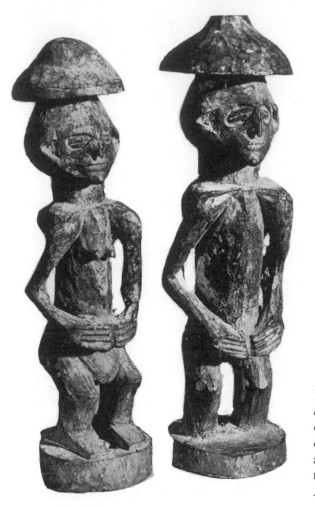

FIG. 34 *Mahamba a yimbali*, portrait of a Portuguese couple with aquiline noses and thin lips (Cokwe, Angola).

sculpture, can be seen as a manifestation of the alien spirits in the material culture.

The Lovale, for instance, erected a pole with a platform on which the spirit host seated himself like some stylite, if only for the duration of the ritual. This can be traced back to a European trader in Lovaleland who built himself a tower, atop of which he was accustomed to sing and dance; the Lovale believed that he was possessed by a spirit, and this spirit had infected them. Other spirit hosts who lay flat on their bellies in trance and, imitating

FIG. 35 *Mahamba a yimbali*, priest and nun (Cokwe, Angola).

aeroplanes, extended their arms and legs, decorated the poles before their houses with wooden aeroplanes.[21]

Those who were possessed by *vindele*, the spirits of the Europeans, created a complete environment; after dreaming of European consumer goods, they would build their own cult house or temple, as it were, specially for the purpose, furnishing it with a carpet, table and chairs; here in this house they carried out all the rites of eating and drinking which we have encountered in so many cults of spirit possession.[22] In the ritual they lived as Europeans, although this life had nothing of the everyday about it; secularization was necessary before it could become a new, African form of life.

Digression on the will to verisimilitude

The *hamba* figures of the Cokwe were not supposed to be pure

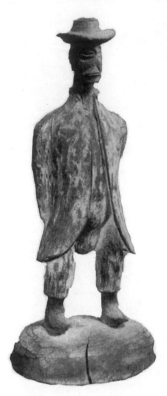

FIG. 36 *Hamba a cimbali*, the
Portuguese (Cokwe, Angola).

inventions; they were supposed to attract and assimilate the *yizulie*,
the archetypal images of the human beings and objects transmitted
by the spirits, by means of their *similarity*. This led to the analysis of
the concept *cizulie*; one could see the degree of verisimilitude which
had been achieved in the carvings made of the Portuguese; and not
least this demand for verisimilitude fitted the *hamba* cult, where the
spirit hosts externalized the images enclosed within them, giving
them plastic form in their dances and emulating them in their
professional lives.

If we compare the Cokwe concept of the image with the elements
of European aesthetics, at first sight one sees a certain affinity with
the traditional formula of art as mimesis of nature; admittedly here
the concept of a *natura naturans* is missing and the matching
concept of an art – or *téchne* – which perfects "that which nature is
unable to complete", but the *hamba* figures of the *cimbanda* and,
even more so, those of the sculptor are nevertheless intended to

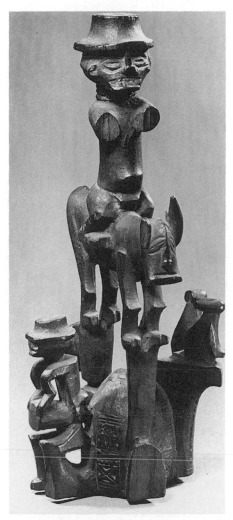

FIG. 37 European horseman, a guardian spirit for travellers. *Hamba* figure of the Cokwe, Angola.

represent "natural existence" with recognizable exactness. The European tradition differs though in that it justifies its demand for an "imitation of nature" with the latter's exemplariness; its premiss lay in the conviction that nature was itself the epitome of the possible. In the minds of the Cokwe, such exemplariness can be found only in the ancestors; the representation of the "new" and the "alien" *mahamba* was not justified in terms of their exemplariness, and the will to verisimilitude was not the will of a human subject; on

the contrary: when one made *hamba* figures, one externalized "images of *passiones*"; according to the Cokwe it was the "natural existence" itself which enforced similar representations.

At this point the difference in the underlying aesthetics of African and modern art can be seen in all its magnitude; the idea of the creative individual, which guided the Expressionists and Cubists as they discovered African art at the start of the twentieth century, has absolutely nothing to do with a verisimilitude demanded by natural existence. The ecstasies of the spirit hosts were regulated by firmly fixed rhythms, having to submit to the compulsion to verisimilitude; the impeccably organized industrial society dreamt, on the other hand, of dropping its inhibitions and letting itself go, and projected this dream on "Negro art". Just as the people possessed by *yimbali* presented themselves as Portuguese, the Expressionists and their successors styled themselves as savages; both detected an element of otherness, and adopted it according to their needs.

"One reacts", wrote Arnold Gehlen,

> to the outer skin of the alien with the feelings of the moment. Without even realizing it, at the same time the mysterious expressiveness presupposes above all the emptied form; one fills it with one's own contents, and one believes one will wrest them from it. [...] Thus we react purely and simply to the surface, and this *reaction becomes the work's function*, just as with abstract art.[23]

The Cubists made a fundamental principle of studying African works – as *objets trouvés* – in abstraction from any resemblance they might have to objects. "The representational aspect of the objects is to be excluded from the surrounding associational field", wrote Carl Einstein in his book *Negerplastik*, "and these forms analysed as formations. With this one sees whether the formal qualities of the sculptures produce an overall notion of form which concurs with those for art forms."[24]

Einstein assumed, however, that the African artists themselves rejected any similarity to objects; in place of "imitating nature" came the creation of one's own unique reality, which he described

as "transcendental" and "mythical". Seen in this way, the work was not supposed to be artificial but "realistic":

> In formal realism, which should not be mistaken for imitative natura-
> lism, there is the presence of transcendence, for imitation is excluded;
> whom should a God imitate, to whom should he subordinate himself.
> This results in a consequential realism of the transcendent form. The
> artwork will not be viewed as an arbitrary and an artificial creation, but
> rather as mythical reality which exceeds the natural in power. [...] It has
> no meaning, is not symbolic; it is the God who maintains his own self-
> contained mythical reality [...]. The religious artwork of the Negro is
> categorical and has a pregnancy which precludes any limitations.[25]

This thesis that art "creates" or "imitates" an "other" – designated as "mythical", "transcendent" or simply "possible" – reality, which "exceeds the natural in power", does not hold for African thought, which brackets together spirit and experience, revealed spirit and viewed reality, as an "image of a *passio*". As part of a theory of modern art, it is based rather on the objection to a tradition which had raised nature to a paragon; its roots reach back to the aesthetics of the eighteenth century, which for the first time gave preference to "possible" worlds over the existing one, for the belief that this was the "best of all possible worlds" had been shaken.[26]

Obviously the will to verisimilitude which we observed in the *hamba* figures of the Cokwe does not determine the whole of African art; exaggerating slightly, one could say in fact that the larger part of African art existed under a traditional *prohibition* of verisimilitude, and was quite the opposite to European art history, which, until the modern movement, was indeed fired by the will to verisimilitude. But here instead of the general inadequacy of nature, as postulated by Einstein and others,[27] considerations of a more political and magical nature come into play, which in some cases encouraged the will to verisimilitude, while in others prevented it.

The nexus of power, magic and verisimilitude can best be illus-
trated by the problem of the portrait, which we have already encountered in the substitution of the portrait by masks. We have seen that differentiations were effected behind the masks of the

personified "forces of nature", which sometimes also indicated the individuality of the deceased person in the ancestor shrine, whereas the emphasis in the representations of the "forces of society" was always on general, superindividual characteristics.

African sculptors often sought solitude in order to avoid any similarity between their carvings and living persons; it was believed that otherwise a person's features would be transmitted to the image without the artist's knowledge or will. Margaret Field reports, for instance, on a woman ceramist from Akim-Kotoku who refused her wish to watch as she worked on a black earthenware sculpture of a deceased person of high rank "lest the likeness or the personality of the spectator rather than that of the dead person should accidentally get into the image".[28] In much the same way Piet Meyer reports that the sculptors of the Lobi used to withdraw to the bush "in order to carve *bateba* (figures) on their own. With this they reduced the danger that they might see people while carving, and unintentionally copy the face of an acquaintance in the *bateba* they were working on."[29]

Such cases of meticulously avoiding portraiture are rooted in the belief in the magical power of effigies bearing a likeness, and the artist's consequent fears of being charged with sorcery. Hans Himmelheber writes in connection with this on a Guro sculptor who, "on being asked whether he would carve the heads of particular people on his loom, answered he wouldn't dare because he would be blamed if anything happened later to the people in question".[30] The Lobi, who believed that a person would be killed if sacrificial blood dripped on to his effigy, were even forbidden to mention any surmised similarities: "Even if the comparison is only made out of fun, it can harm and even kill the person concerned in the way described. Only children are allowed to make such comparisons unpunished."[31]

Beside fears about the magic of likenesses, there was a second reason for banning portraits from public life. As the pure "forces of society", the ancestors had a dignity which was incompatible with the individual characteristics of the living. If a sculptor accidentally gave the ancestors the individuality of a living person, his work was of no use to the ancestor cult. In Liberia the masks worn by Bassa men depicted ancestors; they were meant to lend expression to the

ideal of a sublime, cool, composed femininity; Mario Meneghini reports on a sculptor who gave one of these masks the features of his wife, Kwa-za; the first public appearance of the mask occasioned astonishment:

> "That's Kwa-za," everyone shouted, without knowing whether to be pleased or horrified. But the elders were not amused. The artist's lack of self-control had betrayed and exposed the myth of the masks, showing them to be a human product and subject to human whims and feelings. The mask was discarded and the artist punished.[32]

The ban on portraits was, however, effective only with regard to their public display. It is quite probable that sorcerers fashioned similar effigies in secret; at times the cult of certain portraits of an erotic nature also blossomed in secret. And in numerous "acephalous" cults which, being outside of the politico-jural sphere, were often free of any moral dictates, we find that the prohibition of likenesses was partially revoked: although they were evidently never allowed to make portraits of the males in the tribe, sometimes they had no qualms about producing similar likenesses of outsiders, especially individual strangers and women.

Among the Dan, women who had made their mark as farmers and hostesses danced through the village in male attire; they carried large wooden spoons which, similar to the men's masks, were viewed as spirits; in some of these spoons the handle ended in a head which sometimes portrayed its owner.[33]

The men often asked the sculptors for figures bearing a similarity to a woman they admired. For instance a chief of the Kran "watched his favourite woman dance and, enchanted, said [to a sculptor]: 'Isn't she just too beautiful? Make a figure of her for me!'"[34] The Dan also had figures portraying women they admired (see Figs. 38 and 39).[35] The Baule believed that on certain nights some people are visited by their lovers from the beyond; they then had figures made, which they placed beside their sleeping places;[36] although these figures were supposed to draw the – in fact invisible – spirits by means of their likeness to them, it would seem that sometimes – as and when they portrayed women and not men – they instead resembled a particular female village inhabitant.[37]

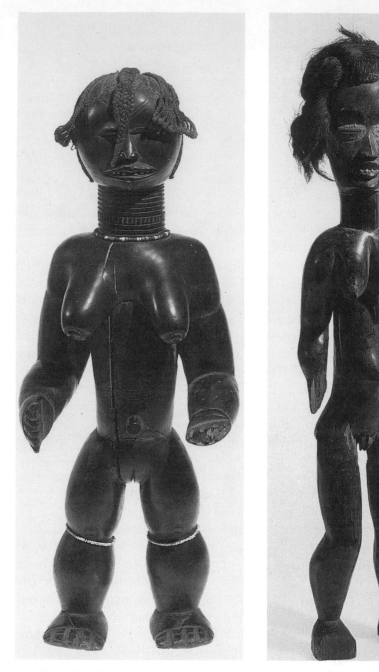

FIG. 38 Portrait figure of a
young woman (Dan, Ivory
Coast).

FIG. 39 Portrait figure of a
young woman (Dan, Ivory
Coast).

The erotic female portrait remained exclusively for the eyes of its owner; in some "acephalous" masquerades the portrait masks of women would, however, be shown in public. This occurred, for instance, in the *seri* masquerade of the Guro, whose mask-embellishments mostly showed scenes from modern everyday life. "Some of the brightly coloured mask-faces were recognized as portraits of particular women from the surrounding region, and some in fact of Diula or Malinke women who had visited the village years before."[38]

The Cokwe put on masquerades which, in terms both of structure and function, resembled the *mbuya* plays of the Pende. Here, beside the *katoyo* figure, the mask of a European with a hooked nose, there was a mask named *pwo*, woman, who was revered like a *hamba*; originally she represented a mature woman, later a young girl. Whenever a sculptor received a commission to make a new mask of this sort, he would retire to the wilds, but use a woman whose beauty he admired for his model; "to this end he took every opportunity to meet her and to study her physical appearance, right down to her tattoos, her figure and her jewellery". Although these portraits were not actually carved in the presence of the model, as we can see from the examples in museums they reveal highly differentiated characteristics; many show what we would term a "personality".[39]

African art has never come so close to the European conception of the inner animation of a portrait as in the depiction of women in the *pwo* masks; for the tendency in African portraits is less to reproduce an overall impression in a lifelike way, and more to place together those isolated features which are felt to be of most importance, without striving to reproduce such features in full. Since the artist never works in front of the actual model, his own features do not simply enter the image unconsciously, as in all art; rather, as Eberhard Fischer observed among the Dan sculptors, he feels his face with his hand and copies, in the literal sense, his own facial lines in the block he is modelling before him. Thus the actual likeness in the portrait comes not from an overall conception of the individuality of the model, but rather from disparate details, from the "inclusion of isolated features or elements from individual human faces in one work of art", which transform, feature by

feature, the basic "self-portrait" in the light of the memory of the model.[40]

This tendency to isolate individual features, which is already noticeable in the portraits of women, even though they are commissioned expressly as representations of a specific individual, is all the stronger in the figures which portray strangers, for these do not spring from a wish to reproduce individuality. We have seen that the figures of strangers in the spirit possession cults are reduced to that which was seen to be typical of them; and at times even the *hamba* figures of the Cokwe concentrated on mere attributes, on costumes and hairstyles; and even the physiognomic peculiarities of the European – the long, arched nose, his thin lips, his beard, his smooth hair – as well as his posture and the way he holds his arms, are more like a list of attributes than the unity of features which make up a portrait.

Nevertheless, the similarity between numerous African sculptures and alien models is astonishing not only to those for whom they were originally made and who understood the significance of the attributes, but also to us as outsiders. As Julius Lips, in an attempt to counter the "otherness" of African art postulated by the Expressionists and Cubists, was able to show, all in all these sculptures give an evocative picture of German, British, French, Belgian and Portuguese national characters, of European professional groups and military ranks, of officers, soldiers, missionaries, traders, teachers and housewives, etc.[41] The highly individual, idiosyncratic features which we recognize in some *hamba* figures provide impressive proof that, on occasion, African artists even came up with complete European character studies, purely on the basis of observation.

Digression on abstraction and empathy

We have seen that, beside the expressive realism of the *hamba* figures, the Cokwe also had another form of genre-like realism; the court art which developed from the *hamba* cult depicted small everyday scenes in the figural embellishments on the chieftains'

stools, sometimes also incorporating figures from their ethnic surroundings.[42] Both versions of realism contrast with the abstraction of the *muyombo* figures which, although being of little significance in art historical terms, stood at the centre of the most important political cult. In anticipation of less stringent ways of incorporating sculptures into cults of spirit possession, it seems meaningful to class both of these versions of realistic depiction under the concept of *empathy*, taken from reception aesthetics, and demarcate them from the opposing tendencies towards abstraction in African art.

As is well known, the pair of concepts *abstraction* and *empathy* was first developed in Wilhelm Worringer's book of the same name. It is concerned not merely with the forms of "absolute artistic intention", but also the underlying "feeling about the world", the "psychic state in which, at any one time, mankind found itself in relation to the cosmos, in relation to the phenomena of the external world". If aesthetic enjoyment means "to enjoy myself in a sensuous object not myself, to empathize myself into it", this must presuppose a "feeling about the world" which is inclined towards the "organic in life", "a happy pantheistic relationship of intimacy between man and the phenomena of the external world".[43]

On the other hand, the "artistic intention of primitive races", of all "primitive art epochs" and certain "developed oriental peoples with art", show, according to Worringer, a tendency to abstraction, and that as an "outcome of a great inner unrest inspired in a person by the phenomena of the outside world". Such people are seen by Worringer as living under an "immense need for tranquillity", and the

> happiness they sought from art did not consist in the possibility of immersing themselves into the things of the outer world, of enjoying themselves in them, but in the possibility of taking the individual thing of the external world from its arbitrariness and seeming fortuitousness, and eternalizing it by approximation to abstract forms and, in this manner, of finding a point of tranquillity and a refuge from appearances.[44]

In the light of early rock paintings alone, Worringer's historico-philosophical-evolutionist construct of a general path from abstract to empathic art must seem pretty untenable. Yet even though highly generalized, his antithesis between abstraction and empathy proves useful when analysing world pictures and art forms which, being mutually related, exist simultaneously in one and the same society. In the present study we have already encountered this co-existence, a necessary complementary relationship between abstraction and empathy, on a number of occasions.

In the circle of the "acephalous" spirit possession cults, aesthetic "empathy" took the form of possession; in the language of these cults it was not the person who empathized himself into the phenomena of the outside world, but rather these themselves entered the person in order to make themselves visible – to "enjoy themselves". But this was solely the internal view of a process which, from our standpoint, depended precisely on the spirit hosts empathizing with an observed, remembered or handed-down phenomenon. The aesthetic side of this process expressed itself in costumes, music, songs and dance; empathy ended up as festival.

The ancestral spirits, the epitome of an ideal community and the appointed guardians of unity and equality among their descendants, came into being during the funerary rites, which purged the deceased of all "arbitrariness and apparent fortuitousness". In the face of the ancestors, the unsettling diversity of the real world came to rest; the actual differentiation of the corporate group, the contradictions, the opposing interests and characteristics of the clansfolk were suspended in their image.

The complementary relationship between abstraction and empathy was no less evident where "acephalous" cults of spirit possession were practised in the shadow of advanced monotheistic religions, as opposed to alongside the ancestor cult. Thus in Sudan, the *zar* of the women stood alongside the *zikr* of the men; the women, excluded from open society and having little differentiation among themselves, created a cultic sphere of animation and differentiation for themselves in which they represented "worldliness" as the "other" to their own women's culture, i.e. in which they empathized themselves into the "world" which was closed to them. The Sufi orders, on the other hand, practised with their *zikr* an

ecstatic cult in which they eliminated "worldliness", with its divisions and injustices, in favour of the ideal equality of a community in the beyond; they turned their backs on the normal form of life in order to find their "point of rest" in mystical rapture.

We have already encountered the realization of these complementary "world feelings" in forms of "artistic intention" in the contrast between the *minganji* and *mbuya* masks of the Pende, and in the *hamba* figures of the Cokwe, among which the *muyombo* pole raised the abstraction of the ancestor spirits virtually to the point of total non-representation. Behind the *mbuya* masks the players were transformed into the diverse figures of their outside world; and, together with their representational dances, the realistic faces on these masks allowed the spectators to empathize with these phenomena. On the other hand, the *minganji* masks, with their abstract forms which were far removed from life, demonstrated the ideal community of enraptured, depersonalized ancestors, in whom the boys in the circumcision site glimpsed the society's eternalized values.

Beside the realistic, life-like sculptures of the "acephalous" masquerades and spirit possession cults, there were also the court arts, which demanded no less empathy; this was to be found among the Pende, say, in the figures on the chieftains' huts, whose faces resembled those of the *mbuya* masks, and among the Cokwe in the ornamented chairs and a number of figures representing status, which developed in an analogous way from the *hamba* figures. The simply enormous diversity in African art can be divided into three classes, according to their ritual contexts: that of the ancestors, that of the kings, and that of the "acephalous" cults. The abstract art of the ancestors contrasts with the "empathic" art of the courts and the differentiating cults. The difference here between the latter forms is only partly a result of their styles; generally speaking this difference is a function of its visibility.

As the British art historian Denis Duerden was able to show, African art as a whole strove to avoid imposing any rigid pattern on the present which might be considered permanent and binding. While in some cases the advanced literate cultures, especially the

Egyptian, faithfully reproduced their abstract types – signs of a totally structured, "eternal" form of rulership – in their carvings for centuries on end, the African cultures south of the Sahara rejected writing as being a medium which sets down a way of life irrevocably, and likewise they ensured that their carvings did not mould the present in the die of the past. Where art did, however, create abstract forms, its influence on the universe of "guiding principles" remained slight, for the works were hidden away.

Thus the relationship between abstraction and empathy, individuality and universality in African art was modified by the time and the manner in which the works were exhibited. "The art of the ancestors", writes Duerden,

> remains very general, but it must be hidden away; the art of the kings can be displayed openly and permanently but must remain fixed in its particular individuality and avoid any expression which is so static and general that it would be imposed on the society if it were allowed the kind of permanent display reserved for the king's temporally limited individuality; and the art of the young adults must appear for very fleeting moments and must constantly be reviewed.[45]

The life of the king was regarded as flawless and exemplary; the subjects could and should empathize with this form of life, which was also shown in the court art. The figure of the ancestors, on the other hand, represented an ideal which was so remote and removed from humanity that the living could not have stood its constant proximity; for this reason the art of the ancestors was relegated to the shrines and their masks only appeared under such exceptional circumstances as initiations. The "acephalous" masquerades appealed in their own way, at times in the form of comic deviation, to the values which society by necessity repudiated; their art was revealed in the fleeting moment of the festival, not having the right, like the king, to be displayed permanently. The art of the individual, the sculptures of the spirit hosts, diviners, healers and hunters, as well as the erotic figures, did not represent general values and, like the art of the ancestors, albeit for opposite reasons, had to be kept hidden in the owners' shrines.

The art of the kings and of the "acephalous" cults served "empathy" with the phenomena of the outside world to the same extent; the one was permanently visible, the other appeared only during the festival; both categories represented their own respective cultures and "others", the powers of the wilds and that which *we* designate as foreign culture; yet the intention pursued by the court arts when portraying the "other" had nothing to do with the corresponding needs for depiction in the "acephalous" cults.

We know from European art history that pictorial representations of strangers, particularly those of another race, can serve as status symbols; the picture of the stranger maps out the size of the realm it glorifies; it shows that the domain is not restricted to its own people, but also embraces subjects, slaves and servants from other tribes, or even, as in the age of imperialist world fairs, distant lands and exotic continents. Right from the earliest depictions of black Africans in Egyptian art we find conquered or slain enemies, captives, slaves, female dancers and women servants bearing vessels or mirrors. Greek art had a penchant for assigning Africans comic roles or those of servants, showing them as dancers, boxers, jockeys and stable boys. In the Venetian pictures of courtesans, the Moor drapes the curtains and presents flowers; he acts as part of the furnishings, holds sheet music or lamps. Although he appears at the crib in the form of a king, wise man or magus, in fact he represents nothing more than the exotic part of humanity which shared in the Christian miracle.[46]

The Portuguese satisfied the need for shows of status at the court of Benin in the same way the Moors had done for the Europeans. Although the Portuguese enjoyed certain privileges in Benin between the end of the fifteenth and the middle of the seventeenth centuries, they by no means appear in the carvings as a result of their own power; Portuguese soldiers, armed with rifles or crossbows, glorify, for instance, a foray the king made against the Igala which was supported by the Portuguese. Bearded Portuguese, stylized to form an ornamentation, encircle ivory bracelets in rows; they form a sort of crown on an ivory mask worn by the king during the rites of remembrance for his mother, and which probably depicted the mother of the king who ruled as the first Portuguese arrived in Benin (see Fig. 40).[47]

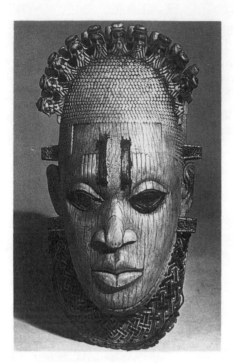

FIG. 40 Hip mask made of
ivory, early sixteenth century,
with a tiara consisting of
Portuguese figures (Benin).

However, during the colonial period there was a shift in the
borders between the subsumption of the stranger for status pur-
poses, as in court art, and the depiction of one's own otherness
through the form of an "other" to one's own culture, as in the
"acephalous" cults; this came about because, on the one hand, the
power of the segmentary systems and central powers started to
disintegrate, but, on the other, African art was able to rise to new
tasks and challenges on the basis of its own independent traditions.
Signs of outside colonial rule found their way into court art, which
no longer glorified control over the "other", but formulated rather
the equality of the traditional and new rulership. Also some "ace-
phalous" cults adopted the genre-like realism of court art, along
with imported European forms; they began to put their art on
permanent display – even though, or because, the quickly changing
times no longer allowed the way of life they recorded to be fixed.

The façade of the Fante *posuban*

In the *asafo* companies of the Fante in the south of the Gold Coast, now Ghana, a women's cult of spirit possession was integrated into a men's martial organization. As warfare became obsolete for the Fante during the colonial period, the companies began to erect shrines which, with their façades decorated by a wealth of anecdotal figures, displayed their power via a symbolic appropriation of their colonial, and later modern, environment. Spirit possession and sculpture, which the *hamba* cult of the Cokwe bracketed together as a result of their *cizulie* concept, diverged in the cult of the Fante, being linked solely by the identity and ambition of the companies.

In this centralized, matrilinear society – which, lying on the coast, had to tackle the arrival of the Europeans particularly early on and intensely, while being simultaneously under pressure from the Asante to the north – the politico-jural system was regulated by corporate matrilineages, while the military organization recruited through complementary paternal filiation. The matrilinear corporate groups were formed by the mystic bonds of the maternal blood, the companies by those of the father's semen. The central authority to which both forms of organization were answerable lay in the hands of the aristocratic lineage which had founded the particular polity in question. The egalitarian culture of the companies stood in contrast to the aristocratic, rigid culture of the matrilineage and the state. Men and women belonged to the politico-jural organization thanks to their mothers, and the martial-ritual organization by virtue of their fathers.

During the colonial period, the *asafo* companies developed a form of "acephalous" cult which can best be compared with the competitive dance societies of the *beni ngoma* on the East Coast. Excluded from any genuine military activity, in both cases they concentrated on mutual competition, on reciprocal emblematic demarcation and outdoing one another in the pomp of their military parades, costumes and symbolic drill exercises. Here as there the agonal impulse shifted from warring against outsiders to the agonal occupation of symbolic fields; the once egalitarian companies became playful, "acephalous" societies which, however,

unlike our own riflemen's associations, retained their traditional ritual backgrounds and created a new, unique type of sculpture.

At the centre of all the activities of an *asafo* company was their *posuban*, a large concrete shrine surrounded by numerous brightly painted concrete sculptures. If the art which served the aristocratic matrilineages and the state still hung on to at least a part of its traditional functions, forms and motifs, the art of the *posuban*, with its choice of materials, its architecture, its style and the contents of its figural embellishments, revealed an astonishing openness to the influence of the Europeans, with whom the companies had often teamed up in the past when fighting the Asante in the north.

The first *posuban* were built towards the end of the nineteenth century, although their models were warships or European forts of earlier centuries; surmounting a one-or-more-storey building were rows of arches, having neither doors, walls nor vaults, and no architectonic function (see Fig. 41); standing within were naturalistic statues of horsemen, animals and fabulous creatures, which are reminiscent of the adornments on European fair booths. Many of these figures were based on European models, such as the mermaid, which may well have been copied from the figurehead of an old sailing ship; beside indigenous animals and cultural artefacts there were dragons and unicorns, angels and devils, as well as modern instruments, clocks, cannon, machine-guns and aeroplanes.[48]

Each *posuban* brought together the marks of identity of the company to which it belonged; the right to display particular motifs was often contested by the companies, and some of the most bitter struggles were fought over just such emblems of the modernity, technology and wealth of the Europeans. Thus the figural embellishments of a *posuban* could be seen as virtually a collection of cups and trophies which, in a game played for a symbolic capital, its company had been able to wrest from and hold against its competitors.[49]

The ritual power proclaimed by the façade of the *posuban* was located within; after all, the chief purpose of cult shrines is to conceal the secrets of the cult from the eyes of the uninitiated; only that which is kept from sight at profane times can be brought out and revealed in a spectacular way at festivals. Admittedly the most

FIG. 41 *Posuban* of the Fante, Ghana. A shrine in the form of a
European warship.

strictly guarded secret of the *asafo* companies, that which anthropo-
logists commonly term the "medicine", was kept in inconspicuous
earth mounds, which were undoubtedly older than the *posuban* and
also fitted better into the fabric of the traditional Akan ritual
practices, and was brought out very rarely, only when a new
"commander" was installed.[50] But the *posuban* contained the com-
pany's drums. Since the companies recruited via complementary
paternal filiation, rather than choose the ancestors of the maternal
lineage, the "forces of society", as their tutelary spirits, they chose

the powers of the wild, the "forces of nature" which, according to Akan belief, resided in the waters and forests outside of the cultivated land. The power which served a company as their chief tutelary spirit was their drum, made from the wood of a tree which had revealed itself as a spirit to a hunter or wanderer.[51]

The constellation between the inside of the *posuban* and its façade, between the "forces of nature" and the images of the "other", of the symbolic cathexis between the spirits of the possessed and those of the images, recurs in the division of the companies into male and female wings. The position of the women was not the same in all *asafo* companies; but generally the women had formerly accompanied their companies into war as cooks and nurses; they encouraged the combatants and harangued the cowards; and otherwise they entertained the men with songs and dance.[52] But most importantly both before and after colonial subordination they constituted the priesthood; every woman who hosted her company's tutelary and helping spirit of the wild could become a priestess. The possessed women imparted the guardian spirit's instructions and advice; they exerted a far-reaching influence on all activities, but above all on military strategy. Bosman already described the scarcely predictable military tactics of the *asafo* companies in 1704, and believed them to be the work of "priestly cunning".[53] Nowadays this spirit possession cult has, like the military operations themselves, lost its importance, but possessed women dancers still appear at the companies' festive processions (see Fig. 42).[54]

In contrast to the drums inside the building, as well as the "medicine" and the spirit hosts' prophecies, the processions and the permanently visible art on the façade of the *posuban* are aimed at the profane eye of the uninitiated, the public. In this the art of the *posuban* resembles the old art of the kings. The observer needs no initiation into the arcana of the cult in order to unravel the contents of the images in this art. Even when these involve allegories or symbolic illustrations of sayings, the image merely holds back its meaning in a way which prompts the observer to decipher it. The allegory has nothing to do with secrets; rather it is didactic in its encouragement of reflection.

FIG. 42 Members of an *asafo* company with possessed priestess (Fante, Ghana).

Thus one *asafo* sculpture, for instance, shows an armed company leader who prevents one of the uninitiated from looking into a bag.[55] The bag symbolizes the company's secret, and the group of figures as such tells of nothing more than the power of an organization which is able to prevent unauthorized persons from gaining access to its arcana. Another group which shows a European and an African seated at a draughtboard also expresses their superiority: the European clasps his hand to his mouth in astonishment, for the African has beaten him (see Fig. 43).

This art can only fulfil such didactic or glorifying purposes if it makes its subject matter legible to all. Since the motifs of the *posuban* came, ultimately, from a foreign culture, they could not already have a uniform iconographic convention; rather the artist had to strive to create versions with a genre-like naturalism, such as the esoteric *hamba* figures, with their expressive realism, did not have to concern themselves with.

Allegoric sculpture in Asante

The rhetoric which was cultivated in Asante, as in many other African kingdoms, liked to avail itself of a wealth of witty and eloquent allusions; both in day-to-day life and in official and diplomatic communications, the greatest pains were taken to avoid speaking candidly and forcing opinions on others; everyone had an inexhaustible supply of phrases and sayings with which he could just as carefully cloak as insinuate his opinions and wishes.

> By quoting one proverb after another, by offering proverbs with contrary or differing meanings or by changing the relationships contained in the proverbs, a matter could be discussed and approached in a broad spectrum of ways, and a number of possible solutions, or strings of possible relationships, could be considered without being referred to directly. There was also, of course, an essential ambiguity in this process, for it was the individual's responsibility to perceive which party, or which event in the social situation, was being alluded to in one or other element of the proverbial relationship.[56]

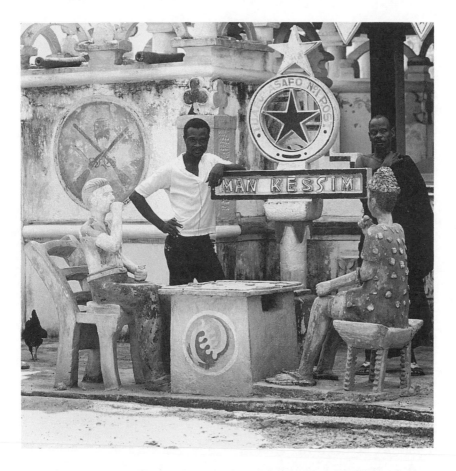

FIG. 43 Group of figures in a *posuban*: European and African playing
draughts; the African wins and the European clasps his hand to his
mouth in surprise (Fante, Ghana).

A discourse of this sort was allegoric in the strict sense of the word,
i.e. what one said pointed to something else; it veiled something
which the listener had to guess. Hence it was natural to convert this
ornate language into three-dimensional images, which made refer-
ences to artefacts from the material culture, and visual images were
also the best starting points for seemingly innocuous conversations.
Sculptures and richly ornamented status symbols became allegories
which had to be just as ambiguous as the allegorical speech itself;

the meaning was open, a knowing wink which, depending on its topicality, took on new or indeed contradictory meanings every time it was referred to.[57]

Be that as it may, a number of sculptures completely resisted allegorization. The so-called fertility dolls, *akua ba*, which young women strapped like children on their backs, not only to give expression to their wish for children, but also in magical anticipation, as it were, of the unborn child which should approximate the ideal form of these figures, formulated the central value of this matrilinear society, motherhood, which tolerated no ambiguity. Likewise sculptures of a mother with child, which were made to honour mothers of large families, used a clear formal language. In both of these groups of sculptures we encounter once again the will to abstraction, which determined the pictorial representation of obligatory societal values in all African art.

In contrast to the abstract style of these sculptures came the anecdotal, narrative realism of court art, which included the art of the nobility and of the shrines. The figural embellishments on the so-called "spokesman's staffs" developed in an analogous way to the figures on the *posuban* of the Fante. As Malcolm McLeod has shown, the custom of decorating the heads of these staffs, whose function goes back to the negotiation staffs introduced by the Europeans, with groups of figures, first came into being during the colonial period as a countermove to the palpable crumbling of the traditional system of authority. Especially in the 1940s, as the modern infrastructure made the diplomatic services of the spokesman obsolete, the staffs were decorated with magnificent sculptures which now marked status in place of function; a staff bore, for example, the image of a cock and a hen, an illustration of the saying that a hen knows when dawn will break, but leaves it to the cock to make all the noise;[58] and often watches and fob-chains were depicted, signs of the chieftain's power which was allegorized in very diverse and contradictory ways. Thus inasmuch as attributes were quoted here from the European or modern world, they were allegories of the old social order and by no means attempts to contain some power of the manifest in an image, as in the sculpture of the spirit hosts.

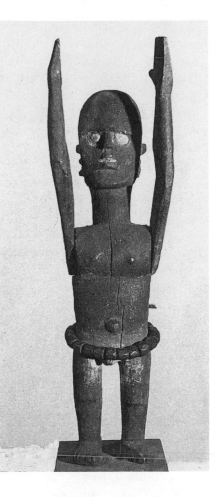

FIG. 44 Display figure from a chieftain's parasol, collected 1894. The motif comes from the Gold Coast and signifies: "God save the King," here referring to the chieftain (Ewe, Togo).

Much the same applies to the figural embellishments atop the chieftain's parasols. Thus a figure collected in 1894 from the neighbouring Ewe in Togo, but which, judging by its motif, was an import from the Gold Coast, shows a woman with both arms extended upwards; it is reputed to be a "goddess of peace", but the motif goes back to the English traders and the way they raised their arms to indicate the singing of "God save the King"; the people raised their arms to greet the chieftain, as the figure indicates (see Fig. 44).[59]

Examples of secular art, the spokesman's staffs and the groups of figures which some entertainment orchestras, especially in the 1930s and 1940s, put on display beside their drums, differ neither stylistically nor in their liking for allegory from their models in court art. Figures from the colonial period, wearing uniforms and tam-o'-shanters or pith helmets, could be placed beside the classic mother-with-child figures, and the reliefs on the drums showed not only the native fauna, but also clocks, castles and cars.[60]

There were no images of the traditional deities, but in the course of time their shrines became cluttered with all manner of sculptures of differing origins in the form of votive gifts, fertility dolls, mother-with-child figures and elements of court art, which partly documented and glorified the history of the shrine and its proven powers. These carvings could also all be found stored in the "new" shrines of the witch-finders, which largely had been imported from the northern savannahs at the beginning of the colonial period, partly as proofs of the shrine's power to convict witches, as and when the figures had once been used by witches, and partly to lend expression to this power via the signs of traditional authority, i.e. swords, parasols and spokesmen's staffs. The drums belonging to these shrines resembled, with their decorative reliefs, those of the entertainment orchestras, and the flags those of the *asafo* companies; individual figures could just as equally have been secular display figures as decorations on spokesmen's staffs or parasols.[61]

The openness of the figural representations to allegorical interpretations permitted the great diversity of the ways in which they were exhibited. Just as the sculptures referring to the central value of motherhood were intended to be unambiguous, a number of figures from the witch-finder shrines were given an unmistakable allegorical meaning. In shrines which permitted a revival of the pre-colonial tradition of the "executioners" who despatched the witches, one sometimes saw figures which held a severed head in their hand, allegories of the mystical power of the shrines. Other figures, likewise endowed with mystical power, allegorized another side of the same power, namely the power to coax money from the convicted witches; they show a person holding his hand out in readiness, a gesture which was given additional strength by a shilling set in the top of the figure's head.[62]

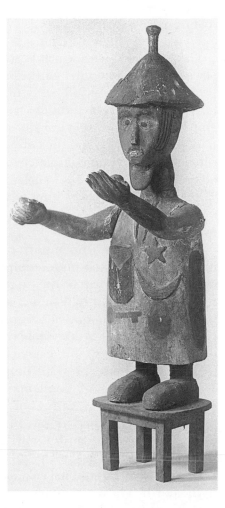

FIG. 45 Figure of a witch-finder
in the typical dress of the north,
with mossi hat and Islamic
"cabbalistic" signs (Ewe, Togo).

Figures were placed in the witch-finders' shrines – and in some
of those for certain native deities – which depicted the shrine
power's "assistants". Although they could also be allegoric, these
images had, as it were, a spiritual counterpart, a spirit who con-
veyed messages for the shrine power which protected the adepts of
the cult community against mystical attacks and tracked down
witches. Such images, which, being primarily magical and not
visual powers and in any case virtually hidden beneath a thick

coating of magical substances, were often sloppily made, were intended nevertheless to impress the shrine's clients.[63]

The *objet trouvé* with which I introduced the present study can be placed into one or other of these contexts.[64] It portrays a soldier from the colonial period, recognizable as such by his uniform and fez, who, as the scarifications reveal, comes from the northern grasslands. Both allegorical speech and the art of allegory create smooth cross-overs, and the boundaries between secular, court and ritual art opened up completely during the colonial period. Some of the sculptures in the witch-finder shrines, which, becoming spirits, could themselves hunt witches, wear the characteristic cotton smock of the people from the grasslands, like the possessed priests of these shrines.[65]

Among the Ewe, who imported these shrines, there were a large number of such witch-finder sculptures which were recognizable as people from the north by their national dress; beside the obligatory cotton smock one might find a mossi hat, and "cabbalistic" signs which, like Islamic amulets, were also linked with the savannahs (see Figs. 7 and 45). At the same time it seemed obvious to associate the mystical power of the "executioners" with the military power of the colonial rulers and their native soldiers. Sometimes one also found the images of gentlemen dressed in European fashion standing in the "new" shrines of the Akan – and the Ewe.[66] Thus the point of departure for our investigation, the allegorical found object with its uniform, fez and facial scars – be it a pure display piece or a cult figure with spiritual power – might have been associated with the colonial rule, with Islam or the foreign ethnicity of the north. These meanings were open to the genesis of allegory in cultic practice; but in any case what was meant, as with all of the forms and figures we have encountered, was an allegory of the other.

6

The Guinea Coast and the

woman from the water

The pact with the sea-creatures on the coast of Cameroon

On the Guinea Coast between Sierra Leone and the mouth of the Zaïre, and on many of Africa's lakes and rivers, we sometimes come across the counterpart, the "other" to the culture in question, in the form of a mythical world lying on the bed of lakes, rivers or the sea, wherein the order of life on land is mirrored in water and its fauna. We have seen in the spirit possessions and masquerades of the Kalabari how one could depict the figures from this counterworld in order to articulate one's own otherness, partly by ritually acknowledging this, partly by in this way confronting the comical idiosyncrasies of one's fellow citizens with the mirror of satire. In the latter case the differentiated inventory of water spirits played a similar role to the ethnic types in the spirit possession cults in East and Central Africa. In other cultures, however, these sorts of societies were arranged into leagues and had tighter links with organized society, as we have already seen with the pre-Islamic *bori* cult of the Hausa.

Living by the coast of Cameroon were the water spirits, *mengu*, who were human-like and yet not human, fish-like and not fish. They lived in lakes, waterfalls and whirlpools, but above all in the sea, in spots which were dangerous for the fishers and sea-farers. Their external appearance alone revealed their ambivalent nature; sometimes they looked frightful and hideous: "their whole bodies hirsute, with a broad mouth which divided their faces from ear to ear, and gaping eyes too large for their small bodies"; on other

occasions they were fair-skinned and captivatingly beautiful; the men often succumbed to their enticements and married them. Sometimes a fisher saw a mermaid sitting on a rock by the shore or on a solitary island; if she bestowed her grace upon him, he could wish himself riches, fame, children or wisdom; but if he should be unfaithful to his loved one, she would turn his fortune into his undoing.[1]

The *mengu* ruled over the seas and rivers, the ancestors over the cultivated soil; the former were fickle, unpredictable and free of any moral ties, the latter watched over the doings of their descendants, punishing any offences against the solidarity of the descent group and rewarding compliancy with fecund lands. This situation repeated itself in the relationships between the political system, represented by the chieftains, and the league of adepts of the *mengu* cult, for the latter did not merely form a loose society, but were well organized and competed with the binding political authorities. We know that already in 1879 the chieftains attempted to regain the political and jural functions which the *djengu* league had assumed, and indeed to terminate the league and destroy its ritual paraphernalia.[2]

The adepts of the league, who likewise called themselves *mengu*, consecrated cult sites by the sea in which they made offerings to the water spirits; each year they celebrated their large cult festivals on the beach or the banks of the rivers. The league controlled both fishing and shipping; it had magic means at its disposal, and only with their aid could one pursue one of a number of specific professions: diviner, healer, weather-maker, warrior or judge. And last but not least the league had considerable material resources, for not only did it demand money from the initiates on their admittance – that was common practice among spirit possession societies and conventicles – it also imposed fines and collected regular subscriptions, rather in the manner of taxes. As Ittmann established, with this system of a professional association, taxation and adjudication, the *djengu* league was on the verge of being a state. All the male members of a tribe, but not the slaves and the foreign quasi-citizens who had no rights of election, and only certain women, were initiated into the league in order to gain access to the magical secrets; they submitted themselves to its discipline,

while still remaining under the system headed by the chiefs and the descent groups. Although a germinal state, the league still stood in a complementary and antagonistic relationship to the hereditary political authorities – just as the *mengu* to the ancestors.[3]

Unlike the youths and men who entered the league for reasons of custom and opportunism, the girls who were initiated into the league, generally at the onset of puberty, were possessed women who sought release from sickness and distress. "The afflicted women", writes Ittmann,

> lose weight, suffer from diarrhoea and vomiting, and expel worms, not infrequently from the mouth and nose; they become apathetic, complain of aches in their heads and bodies and pains in their limbs; they talk in their sleep, and see faces, mainly *mengu* demons; symptoms of second-sight become apparent, whereby they perform all manner of nonsensical actions, as if they were being led by an alien power; they sing popular *mengu* songs [...]; shortly after they moan and groan as if being tortured, dancing, screaming and tossing about on their mattresses, then lie there again as if dead.[4]

The initiation scarcely differs from the pattern we already know from the "acephalous" cults of spirit possession; once a diviner had made the diagnosis, various rhythms were drummed to the novice until she responded to one, and with that acknowledged the spirit which had possessed her; she would then jump up, either spontaneously or in a generally familiar manner, and run into the forest where she allegedly wandered about, penetrating dense brambles without injuring herself and crossing rivers without getting wet. The initiated women would then scour the forest in search of her, singing the songs of the *mengu* until the novice answered. Once she had been found and accompanied back to her village, the initiate had to observe certain taboos; she underwent rites which were intended to strengthen her for the actual act of initiation. At the climax of this process the girls were lowered into the watery depths on belts, into the "abyss of the *mengu*", into which they gazed with eyes open. With this they lost their horror of the powers of the depths; they were reborn and could return to the community with the gift of being able to see the invisible.[5]

The different rhythms which were used to identify the spirit which possessed the woman are reminiscent of differentiating spirit possessions in the women's cults of *bori*, *zar* or *pepo*. Instead of the costumes, the foreign dress, the women possessed by *mengu* put on a uniform made of raffia and leaves which was uniquely their own; at certain festivals they appeared naked; and in both cases it was the unity of the women which was shown rather than differentiation, the association with nature, growth and water instead of any associations with strangers.

> They wear their hair in thick plaits which hang down over their shoulders; balanced on top is a dance-hat made of leaves and feathers; their faces are painted with white earth, and an apron woven from banana bast covers their genitals. Hanging round their hips is a garland of ferns, and brass rings shine from their wrists and ankles. Some of them have leg-rattles made from the pods of a forest fruit strapped above their ankles. Their upper bodies are entwined with cords on which small bells are affixed [...]. In one hand they carry a staff, in the other a basket fashioned out of reed fibres which rattle to the sound of the pebbles and berries inside. A second rattle hanging from the hips shows that its bearer is a freewoman. The dancers beat the rhythm with their rattles to the din of the drums.[6]

Dressed in this manner, the spirit hosts occupied the community's public domain; a forerunner warning others of the advancing procession drummed or played the flute in order to drive away the uninitiated. And when the women proceeded naked through the village, the boys and men had to remain hidden in their houses.

> All of the women carry a bunch of broad-bladed *ngongi* grass as a sign that the village is in a state of danger; they proceed through the village and cast themselves down on the open ground before each compound. [...] Stooping, they stride along with their faces turned to the ground. Their postures and songs are supposed to dispel any grievous quarrels from the compound and village and bring peace.[7]

Their unusual bast and leaf clothing, their nudity, the pods from forest fruits and baskets of reed fibres – all this points to a *life*-power which, personified as *mengu*, is embodied by the possessed

women and used by them against the contradictions in the domestic and political order. The women's wing of the *djengu* league constituted the women's organized power; its processions were not just intended to encourage the growth of the yams, but also admonished the men to peace; the possessed women were even able to animate the women in the community to strike, and thus enforce particular political decisions on the men.[8]

The reverse side, and one consequence of the way the women possessed by *mengu* united with the forces of nature and of water, was a radical rejection of anything new or foreign. The stiffest taboo imposed on a novice during her initiation period was a strict avoidance of all objects which came from Europe; the most effective magic practice used by the fishermen to ward off the dangerous *mengu* from their boats was to scatter snippets of paper – the epitome of European culture – on the water; and on one occasion the *mengu* women demanded that no women's work, apart from the tending of babies, should be performed in order to prevent the men from adopting European customs and goods. It was very rare that the *mengu* themselves took on the treacherous form of a European woman, and then only under its most negative and dangerous aspect, namely when she visited the bed of a man by night to bring him death and misfortune.[9]

Land as order and water as nature

In many African mythologies we find mainly female water spirits with human trunks and either theriomorphic lower halves, or human legs and feet which are in some way peculiar; as with the nixie in Germanic mythology, the lower half had the form of a fish tail; or sometimes it resembled the rear section of a crocodile; in some cases the whole body was divided laterally, being half-crocodile and half-human; there were, like the *mengu*, completely human forms where, however, the feet pointed backwards or the soles upwards, or with legs in the shape of fish with fishheads for feet; finally the feet could even be attached to the knees. As different as these forms were, they all show that these creatures could live in water but not on land. They were frequently thought

of as fair skinned, and their hair as long and either smooth or wavy; on the Guinea Coast it was also thought that they turned into humans and left the water on market days, and that one could sometimes catch sight of them in the distance, amid the market crowds.

It is clear that one cannot interpret these sorts of hybrid beings, symbols in the sense of fictions assembled out of elements of reality which cannot be combined in nature, as "images of *passiones*", in the way one could or had to for, say, the alien spirits on the East Coast. Doubtless fantastic distortions and the mythical notion of a world upside down at the bottom of the seas, rivers and lakes made their contribution to these symbols. But actual experiences have also been advanced where these handed-down symbols were used as interpretations. Examples of this include the fleeting glimpse of a woman in the anonymous crowd at the market, and above all the sight of a sea-cow, *Manatus senegalensis*, from the order of the Sirenia, which, with its almost anthropomorphic head and feminine breasts, emerges unexpectedly from the water. Moreover, the momentary reflection of a moonbeam, or a sunray piercing the fog, on the waves of the water, or sometimes even their reflection in a diamond in one of the rivers of Sierra Leone, recalls her long, undulating hair.

The *tingoi* of the Mende in Sierra Leone, a mermaid of exquisite beauty with soft white skin and long flowing tresses, was sometimes spotted in the distance by fishermen as she sat on a rock combing her hair; she would slide into the water, so that a canoe entering the ensuing eddy would be in danger of capsizing. If a fisher found a *tingoi*'s comb, he would keep it so as to demand a payment when the mermaid came to ask for its return. If she bestowed her grace upon him, he would receive considerable wealth which he would just as suddenly lose if he was unfaithful to her, or if she succeeded in recapturing her comb.[10]

The neighbouring Kpelle in Liberia attributed a similar ambivalence to the water spirits. "Her head is a human's and the rest of her body resembles that of a fish; they have a long head of hair. One sees them sunning themselves on the rocks in the river by the morning sun." They also grant

wealth, public esteem and a long life, save one from harm, give protection from dangers and bestow supernatural powers. For this they demand white sheep, white cloth and at certain intervals human sacrifices. If a man goes to his mermaid one night, and shortly after his wife sickens and dies, everyone knows that he has handed her over to his mermaid. [...] The mermaids are unpredictable and malicious. They bestow wealth, but can just as easily bring a person to rack and ruin, making him sick or letting him suddenly die or end up in complete poverty. Thus to accept their services involves a certain daring, and one must be meticulous in fulfilling their demands.[11]

The Tembu and Fingo in South Africa believed that the half-fish, half-human river people lived in kraals at the bottom of the rivers. Sometimes they could be seen sitting on rocks in the river, drying their hair in the sun. People who heard their call walked about restless and oppressed, not answering when spoken to, then one day would run off and disappear beneath the water. After days, during which they learned the arts of the healer and diviner from the river people, they returned draped with roots and bark, and began to convict witches, heal and divine. Others, who entered into sexual relations with the women of the water, became rich in cattle and had bountiful harvests.[12]

Myths, dreams and reveries of this sort formed the substratum for a number of cults which, for all their diversity, we can attribute in turn partly to the political order and partly to the need for individual differentiation. In the *mengu* league on the Cameroon coast we have already encountered a form which lay at the intersection between the two, both vindicating the "forces of nature" as well as laying claim to political import and in the end challenging the authority of the chieftain. More often, however, we find that the cult of the water spirits has a clear tie either – in centralized societies – to the mythical person of the king, who then assumes their ambivalence, or – in societies which either had no kings, or in those in which these had not enforced any claims to rulership over the waters – to "acephalous" cults of spirit possession, in which the individual entered a qualifying pact with the figures from the

water, and where those possessed by the same spirit gathered for festivals in its honour.

The wild, uncontrolled power with which the myth invested the sea and the rivers held a challenge to the social order. Even where no cult of the open waters was stage-managed by some political power, there was a certain tendency to attribute to the moral authority of the ancestors an assuaging influence on the powers of the waters. The Mende, for instance, believed that very distant ancestors lived with the nixies on the riverbeds and exerted a restraining influence on them; and the Tembu and Fingo believed, perhaps as a result of a similar notion, that, hostile and dangerous though they generally were, the river people sometimes interceded with moral intentions in the fortunes of the humans.[13]

In the old Kongo kingdom, the installation of the Count of Soyo was accompanied by the ceremonial hunt of a sea-cow, the most important prototype of the nixies, evidently in order to lend expression to the future ruler's power over the River Zaïre.[14] In Benin, Oba Ohen, who probably ruled during the fourteenth or fifteenth century and whose lame legs were pictured in the form of fishes, was connected with Olokun, the divinity of the sea, wealth and human fertility, by whom he was possessed.[15]

Nyikang, the founder of the Shilluk kingdom on the White Nile, also had ties with the women from the water. In the beginning, as a version of the myth about Nyikang's origins relates, God created a large white cow which came from out of the Nile; the cow gave birth to a human, and one day his great grandson, Ukwa, saw two comely maidens with long hair emerge from the waters of the Nile and frolic in the shallows. In place of legs they had the tails of crocodiles. One day Ukwa saw them sitting on the bank; he approached them and seized them; their screams alerted their father, a figure whose left half was green and had the shape of a crocodile, the right half having human form, who came hurrying from the depths of the river. The daughters struggled with Ukwa, but their father consented to his marrying them. The first-born son of the older daughter was called Nyikang, and he inherited the crocodile attributes from his mother and grandfather. After Ukwa's death there ensued a bitter struggle between Nyikang and his half-brother,

Duwat; Nyikang fled with his brothers and sisters and founded the Shilluk kingdom. His mother lives to this day in the waters of the White Nile and the Sobat, where she can be seen as a crocodile on the banks; although no offerings are made to her, no one can begrudge her her victims among the animals and people.[16]

We have seen that the Shilluk myths about the origins of the various cultures and races depicted all of the progenitors of mankind as brothers; in the myth of the origins of the kingdom, the relationship between land as order and water as nature is, however, equated with a marriage; the dynastic founder in the paternal line, which is binding for the Shilluk, came from a cow, the personification of male possessions, and in the complementary maternal line from the crocodile-people. The king's power encompasses the land and the Nile, for the father of the first king managed to capture the women from the water and domesticate them, albeit not so completely that they still refrain from taking victims.

The humans made love matches with the water spirits in the "acephalous" spirit possession cults as well, but here the former never took the initiative. A ceremonial sea-cow hunt established the rule of the Count of Soyo over the River Zaïre; the father of the first Shilluk king abducted the crocodile women from the water by force. But in Tembu and Fingo society the river people enticed the future diviner into their kraal; among the Shona there were diviners who were not possessed by *shave*, receiving instead their abilities from the mermaids who seized them on the river bank, dragged them into the water and bestowed on them the gift of divination.[17]

The initiation rites of the nixie cults often drew on this symbolism, as in the *mengu* cult, where the girls were lowered into the water on belts in order to look the horrors of the depths in the eye, and similarly in one Congolese cult in which young girls were initiated by being tied to a cot made of fresh leaves and lowered into the river, thus offering them symbolically to the nixies.[18] However, since the water creatures are seen almost entirely as women, these images, the irresistible lure of the water, also remind one of the female ancestors of the Tallensi, whose demands for devotion a man in the middle of his life was unable to withstand for

long. Like the female ancestors of the Tallensi, the moody, seduct-
ive and simultaneously evasive water creatures are often inter-
preted by psychoanalysts as mother images.[19] And in the same way
the female ancestors, as mother images, sometimes took on the
form of a *foreign* woman, so the image of the nixie in "acephalous"
spirit possession could fuse with the characteristics of a European
woman to produce a twice estranged counterpart to the cultural
order.

From the water spirits to *mammywater*

The first Europeans sighted on the Guinea Coast came in ships
which seemed to emerge from the sea, for it was the mast-tops which
were glimpsed first; their skin was pale like the skin of water-borne
corpses; and they had unfamiliar pieces of equipment which were
thought to be the work of the capricious water spirits. They
travelled like fish up the great rivers to the heart of the land.[20]

The mythical figures of the water spirits had consisted since time
immemorial of a mixture of watery attributes and attributes from
foreign cultures or races. In the *mengu* cult on the coast of Camer-
oon, various taboos marked a sharp contrast between the whites
and their culture, on the one side, and the *mengu* as representatives
of both tradition and the world of water, on the other. But the
mengu were identified with the Pygmies because both distinguished
themselves by their superhuman strength and their mysterious
ability to disappear in the forest or waters. On the East Coast the
Segeju, for example, believed that the *ruhani*, nixies which lived on
the floor of the Indian Ocean and endangered fishermen, while
also promising fortune, were of Arabian origin.[21]

In large areas of the Guinea Coast, and in parts of Central and
East Africa, it was customary during the colonial period – and to an
extent still is to the present day – to equate the nixies, with their fair
skins, their long, smooth or wavy hair, their riches and their
foreignness and unpredictability, with European women, or at least
to imagine and represent them with the typical attributes. A large
number of once highly differing water spirits were renamed with

the pidgin word *mammywater*, also written *mami wata* or similar, and equipped with a number of new, surprisingly uniform attributes.

The name *mammywater*, which was probably unknown in Africa before the twentieth century, can be first traced in the African exclaves of the New World, such as Surinam and Haiti, where it was recorded as early as the mid eighteenth century as *waturmamma* or *watramamma*. It is possible that the name, along with certain iconographic elements, was imported by liberated slaves to the Guinea Coast, such as to Liberia. Sea-farers and migrant workers may then have spread it, thus contributing to the unification and, as it were, modernization of a diversity of traditional and even misoneistic water spirit myths and cults.[22]

The new form of *mammywater* drew its uniformity above all from figural representations of European origin, which, in the end, were circulated in print form on the markets and copied repeatedly by African sculptors and muralists. The basis for the imaginary portraits of the water people were initially popular-traditional images of nixies, then a showman's poster and finally photographs from illustrated magazines.

The first "northern" nixies to appear on the Guinea Coast were the figureheads of sailing ships; a nixie image of this sort was copied, for instance, by an African artist in an Afro-Portuguese ivory carving which found its way to Europe as early as 1743.[23] One still finds similar copies in the figural adornments the Fante gave their *posuban*.[24]

Often the exchange of images between cultures follows unpredictable patterns. The world of the saints' portraits which the Catholic missionaries impressed upon their pupils usually met with lukewarm enthusiasm in Africa, and on occasion the saints got demoted to hunting fetishes. Shortly before the First World War, at the time, that is, when the Cubists and Expressionists were discovering abstraction in African art, an obscure poster from Hamburg started to seize the African imagination, for it was suited to furthering the ritual encounter with the European world along mythical lines, and to merging the form of the water spirits with the image of the white mistress.

FIG. 46 Arnold Schleisinger,
"the woman snake-tamer",
poster.

Discovered in the records left by Kenneth Murray, the colonial
administrator for art monuments in south-east Nigeria, was a note
about a British district officer who approached Akpan Chukwu, a
famous Anang carver, with the request to copy a print he handed
him, for he wanted the wooden figure as a souvenir. The print was
a sort of show poster which Murray attributed to one Arnold
Schleisinger; although the picture is of a woman, the title is *Der
Schlangenbändiger* (the *male* snake-tamer) (see Fig. 46). The picture
shows a woman with luxuriant black hair staring into vacant space,
as if lost in her dreams; coiling round her arms and neck is a snake,
while another has wrapped itself round her hips and rested its head
on her breast. Inserted in the bottom right corner is a square
balanced on one corner, showing a young boy with further, danc-
ing snakes. The motif, the milieu and the woman's physiognomy
make one think of India, and since the poster was later printed
there with the title in Urdu, it is often associated by Africans – and
art historians – with that continent. The poster, distributed on
many West African markets, decorates the walls of numerous
houses in which *mammywater* hosts congregate; the motif, in the

form of murals and sculptures made of wood or cement, acts as a cult figure and shop sign for diviners and healers, while the men display it in their masquerades without any ritual purpose.[25]

The picture of the woman snake-tamer, which actually has nothing whatsoever to do with water, was probably first identified with the water spirits and designated as *mammywater* in the Niger Delta and Cross River area, for there existed both traditional snake cults as well as the same cult of the water spirits which we encountered in connection with the masquerades of the Kalabari. The oldest copies attested to in the literature were located, however, further north in the *mbari* houses of the Igbo, temples decorated with clay figures and murals and dedicated to local tutelary deities. Among these figures P.A. Talbot discovered in 1914 the image of a woman with a python encoiled about her, but which, at that time, was yet not designated as *mammywater*.[26]

In south-east Nigeria, between the Niger Delta, Cross River and the Benue, the motif of the snake-tamer *mammywater* features as a cult image in the form of murals and wood or cement figures in spirit possession cults, which are largely practised by women; women who had had themselves initiated into the *mammywater* cult sometimes danced across the market place, a *mammywater* figure on their heads, in order to solicit clients as diviners (see Fig. 47).[27] The same motif appears as a life-size jointed doll in the *ekong* play of the Anang, and yet further to the north as a mask decoration in the Tiv men's masquerades, where it has no connection with *mammywater*.[28] Up the Niger, in the region of the *hauka* cults, there was one specimen of the Hamburg poster, for example, in Timbuktu. Doguwa, the chief of the Fulani spirits in the *bori* cult, to whom the fishers made offerings, was regarded as a white woman, and in Timbuktu the snake-tamer was identified not with *mammywater* but with Harakoi, Doguwa's husband, and the snake twisting round his arms and neck with the *hauka* themselves, which, as we have seen, were thought of as the spirits of modern civilization.[29]

Looser adaptations of the snake-tamer can be found in the art of the Baule and Guro on the Ivory Coast. The Baule interpreted the picture as "priest-king"; in the *seri* masquerades of the Guro the

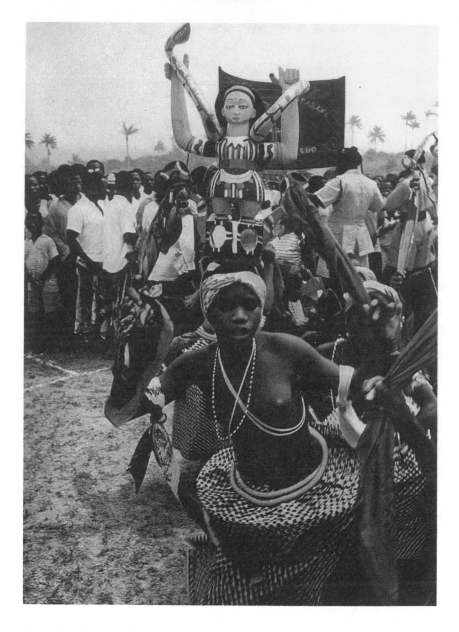

Fig. 47 Novice of the *mammywater* cult dancing with her figure, a copy of the poster by Schleisinger, across the market to solicit clients as a diviner and healer (Ibibio, Nigeria).

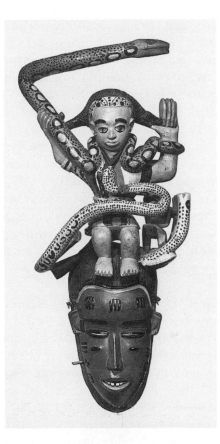

FIG. 48 *Seri* mask with figurative headpiece, copy of the poster by Schleisinger (Guro, Ivory Coast).

motif appeared in their mask decorations, which depicted traditional themes and scenes from modern everyday life; the iconography of the woman snake-tamer had no importance here, belonging as it did simply to the array of images one encountered at the market. Sometimes a replica remained close to the original (see Fig. 48); but removed from any cultic purposes, it was also possible to depict the figure naked, either retaining the original asymmetrical arrangement of the snakes or subjecting them to the traditional ideal of lateral symmetry; finally this foreign model could be made to submit completely to the Guro ideal of form by letting the snake curl round the mask's face.[30]

Nevertheless, the classic motif of the "northern" nixie was also able to gain favour alongside the motif of the woman snake-tamer,

especially in murals and panel paintings. The Dan, who sometimes drew simple line drawings on the walls of their houses to record passing events, depicted *mammywater* as a woman with a snake-shaped torso, holding a modern handbag in one hand and a comb in the other; and by the Cavally River there were similar drawings in which, however, the fish-body ended in human legs.[31]

In the mining regions of Shaba there was a fashion, copied from the Belgians and perhaps only short-lived, for hanging framed pictures in the living room, whereby the most common motif was *mamba muntu*, the crocodile's wife, who had the form of the "northern" nixie and was supposed to bring its owner luck. Not only were these nixies generally identifiable as European women, they were often specific French or Belgian women who had been copied with meticulous accuracy from illustrated magazines or fashion journals.[32]

In all these images the ethnic foreignness of the nixie seems, on the one hand, to correspond to the foreignness of the water as contrasted with the land and the human world, and, on the other hand, to underline that particular impression of eeriness which conceals the highly secretive, the suppressed, which must not become conscious – analogous to the eeriness of the foreign God which, as Theodor Reik has shown, is the form in which one's own, suppressed God returns. As such the figure of *mammywater* blends together a mother image and the image of the unapproachable white mistress, who alone could grant total, incomparable satisfaction.[33]

Irrespective of such psychoanalytic interpretations, the designation of the nixie during the colonial period as a European woman also proves to be the reverse side of another, simultaneous designation of ethnicity, namely the one by which Jesus became an African for many African churches and a symbol of African identity. The water spirits of African origin became European women, while Jesus, introduced by the Europeans, became an African.

African art had already lent the Christian figures African characteristics at a very early stage; in the old Kongo kingdom, Jesus was portrayed according to the model of African deities as a bisexual

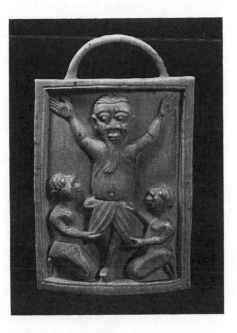

Fig. 49 Crucifixion (Congo).

being, and, thanks to the physiognomic elements and mourning customs which were used in his depiction, the crucifixion was situated in its entirety in an African milieu (see Fig. 49).[34] This was certainly not in contradiction to the idea, then prevalent in Europe, that the stories of the New Testament should be conveyed by means of devotional pictures abstracted from their historical setting. If it was less a question of the image's likeness, but rather of its inspirational value, one could depict the biblical characters as Dutchmen, Italians, Chinese or Africans.

In the 1920s, the question as to the ethnicity of Jesus took a political turn in Africa; it became acute as independent African churches in the circles around Marcus Garvey began to lay claim to the historical Jesus as an African. Either a black messiah was supposed to build a black Israel, or African leaders were themselves equated with Jesus. The reason behind this new ethnic designation for Jesus was political nationalism, which used the Christian cult as a symbol for pan-ethnic unity, to which end it was vital to remove him from any ties with the colonial rulers. The

ethnicity of the cult figure had to become identical with the ethnicity of the community.[35]

Against this, the capricious powers of the water were outside of the social order and beyond good and evil; just as the old water spirits had behaved in a complementary manner to the ancestors, concerning themselves with the fortunes and misfortunes of the individual rather than the morals, solidarity, equality and unity of the community, so the image of *mammywater* formulated the individual's political identity not in terms of the whites, but rather in terms of his hopes and fears, the dangers and enticements to which he felt exposed, the fortune which chanced his way and not that of his fellows. To be possessed by *mammywater* meant being an other in a part of oneself, and since the European world became the personification of otherness, it could mark a *boundary*; the political community opposed it, while the individual could be possessed by it.

The festival of *mami wata* in Togo

Almost everywhere in Africa, the independent manner in which many "acephalous" cults of spirit possession dealt with foreign cultures and modern civilization before and during the colonial period has been superseded by heteronomous economic and cultural forms of incorporation into modern global civilization. Just like the colonial rulers, post-colonial governments have often forbidden cults of spirit possession and effectively stopped them. And with the present economic crisis, it is also not seldom that the modest financial surplus needed to fund the festival of transformation is simply missing. Only in a few countries, such as Togo, has anything of this institution remained; in places with a very modest yet widespread prosperity, an indigenous culture can develop which, now even more than in the colonial period, will erect a modern façade so that the cults' traditional ways can continue all the more tenaciously.

The Ewe in southern Togo – and in south-east Ghana – practise a *mami wata* cult which has many of the same characteristics as the old and new water-spirit cults of the Guinea Coast; but, in terms of the

high value it places on modern consumer goods, it constitutes a complete antithesis to the purist natural symbolism and conservatism of the *mengu* cult in Cameroon. No later than at the beginning of this century the Ewe believed in water people who lived at the bottom of the sea, leaving it on market days in human form to visit the market;[36] and even in those days the Ewe worshipped a small sea-deity, *wumetro*. Just like the East Africans with their alien spirits, the Ewe hoped that this deity, whom they depicted in their cult pictures as a European on horse-back, accompanied by his wife, his employees and his boats, would have a propitious influence on their transactions with Europeans.[37] In later decades, perhaps since the 1950s, the cult of *mami wata* was shaped by a similar association between sea, wealth and European culture.

The Ewe have integrated the cult of *mami wata* firmly into the old system of *vodu* societies. They borrowed the names and iconography from their neighbours to the east and west, but they subsumed *mami wata* under the divinity *da*, the *vodu* of money, traders, precious stones and pearls, who is pictured as a rainbow or snake.[38] Also assigned to this pantheon was *ablo*, the *vodu* of the sea who once presented his followers with a pot which constantly refilled itself with cowrie shells as fast as it could be emptied.[39] A whole row of old deities now appeared in *mami wata*'s entourage, all equipped with the attributes of modernity: *mami-densu*, *mami-tohosu*, *mami-ablo*, etc. As a consequence of an extreme syncretism, this pantheon also appears simultaneously in a Hindu version as *mami-vishnu*, *mami-rama*, etc., while the Christians equate *mami wata* with the Virgin Mary and assign *mami-josef*, *mami-jesuvi*, *mami-gabriel* and other saints and angels to her entourage.[40]

The impressiveness of the images used in these cults has certainly nothing to do with their aesthetic quality, but rather results from the heterogeneity of the visual sources which are mixed and pieced together to produce the forms and motifs – an eclecticism which even eclipses their religious syncretism. The old *vodu* societies of the Ewe already had a wealth of sculptures made of clay and wood, but these were less finished and also stylistically derivative from the Akan to the west and the Fon to the east. These old influences, which never became integrated to form an independent style, were augmented in recent times by printed works from India

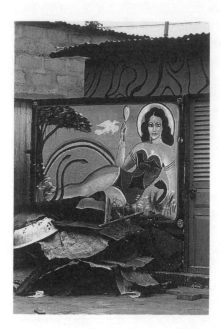

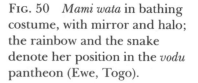

FIG. 50 *Mami wata* in bathing costume, with mirror and halo; the rainbow and the snake denote her position in the *vodu* pantheon (Ewe, Togo).

or Europe which were reinterpreted as emblems and portraits of *mami wata* and copied in murals and sculptures.

In the *mami wata* societies of the Ewe, we find once again the Hamburg poster of the "woman snake-tamer", as well as the other favourite, the "northern" nixie motif. Three-dimensional replicas in wood or cement, brightly painted with car lacquer, show a European woman, either cake-icing white or sugar-mouse pink, with black or golden hair, vacant eyes and a sad-looking face, encoiled by schematized snakes; sometimes in Hindu versions she has the attributes of the Indian gods, numerous arms and a caste mark on the middle of her brow.[41] Yet more curious are the murals of blonde nixies with fish-tails and ample bosoms who comb their hair in a mirror held in one hand, whom one would take for cover girls or pin-ups were they not encircled by a rainbow, an unmistakable sign that these are not modern bathing beauties but deities from the retinue of *vodu da*.[42] Hindu versions show *mami wata* accordingly with brown skin, black hair, three heads, six arms, brassière and panties.[43] Finally there are even pictures of women

236

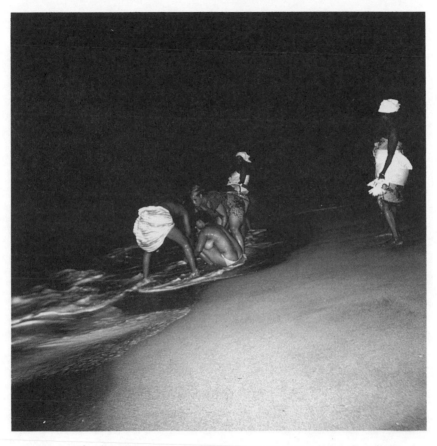

FIG. 51 The first phase of the initiation into the *mami wata* cult (Ewe, Togo).

with human legs instead of a fish-tail, taken from magazines and fashion booklets; only the bathing suits they sport trigger associations with the beach and the sea: the secularization of the cult image has reached its culmination, even though it still shows a divinity of the possessed (see Fig. 50).[44]

The festival of *mami wata*, which serves primarily the initiation of girls and women, reveals the same ambivalence, for it celebrates both the ocean of myth and the world of luxury. Once again the possession announces itself to girls and women, rarely men, in dreams, illnesses or afflictions which prompt the person to visit the

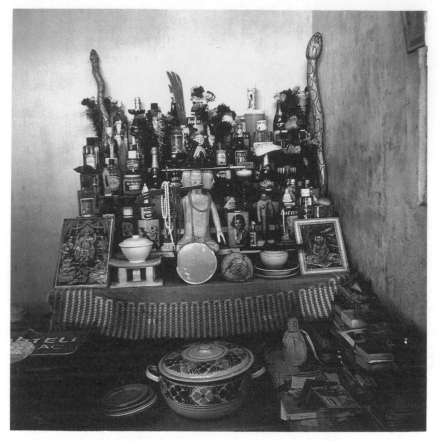

FIG. 52 Altar of the *mami-wata* cult (Ewe, Togo).

local meeting of the *mami wata* congregation and, if the lady diviner confirms the diagnosis, have herself purified and initiated. The initiation follows the customary pattern, but because it has been incorporated into the *vodu* cult, the novice does not wear a costume; rather her upper body is bared and whitened with kaolin. Part of the initiation takes place by night on the beach, where the novice stands in the surf, her face to the sea, and is doused with water (see Fig. 51). While this rite, which is reminiscent of the "look into the depths" of the *mengu* cult, binds the possessed woman to the natural power of the sea, the communal feast of the initiates links her with the luxurious table manners of the Europeans and the rich.

This ritual meal of European food, which we have encountered in so many cults of spirit possession, takes place within the *mami wata* society. A white cloth is spread on the table, and as far as possible the initiates are served European dishes which they eat with knife, fork and spoon, also drinking expensive liqueurs and smoking cigarettes. An integral part of the ambience is an altar, which, following the model of both Christian altars and shop window displays, is cluttered with all manner of real or presumed luxury goods: on top of the altars are toys and plastic dolls, flowers and aromatic candles, chinaware and liqueur bottles, cakes, sweets, fruit and coffee, face powder and costume jewellery (see Fig. 52).[45]

7

Trans-Saharan comparisons

of mimesis

Alien spirit possession and ethnography

The "acephalous" masquerades and cults of spirit possession, in which Africans portrayed the "other" to their own respective cultures, did not fulfil a homogeneous task; they served to heal and divert, to criticize divergencies and to legitimate them, to fuse to a festive oneness and to differentiate the individual from his corporate group; they became the richest expression of sequestered women's cultures, and they created the distance needed by hunters and diviners, healers, women potters and hair-dressers to pursue their professions; they fixated alien phenomena, raising them to the status of types and making them part of their own tradition; they discovered the figures which art then drew on for the masks and sculptures, so as to place them once again at the disposal of the cult. Their unity lies not in some function, but rather in their representational character and their concept of reality. It is not possible to explain them from the perspective of some institution in our own society based on division of labour, for they are always both more and less than therapy, art, entertainment, social criticism, profession, fashion or ethnography.

One aspect, namely the encounter with the "other" to one's culture, appeared, however, in all of these perspectives; the spirit hosts always felt the need to represent an "other", and with that their own otherness, and acknowledge it in ritual. Since we name this "other" a foreign culture, it is obvious to compare the "acephalous" cults with our own ethnographies, which also deal with

foreign cultures. A comparison of this sort cannot make any contribution to explaining the phenomena discussed here, but it can specify the way their own special qualities are determined, and pave the way for a final assessment of their value.

If one surveys modern ethnography, as it was founded by Malinowski and viewed until recently as altogether exemplary and binding, one finds that it has scarcely any points in common with the cults of spirit possession; the sobriety of the one contrasts with the ecstatic climax, the rapture of the other, analytic differentiation with impoverished eclecticism, dryness with dancerly verve.

The maskers and spirit hosts seized on seemingly arbitrary details: an article of headgear, the colour of a piece of cloth, a gesture, an inflexion in the voice, above all food and table manners. This patently arbitrary approach, which is at most oriented to the spectacular, comes closest to the likewise arbitrary collections of observations on customs and manners which were common among nineteenth-century travellers. From the curio gallery to the ethnographic museum, Europeans assembled the artefacts which the spirit hosts either worked directly into their costumes or copied using other materials. Neither made any connections between these details, both removed them from their social and cultural contexts. Only now with modern ethnography has the collection of details come to be placed in the service of a systematic analysis of the whole.

From the perspective of modern ethnography, the eclecticism of the spirit hosts seems just as primitive and pre-scientific as the omnia-gathera of the nineteenth-century ethnographic collectors. Seen in reverse, one could object that modern ethnography categorizes what it observes in a system which, however stringent it might be, is never completely removed from the sphere of theoretical wranglings; the ecstatic dances and their figures gain in comprehensibility and acquire a binding character, while modern ethnography has not yet managed to reshape the modern in terms of its "other", for the way the visible is subordinated to system involves renouncing its plasticity. One cannot get rid of the suspicion that the contradictory nature of experienced reality is suppressed during the analysis.

The ethnographic collectors of the nineteenth century were not aware of any devotion to the objects they collected; it is possible that they marvelled at the strange and curious things they encountered, but the ideal of scientific positivism excluded the concept of the wondrous. Perhaps these ethnographers did collect with passionate devotion, but it was of no consequence for either the museum archives or publications.

One tends to find an unmistakable admiration for the "savages" more among the champions of the Enlightenment – and their opponents – in the eighteenth century. But the "savage" of the eighteenth century was very much a projection of the bourgeoisie which wished to distinguish itself from the nobility, and a continuation of the classicist ideal; his image depended least of all on actual encounter; their admiration was for a figure which had been already preparing to assume leadership for some time.

Before the Enlightenment, the marvellousness of the "other" could occasionally be recognized and acknowledged just as much in Europe as in Africa. Thus, for instance, a journey to Europe by a Japanese delegation in 1585 triggered a veritable shock among the common people; the strangers were touched with hands and rosaries as if they were holy relics; and in a report published in 1687 on the journey undertaken by a Siamese legation we read: "All who visited these ambassadors [...] returned completely filled with their spirit."[1] Often such devotion to the strange and marvellous will have been hindered by the Inquisition, for it even persecuted foreign religions as heresies. And with the psychologization of this feeling of being "full of emotion" and the secularization of spirit into culture, the basis for a devotion or dedication of this sort – comparable to the African way of tackling the "other" – to the spirit of a "foreign ambassador" was lost once and for all.

Various currents of the "baroque" – or "alternative" – ethnography, which has attempted to work against the claims of modern ethnography during the last two decades, have fallen back, partly out of irony, partly filled with impassioned enthusiasm, on a view of the "other" whose assumptions were undermined by the Enlightenment. I would like to focus here on two attempts within this heterogeneous mass which in a way come closer again to alien spirit

possession: the postulate of devotion, which already appeared once in neo-Romantic ethnography, and the substitution of the scientific representation of foreign cultures by the performative.

The modern ethnographer, who, for the duration of his field research, is largely isolated from his own culture and adapts himself with greater or lesser success as a stranger – but not as a representative of a foreign culture – to the social and cultural life of the other, will not always maintain the cool, sober distance which is expected from him as a scientist. At first he will not recognize any structures whatsoever, but rather figures which impress or repulse him, which fill, move or possess him.

> But field work means that the anthropologist does not even have the chance slowly to approach a reality and carefully to set up an observation post, *but rather he himself will typically be overwhelmed by the reality and will have to see how he can best come to terms with it.* Here "participant observation" is not some peaceful activity in which one carefully prepares the best way of approaching one's subject; here nothing can be predicted in advance, indeed the decisive skill for the observer is the ability to let oneself in for surprises. *With that, being overwhelmed becomes something of a permanent state.*[2]

There is no contesting the fact that such an experience of confusion, indeed an experience of being truly overwhelmed and moved which accords precisely with the *passiones* of the African alien spirit hosts, often determines the course of a field study, so that completely unforeseen events will lead the anthropologist to follow new trails. The methodological postulate of *empathy*, which is sometimes related to such experiences, is not, however, without its problems. In keeping with a tradition founded by Herder and continued by Romantic mythology and Adolf Bastian, Leo Frobenius, especially, raised "being moved" by foreign cultures and empathizing with them, understood here as "looking intuitively", to the principle of a "paideumatic" ethnology or cultural research. Academic anthropology, however, never accepted this approach, for as long as the "gestalts" remained untested by observation of the

facts, which Frobenius rejected, they remain ethnocentric projections.[3]

Outside of this neo-Romantic tradition, one still often finds reminiscences of the experience of being moved or obsessed in ethnographic field research in metaphors and ironic alienation, and these testify to at least a *fractured* relationship between scientific ethnography and the spirit hosts' experience of strangers. Thus already Malinowski liked to present himself as the "spokesman" for the Trobriand Islanders and let "others speak through his mouth".[4] And I.M. Lewis has forwarded even more explicit parallels between the shaman, who for him is identical with the spirit hosts, and the ethnographer:

> Like shamans, anthropologists go on trips to distant and mysterious worlds, from which they bring back rich stores of exotic wisdom. They mediate between their own group and the unknown. They speak in "tongues" that are often unintelligible at home, and they act as mediums for the alien cultures through which they roam and which, in a sense, they come to incarnate.[5]

If one concedes that a part of modern ethnographic *experience* can be directly equated with the *passiones* of the "acephalous" cults, the difference between the two culture-specific modes of mental and emotional *assimilation* will become all the more apparent, and especially when one does not orientate oneself to the superficial difference between written discourse, on the one hand, and dance, masks and cult figures, on the other, but takes rather one of the admittedly rare "performative" versions of the modern ethnography by way of comparison.

In 1982 Victor Turner, who had already developed the conception of *social dramas* in the 1950s in order to add vividness to his descriptions of structures, published the results of his experiments with American actors who performed the rituals of the Ndembu, which he had studied in the field, on a New York stage. He rewrote parts of his ethnography as playscripts, so that actors who otherwise merely "take the role of the other" in their own culture could for once "get inside the skin of members of other cultures".[6]

Although externally this "performative" ethnography might well resemble the rituals of alien spirit possession, naturally Turner did not act here as a "medium for those alien cultures"; the "rich stores of exotic wisdom" consisted rather of the structural analyses of the Ndembu with which he provided the actors, and in fact they ended up concentrating on the matrilinear structure of this society, which they interpreted in a feminist way. The actors saw the rituals, in which the Ndembu portrayed their own social relationships, as the best way of getting into the Ndembu life- and world-feeling, as conversely the Africans have so often placed the rituals of the Europeans, their table manners and their military ceremonies, at the centre of their possessed representations of European cultures. But even these rituals were discussed at length, both in the light of the actors' own conceptions and experiences of "belonging together," as well as Turner's analysis of the matrilinear *structure*.[7] The final corrective in all these processes could only be ethnographic analysis, and here the contrast between the ways the spirit hosts and science tackles foreign cultures becomes tangible in the extreme: the alien spirit hosts took – or were seized by – gestures, articles of national dress, ways of moving, etc., which they adopted and transformed into a dance or a masquerade, without ever wondering about their meaning, while right from the start the "performative" ethnographers searched for meaning and context and thought about the nature of the other in order finally to be able to see themselves in it.

By submitting even "performative" ethnography to the programme of slipping *"inside"* the skin of the stranger, combined with self-revelation, Turner was working completely under the spell of a specifically modern type of confrontation with the other in which, as Hegel wrote, the European spirit wishes to *recognize itself*:

This is a different style of acting from that which relies on superb professional technique to imitate almost any Western role with verisimilitude. Schechner aims at *poiesis*, rather than *mimesis*: making, not faking. The role grows along with the actor, it is truly "created" through the rehearsal process which may sometimes involve painful moments of self-revelation. Such a method is particularly appropriate for anthropological teaching because the "mimetic" method will work only on

familiar material (Western models of behaviour), whereas the "poietic", since it re-creates behaviour from within, can handle unfamiliar material.[8]

With this, the contrast between the modern, theatre, which comprehends itself as "creative", and the mimesis of the masquerades and cults of spirit possession, which are oriented to external, visible and unquestioned phenomena, is shown just as poignantly as that between the ritual acknowledgement of the "other" to one's culture in the African cults and the process of analysis and systematization in modern ethnography: here we are dealing not with a difference between art and science, but rather with divergent forms of self-interpretation via the other.

Mimetic and rational action

I have attempted to make the contents, the functions and the societal contexts of the African "acephalous" masquerades and cults of spirit possession slightly more comprehensible. Seemingly comprehensible were, for instance, the relationships between the actual contents and the social composition of the cults, between the women's cultures and the figures which were represented therein, and which gave form to the world outside of the women's culture; or between the young men and the masks they danced, and which allowed them to empathize playfully with the roles that society's rules prevented them from assuming in reality. No less comprehensible seemed to be the fact that no one had themselves initiated into a cult of spirit possession without there being some necessity to do so; oppressive, recurring dreams, affliction, sadness, apathy and sickness were the grounds for initiation, and there can be no doubt that the swing from suffering to the ecstasy of costumes and dances had healing power. At the same time the initiation created a distance to society, by which the individual could develop special, distinguishing gifts and pursue a special profession. It was necessary to show such configurations, for otherwise the material which has been transmitted to us would remain nothing more than an accumulation of details.

But none of these configurations is able to explain why in fact masquerades and possession are practised in any given society. The functions which here and there have become attached to the cults are nullified by their very number; the therapeutic function is too unspecific to explain the ritual practices; only seldom is there a stringent connection between specific illnesses and the figures which are represented, namely when a trauma is overcome by a new figure; later the figures free themselves from their original contexts and become available for any desired initiation; in the end one can even be initiated because a relative is sick. The secondary character of the functions becomes even clearer where masks and possession are used as badges for professions or to solicit for brothels or political parties. On occasion professionally linked possession turns out to be a source of income, and sometimes women bury rivalries by being initiated into a cult; occasionally women also exert pressure on their husbands by having themselves declared as possessed. Such manipulations are a factor in all institutions, but explain none.

When the explanations cancel each other out, and secondary aspects are made central or prove to be mere rationalizations – such as when women are accused of jealousy and diviners of swindling – the one remaining possibility is to view the practice of the masquerades and possessions in the "acephalous" cults as non-purposive behaviour, whereby this or that purpose, this or that function or aim, can obviously come to be attached to it. But this means that we must accept that this practice is as such "irrational", even though it appears in contexts which are otherwise determined by rational actions. Ethnographically speaking, this interpretation does full justice to the self-conception of the spirit hosts, who understand their possession not as rationally expedient or intrinsically worthwhile, but rather as the consequence of a compulsion exerted on them by the "powers". Yet there remains one last difficulty for us in understanding the "acephalous" cults, namely the fact that, for modern consciousness, "irrational" actions are legitimate only as art, and are thus "creative", while "creativity" has absolutely nothing to do with the self-conception of the spirit hosts. For this reason I would like to go back in the European tradition to the

concept of mimesis, as a quintessence of the "irrational" in which we find no contradictions between "creativity" and "possession".

Victor Turner's contention that the actor can get into the role of a stranger from a different culture only by an inner assimilation which reflects one's own identity, and not by mimesis, is based on an unrecognized ethnocentricity, namely the verdict which modern thought has passed on mimesis. The "correct" assimilation of a foreign culture appears to him to be *poiesis*, understood as a "creative process", because mimetic behaviour is disparaged from the start as inferior "copying". It is useful to remember that as long as art was seen as *téchne*, it was supposed to be the mimesis of nature, and that naturally the *imitatio Christi* was never understood as some form of aping.

We have already seen that modern artists discovered African art for themselves in precisely that moment when they were radically disassociating themselves from the classical formulation of an "imitation of nature"; from their viewpoint African sculpture *appeared* especially "creative", partly because they largely preferred to look at the "more abstract" forms, and partly because they overlooked its proximity to nature because it was formulated in an alien manner. We have been able to show that African art sometimes strived towards verisimilitude, as in the art of the spirit hosts and in court art, and sometimes, above all in the art of the ancestors, had to avoid verisimilitude. The explicit or explicable reasons for avoiding verisimilitude turn out to be in part magical awe, and partly the dictates of idealization or abstraction which were involved in the purging of personal characteristics from the transfigured ancestors. While modern art's renunciation of mimesis originated in some assumed inadequacy in nature, which in turn was paralleled by a technological processing of nature, African abstraction originated ultimately from a view of necessary contradictions which can be resolved only in the ideal world, and not the real one. But conversely African mimesis is rooted not in a belief in the exemplariness of nature, as is the European version, but rather in the aims of confining spirits or allegorizing.

Spirit possession, especially in the "acephalous" cults, can be understood in terms of the concept of mimesis even better than can

African sculptures. Possession is experienced not merely as non-independent action, but in fact as an express compulsion to "imitate", to resemble an other which is different to the subject and which wishes to be represented. Although this "other" is considered to be not the visible reality as such, but rather "spirit", here "spirit" is understood as an "image of a *passio*", as a piece of reality which has detached itself and become independent, often being that which makes the visible entity the member of its class. The spirit host seems to have ceased to be his self; he acts and speaks *as an other*; and precisely this is also the oldest and probably most original distinguishing feature of mimesis in the European tradition.

Mimesis, "imitative representation" as opposed to simple narration, which, however artful it may be, uses indirect speech, is what Plato in Book III of the *Republic* (392d–398b) names the attempt to "make one's manner or voice similar to another", the form of a delivery in which the person speaks "as if another were the speaker". This definition had been culled from certain passages of Homer and from the masked comedies and tragedies, but it applies even more accurately to the speech of the spirit hosts, which may once have preceded the epos and the play.

Plato was also the first to recognize the irrationality and lack of reason behind mimesis, and formulated the irreconcilable contradiction between mimetic and rational acts. His verdict on mimesis, stated at its clearest in Book X of the *Republic*, where mimesis is spurned as being "at the third remove from reality", was also a factor in the later treatments of the Aristotelian arguments for mimesis, and in some respects it found its completion in the modern idea of the creative individual.

In the preliminary discussion of mimesis in Book III, Plato criticizes the non-identity of the person who acts mimetically. As he shows with the poets and actors of the tragedies and comedies, there must be a relationship between the character of the performer and his figure, for otherwise there would be no differences in suitability for various roles. From this it is concluded that the performer's character is shaped by that which he represents – which is similar to the belief held in spirit possession cults that the

spirit moulds the character of its medium. According to Plato, one should not imitate the noble, but attempt to be noble oneself. One would therefore expect that the representation of ignoble characters would in a way rule itself out of its own accord, for it would augment or even produce bad characters. But significantly enough, at this point Plato lists a whole catalogue of "ignoble" roles which is quite superfluous to the development of his argument. This catalogue seems like a sudden irruption of reality in a utopian debate; it stands on the same footing to the ideals which are being championed as do the inventories of a *zar* or *bori* cult.

Men should portray neither women, neither young nor old, neither a sick woman nor one in love or in labour, neither maids nor men servants, and neither cowards nor madmen; also neither men in the act of smithying or engrossed in handicrafts, nor rowers in warships and their commanders, nor "neighing horses and roaring bulls and bubbling streams and roaring seas and thunder". But a list of this sort speaks for itself; it actually vouches for the attraction exerted by an everyday and natural reality by accusing the latter of ignobility, of being a degenerate form of the idea, and condemning its mimesis, with which it is partly involved, as contrary to reason.

The interpretation of the alien by mimesis

Fundamentally, mimesis means conforming with something else or an other; hence it would be obsolete in social structures which consider themselves to be essentially homogeneous. A person who presents himself as a fellow clansman is not representing some other, but basically that which makes up his social identity and that of all his clansmen. Although he is not really identical with his fellow clansmen, during the clan rituals he merges with an ideal – that which he should be and not merely portray. In mimesis, on the other hand, one conforms with something one is not and also should not be. Hence a generally recognized difference of some sort between the portrayer and the portrayed is an absolute prerequisite for mimetic behaviour.

Although in culturally homogeneous societies which have no division of labour one finds differences based on sex and age – and also distinctly different characters – the objects of mimetic representations are selected chiefly from the extra-human world, above all animals, "copying" their appearances in costumes, masks and dances. Anthropology has advanced various hypotheses over the years in the attempt to make these animal representations comprehensible; it has interpreted them as expressions of the fear of the unknown, as hunting magic, as totemism, as expressions of the belief in the transformation of people into animals. But if one looks at mimesis as a basic form of human behaviour which is not primarily purposive, one is struck first of all by the fact that in such homogeneous, segmentary societies it is the highly dissimilar animals which inspire mimesis and not the highly similar people. Despite their differentiation according to sex, age and character, the people in these social forms are familiar with one another; there is no need for any mutual interpretation by mimesis, and in some cases there are overt prohibitions on the production of likenesses, which show that the mimesis of kinsmen would be understood as aggression. But the figures of animals are overwhelming, they seem to compel the humans to mimesis.

We have seen that the mimesis of other people comes about when cultures mix, when someone lives in another society as a stranger, and where a society comes in contact with other cultures through the strangers it has accommodated. In some respects the "difference" between two people of the same age and sex who are strangers to one another is, even if not actually measurable, certainly no larger than that between two people taken at random from a homogeneous society; but they are not familiar with one another; they are not subject to any mutual restrictions regarding the production of verisimilitude, so the unfamiliarity of the other can overwhelm and compel mimesis. A figure comes into being which interprets the other by means of mimesis, then becoming autonomous so that it can be adopted by others and introduced into the inventory belonging to their tradition. Should one enter a social relationship with the strangers and their strangeness disappear, mimesis becomes obsolete and is replaced by social practice; the invented figure can now survive only outside of this relationship.

A similar constellation appears in heterogeneous political sys-
tems which either amalgamated once differing cultures, and in
which various social milieux have come into being through indus-
trialization and the division of labour, or which have become
differentiated as a result of historical crises, religious revivals or
conquests. Thus, for instance, the Islamization and colonization of
the Hausa led to a women's culture being placed outside of and
becoming alien to public life, so that the latter had to be given form
by mimesis; and with the emancipation of this women's culture, the
bori cult could be invested with a political function. Not least as a
result of a global expansion in modern means of transport, the
nineteenth century saw an immense acceleration in both cultural
intermingling and the differentiation of social milieux, which were
accompanied in Africa by a wave of mimetic cults. This wave ebbed
to the degree that the process of intermingling finally led to a
general levelling-out.

In a homogeneous society, the types which are handed down – not
only in the visual arts, but also in tales, songs and dances – from one
generation to the next distinguish themselves by a high degree of
permanence and stylistic consistency. It was admittedly an illusion
to think that these societies were locked in immutable, archaic
forms. On the contrary: the very lack of a written tradition and the
preference for ephemeral materials, such as wood and clay, in the
plastic arts allowed a constant revision of the represented types and
forms, while the class societies of the advanced cultures, such as the
Egyptian, allowed them to stagnate in monuments and texts. But
these revisions tended to affect the details more than the actual
types themselves, the way they were fashioned more than the
overall style.

The realism with which animals were represented in such soci-
eties, such as in rock paintings, still astonishes; it accords with the
realism with which animals are represented in costumes and
dances. The human figure, however, is often subject to prohibi-
tions on verisimilitude; the ancestral portraits especially, which are
kept hidden away, are abstractions and must be so because they
represent not the real, living human beings but a purified ideal free
of personal characteristics. Faced with this task – or under this

compulsion – to discover the specific type of a foreign culture, or indeed of a foreign race, i.e. reducing the diversity of its visible manifestations to its "essential nature" or "spirit" and representing it in dance, in masks or cult objects, the dancer or artist cannot simply fall back on his inventory of conventionalized types and stylistic forms; he is relieved of the rules of abstraction and the prohibition on verisimilitude, and may, indeed must, leave his normal canon. The observed reality begins to penetrate the relatively closed universe of that culture which observes or feels itself overwhelmed.

The images which a homogeneous culture dances, drums, narrates and carves are closely interwoven with its everyday world. This is because they originate in it, and unite and concentrate its self-image, its hopes and fears, within themselves, and also because they react in turn to the lived reality. The stranger has a different universe of images which stamps his appearance, his habits and way of behaving; hence his representation demands a mixture of styles and types which has something broken and contradictory about it. The break with the canon is a break with the aesthetic ideal, and while perhaps uncertain and vacillating, it is thus also closer to the reality.

From these considerations it follows that epochs of cultural intermingling are the most likely to break with the canon and produce realistic representations, though admittedly the canon may well survive alongside the new realism. We have seen that this was the case in the African spirit possession cults, masquerades and cultic figures of the late nineteenth and early twentieth centuries. It is probable that this realism was preceded by similar epochs of realism in those societies which were already culturally heterogeneous, or were in contact with strangers, before the colonial period, though unfortunately the historical material is insufficient to corroborate such a thesis.

But the notion of an intimate connection between cultural intermingling and mimesis, absorption of alien everyday worlds and realism, does hold in the European history of art and letters. As Erich Auerbach has shown, realism in Western literature rose from the break with the doctrine of decorum which was evoked by the

story of Jesus, in which the everyday mixes with the tragic.[9] The interpretation of the real by literary mimesis reached its first peak in the Middle Ages, a second in the nineteenth century. An inner connection between mimesis and the experience of the alien becomes particularly tangible, however, in this second epoch of European realism.

The novels of Stendhal and Balzac were written at a time and in a historical setting in which, as a consequence of the Revolution, the classes and estates were beginning to come in contact in a previously unknown manner. Any person could rise just as rapidly as he might fall, so that the whole of society, with all its highly varying milieux, could be shown through one individual fate.

In the realistic novel, as in African spirit possession, it is a question not of some rational understanding of systems and cohesion, as is true, say, of modern ethnography, but rather of suggestive, intuitively grasped images which overwhelm the author, whether of the text or of the dance. Thus Auerbach writes of Balzac:

> The lack of system and the inattention to rationality in the texts are consequences of the haste with which Balzac wrote. Yet they are no accident, for this very haste is to a large extent the result of his obsession with suggestive images. The motif of the discrete milieu moved him with such a force that the objects and personalities which form a milieu often take on a secondary significance for him which not only differs from that which is grasped rationally, but is also much more fundamental: a significance which can best be described with the adjective "demonic".[10]

This description can be applied without reservation to the *hauka* cult, for instance, which portrayed the milieu of the colonial rulers not in terms of their rational order, but rather on a "demonic" level which has become independent in the form of "spirits", which were quite simply the images of *passiones* by which the performers were possessed. And just as the *hauka* came and watched the French and English military ceremonies in order to gain "inspiration" for their cult, realistic writers of the nineteenth century, the Goncourt

brothers or Zola, went to the workers' quarters and the coal pits in order to study and depict alien social milieux.[11]

Auerbach was convinced that the possibility of unravelling an alien social milieu had already disappeared by the onset of the twentieth century.

> The social strata and their various forms of life have been jumbled up, and there are no exotic peoples any more; a century ago the Corsicans and Spaniards (as in Mérimée, for instance) still seemed exotic, nowadays the word would be fully out of place for Pearl Buck's Chinese farmers.[12]

But then the realistic novel must also level itself to the same extent that the differences in cultures or everyday worlds do; it attains global dominion, but the differentiation of the social milieux is lost. We have seen that this observation applies just as equally to the quite different perspective of African dance and sculpture; the levelling of cultures removes the exotic character not only from the non-European peoples, but even from Europe when seen from outside. The colonial period was thus not the end of African art, as is so often maintained, but more its last flowering, after which it can no longer escape the general levelling-out.

To this train of thought we can now also add the question as to the differences in the realism of African and European art with regard to the visual representation of strangers. Certainly Julius Lips's most astonishing discovery, as he compared African pictures of Europeans with European pictures of Africans and other non-Europeans, was that many African artists reproduced the European physiognomy with great exactitude, even showing nationality, professional status and character, while the European ethnographic artists produced totally unspecific figures which betrayed more of the artist's nationality than even the racial affiliation of the person drawn. This observation must, however, be rethought in a historical perspective.

Medieval European art showed the African physiognomy with complete realism; in its eyes the Moor at the Crib of Bethlehem was a *figura*, namely the representative of exotic humanity or indeed of

the very diversity of humanity itself; there was no canon to prevent mimesis of the African, his real image was in keeping with the aims of "figural" realism. This pictorial tradition ended, however, with Dürer's famous portrait of Katharina which he drew on his travels in the Netherlands in 1521. Perhaps the artists on the seventeenth- and eighteenth-century expeditions were not so much unskilled at portraying foreign physiognomies, as Lips suggests, but rather were uninterested; they guided themselves according to the classical canon – their Africans remind one of the illustrations in the anatomical atlases of the time, or baroque or classicist sculptures in a park. These artists lived on board the expeditionary ships, and not actually in the foreign cultures. At this clearly prepared distance, they did not have to be overwhelmed by any alien phenomena. But probably of greater importance here was that the audience for whom they worked had only a semblance of interest in foreign peoples; this audience demanded pictures of the noble savage, which above all had to correspond to the classicist ideal. In this they resembled in a certain way the court at Benin, which was also interested in pictures of the Portuguese only for the sake of their own glory. Just as the pictures of Africans in the Enlightenment showed idealized and costumed citizens, the court art in Benin showed the Portuguese as idealized and costumed Africans.

It seems that the idea of realism in the art of foreign portraiture first won favour only in the nineteenth century, both in Africa as in Europe, and is connected with the way cultural mixing was accelerated. Above all the *hamba* figures of the Cokwe showed us just how closely being possessed by Europeans was linked with expressive realism in sculpture. But at the same time a new type of European traveller and artist emerged, one who was deeply impressed by the African peoples and their cultures. Georg Schweinfurth produced pictures of the Bongo and other peoples of southern Sudan which were at least exact, and developed an eye for their art very early on. Although his manner of drawing, which was to some extent guided by an ethnographical eye, never caught on, no doubt this was simply because it was replaced shortly after by photography. And much later the watercolours which Emil Nolde, say, painted as an expeditionary artist in New Guinea show the true obsession which

even European artists could demonstrate in their portrayals of foreigners.

In the meantime photography, in which European realism has both found its culmination and reached a complete levelling-out, has also long since deprived the African representations of foreigners of their power, and that above all within the setting of the alien possession cults. We have seen that the central cult image of the *mammywater* cult originated from a three-dimensional copy of a European print already made shortly before the First World War; and nowadays the murals in the majority of cult congregations actually originate from photographs in illustrated magazines. As such they are more realistic than everything which has ever been produced by African art; but they are copies of a flattened reality which has lost the magic of the foreign and the exotic, both for us and, to a lesser extent, for the Africans themselves. As such they come a very poor second to the expressive figures, both danced and painted, of the older spirit possession cults, which developed from the first encounters with European or other civilizations. These alone have the quality and beauty of incunabulae. For all the levelling-out, in some parts of Africa alien spirit possession has not completely disappeared, as in the *mammywater* cult, which, with its trances, dances and initiations, still provides an independent way of assimilating modern culture. When one piles elements of the modern consumer world on an altar, or eats modern foods in ritual manner, the foreignness of the form of life in which this normally occurs cannot have been completely levelled. And however close the novice in the *mammywater* cult might seem to our beach and leisure time culture when she sits by night in the surf and lets herself be doused with water, she has still certainly not turned into a bathing beauty.

Notes

1. The Asante and the people from the grasslands

1. Cf. the catalogues Jahn 1980; 1983.
2. Cf. the figures in Jahn 1980, ill. 18, 19; 1983, ill. 44, 45, 51, 52.
3. Cole and Ross 1978, pp. 26 f.
4. Cf. Fortes 1975; Schildkrout 1979.
5. Rattray 1916, p. 142, No. 533.
6. Fortes 1975, p. 241.
7. Fortes 1969, p. 263.
8. Rattray 1929, p. 35.
9. Schildkrout 1979, p. 190.
10. On *xenos* and *barbaros* cf. Pauly's *Realencyclopädie der classischen Altertumswissenschaften*, under "Barbaren", "Xenoi"; for *ger* and *nokri* cf. Weber 1976, pp. 32–43; cf. also Cohen 1966, pp. 131–66.
11. Simmel 1908, p. 512.
12. Evans-Pritchard 1940, pp. 217 ff.
13. Cf. also Newcomer 1972.
14. Fortes 1945; 1949.
15. Fortes 1945, p. 22.
16. Fortes 1975, pp. 232 f.
17. Ibid., p. 230.
18. All centralized societies "appear to be an amalgam of different peoples, each aware of its unique origin and history. [...] Centralized authority and an admistrative organization seem to be necessary to accommodate culturally diverse groups within a single political system. [...] A centralized form of government is not necesary to enable different groups of closely related culture and pursuing the same means of livelihood to amalgamate, nor does it necessarily arise out of the amalgamation. The Nuer have absorbed large numbers of conquered Dinka, who are a pastoral people like themselves with a very similar culture. They have incorporated them by adoption and other ways into their lineage system; but this has not resulted in a class or caste structure or in a centralized form of government. Marked divergencies in culture and economic pursuits are probably incompatible with a segmentary political system." (Fortes and Evans-Pritchard, 1940, pp. 9 f.)

19. Cf. also Simmel 1908, pp. 125 ff.
20. Southall 1956, p. 202.
21. Cf. Schnelle 1971.
22. Southall 1956, p. 230.
23. Wilks 1975, pp. 308 ff.
24. Skinner 1974, pp. 8 f.
25. Colson 1970.
26. Schaar 1917–18, pp. 97 f.
27. Vedder 1923, p. 9.
28. Evans-Pritchard 1940, p. 125.
29. Gen. 9, 18–27.
30. Enderwitz 1979, pp. 26 f.
31. Tremearne 1914, p. 28.
32. Bosman 1704, p. 149.
33. Hofmayr 1911; H. Baumann 1936, p. 333; Beidelman 1963; Görög-Karady 1976; Duchâteau 1980.
34. Duchâteau 1980, p. 56; Samarin 1980.
35. Hofmayr 1911, p. 130.
36. Westermann 1912, p. 178.
37. Hofmayr 1925, p. 241.
38. Frazer 1957, pp. 352 f.
39. Ellis 1887, p. 339.
40. Cited in H. Baumann 1936, p. 333.
41. Cf. Fortes 1983.
42. Muratori 1936, I, pp. 2 f. I quote from the original here because the text is unpublished: "At that time Ajok took a shield and a rifle, and he said to the red man and the black man: 'Run a race.' They ran the race and the Black man chose the shield for himself and left the rifle to the red man. Then Ajok had the shield and the rifle returned to him and hung them once again on the tree, and said: 'Run a race and let it be a contest for those things!' And once again they ran the race, the Black man was the winner and he chose the shield for himself and left the rifle to the red man. Then Ajok told the Black man: 'This means you wish to have the shield. Here is the shield for you. Take the lances too.' Then he said to the red man: 'You are to take the rifle. Come, punish the Black men, make them carry things for you like slaves. I had thought "let the Black man take the rifle", but he did not want to. And so, come, Black men, and bear your punishment.' "
43. H. Baumann 1936, pp. 284 ff.
44. Ibid., pp. 280 f.
45. Bastian 1874, II, p. 218.
46. Hofmayr 1911, pp. 130 f.
47. Görög-Karady 1976; H. Baumann 1936, p. 333.
48. Inasmuch as the African differentiation myths actually relate to Europeans, they can only have come into being directly after the first encounter; but they do not reveal a sense of being overwhelmed by something new and unknown. Often the mythical negation of historical changes is linked with cyclical notions of time which are reminiscent of Eliade's thesis on the "myth of eternal return" (cf. Eliade 1954). "In Burundi, history is cyclical. The names of the kings form a cycle, and as one king succeeds the other, history runs its course and begins again. After a Mwaambutsa comes a Ntare, then a Mweezi, and finally a Mutaaga who precedes a

new Mwaambutsa. Each king in the cycle has an ideal character, and every fourth generation each ideal type reappears. Ntare is the conqueror who founds a dynasty, Mweezi the ruler who has to maintain his power in the face of rebels, but who is very long-lived; Mutaaga is the good but unlucky king, and Mwaambutsa the king who prepares the way for a new Ntare." (Vansina 1965, p. 104.) In the cyclical age-set system of the East African Kalenjin we find, in place of the ideal-typical character of the kings, the ideal-typical character of the eight age-sets which follow one another in an eternal cycle; all "historical events" return with each ninth age-set, and the Tugen, for example, are so consistent that for them their first encounter with the Europeans was simply a repetition of their encounter with the Sirikwa (cf.: Blackburn 1976, pp. 75 ff.; Sutton 1976, pp. 48 ff; Mwanzi 1977, pp. 26 ff.) and that the colonial era will repeat itself after decolonization (Behrend 1983). Although such an outlook on history cannot be harmonized with modern optimism regarding progress, only in this perspective does it seem "pessimistic", just like Nietzsche's philosophy of the eternal recurrence of the same.

49. Cf. Fernandez 1982, p. 70.
50. Sundkler 1961, pp. 57, 59.
51. Hegel 1955, pp. 218 f.
52. Fortes 1983.
53. Fortes 1949, p. 325.
54. Ibid., p. 327, footnote 1.
55. Rattray 1923, p. 150.
56. Cf. the analysis in Horton 1983, pp. 64–71, which I have basically followed here.
57. Cf. Fortes 1969, pp. 179–83.
58. Rattray 1927, pp. 28–30.
59. Ibid., pp. 29 f.; Debrunner 1961, pp. 101–104.
60. Rattray 1927, pp. 29 f.
61. Field 1960, pp. 87 ff. – Cf. Ward 1956; Debrunner 1961; McLeod 1975.
62. McLeod 1975, p. 112.
63. Debrunner 1961, p. 107.
64. Cf. Fortes 1945, p. 106; 1975, p. 231; Debrunner 1961, p. 107.
65. Debrunner 1961, p. 127.
66. Ward 1956, p. 52; Field 1960, p. 99; McLeod 1981, p. 148.
67. Field 1960, p. 90; Debrunner 1961, p. 107; cf. Chesi 1979, ill. 5.79.

2. Concerning trans-Saharan convergences

1. Horton 1983.
2. Ibid., pp. 74–7.
3. Ibid., pp. 50–57.
4. Naturally it has often been noted that a pair of such opposites is constitutive for African cosmologies (and probably all world pictures); only the designations vary: the contrast between nature and society "corresponds" to the contrast between the bush and the settlement (sometimes also water and land), the wilds and culture, nature and culture, the wilds and civilization. These problems have been examined from an anthropological perspective by Duerr (1985).

5. Evans-Pritchard 1956, pp. 106 ff.
6. Horton 1970; 1983.
7. Lienhardt 1961.
8. Ibid., p. 151; cf. Kramer 1984.
9. Lienhardt 1961, p. 150.
10. Cf. Weber 1968, p. 328.
11. Lienhardt 1961, pp. 151 f.
12. Benz 1972, p. 125.
13. Ibid., p. 141.
14. Ibid., p. 125.
15. Cf. Mühlmann 1972, p. 69.
16. Zutt 1972, p. 23.
17. Ibid., pp. 15 f.
18. Siroto (1976) speaks explicitly of invented spirits in connection with certain African figural representations.
19. Minkus 1980, pp. 182–4.
20. Ibid., pp. 184–5.
21. Colson 1969, p. 72.
22. Baumann 1975, p. 626.
23. A similar "essentialism" can be observed, say, in the "black" *mbandwa* spirits of the Nyoro; the Nyoro speak not of the "spirit of the Europeans", which in their language would be called *mujungu*, but rather of the "spirit of Europeanness", a *mbandwu* called *njungu*, and not of the "spirit of the Pole", *mupolandi*, but rather of the "spirit of Polishness", *mpolandi*. In keeping with this, the people possessed by a "black" *mbandwu* personify not specific individuals, but rather, as Beattie says, "the generalized force or power by virtue of which the Poles, or other Europeans, are thought to be what they are" (Beattie 1969, p. 162).
24. H. Baumann 1935, p. 194; Lima 1971, p. 347.
25. H. Baumann 1935, pp. 206 f.
26. Cf., for example, H. Baumann 1938.

3. In the grip of another culture

1. Cf. the compilation in Heintze 1970, pp. 168–90.
2. Gelfand 1962, p. 162 – cf. summary by Bucher 1980.
3. Fry 1976, p. 19; Garbett 1969.
4. Gelfand 1959, pp. 30 f.; cf. Sicard 1967, p. 46; Gelfand 1962, pp. 155, 151.
5. Garbett 1969.
6. Gelfand 1959.
7. Ibid., pp. 141–3.
8. Ibid., p. 121.
9. Ibid., pp. 139–41.
10. Ibid., p. 150.
11. Ibid., pp. 136–8.
12. Ibid., pp. 138 f.
13. Ibid., pp. 129–36.
14. Ibid., p. 143.

15. Gelfand 1973, p. 139.
16. Ibid., p. 139.
17. Ibid., p. 140.
18. Fry 1976, pp. 20 f.
19. Cf. Garbutt 1909, p. 548; Morkel 1933, p. 114; Hugo 1935, p. 52; Heintze 1970, pp. 54 f.; Fry 1976, pp. 20 f.
20. Gelfand 1959, pp. 121 f.; Fry 1976, p. 21.
21. Fry 1976, p. 22.
22. Gelfand 1959, pp. 136–8.
23. Junod 1913; Lindblom 1920.
24. E.g. Frobenius 1921; 1931; 1933; 1938, in particular p. 194; cf. also Kramer 1986.
25. Frobenius 1933, p. 296. The concepts "shamanism" and "possession" are demarcated very differently, often in the interest of certain evaluative perspectives. Mircea Eliade left out the African continent in his otherwise very global observations on "archaic techniques of ecstasy" (Eliade 1964), although his praise for shamanism is essentially no different to Frobenius's praise for African "*Ergriffenheit*". The "shamanism" praised by Eliade is not what Frobenius castigates as desertion from and rebellion against the natural order of reality. According to Eliade, the ascent into higher worlds and the beyond constitutes the core of genuine shamanic ecstasies, wherein one flees from "history". In Eliade's eyes, the world of history means roughly the same as the world of facts for Frobenius; the "archetypes" have a similar relation to history as reality has to the facts. Here as there, praise is given to turning one's back on the profane and to devotion to the sublime. For Frobenius the sublime is the subject of *Ergriffenheit* (being deeply moved), the "ego potency" the subject of decline, whereas Eliade understands ecstasy as "technique". The phenomena accompanying spirit possession, which incontestably enter into both the cults of spirit possession and shamanism, seem to both Eliade and Frobenius to be a "late" addition which has clouded or ousted an original, purer form. Picking up on a criticism of Eliade by Dominik Schröder (1953), Laszlo Vayda (1964) attempted to distinguish between shamanism and spirit possession in anthropological-culture historical terms by emphasizing the differing self-images of shamans and spirit hosts. While the shaman commands his helping spirits and sends his own soul on journeys, the spirit host experiences himself merely as a medium for an alien spirit which takes over his will or mind. This difference in self-presentation is supposed to correspond to a difference in the outward manifestation of spirit possession and shamanic ecstasy; the difference between the hyperkinesias of the spirit host and rigidity, insensitivity and lack of animation seems not "inessential" to Vayda, because "mostly the two basic forms of ecstasy can be clearly divided in terms of dispersion, cultural milieu and historical contexts" (Vayda 1964, p. 269). Vayda sees the cosmological background to Siberian shamanism as different, and in cultural-historical terms this difference in the cosmologies outweighs the fact that Siberian shamans sometimes act like spirit hosts. For the observer shamans are possessed, as Eliade admitted (Eliade 1951, pp. 85 f.), and Vadya also does not contest this. But on the other hand the question here is once again to distinguish a "pure" picture of shamanism from any later impurities: "originally Siberian shamanism seems to have been alien to spirit possession" (Vayda 1964, p. 269).
26. Bourguignon 1976, p. 19.

27. Ibid., pp. 22–4.

28. Cf. Heusch 1962; Heintze 1970, p. 5; Rouget 1980; Lewis 1986, pp. 78–93. Heusch (1962), who, like Eliade, relates shamanism and spirit possession to two specific cosmologies and forms of religion, contrasts, for instance, an "authentic" with an "inauthentic", "unwilled" and "sinister" possession. Posited at a tangent to the difference between shamanism and spirit possession is a contrast between "adorcism" and "exorcism". Authentic possession is the taking in of the spirit into the medium, and corresponds with the shamanic model, although admittedly a shaman does not take a stray soul into himself, but rather returns it to the body of his patient; inauthentic possession leads to casting out the spirit from its vessel and is seen as corresponding to the shamanic practice of removing the cause of an illness from the patient. Finally, Mary Douglas distinguishes whole societies on the basis of what she takes to be a dominant and uniform attitude to psycho-motor phenomena. On the one side are societies which have the individual in their "grip" by means of group pressure and a rigid perceptual grid; thus the Dinka are viewed as having a less rigid pattern of perception and as being exposed to little collective pressure, so that they do not repress the psycho-motor manifestations of possession, while the "collectivistic" Nuer classify perceptions rigidly, and consider the sort of uncontrolled outbursts accompanying possession to be dangerous, and attempt to stop them (Douglas 1973, pp. 119–30). Adolf Friedrich (1939, pp. 256 f.) also had a category of societies which promote possession, contrasted completely with those which hinder it; Friedrich picked up here on Frobenius's theory of "manistic" cultures which yielded themselves to reality in intense emotion (*Ergriffenheit*). *Ergriffenheit* – named "possession" by Friedrich – was genuinely part of these cultures, so that they reacted positively to these manifestations, while other cultures were shaped by "religious elements of a different kind" which hindered the development of spirit possession, so that only the "dark" side, i.e. the negative, ostracized aspect, could form.

29. Firth 1964, pp. 247 f.; 1967, p. 296; 1970, p. 178.

30. Beattie 1964, p. 229; Heintze 1970; Lewis 1971.

31. Lewis 1983, p. 179.

32. Ibid., p. 187.

33. Durkheim 1976, p. 210.

34. Ibid., p. 218.

35. Ibid., pp. 269–72.

36. Ranger 1972, p. 12.

37. Elsewhere in Africa there are, however, women who pursue specifically female professions as spirit hosts; thus beside the possessed men of the Nyancka-Humbi, who worked as hunters, blacksmiths, diviners or healers, there were possessed women who worked as hairdressers or potters. Cf. Estermann 1954, p. 9; Heintze 1970, p. 15.

38. Krapf 1858, p. 294. Cf. with Krapf: Southall 1979.

39. Krapf 1858; O. Baumann 1891; Werth 1915; Skene 1917; Koritschoner 1936.

40. Velten 1903, pp. 185, 205; Skene 1917, p. 422.

41. Gray 1969, p. 174.

42. Lindblom 1920, pp. 229, 234.

43. Noble 1961, p. 52.

44. Lindblom 1920, pp. 239 f.

45. Parkin 1970, p. 225.
46. Harris 1957, p. 1048.
47. Faulkingham 1979, p. 1.
48. Messing 1958, p. 1122.
49. Westermann 1912, p. 178.
50. Krieger 1967, p. 97.
51. Ibid., Table 19.
52. Ibid., Table 22.
53. Ibid., Table 23.
54. Ibid., Tables 30, 9.
55. Ibid., Table 8, p. 110.
56. Ibid., pp. 110 f.
57. Ibid., pp. 112 f.
58. Ibid., p. 111.
59. Ibid., p. 97.
60. Onwuejeogwu 1969, pp. 293–5.
61. Ibid., pp. 293–303.
62. Ibid., p. 290.
63. Ibid., p. 286.
64. Ibid.
65. Tremearne 1914, p. 157; for an opposite view, see P.G. Harris 1930.
66. Onwuejeogwu 1969, p. 292; cf. also Besmer 1977.
67. Haberland 1960, p. 143.
68. Lewis 1969, p. 205.
69. Ibrahim 1979, p. 173.
70. Messing 1958, p. 1122; Leiris 1958, Chapter 2.
71. Ibrahim 1979, pp. 172–5; Zenkovsky 1950, pp. 70 f.
72. Cloudsley 1983, p. 70.
73. Lewis 1971, p. 204.
74. Onwuejeogwu 1969, p. 290.
75. *The Birth of Tragedy*, section 8.
76. Klunzinger 1877, pp. 388 f.; Littmann 1952, p. 58; Simon 1975, p. 254.
77. Cf., for example, Kahle 1912, p. 23.
78. Ibrahim 1979, p. 175; Noble 1961, p. 51.
79. Beattie 1969, p. 161.
80. Colson 1970, p. 36.
81. Colson 1960, pp. 122–61; 1962, pp. 1–65.
82. Colson 1969, pp. 71 f.
83. Ibid., pp. 70, 73–8.
84. Ibid., pp. 83, 95.
85. Ibid., pp. 79 f., 86. This way of behaving towards modern technology is very widespread and characteristic of the sychronicity of traditional ecstatic techniques and modern technology; a dismaying example was the "shamanic" mimesis of the atom bomb of Nagasaki (cf. Kramer 1983, p. 113).
86. Colson 1969, pp. 85 f.
87. Ibid., pp. 91, 94–102.
88. Ibid., p. 86.
89. Colson 1967; 1969, pp. 85 f.
90. Colson 1984, p. 11.

91. Junod 1913, p. 436.
92. Gelfand 1954.
93. Ngubane 1977, pp. 142–4; Sundkler 1961, p. 23.
94. Ngubane 1977, p. 142.
95. Sundkler 1961, pp. 21 f.
96. Ngubane 1977, pp. 144–50.
97. Sundkler 1961, pp. 248 f.
98. Sartre 1967, p. 7.
99. Ibid., pp. 15 f.
100. Cf., for example, Rotberg 1971.
101. Gwassa 1972, pp. 204–15. A similar, if more restricted, movement, whose prophet was likewise possessed by a giant snake, was the Mumbo cult by Lake Victoria (cf. Wipper 1977, pp. 23–85).
102. Ranger 1967, p. 213.
103. Ibid., p. 215.
104. Ranger 1975, p. 9; Mitchell 1956, p. 2.
105. Fernandez 1982, p. 299; Binet 1972, p. 128.
106. Fernandez 1982, p. 297; Binet 1972, p. 27.
107. For the sociology of fashion cf. Simmel 1983, pp. 26–51.
108. Fernandez 1982, pp. 296 f.
109. Magubane 1971.
110. The anarchistic element which could be found in the cults of spirit posses- sion before and during the colonial period has been especially emphasized by Lewis (e.g. Lewis 1971, p. 117). Authors who are primarily interested in the "collapse" of traditional structures or in the "colonial situation" tend, on the other hand, to contrast the cults during the colonial period with the "harmonious" pre-colonial cults of spirit possession as an expression of social disintegration. Thus, for instance, Bleyler, who sees nothing else being expressed in alien spirit possession cults but the inability to digest the changes and irruptions caused by colonization and social change; according to his thesis the alien spirit hosts would be at the complete mercy of the uncontrollable forces of the colonial rulers, while the "mediative spirit hosts" – i.e. the charismatic mediums – would have controlled and balanced all anti-social powers (Bleyler 1981, pp. 69–76).
111. Cf. Herskovits 1938.
112. Cf. Burton 1961, pp. 173–7.
113. Rouch 1960, pp. 73–7, 133 f.
114. Rouch 1954–55; 1983, pp. 217–28.
115. Rouch 1960, p. 207.
116. Ibid., p. 134.
117. Cf. Eaton 1979, pp. 5–7; CinémAction 1980, p. 7.

4. In the masks of strangers and the dead

1. Sousberghe 1959, pp. 83 ff.; 1960, p. 521. Cf. the key whistles in Krieger 1965–69, III, ill. 193; Kecskési 1982, ill. 322; cf. also Lips 1983, p. 154.
2. Sousberghe 1959, p. 4.
3. Cf. Curnow 1983.

4. Torday and Joyce 1922, p. 334.
5. Olbrechts 1946, p. 49.
6. Kjersmeier 1936, p. 22.
7. Sousberghe 1959, pp. 29–32, 72; Kibango 1976.
8. Sousberghe 1960, p. 505.
9. Turner 1969, p. 82; Leach 1961.
10. Sousberghe 1981, p. 18; Kibango 1976, p. 2.
11. Sousberghe 1963, pp. 53 ff.; Munamuhega 1975, p. 143.
12. Sousberghe 1956, pp. 4–8; 1959, p. 35.
13. Sousberghe 1959, p. 30; Mudiji-Malamba 1979.
14. Sousberghe 1959, pp. 56 f.; Gangambi 1974; Munamuhega 1975; Röschenthaler 1985, pp. 89–94.
15. Sousberghe 1959, p. 40.
16. Ibid., pp. 40 ff.; Röschenthaler 1985, pp. 95 f.
17. Sousberghe 1959, p. 49; Röschenthaler 1985, pp. 98 ff.
18. The bird-catchers of the Dinga: Sousberghe 1959, p. 33; the itinerant diviner of the Dinga: ibid., pp. 52 f. (this mask also appeared on the cover of the first publication on African art, Carl Einstein's *Negerplastik*; see Einstein 1915); the slave: Munamuhega 1975, p. 53; the pygmy: Sousberghe 1959, p. 54; the stranger: ibid., p. 52; Munamuhega 1975, pp. 12, 85; the dirty white man: ibid., p. 275; the missionary: Gangambi 1974, p. 83; the industrious Dinga, the uncouth Yaka: Munamuhega 1975, pp. 331 ff.; Gangambi 1974, pp. 123 f.; the various figures: Röschenthaler 1985, pp. 72–6, 86.
19. The industrious Dinga: Munamuhega 1975, pp. 331 ff.; the wood-cutter: ibid., p.183; Gangambi 1974, p. 118; the buffalo, the old woman: Munamuhega 1975, pp. 291, 223; the old spinster: ibid., p. 321; the sick pig: ibid., p. 173; the cannibal: ibid., p. 271; the dirty Yaka: ibid., p. 108; the itinerant diviner: ibid., p. 261; – cf. the compendium by Röschenthaler 1985, pp. 102 f.
20. Sousberghe 1960.
21. Sousberghe 1959, pp. 6 f.; Röschenthaler 1985, pp. 24 f.
22. Sousberghe 1960, pp. 517, 521, 525.
23. Sousberghe 1959, p. 65; 1960, p. 519; on the dispersion of these "therapeutic" masks cf. Bastin 1984.
24. Sousberghe 1959, p. 45; Röschenthaler 1985, p. 9.
25. Sousberghe 1959, p. 11; 1960, p. 512; Röschenthaler 1985, p. 48.
26. Sousberghe 1959, p. 59, n. 1.
27. Ibid., pp. 73–9; Himmelheber 1960, pp. 345–7.
28. Mauss 1975 (first published 1938).
29. Cf. Heurgon 1977, pp. 304–9.
30. Boas 1966, p. 196.
31. Caillois 1962, p. 96.
32. Ibid., p. 107.
33. Himmelheber and Himmelheber 1972, pp. 120 f.
34. Mühlmann 1981, pp. 28 f.
35. Weston 1984, pp. 157–9. The sole institutionalized female masquerade in Africa, performed by the Sande-Society of the Mende in Sierra Leone, follows the (male) pattern of initiation masks which the Pende exemplify: beside the ideals of femininity came the relief-bringing, comical masquerades in which women played

learned Muslims or leaders of the male secret society. Cf. Phillips 1978, p. 275; on the configuration of man and woman in the Sande masquerades cf. also Jedrej 1976.

36. Frobenius 1933, pp. 210, 297.
37. Ibid., p. 209.
38. Thompson 1974, pp. 126–33.
39. Messenger 1971, p. 209.
40. Ottenberg 1975, p. 11.
41. Ottenberg 1972, pp. 109–13; 1975, pp. 87–143.
42. Jeffreys 1951; Messenger 1971, pp. 216–21.
43. Ottenberg 1975, pp. 20 ff.
44. Messenger 1971, p. 213.
45. Lips 1966, p. 58.
46. Jeffreys 1951, p. 45.
47. Schoffeleers 1968, p. 362; Schoffeleers and Linden 1972, p. 261.
48. Horton 1963, p. 94; Talbot 1932, p. 309. Elsewhere the connection between the spirits of the wild and strangers could also be formulated genealogically; the comic, embellished masks of the Guro are viewed as the "children" of *gyela*, a mask which in turn is a "child" of *zamble* and *gu*; *zamble* is a male, theriomorphic mask figure who, together with his anthropomorphic wife *gu*, caught a hunter in the wild and "domesticated" him; the foreignness of *zamble*, as a power of the wild, is marked by his theriomorphic form, whereas the *gu* faces were evidently intended to "emphasize the foreign, animal-like aspect [...] by giving the face horns, or for similar reasons carving them with the physiognomy of the beautiful 'strangers', the uncanny yet beautiful women who travelled through the land [both Fulbe and Hausa]." *Gyela*, their "child", had the human face of the mother, with horns above and an additional animal mouth below from the father, while the comical masks are fashioned purely in human style and are largely not of strangers, but rather of women from their own community. Cf. Fischer and Homberger 1985, pp. 131 ff., 157 f.
49. Horton 1983, pp. 54 f.
50. Horton 1965, p. 11.
51. Horton 1969, pp. 27 f.
52. Ibid., pp. 29–31.
53. Cf., for example, Horton 1965, ill. 17.
54. Horton 1963, pp. 101 f.
55. Ibid., p. 102.
56. Horton 1969, p. 31.
57. Horton 1963, p. 98.
58. Ibid., p. 97.
59. Talbot 1932, p. 310.
60. Horton 1965, p. 9.
61. Ibid., pp. 11 f.
62. Horton 1963, pp. 100, 106.
63. Jones 1984, p. 56.
64. Horton 1965, ills 4–9. The inheritable miniature masks of the Dan also belong in this context. Cf. Fischer and Himmelheber 1976, pp. 139 ff.

5. The art of the possessed as fixation and allegory

1. Lima 1971, p. 183.
2. Ibid., p. 197.
3. H. Baumann 1935, p. 200; Lima 1971, pp. 179–89.
4. H. Baumann 1935, p. 200.
5. Ibid., p. 195.
6. Ibid., p. 201.
7. Ibid., pp. 197 f.
8. Ibid., pp. 201–6; Lima 1971, pp. 203–89.
9. Hunting dog and lion: H. Baumann 1935, p. 202; Heintze 1970, p. 28; Lima 1971, pp. 236 ff.; diviner's basket: H. Baumann 1935, p. 202; bird and snake: ibid., p. 202; Lima 1971, p. 238, 260; tooth, village guard and masks: H. Baumann 1935, p. 203; Lima 1971, pp. 221, 256.
10. Lima 1971, pp. 254 ff.
11. Ibid., pp. 252 ff. – frames of this sort were also widespread among the neighbouring peoples; cf., for example, Neyt 1982, ills 85–92; Thiel 1984, ill. 116–23.
12. H. Baumann 1935, pp. 204 f.
13. Lima 1971, pp. 207–13.
14. Ibid., ills 142–6, 153.
15. H. Baumann 1935, p. 204; Hauenstein 1961, p. 144.
16. H. Baumann 1935, p. 205; Lima 1971, pp. 287 f.
17. Lima 1967, pp. 142–50.
18. Lima 1971, ills 142–51, 153.
19. Bastin 1961a, ill. 12.
20. Bastin 1961b, ill. 4. On the position of the *hamba* figures in the art of the Cokwe cf. Lima 1971, especially pp. 355 ff.; cf. also Brain 1980, pp. 35–43.
21. White 1949, p. 330.
22. Ibid., p. 329; 1961, p. 50.
23. Gehlen 1965, p. 20.
24. Einstein 1915, p. vii.
25. Ibid., p. xv.
26. Cf. Blumenberg 1957. Blumenberg points to Breitinger's *Critische Dichtkunst* of 1740, in which the notion of "creative man" is formulated in analogy to the Aristotelian formula: "The poet finds himself in the condition of God *before* the creation of the world, faced with the infinity of the possible from which he may choose: thus [...] poetry is 'an imitation of the creation and nature, not only in the real, but also the possible'" (Blumenberg 1957, pp. 281 f.).
27. As Franz Marc, for instance, reported: "Trees, flowers, earth, with each year everything revealed more and more ugly sides to me which repelled my feelings, until suddenly I at last became aware of the ugliness and impurity of nature." And, even more succinct, Raoul Dufy: "Nature, my good man, is a hypothesis . . . " (quoted in Blumenberg 1957, p. 282).
28. Field 1948, p. 44. Cf. also Davies 1956, p. 149; Cole and Ross 1978, p. 125.
29. Meyer 1981, p. 124.
30. Himmelheber 1972, p. 261; cf. also 1960, p. 48.
31. Meyer 1981, p. 124.

32. Meneghini 1972, p. 47.
33. Fischer and Himmelheber 1976, pp. 156–68.
34. Himmelheber 1960, p. 47.
35. E.g. Fischer and Himmelheber 1976, pp. 149 ff.
36. Vogel 1973. Nowadays such figures are often shown in fashionable dress; cf. Ravenhill 1980.
37. Himmelheber 1972, pp. 286 f.
38. Fischer and Homberger 1985, p. 204.
39. Lima 1967, pp. 142–50; Bastin 1984, p. 44.
40. Fischer 1970, pp. 30 ff.
41. Lips 1937; 1983.
42. Cf., for example, Krieger 1965–69, III, ills 292–5.
43. Worringer 1953, pp. 37, 41, 42, 46, 49.
44. Ibid., p. 50.
45. Duerden 1977, p. 153.
46. Cf. Bugner 1976.
47. Fagg 1970, ills 23, 17; Ben-Amos 1980, ill. 86.
48. Cole and Ross 1978, ills 367, 368, p. 189.
49. Datta 1972, p. 313.
50. Preston 1975, p. 38.
51. Christensen 1952, pp. 113 f.
52. Ibid., p. 111.
53. Preston 1975, p. 69.
54. Cole and Ross 1978, p. 201; plate XVII.
55. Ibid., ill. 372.
56. McLeod 1981, p. 181.
57. The customary meaning of allegory in European art, as the representation of a generality in human form, is not meant here.
58. McLeod 1981, ill. p. 100.
59. Krieger 1965–69, I, ill. 33.
60. Cole and Ross 1978, pp. 170–79.
61. McLeod 1981, p. 67; Debrunner 1961, pp. 123 & ills 5, 21, 23, 28.
62. McLeod 1981, ill. p. 174, ill. p. 70.
63. Ibid., pp. 71, 175.
64. E.g. Norris presumes that the figures from Jahn 1983, ills 44, 45, 51, 54, stood in anti-witchcraft shrines (Norris 1983, pp. 62 f.).
65. Warren 1976, p. 34; ill. 6.23.
66. Jahn 1980, ill. 46; Warren 1976, ills 6.24, 25.

6. The Guinea Coast and the woman from the water

1. Ittmann 1957, pp. 141, 144.
2. Ibid., p. 176.
3. Ibid., especially pp. 137, 163 f., 175.
4. Ibid., p. 149.
5. Ibid., pp. 155 f.
6. Ibid., pp. 139 f.

7. Ibid., p. 169.
8. Ibid., p. 167.
9. Ibid., p. 145, footnote.
10. Harris and Sawyerr 1968, pp. 39 ff.
11. Westermann 1921, pp. 225 f.
12. Laubscher 1937, pp. 1 ff., 32 f.
13. Harris and Sawyerr 1968, p. 44; Laubscher 1937, p. 1.
14. Dupré 1982, p. 382.
15. Fraser 1972, p. 269; Witte 1982.
16. Westermann 1912, pp. 156 f.
17. Gelfand 1962, pp. 147 f.
18. Ogrizek 1981–82; 1982.
19. Laubscher 1937, p. 6; Ogrizek 1981–82; 1982; Wintrob 1970. For an interpretation cf. Duerr 1984, p. 227.
20. Cf. Duchâteau 1980, pp. 56 f.; Görög-Karady 1976, pp. 218 f.
21. Ittmann 1957, p. 141; Gray 1969, p. 174.
22. Paxson 1983, pp. 418 f.
23. Fraser 1972, ill. 14.10.
24. Cole and Ross 1978, ill. 369.
25. Salmons 1977, p. 13.
26. Cole 1982; Jones 1984, pp. 82 ff.; Talbot 1932, p. 93. Herrmann Baumann interpreted a *mbari* copy of this sort as a "Cretan snake goddess", seeing in it evidence of "old Mediterranean" influences in western Africa (H. Baumann 1940, pp. 68 f.). Kunz Dittmer also interpreted copies of the "snake-tamer" made by the Ibibio as "a female deity which is simultaneously a fertility, moon and water goddess" (Dittmer 1966, p. 36, ill. 33).
27. Salmons 1977, p. 11; for the *mammywater* cult of the Igbo cf. also Jell and Jell-Bahlsen 1981; Jell-Bahlsen 1985.
28. Till 1983, p. 238; Jahn 1983, ill. 124; Kasfir 1982, p. 51.
29. Harris 1930, p. 330; Pâques 1964, p. 585 and ill. 17.
30. Himmelheber 1965, p. 116; Fischer and Homberger 1985, ills 133, 132; Himmelheber 1965, ill. 3.5.
31. Fischer and Himmelheber 1976, ill. 230; Holas 1949, ill. 2; 1952, ill. 184.
32. Szombati-Fabian and Fabian 1976, ills 7–10; Fabian 1978, ill. 1; Fabian and Szombati-Fabian 1980, ills 5, 12, 13; Eckhardt 1979, ills 128–30, 242–52. It is in keeping with the modernity of *mammywater* that she could also be turned into a figure in a film, as in *La cage*, made in Gabun with Marina Vlady as Mammy Watta; cf. Faucher 1963.
33. Reik 1923; Wintrob 1970, p. 151.
34. Thiel 1984, ill. 98; Krieger 1965–69, III, ill. 167.
35. Firth 1973, p. 410.
36. Spieth 1911, p. 302.
37. Spieß 1910, p. 13, ill. 5.
38. Weise 1984, p. 64, footnote 2.
39. Spieth 1911, pp. 133 f.; Wendl 1986, p. 6.
40. Wendl 1986, pp. 5 f.
41. Chesi 1979, ill. p. 245; 1983, ills pp. 303–305.
42. Wendl 1986, ill. 2.
43. Chesi 1979, ill. p. 192 bottom right.

44. Wendl 1986, ill. 4.
45. Chesi 1979, ill. 5.85, ill. p. 237 top; Wendl 1986, p. 101, ills 6–8.

7. Trans-Saharan comparisons of mimesis

1. Weißhaupt 1979, pp. 82, 86.
2. König 1984, p. 25.
3. Cf. Kramer 1985.
4. Malinowski 1954, p. 94; 1981, p. 15.
5. Lewis 1986, p. 6.
6. Turner 1982, p. 90.
7. Ibid., pp. 96 f.
8. Ibid., p. 93.
9. Auerbach 1982.
10. Ibid., p. 439.
11. In many respects modern ethnography appears to be a continuation of such studies; but their modes of depiction only rarely approximate those of literature (such as, for instance, Evans-Pritchard 1974).
12. Auerbach 1982, p. 514.

Bibliography

Ardener, Edwin, 1972. "Belief and the Problem of Women", in *The Interpretation of Ritual*, ed. J.S. La Fontaine, London.

Auerbach, Erich, 1982 (1946). *Mimesis. Dargestellte Wirklichkeit in der abendländischen Literatur*, Berne and Munich.

Bastian, Adolf, 1874. *Die deutsche Expedition an die Loango-Küste*, 2 vols, Jena.

Bastin, Marie-Louise, 1961a. "Art décoratif Tshokwe" (= *DIAMANG, Publicaçoes Culturais* 55), Lisbon.

Bastin, Marie-Louise, 1961b. "Quelques oeuvres Tshokwe des musées et collections d'Allemagne et de Scandinavie", *Africa-Tervuren* 7.

Bastin, Marie-Louise, 1984. "Ritual Masks of the Chokwe", *African Arts* 7 (4).

Baumann, Herrmann, 1935. *Lunda. Bei Bauern und Jägern in Inner-Angola*, Berlin.

Baumann, Herrmann, 1936. *Schöpfung und Urzeit des Menschen im Mythus afrikanischer Völker*, Berlin.

Baumann, Herrmann 1938. "Afrikanische Wild- und Buschgeister", *Zeitschrift für Ethnologie* 70.

Baumann, Herrmann 1940. "Die Kulturen Afrikas", in *Völkerkunde von Afrika*, ed. H. Baumann, R. Thurnwald and D. Westermann, Essen.

Baumann, Herrmann, 1975. "Die Sambesi-Angola-Provinz", in *Die Völker Afrikas und ihre traditionellen Kulturen*, ed. H. Baumann, vol. 1 (= *Studien zur Kulturkunde* 34), Wiesbaden.

Baumann, Oskar, 1891. *Usambara und seine Nachbargebiete*, Berlin.

Beattie, John, 1964. *Other Cultures*, London.

Beattie, John, 1969. "Spirit Mediumship in Bunyoro", in *Spirit Mediumship and Society in Africa*, ed. J. Beattie and J. Middleton, London.

Behrend, Heike, 1983. "Die Zeit geht krumme Wege", *Kursbuch* 73.

Beidelmann, T.O., 1963. "A Kaguru Version of the Sons of Noah", *Cahier d'études africaine* 12.

Ben-Amos, Paula, 1980. *The Art of Benin*, London.

Benz, Ernst, 1972. "Ergriffenheit und Besessenheit als Grundformen religiöser Erfahrung", in *Ergriffenheit und Besessenheit*, ed. J. Zutt, Berne and Munich.

Besmer, Fremont E., 1977. "Initiation into the Bori Cult. A Case Study in Ningi Town", *Africa* 47.

Binet, J., 1972. *Sociétés de danse chez les Fang du Gabon* (= *Travaux et Documents ORSTOM* 17), Paris.

Blackburn, R.H., 1976. "Okiek History", in *Kenya before 1900*, ed. B.A. Ogot, Nairobi.

Bleyler, Karl-Eugen, 1981. *Religion und Gesellschaft in Schwarzafrika. Sozialreligiöse Bewegungen und koloniale Situation*, Stuttgart.

Blumenberg, Hans, 1957. "'Nachahmung der Natur'. Zur Vorgeschichte der Idee des schöpferischen Menschen", *Studium Generale* 10.

Boas, Franz, 1966. *Kwakiutl Ethnography*, ed. H. Codere, New York and London.

Bosman, W., 1704. *Nauwkeurige Beschrijving van de Guinese Goud-Landen*, Utrecht.

Bourguignon, Erika, 1976. "Spirit Possession Belief and Social Structure", in *The Realm of the Extra-Human. Ideas and Actions* (= *World Anthropology*), ed. A. Bharati, The Hague and Paris.

Brain, Robert, 1980, *African Art and Society*, London.

Bucher, Hubert, 1980. *Spirits and Power. An Analysis of Shona Cosmology*, Cape Town.

Bugner, Ladislas, ed., 1976. *The Image of the Black in Western Art*, 3 vols, n.p. (Office du Livre).

Burton, W.F.P., 1961. *Luba Religion and Magic in Custom and Belief*, Tervuren.

Caillois, Roger, 1962 (1958) *Man, Play and Game*, London.

Chesi, Gert, 1979. *Voodoo. Afrikas geheime Macht*. Wörgl.

Chesi, Gert, 1983. "Voodoo", in *Colon. Das schwarze Bild vom weißen Mann*, ed. J. Jahn, Munich.

Christensen, J.B., 1952. *Double Descent among the Fanti*, New Haven (HRAF).

CinémAction, 1980. "Rouch d'hier à demain", *CinémAction* 17.

Cloudsley, Anne, 1983. *Women of Omdurman*, London.

Cohen, Hermann, 1966 (1919). *Religion der Vernunft aus den Quellen des Judentums*. Darmstadt.

Cole, Herbert M., 1982. *Mbari. Art and Life among the Owerri Igbo*, Bloomington.

Cole, Herbert M. and Aniakor, Chike C., 1984. *Igbo Art. Community and Cosmos*, Los Angeles.

Cole, Herbert M. and Ross, Doran H., 1978. *The Arts of Ghana*, University of California.

Colson, Elizabeth, 1960. *Social Organization among the Gwembe Tonga*, Manchester.

Colson, Elizabeth, 1962. *The Plateau Tonga*, Manchester.

Colson, Elizabeth, 1967. "Competence and Incompetence in the Context of Independence", *Current Anthropology* 8.

Colson, Elizabeth, 1969. "Spirit Possession among the Tonga of Zambia", in *Spirit Mediumship and Society in Africa*, ed. J. Beattie and J. Middleton, London.

Colson, Elizabeth, 1970. "The Assimilation of Aliens among Zambian Tonga", in *From Tribe to Nation in Africa*, ed. R. Cohen and J. Middleton, Scranton.

Colson, Elizabeth, 1984. "The Reordering of Experience. Anthropological Involvement with Time", *Journal of Anthropological Research* 40.

Curnow, Kathy, 1983. *The Afro-Portuguese Ivories. Classification and Stylistic Analyses of a Hybrid Art Form*, 2 vols, Ann Arbor (University Microfilms International).

Datta, Ansu, 1972. "The Fante Asafo. A Re-Examination", *Africa* 42.

Davies, Oliver, 1956. "Human Representation in Terracottas from the Gold Coast", *South African Journal of Science* 52 (6).

Debrunner, H., 1961. *Witchcraft in Ghana*, Accra.

Dittmer, Kunz, 1966. *Kunst und Handwerk in Westafrika* (= *Wegweiser zur Völkerkunde* 8), Hamburg.

Douglas, Mary, 1973. *Natural Symbols. Explorations in Cosmology*, New York.

Duchâteau, Armand, 1980. "Das Bild der Weißen in frühen afrikanischen Mythen und Legenden", in *Europäisierung der Erde*, ed. G. Klingenstein et al., Munich.

Duerden, Denis, 1977. *African Art and Literature. The Invisible Present*, London.

Duerr, Hans Peter, 1984. *Sedna oder die Liebe zum Leben*, Frankfurt a. M.

Duerr, Hans Peter, 1985 (1978). *Dreamtime, Concerning the Boundary between Wilderness and Civilization*, Oxford.

Dupré, Georges, 1982. *Un ordre et sa destruction*, Paris.

Durkheim, Émile, 1976 (1915) *The Elementary Forms of the Religious Life*, London.

Eaton, Mick, ed., 1979. *Anthropology – Reality – Cinema. The Films of Jean Rouch*, London.

Eckhardt, Ulrich, ed., 1979. *Moderne Kunst aus Afrika* (Horizonte '79), Berlin.

Einstein, Carl, 1915. *Negerplastik*, Leipzig.

Eliade, Mircea, 1951. "Einführende Betrachtungen über den Schamanismus", *Paideuma* 5.

Eliade, Mircea, 1954. *The Myth of the Eternal Return. Cosmos and History*, New York.

Eliade, Mircea, 1964 (1951). *Shamanism, Archaic Techniques of Ecstasy*, Princeton.

Ellis, A.B., 1887. *The Tshi-speaking Peoples of the Gold Coast of West Africa*, London.

Enderwitz, Susanne, 1979. *Gesellschaftlicher Rang und ethnische Legitimation*, Freiburg.

Estermann, Carlos, 1954. "Culte des esprits et magie chez les Bantous du sud-ouest de l'Angola", *Anthropos* 49.

Evans-Pritchard, E.E., 1940. *The Nuer. A Description of the Modes of Livelihood and Political Institutions of a Nilotic People*, Oxford.

Evans-Pritchard, E.E., 1956. *Nuer Religion*, Oxford.

Evans-Pritchard, E.E., 1974. *Man and Woman among the Azande*, London.

Fabian, Johannes, 1978. "Popular Culture in Africa. Findings and Conjectures", *Africa* 48.

Fabian, Johannes and Szombati-Fabian, Ilona, 1980. "Folk Art from an Anthropological Perspective", in *Perspectives on American Folk Art*, ed. I.M.G. Quimby and S.T. Swank, New York and London.

Fagg, William, 1970. *Divine Kingship in Africa*, London.

Faucher, André, 1963. *La cage. Mamy Watta*, Paris.

Faulkingham, Ralph H., 1979. *The Spirits and their Cousins. Some Aspects of Belief, Ritual, and Social Organization in a Rural Hausa Village in Niger*, Amherst.

Fernandez, James, 1982. *Bwiti. An Ethnography of the Religious Imagination in Africa*, Princeton.

Field, M.J., 1948. *Akim-Kotoku. An Oman of the Gold Coast*, London.

Field, M.J., 1960. *Search for Security. An Ethno-psychiatric Study of Rural Ghana*, London.

Field, M.J., 1969. "Spirit Possession in Ghana", in *Spirit Mediumship and Society in Africa*, ed. J. Beattie and J. Middleton, London.

Firth, Raymond, 1964. *Essays on Social Organization and Values*, London.

Firth, Raymond, 1967. *Tikopia Ritual and Belief*, London.

Firth, Raymond, 1970. *Rank and Religion in Tikopia*, London.

Firth, Raymond, 1973. *Symbols, Public and Private*, London.

Fischer, Eberhard 1970. "Selbstbildnerisches, Porträt und Kopie bei Maskenschnitzern der Dan in Liberia", *Baessler-Archiv*, N.F. 18.

Fischer, Eberhard and Himmelheber, Hans, 1976. *Die Kunst der Dan*, Zurich.

Fischer, Eberhard and Homberger, Lorenz, 1985. *Die Kunst der Guro, Elfenbeinküste*, Zurich.

Fortes, Meyer, 1945. *The Dynamics of Clanship among the Tallensi*, Oxford.

Fortes, Meyer, 1949. *The Web of Kinship among the Tallensi*, Oxford.

Fortes, Meyer, 1969. *Kinship and the Social Order*, Chicago.

Fortes, Meyer, 1975. "Strangers", in *Studies in African Social Anthropology*, ed. M. Fortes and S. Patterson, London.

Fortes, Meyer, 1983 (1959). *Oedipus and Job in West African Religion*, ed. J. Goody (= *Cambridge Studies in Social Anthropology* 48), Cambridge.

Fortes, Meyer, and Evans-Pritchard, E.E., 1940. "Introduction", in *African Political Systems*, ed. M. Fortes and E.E. Evans-Pritchard, London.

Fraser, Douglas, 1972. "The Fish-Legged Figure in Benin and Yoruba Art", in *African Art and Leadership*, ed. D. Fraser and H.M. Cole, Madison.

Frazer, James G., 1957. *The Golden Bough* (abridged version), London.

Friedrich, Adolf, 1939. *Afrikaniche Priestertümer* (= *Studien zur Kulturkunde* 6), Stuttgart.

Frobenius, Leo, 1921. *Paideuma. Umrisse einer Kultur- und Seelenlehre*, Munich.

Frobenius, Leo, 1931. *Erythräa. Länder und Zeiten des heiligen Königsmordes*, Berlin and Zurich.

Frobenius, Leo, 1933. *Kulturgeschichte Afrikas. Prolegomena zu einer historischen Gestaltlehre*, Zurich.

Frobenius, Leo, 1938 (1932). *Schicksalskunde*, Weimar.

Fry, Peter, 1976. *Spirits of Protest. Spirit Mediums and the Articulation of Consensus among the Zezuru of Southern Rhodesia (Zimbabwe)* (= *Cambridge Studies in Social Anthropology* 14), Cambridge.

Gangambi, Muyaga, 1974. *Les masques Pende de Gatundo* (= CEEBA, s. II, 22), Bandundu.

Garbett, G. Kingsley, 1969. "Spirit Mediums as Mediators in Korekore Society", in *Spirit Mediumship and Society in Africa*, ed. J. Beattie and J. Middleton, London.

Garbutt, H.W., 1909. "Native Witchcraft and Superstition in South Africa", *Journal of the Royal Anthropological Institute* 39.

Gehlen, Arnold, 1965. *Zeit-Bilder. Zur Soziologie und Ästhetik der modernen Malerei*, Frankfurt a. M. and Bonn.

Gelfand, Michael, 1954. "Chikwambo (Runhare)", *Nada* 31.

Gelfand, Michael, 1959. *Shona Ritual*, Cape Town.

Gelfand, Michael, 1962. *Shona Religion*, Cape Town.

Gelfand, Michael, 1973. *The Genuine Shona*, n.p. (Mambo Press).

Görög-Karady, Veronika, 1976. *Noirs et Blancs, leur image dans la littérature orale africaine* (= *Tradition Orale* 23), Paris.

Gray, Robert, 1969. "The Shetani Cult among the Segeju of Tanzania", in *Spirit Mediumship and Society in Africa*, ed. J. Beattie and J. Middleton, London.

Gwassa, G.C.K., 1972. "Kinjikitile and the Ideology of Maji", in *The Historical Study of African Religion*, ed. T.O. Ranger and I.N. Kimambo, London.

Haberland, Eike, 1960. "Besessenheitskulte in Süd-Äthiopien", *Paideuma* 7.

Harris, Grace, 1957. "Possession 'Hysteria' in a Kenyan Tribe", *American Anthropologist* 59.

Harris, P.G., 1930. "Notes on Yauri (Sokoto Province), Nigeria", *Journal of the Royal Anthropological Institute* 60.

Harris, W.T. and Sawyerr, Harry, 1968. *The Springs of Mende Belief and Conduct*, Freetown.

Hauenstein, Alfred, 1961. "La corbeille aux osselets divinatories des Tchokwe (Angola)", *Anthropos* 56.

Hegel, G.W.F., 1955. *Die Vernunft in der Geschichte*, ed. J. Hoffmeister, Hamburg.

Heintze, Beatrix, 1970. *Besessenheits-Phänomene im Mittleren Bantu-Gebiet* (= *Studien zur Kulturkunde* 25), Wiesbaden.

Herskovits, Melville J., 1938. *Dahomey. An Ancient West African Kingdom*, vol. II, New York.

Heurgon, Jacques, 1977. *Die Etrusker*, Stuttgart.

Heusch, Luc de, 1962. "Cultes de possession et religions initiatiques de salut en Afrique" in *Religion de salut* (= *Annales de Centre d'Etudes des Religions* 2), Brussels.

Himmelheber, Hans, 1960. *Negerkunst and Negerkünstler*, Brunswick.

Himmelheber, Hans, 1965. "Schmuckhalt überladene Negerplastik", *Paideuma* 11.

Himmelheber, Hans, 1972. "Das Porträt in der Negerkunst", *Baessler-Archiv*, N.F. 20.

Himmelheber, Hans and Himmelheber, Ulrike, 1972. "Hysterische Erscheinungen bei einem Maskenauftritt der Dan (Elfenbeinkuste)", *Ethnologische Zeitschrift Zürich* 2.

Hofmayr, P. Wilhelm, 1911. "Religion der Schilluk", *Anthropos* 6.

Hofmayr, P. Wilhelm, 1925. *Die Schilluk*, 2 vols, Mödling b. Vienna.

Holas, B., 1949. "Les monstres du Cavally", *Notes Africaine* 41.

Holas, B., 1952. "Mission dans l'est Libérien"; *Mémoires de l'IFAN* 14.

Horton, Robin, 1963. "The Kalabari Ekine Society. A Borderland of Religion and Art", *Africa* 33.

Horton, Robin, 1965. *Kalabari Sculpture*, Department of Antiquitics, Nigeria.

Horton, Robin 1969. "Types of Spirit Possession in Kalabari Religion", in *Spirit Mediumship and Society in Africa*, ed. J. Beattie and J. Middleton, London.

Horton, Robin, 1970. "African Traditional Thought and Western Science", in *Rationality*, ed. B.R. Wilson, Oxford.

Horton, Robin, 1983. "Social Psychologies: African and Western", in M. Fortes, *Oedipus and Job in West African Religion*, ed. J. Goody (= *Cambridge Studies in Social Anthropology* 48), Cambridge.

Hugo, H.C., 1935. "The Mashona Spirits", *Nada* 13.

Ibrahim, Hayder, 1979. *The Shaiqiya* (= *Studien zur Kulturkunde* 49), Wiesbaden.

Ittmann, Johannes, 1957. "Der kultische Geheimband djengu an der Kameruner Küste", *Anthropos* 52.

Jahn, Jens, ed., 1980. *Colonne. Colon. Kolo* (Galerie Fred Jahn), Munich.

Jahn, Jens, ed., 1983. *Colon. Das schwarze Bild vom weißen Mann*, Munich.

Jedrej, M.C., 1976. "Structural Aspects of a West African Secret Society", *Journal of Anthropological Research* 32.

Jeffreys, M.D.W., 1951. "The Ekong Players", *Eastern Anthropologist* 5.

Jell, Georg and Jell-Bahlsen, Sabine 1981. *Divine Earth – Divine Water*, Film.

Jell-Bahlsen, Sabine 1985. *Mami Wata. Water Rites of Healing in Nigeria*, Ms.

Jones, G.I., 1984. *The Art of Eastern Nigeria*, Cambridge.

Junod, Henri A., 1913. *The Life of a South African Tribe*, vol. II, Neuchatel.

Kahle, Paul 1912. "Zar-Beschwörungen in Egypten", *Der Islam* 3.

Kasfir, Sidney L., 1982. "Anjenu. Sculpture for Idoma Water Spirits", *African Arts* 15 (4).

Kecskési, Maria, 1982. *Kunst aus dem alten Afrika*, Innsbruck and Frankfurt a.M.

Kibango, Ngolo, 1976. *Minganji. Danseurs des masques Pende* (= CEEBA, s. II), Bandundu.

Kjersmeier, Carl, 1936. *Centre de style de la sculpture nègre africain*, vol. III, *Congo Belge*, Copenhagen and Paris.

Klunzinger, C.B. 1877. *Bilder aus Oberägypten*, Stuttgart.

König, René, 1984. "Soziologie und Ethnologie", in *Ethnologie als Sozialwissenschaft*, ed. E.W. Müller, R. König, K.-P. Koepping and P. Drechsel (= *Kölner Zeitschrift für Soziologie und Sozialpsychologie*, Sonderheft 26), Opladen.

Koritschoner, Hans, 1936. "Ngoma ya Sheitani. An East African Native Treatment for Psychical Disorder", *Journal of the Royal Anthropological Institute* 66.

Kramer, Fritz, 1983. *Bikini oder die Bombardierung der Engel*, with contributions from A. Bentert et al., Frankfurt a. M.

Kramer, Fritz W., 1984. "Notizen zur Ethnologie der *passiones*", in *Ethnologie als Sozialwissenschaft*, ed. E.W. Müller, R. König, K.-P. Koepping and P. Drechsel (= *Kölner Zeitschrift für Soziologie und Sozialpsychologie*, Sonderheft 26), Opladen.

Kramer, Fritz W., 1985. "Empathy. Reflections on the History of Ethnology in Pre-Fascist Germany", *Dialectical Anthropology* 9.

Kramer, Fritz W., 1986. "Die Aktualität des Exotischen. Der Fall der 'Kulturmorphologie' von Frobenius und Jensen", in *Die Restauration der Götter*, ed. R. Faber and R. Schlesier, Würzburg.

Krapf, Johann Ludwig, 1858. *Reisen in Ostafrika*, Kornthal and Stuttgart.

Krieger, Kurt, 1965–69. *Westafrikanische Plastik*, 3 vols, Berlin.

Krieger, Kurt, 1967. "Notizen zur Religion der Hausa", *Paideuma* 13.

Laubscher, B.J.F., 1937. *Sex, Custom and Psychopathology. A Study of South African Pagan Natives*, London.

Leach, Edmund R., 1961. "Time and False Noses", in E.R. Leach, *Rethinking Anthropology* (= *London School of Economics Monographs on Social Anthropology* 22), University of London.

Leiris, Michel, 1958. *La Possession et ses aspects théâtraux chez les Ethiopiens de Gondar*, Paris.

Lewis, I.M., 1969. "Spirit Possession in Northern Somaliland", in *Spirit Mediumship and Society in Africa*, ed. J. Beattie and J. Middleton, London.

Lewis, I.M., 1971. *Ecstatic Religion*, Harmondsworth.

Lewis, I.M., 1983 "Die Berufung des Schamanen", in *Sehnsucht nach dem Ursprung*, ed. H.P. Duerr, vol. 1, Frankfurt a.m.; revised version in Lewis 1986, below.

Lewis, I.M., 1986. *Religion in Context: Cults and Charisma*, Cambridge.

Lienhardt, Godfrey, 1961. *Divinity and Experience. The Religion of the Dinka*, Oxford.

Lima, Mesquitela, 1967. *Os akixi (mascarados) do Nordeste de Angola* (= *Publicaçoes Culturais* 70), Lisbon.

Lima, Mesquitela, 1971. *Fonctions des figurines de culte hamba dans la société et dans la culture Tshokwé (Angola)*, Luanda.

Lincoln, Bruce, 1983. "Der politische Gehalt des Mythos", in *Alcheringa oder die beginnende Zeit*, ed. H.P. Duerr, Frankfurt a. M.

Lindblom, Gerhard, 1920. *The Akamba in British East Africa*, Uppsala.

Lips, Julius E., 1966 (1937). *The Savage Hits Back*, New York.

Lips, Julius E., 1983. *Der Weiße im Spiegel der Farbigen*, Munich.

Littmann, Enno, 1952. *Arabische Geisterbeschwörungen aus Ägypten* (= *Sammlung orientalischer Arbeiten* 19), Leipzig.

McLeod, Malcolm, 1975. "Anti-Witchcraft Cults in Modern Asante", in *Changing Social Structure in Ghana*, ed. J. Goody, London.

McLeod, Malcolm, 1981. *The Asante*, London.

Magubane, Bernard, 1971. "A Critical Look at Indices Used in the Study of Social Change in Colonial Africa", *Current Anthropology* 12 (4–5).

Malinowski, Bronislaw, 1954. *Magic, Science and Religion*, New York.

Malinowski, Bronislaw, 1935. *Coral Gardens and their Magic*, London.

Mauss, Marcel, 1975 (1938). "A Category of the Human Mind: The Concept of the Person and the 'Ego'", in M. Mauss, *Sociology and Psychology*, vol. 2, London.

Meneghini, Mario, 1972. "The Bassa Mask", *African Arts* 6 (1).

Messenger, John C., 1971. "Ibibio Drama", *Africa* 41.

Messing, Simon D., 1958. "Group Therapy and Social Status in the Zar Cult of Ethiopia", *American Anthropologist* 60.

Meyer, Piet, 1981. *Kunst und Religion der Lobi*, Zurich.

Minkus, Helaine, K., 1980. "The Concept of Spirit in Akwapim Akan Philosophy", *Africa* 50.

Mitchell, J.C., 1956. *The Kalela Dance. Aspects of Social Relationships among Urban Africans in Northern Rhodesia* (= *The Rhodes-Livingstone Papers* 27) Manchester.

Morkel, E.R., 1933. "Spiritualism amongst the Wabudya", *Nada* 11.

Mudiji-Malamba, Gilombe, 1979. "Le masque Phende *giwoyo*", *Révue des Archéologie et Histoire d'Art de Louvain* 12.

Mühlmann, W.E., 1972. "Ergriffenheit und Besessenheit als kultur-anthropologisches Problem", in *Ergriffenheit und Besessenheit*, ed. J. Zutt, Berne and Munich.

Mühlmann, W.E. 1981. *Die Metamorphose der Frau. Weiblicher Schamanismus und Dichtung*, Berlin.

Munamuhega, Ndambi, 1975. *Les masques Pende de Ngudi* (= *CEEBA*, s. II), Bandundu.

Muratori, Carlo, 1936. *La tribù Lotuxo*, 2 vols (unpublished ms in the archive of the Missioni Africane dei Padre Comboniani in Verona).

Mwanzi, Henry A., 1977. *A History of the Kipsigis*, Nairobi.

Newcomer, Peter J., 1972. "The Nuer are Dinka", *Man* 7.

Neyt, François, 1982. *L'Art Holo du Haut-Kwango. Die Kunst der Holo aus dem Gebiet des Oberlaufes des Kwango. Holo Art from the Area along the Upper Course of the Kwango*, Munich.

Ngubane, Harriet, 1977. *Body and Mind in Zulu Medicine*, London.

Noble, D.S., 1961. "Demoniacal Possession among the Giryama", *Man* 61.

Norris, Edward Graham, 1983. "Colon im Kontext. Versuch einer Deutung", in *Colon. Das schwarze Bild vom weißen Mann*, ed. J. Jahn, Munich.

Ogrizek, Michel, 1981–82. "Mami Wata. Les envoûtées de la Sirène", *Cahiers ORSTOM, série Sciences Humaines* 18.

Ogrizek, Michel, 1982. "Mami Wata. De l'hystérie à la féminité en Afrique Noir", *Confrontations psychiatriques* 21.

Olbrechts, Frans M., 1946. *Plastiek van Kongo*, Antwerp and Brussels.

Onwuejeogwu, Michael, 1969. "The Cult of the Bori Spirits among the Hausa", in *Man in Africa*, ed. M. Douglas and P.M. Kaberry, London.

Ottenberg, Simon, 1972. "Humorous Masks and Serious Politics among the Afikpo Ibo", in *African Art and Leadership*, ed. D. Fraser and H.M. Cole, Madison.

Ottenberg, Simon, 1975. *Masked Rituals of Afikpo. The Context of an African Art*, Seattle and London.

Pâques, Viviana, 1964. *L'arbre cosmique dans la pensée populaire et dans la vie quotidienne du Nord-Ouest Africain*. Paris.

Parkin, David, 1970. "Politics of Ritual Syncretism. Islam among the Non-Muslim Giriama of Kenya", *Africa* 40.

Paxson, Barbara, 1983. "Mammy Water: New World Origins?", *Baessler-Archiv* N.F. 31.

Phillips, Ruth B., 1978. "Masking in Mende Sande Society Initiation Rituals", *Africa* 48.

Preston, George Nelson, 1975. "Perseus and Medusa in Africa: Military Art in Fanteland 1834–1972", *African Art* 8 (3).

Ranger T.O., 1967. *Revolt in Southern Rhodesia 1896–7. A Study in African Resistance*, London.

Ranger, T.O., 1972, "Introduction", in *The Historical Study of African Religion*, ed. T.O. Ranger and I.N. Kimambo, London.

Ranger, T.O., 1975. *Dance and Society in Eastern Africa 1890–1970*, London.

Rattray, R.P., 1916. *Ashanti Proverbs*. Oxford.

Rattray, R.P., 1923. *Ashanti*, Oxford.

Rattray, R.P., 1927. *Religion and Art in Ashanti*, Oxford.

Rattray, R.P., 1929. *Ashanti Law and Constitution*, London.

Ravenhill, Philip L., 1980. *Baule Statuary Art. Meaning and Modernization* (= *Working Papers in the Traditional Arts* 5).

Reik, Theodor, 1923. *Der eigene und der fremde Gott. Zur Psychoanalyse der religiösen Entwicklung*, Vienna.

Röschenthaler, Ute, 1985. *Die Mbuya Masken der Pende*, unpublished MA thesis, Freie Universität Berlin.

Rotberg, Robert I., ed., 1971. *Rebellion in Black Africa*, Oxford.

Rouch, Jean, 1954–55. *Les mâitres fous*, film.

Rouch, Jean, 1960. *La religion et la magie Songhay*, Paris.

Rouch, Jean, 1983. "Les mâitres fous. Protokoll des Films über das Ritual der Hauka", in *Colon. Das schwarze Bild vom weißen Mann*, ed. J. Jahn, Munich.

Rouget, Gilbert, 1980. *La musique et la transe: esquisse d'une théorie générale des relations de la musique et de la possession*, Paris.

Salmons, Jill, 1977. "Mammy Wata", *African Arts* 10 (3).

Samarin, William J., 1980. Review of Görög-Karady, *Noirs et Blancs*, *Africa* 50.

Sartre, Jean-Paul 1967. "Foreword", in F. Fanon, *The Wretched of the Earth*, Harmondsworth.

Schaar, 1917–18. "Nama-Fabeln", *Zeitschrift für Kolonialsprache* 8.

Schildkrout, Enid, 1979. "The Ideology of Regionalism in Ghana", in *Strangers in African Societies*, ed. W.A. Shack and E.P. Skinner, Berkeley.

Schnelle, Helga, 1971. *Die traditionelle Jagd Westafrikas*, Munich.

Schoffeleers, J. Matthew, 1968. *Symbolic and Social Aspects of Spirit Worship among the Mang'anja*, Doctoral Dissertation, Oxford.

Schoffeleers, J. Matthew and Linden, Ian, 1972. "The Resistance of the Nyau Societies to the Roman Catholic Missions in Colonial Malawi", in *The Historical Study of African Religion*, ed. T.O. Ranger and I.N. Kimambo, London.

Schröder, Dominik, 1953. Review of M. Eliade, *Le Chamanisme et les techniques archaiques de l'extase*, *Anthropos* 48.

Sicard, Harold von, 1967. "Das Reich Butwa-Torwa", *Paideuma* 13.

Simmel, Georg, 1908. *Soziologie*, Berlin.

Simmel, Georg, 1983 (1923). *Philosophische Kultur*, Berlin.

Simon, Artur, 1975. "Islamische und afrikanische Elemente in der Musik des Nordsudan am Beispiel des Dhikr", *Hamburger Jahrbuch zur Musikwissenschaft* 1.

Simon, Artur, 1983. "Musik in afrikanischen Besessenheitsriten", in *Musik in Afrika* (= *Veröffentlichungen des Museums für Völkerkunde Berlin*, N.F. 40), Berlin.

Siroto, Leon, 1976. *African Spirit Images and Identities*, New York.

Skene, R., 1917. "Arab and Swahili Dances and Ceremonies", *Journal of the Royal Anthropological Institute* 47.

Skinner, Elliot P., 1974. *Theoretical Perspectives on the Stranger*, Paper presented at the Conference on Strangers in Africa, Smithsonian Conference Center, Belmont, Maryland.

Sousberghe, Léon de, 1956. *Les danses rituelles mungonge et kela des ba-Pende*, Brussels.

Sousberghe, Léon de, 1959. *L'art Pende*, Brussels.

Sousberghe, Léon de, 1960. "De la signification de quelques masques Pende: *Shave* des Shona et *Mbuya* des Pende", *Zaire* 14.

Sousberghe, Léon de, 1963. *Les Pende: Aspects des structures sociales et politiques* (= *Miscellanea Ethnographica*), Tervuren.

Sousberghe, Léon de, 1981. "Gitenga: un masque des Pende", *Arts d'Afrique Noire* 37.

Southall, Aidan W., 1956. *Alur Society*, Oxford.

Southall, Aidan W., 1979. "White Strangers and their Religion in East Africa and Madagascar", in *Strangers in African Societies*, ed. W.A. Shack and E.P. Skinner, Berkeley.

Spieß, C., 1910. "Verborgener Fetischdienst unter den Evheern", *Globus* 98.

Spieth, Jakob, 1911. *Die Religion der Eweer in Süd-Togo*, Leipzig.

Sundkler, Bengt G.M., 1961 (1948). *Bantu Prophets in South Africa*, Oxford.

Sutton, J.E.G., 1976. "The Kalenjin", in *Kenya before 1900*, ed. B.A. Ogot, Nairobi.

Szombati-Fabian, Ilona and Fabian, Johannes, 1976. *Art, History and Society: Popular Painting in Shaba, Zaire* (= *Studies in the Anthropology of Visual Communications* 3).

Talbot, P. Amaury, 1932. *Tribes of the Niger Delta*, London.

Thiel, J.F., 1984. *Christliche Kunst in Afrika*, Berlin.

Thompson, Robert F., 1974. *African Art in Motion*, Los Angeles.

Till, Wolfgang, 1983. "Colon im Puppenspiel", in *Colon. Das schwarze Bild vom weißen Mann*, ed. J. Jahn, Munich.

Torday, Emil and Joyce, T.A., 1922. *Notes ethnographiques sur les populations habitant les bassins du Kasai et du Kwango oriental*, Brussels.

Tremearne, A.J.N., 1914. *The Ban of the Bori*, London.

Trowell, Margaret, 1967. "Form und Inhalt der afrikanischen Kunst", in M. Trowell and H. Nevermann, *Afrika und Ozeanien*, Baden-Baden.

Turner, Victor W., 1969. *The Ritual Process*, New York.

Turner, Victor W., 1982. *From Ritual to Theatre*, New York.

Vansina, Jan, 1965 (1961). *Oral Tradition*, London.

Vayda, Laszlo, 1964 (1959). "Zur phaseologischen Stellung des Schamanismus", in *Religionsethnologie*, ed. C.A. Schmitz, Frankfurt a. M.

Vedder, H., 1923. *Die Bergdama*, I, Hamburg.

Velten, Carl, 1903. *Sitten und Gebräuche der Suaheli*, Göttingen.

Vogel, Susan M., 1973. "People of Wood. Baule Figure Sculpture", *Art Journal* 33.

Ward, Barbara E., 1956. "Some Observations on Religious Cults in Ashanti", *Africa* 26.

Warren, Denis M., 1976. "Bono Shrine Art", *African Arts* 9 (2).

Weber, Max, 1968. *Soziologie, weltgeschichtliche Analysen, Politik*, ed. J. Winckelmann, Stuttgart.

Weber, Max, 1976 (1923). *Gesammelte Aufsätze zur Religionssoziologie*, vol. III, *Das antike Judentum*, Tübingen.

Weise, Daniela, 1984. *Zur Entwicklung der Kultgruppen bei den Ewe im 20. Jahrhundert*, Unpublished MA dissertation, University of Munich.

Weißhaupt, Winfried, 1979. *Europa sieht sich mit fremdem Blick*, part 1, Frankfurt a. M.

Wendl, Tobias, 1986. *Le Culte de Mami Wata à travers des entretiens avec une soixantaine de ses adeptes*, Ms.

Werth, E., 1915. *Das deutsch-afrikanische Küstenland*, Berlin.

Westermann, Diedrich, 1912. *The Shilluk People; their Language and Folklore*, Berlin.

Westermann, Diedrich, 1921. *Die Kpelle. Ein Negerstamm in Liberia*, Göttingen and Leipzig.

Weston, Bonnie E., 1984. "Northwestern Region", in *Igbo Arts. Community and Cosmos*, ed. H.M. Cole and C.C. Aniakor, Los Angeles.

White, C.M.N., 1949. "Stratification and Modern Changes in an Ancestral Cult", *Africa* 19.

White, C.M.N., 1961. *Elements in Luvale Beliefs and Rituals* (= Rhodes-Livingstone Papers 32), Manchester.

Wilks, Ivor, 1975. *Asante in the Nineteenth Century* (= African Studies Series 13), Cambridge.

Wintrob, Ronald M., 1970. "Mammy Water. Folk Beliefs and Psychotic Elaborations in Liberia", *Canadian Psychiatric Association Journal* 15.

Wipper, Audrey, 1977. *Rural Rebels. A Study of Two Protest Movements in Kenya*, Oxford.

Witte, Hans, 1982. "Fishes of the Earth. Mud-Fish Symbolism in Yoruba Iconography", *Visible Religion* 1.
Worringer, Wilhelm, 1953 (1907). *Abstraction and Empathy*, London.
Zenkovsky, S., 1950. "Zar and Tambura as Practised by the Women of Omdurman", *Sudan Notes and Records* 31.
Zutt, Jürg, 1972. "Ergriffenheit, Erfülltheit und Besessenheit im psychiatrischen Erfahrungsbereich", in *Ergriffenheit und Besessenheit*, ed. J. Zutt, Berne and Munich.

Sources of illustrations

Fig. 1. Wood, 55 cm; private collection; from Jahn 1983, ill. 52.

Fig. 2. Wood, 60 cm; Galerie Fred and Jens Jahn, Munich; from Jahn 1983, ill. 53.

Fig. 3. Photo M. Fortes; from Fortes 1945, frontispiece.

Fig. 4. Wood with beads, 39.4 cm; private collection; from Cole and Ross 1978, ill. 205.

Fig. 5. Photo M.J. Field; from Field 1969, plate 5.

Fig. 6. Photo T. Wendl.

Fig. 7. Photo T. Wendl.

Fig. 8. Photo M. Gelfand; from Gelfand 1959, p. 136.

Fig. 9. Photo M. Gelfand; from Gelfand 1962, p. 103.

Fig. 10. Photo M. Gelfand; from Gelfand 1973, p. 144.

Fig. 11. Photo A.J.N. Tremearne; from Tremearne 1914, ill. 48.

Fig. 12. Photo A.J.N.Tremearne; from Tremearne 1914, ill. 47.

Fig. 13. Postcard.

Fig. 14. From Jean Rouch, *Les maîtres fous*; reproduced from Jahn 1983, p. 226.

Fig. 15. From Jean Rouch, *Les maîtres fous*; reproduced from Jahn 1983, p. 226.

Fig. 16. Ivory, 7.5 cm; Museum für Völkerkunde, Berlin; from Krieger 1965–69, III, ill. 193.

Fig. 17. Photo A. Held; from Trowell 1967, p. 23.

Fig. 18. Wood with raffia, 28 cm; Museum für Völkerkunde, Munich; from Kecskési 1982, ill. 321.

Fig. 19. Wood; Koninklijk Museum voor Midden-Afrika, Tervuren; from Sousberghe 1959, ill. 12.

Fig. 20. Wood; from Einstein 1915, ill. 104.

Fig. 21. Wood, 32.6 cm; Koninklijk Museum voor Midden-Afrika, Tervuren; from Sousberghe 1959, ill. 48.

Fig. 22. Wood; Collection des Pères Jesuites, Louvain; from Sousberghe 1960, ill. 4.

Fig. 23. Ivory. 6.1, 6.4 and 7 cm; by kind permission of the Museum für Völkerkunde, Berlin.

Fig. 24. Wood, 27.9 cm; Koninklijk Museum voor Midden-Afrika, Tervuren; from Sousberghe 1959, ill. 33.

Fig. 25. Map from Frobenius 1933, p. 210.

Fig. 26. Map from Frobenius 1933, p. 297.

Fig. 27. Photo G.I. Jones; from Jones 1984, ill. 9.

Fig. 28. Wood, 34 cm; private collection; from Jahn 1983, ill. 120.

Fig. 29. Wood; from Jones 1984, ill. 74.

Fig. 30. Wood; Pitt Rivers Museum, Oxford; from Horton 1965, ill. 27.

Fig. 31. Wood; British Museum, London; from Trowell 1967, ill. p. 190.

Fig. 32. Wood, 26 cm; Museo do Dundo, Angola; from Lima 1971, ill. 212.

Fig. 33. Wood; Museo do Dundo, Angola; from Lima 1971, ill. 142.

Fig. 34. 18.4 and 18.2 cm; Museo do Dundo, Angola; from Lima 1971, ill. 145.

Fig. 35. 13.5 and 13.2 cm; Museo do Dundo, Angola; from Lima 1971, ill. 146.

Fig. 36. Wood 22.1 cm; Museo do Dundo, Angola; from Bastin 1961a, ill. 12.

Fig. 37. Sammlung Kjersmeier, with kind permission of the National Museum, Kopenhagen.

Fig. 38. Wood, 52 cm; Collection Josef Muller, Solothurn; from Fischer and Himmelheber 1976, ill. 140.

Fig. 39. Wood, 61 cm; private collection; from Fischer and Himmelheber 1976, ill. 145.

Fig. 40. Ivory, 25 cm; British Museum, London; from Fagg 1970, ill. 17.

Fig. 41. Photo T. Wendl.

Fig. 42. Photo H.M. Cole; from Cole and Ross 1978, plate. XVII.

Fig. 43. Photo T. Wendl.

Fig. 44. Wood, 40 cm; Museum für Völkerkunde, Berlin; from Krieger 1965–69, I, ill. 33.

Fig. 45. Wood, 96 cm; private collection; from Jahn 1983, ill. 81.

Fig. 46. Print.

Fig. 47. Photo M.I. Okpara; from *Nigeria Magazine*, October 1960, "Nigeria 1960", Special Independence Issue.

Fig. 48. Wood, 58.2 cm; private collection; from Fischer and Homberger 1985, ill. 133.

Fig. 49. Ivory, 8.5 cm; Museum für Völkerkunde, Berlin; from Krieger 1965–69, III, ill. 167.

Fig. 50. Photo T. Wendl; from Wendl 1986, ill. 4.

Fig. 51. Photo T. Wendl.

Fig. 52. Photo T. Wendl.

Index

abstraction and empathy, 198–204
Abstraction and Empathy (Worringer), 199
Afikpo, 168 169; comedies, 165–7
Akan: spirit, 64
allegory: art, 208, 210; sculpture, 210–16
Alur, 15–16; elected masters, 17
Anang, 167–8; comedies, 165
ancestors: abstraction and empathy, 200;
 Cokwe's personal memories, 181;
 Freudian analysis, 50; Kalabari, 172,
 173, 176–8; morality, 83–4; occasional
 art, 202; pole, 181–2; sculptures, 172,
 176–8; spirits, 65, 68; Tallensi, 12–13
animals, 36; hunter's dance, 120;
 mimesis, 251; *shaves*, 78–9
anthropology *see* ethnology
Arabs: spirits, 99
art: abstraction and empathy, 198–204;
 allegorical, 208, 210–16; diversity in
 Africa, 201–2; ephemeral, 252;
 Europeans discover Africa, 192–3,
 198, 248; mythical, 227–8; new
 realism, 253; verisimilitude, 248
Asante: allegorical art, 210–16;
 assimilation, 13–14; Freudian analysis,
 50–1; group v. individual, 54–5;
 human microcosm, 37; landscape, 57;
 outsiders, 6, 7; portray outsiders, 1;
 strangers, 72; witches, 38–41
assimilation, 7; levelling-out of culture,
 255, 257; mimesis, 248–52; slaves, 13;
 Tonga, 118–19
Auerbach, Erich, 253–5; mimesis, ix

bakologo, 31, 33–5, 45; ancestors v. deities,
 52
de Balzac, Honoré, 254
Bantu: spirits, 66–7; strangers, 72
Bassa, 194–5
Bastian, Adolf, 243
Baule: erotic portraits, 195–7; snake-
 tamers, 229
Baumann, Herrmann, 27, 182; manism,
 66, 72
Baumann, Oscar, 98
Beattie, John, 91
Belgians: duplicated in the Congo,
 133–4
Bemba, 27
beni ngoma, 130–32, 205
Benin: Portuguese in art, 203–4
Benz, Ernst: moved v. possessed, 60, 61
Bergdama: choice myths, 19–20, 22
Boas, Franz, 156
bori cult, 101–10, 133; Islam, 106–9;
 snake tamers, 229; women, 107–10
Bosman, W., 208
Bourguignon, Erica, 90
Britain: and Shona, 73

Caillois, Roger, 157, 158
charismatic cults, 128–37
children: virtue, 83
Christianity, 73; art, 227; breaking the
 taboos, 136–7; charismatic possession,
 129; Cokwe images, 184–5; comedies,
 167, 170; identity of Jesus, 232–4;